# WIDE ANGLE

## NATIONAL GEOGRAPHIC
## GREATEST PLACES

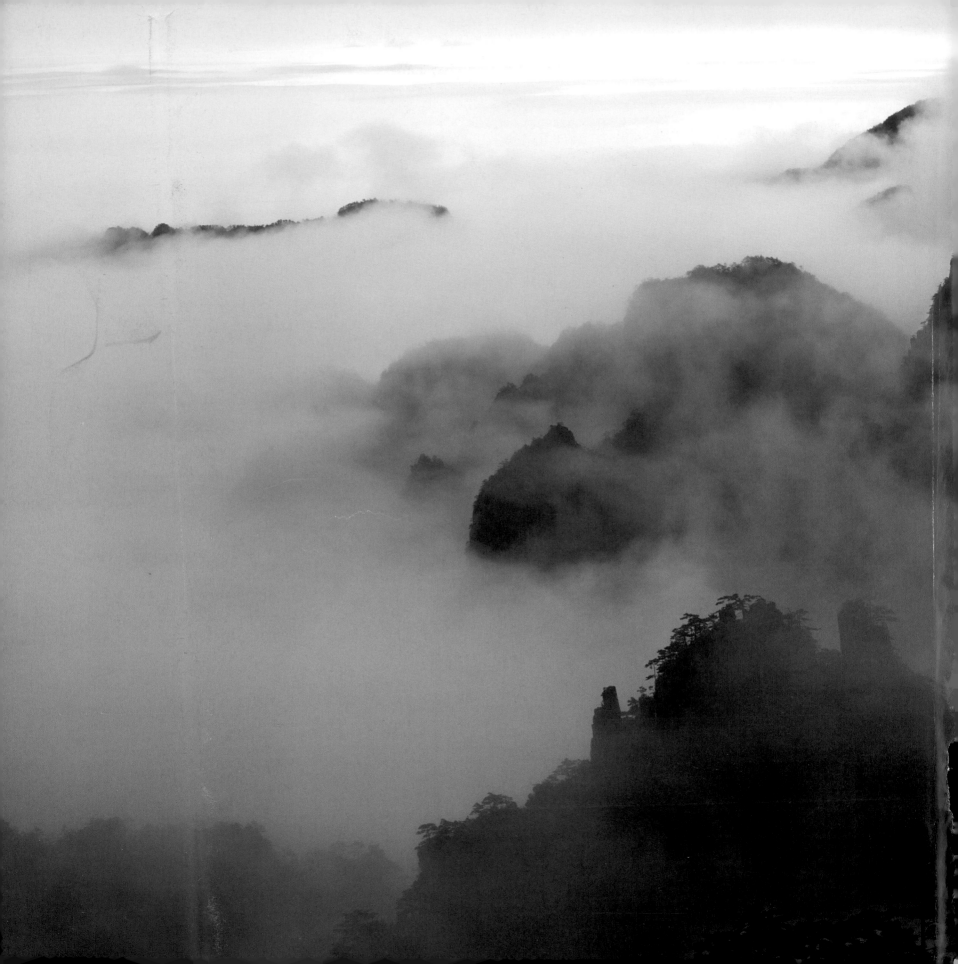

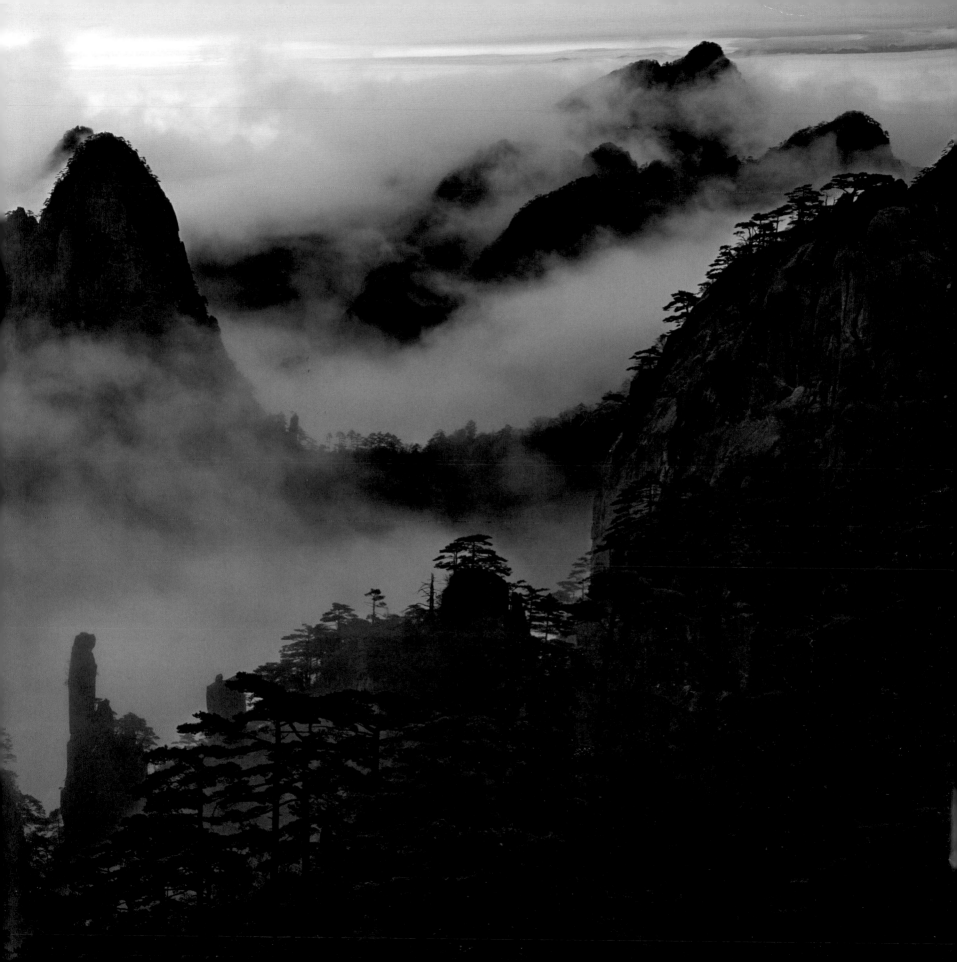

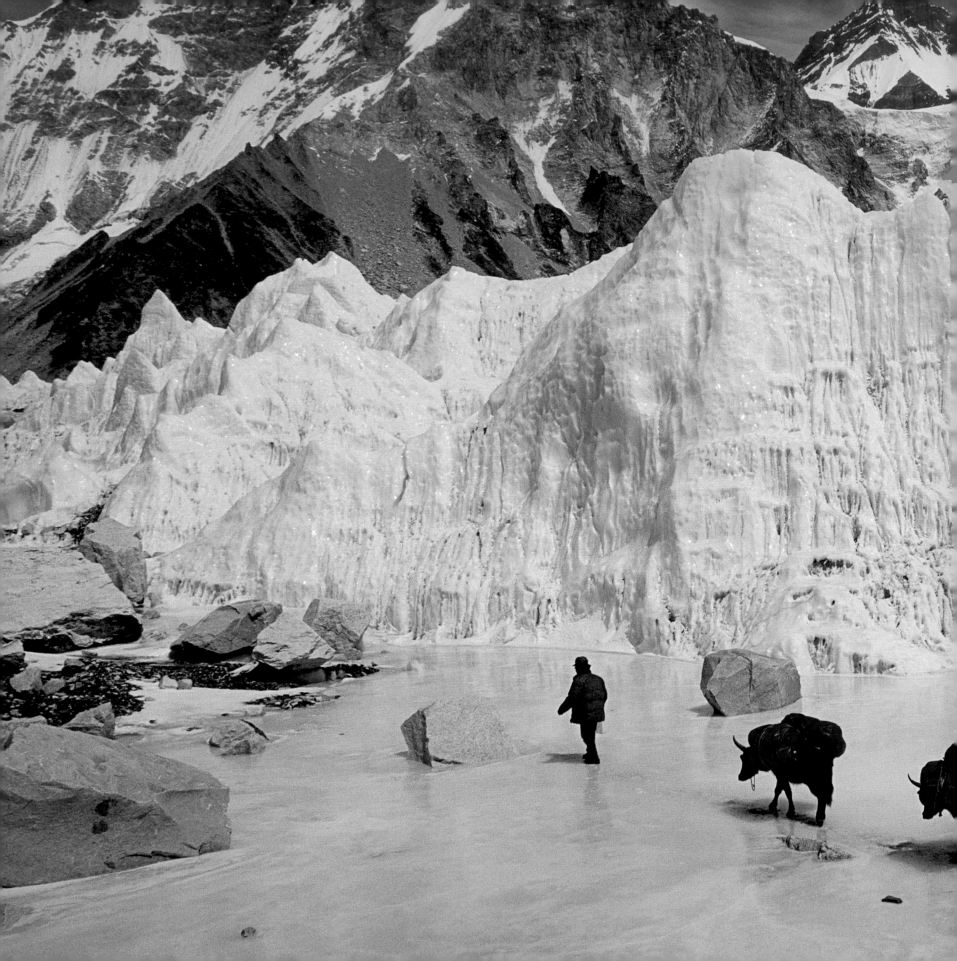

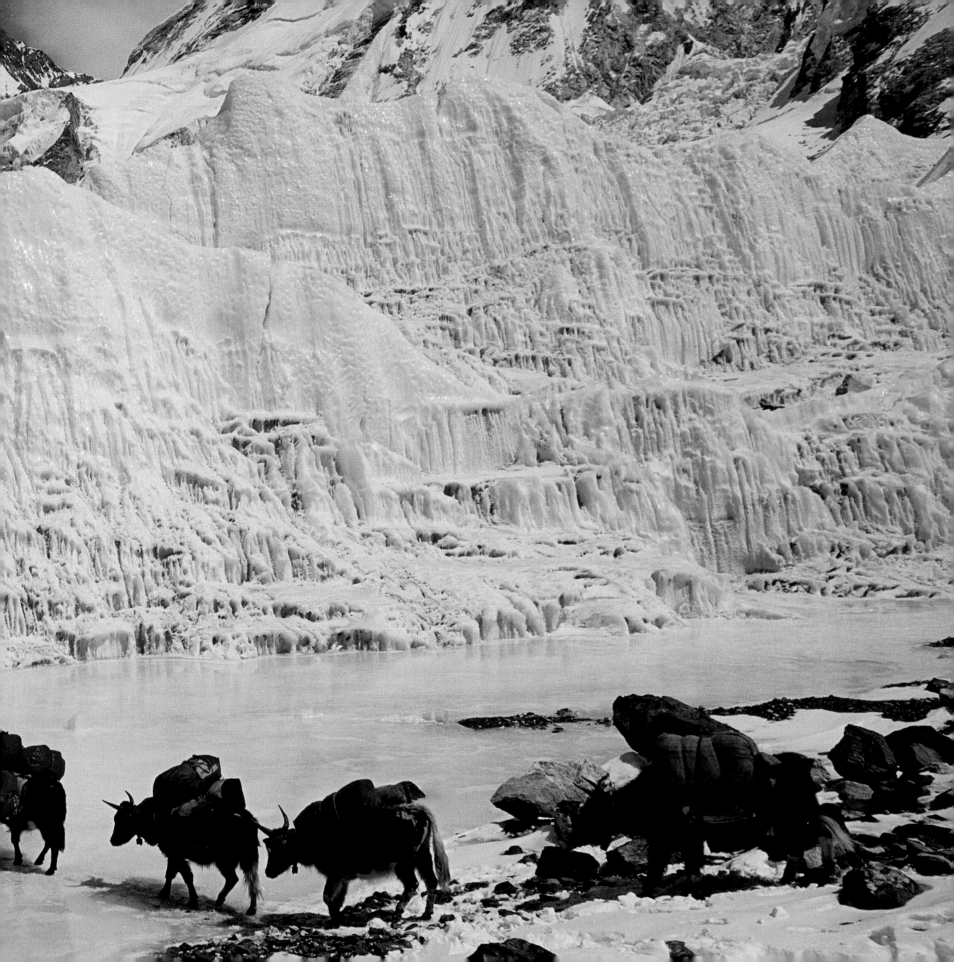

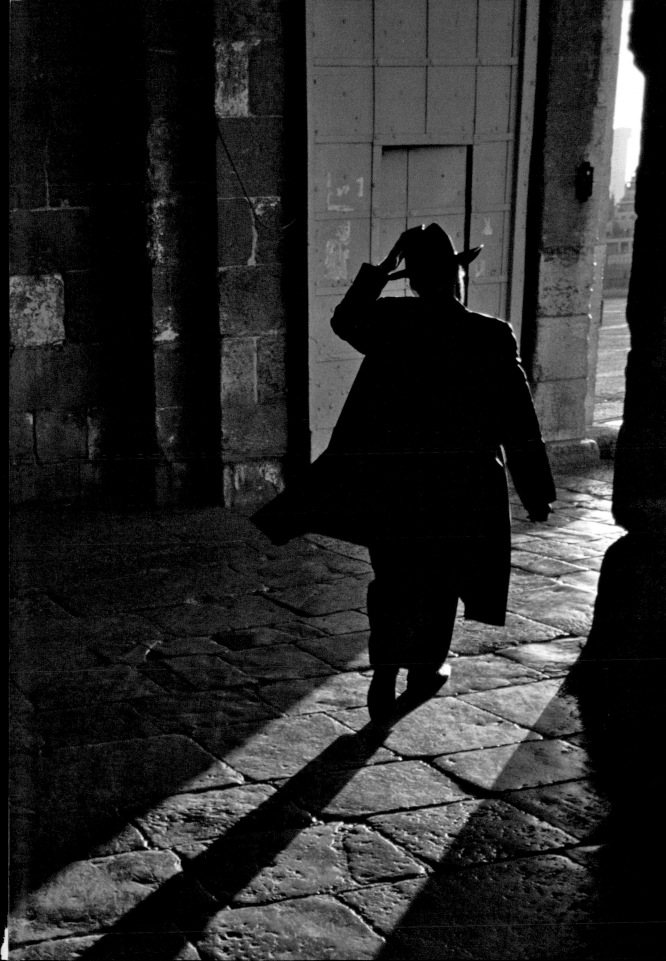

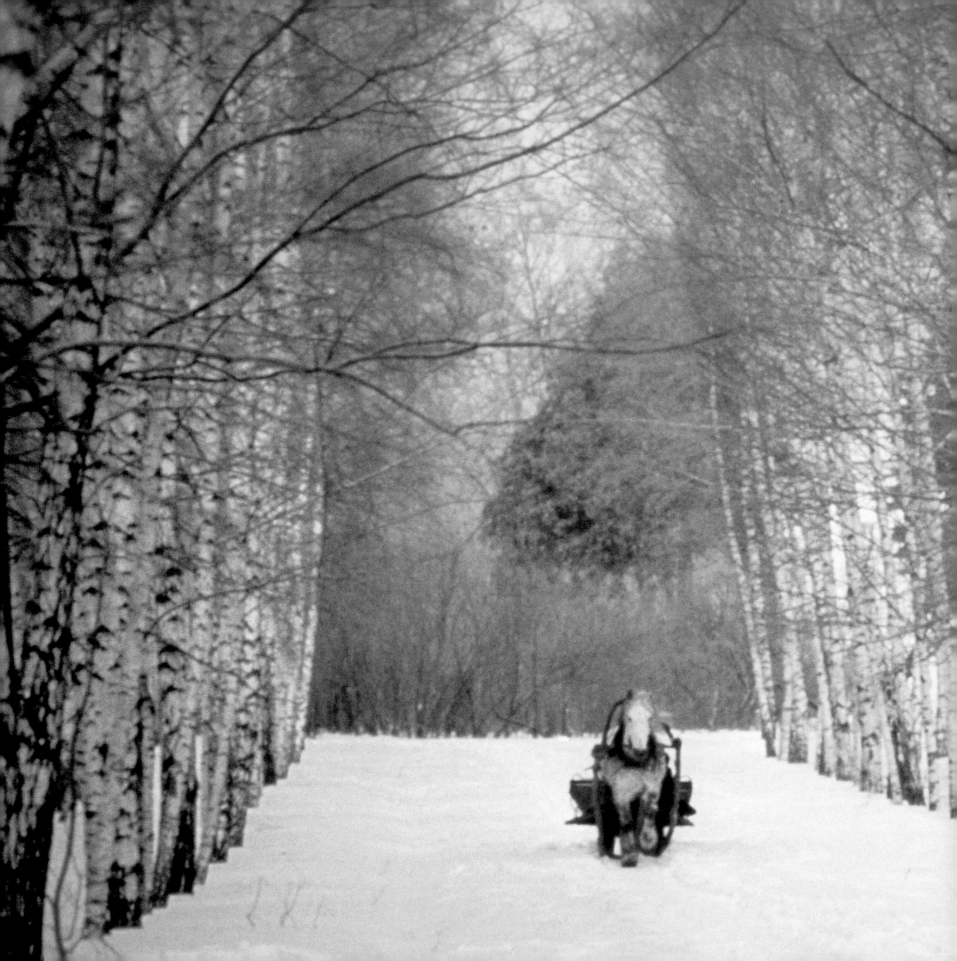

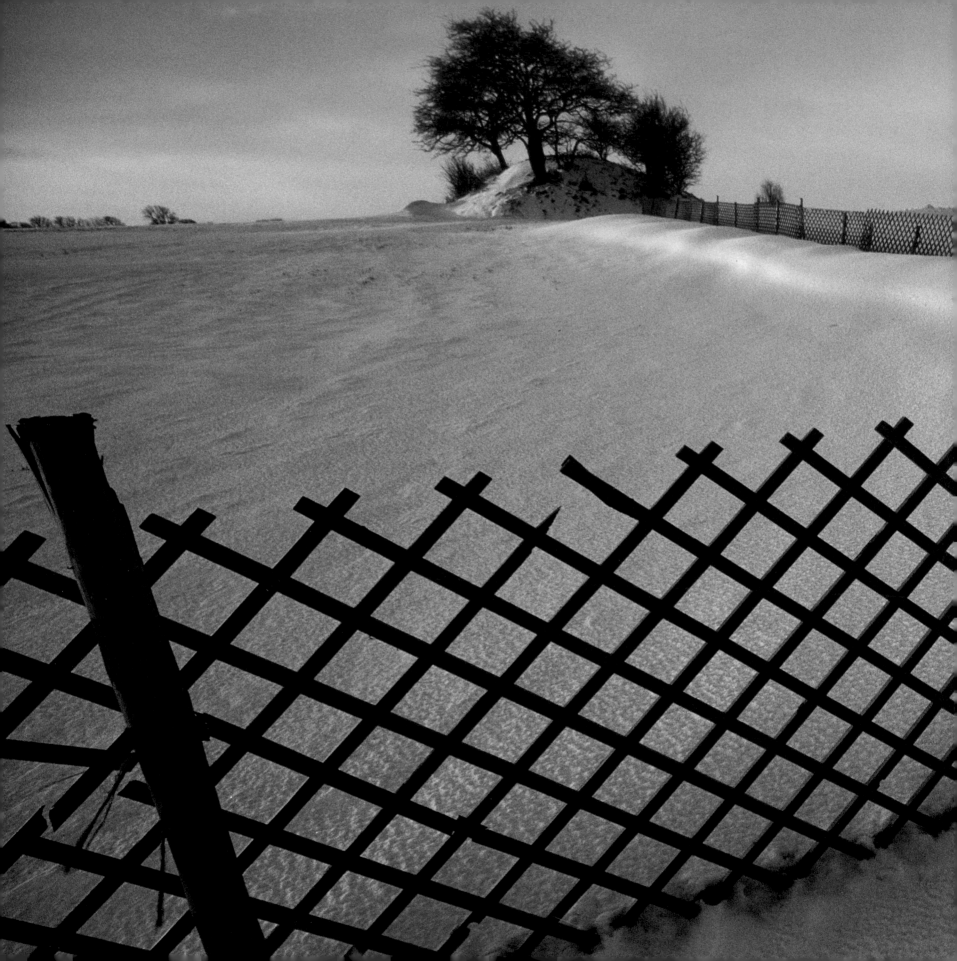

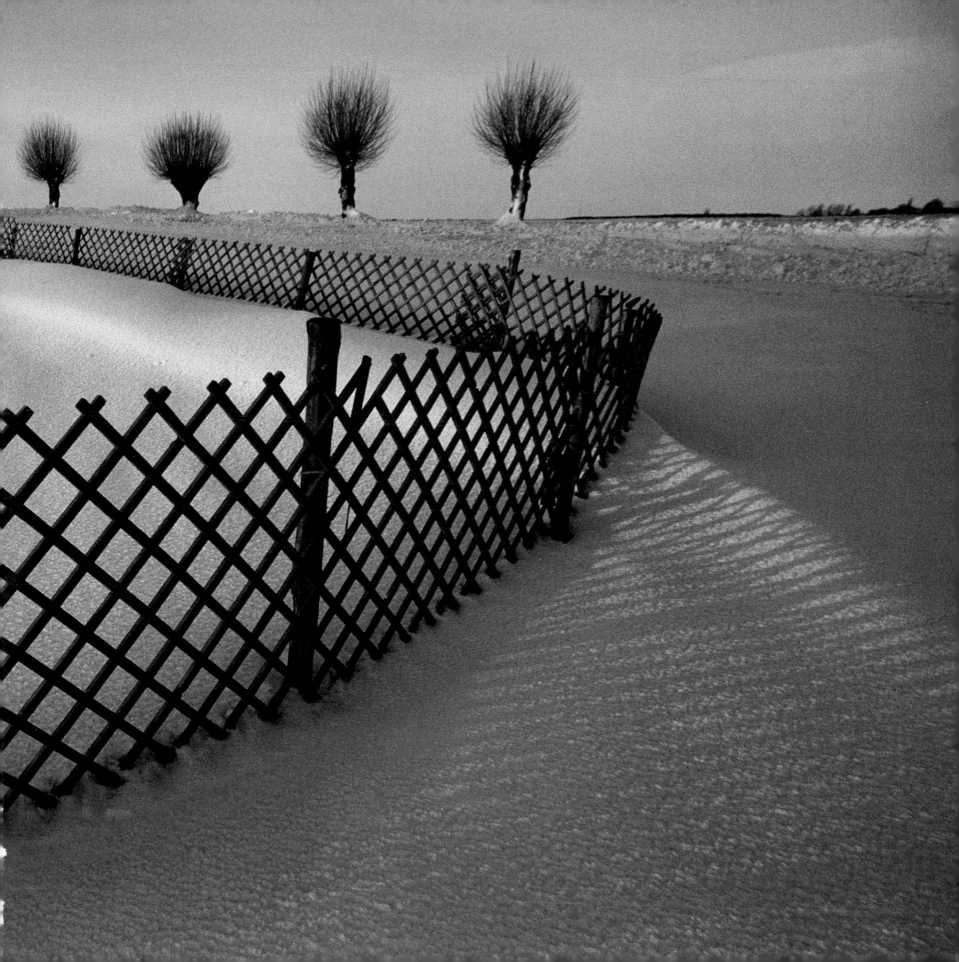

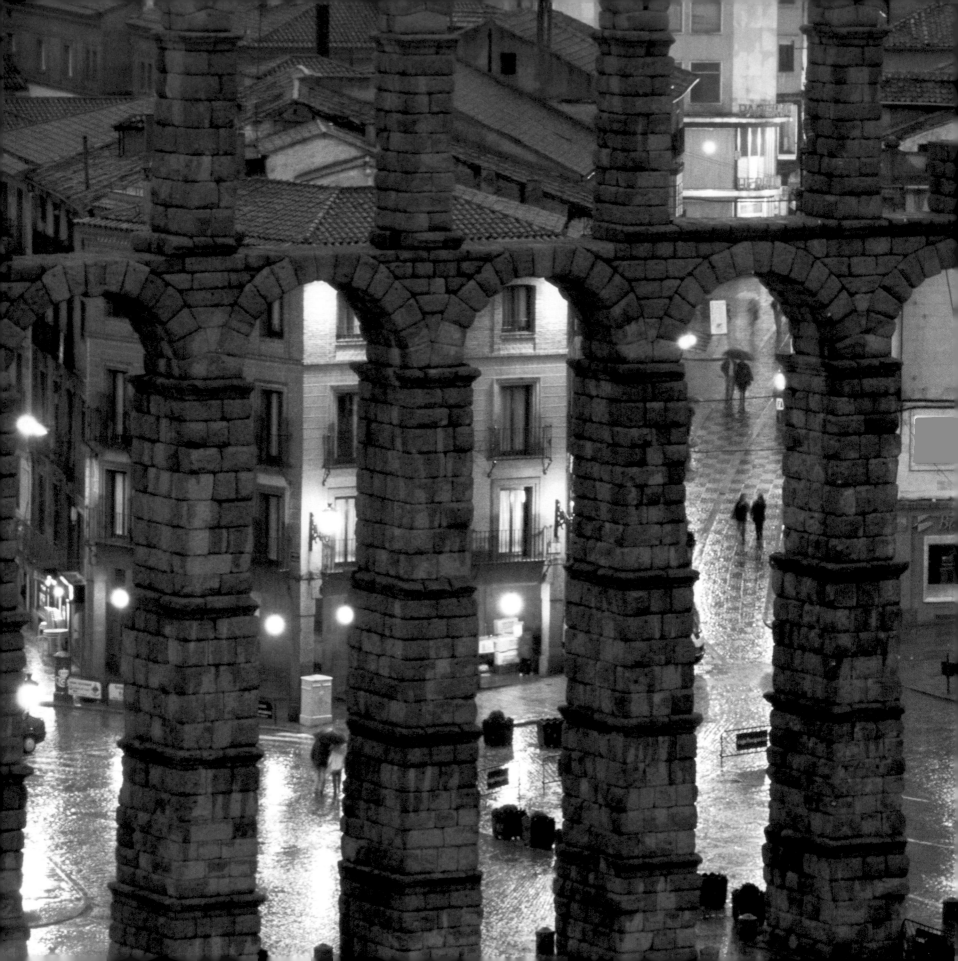

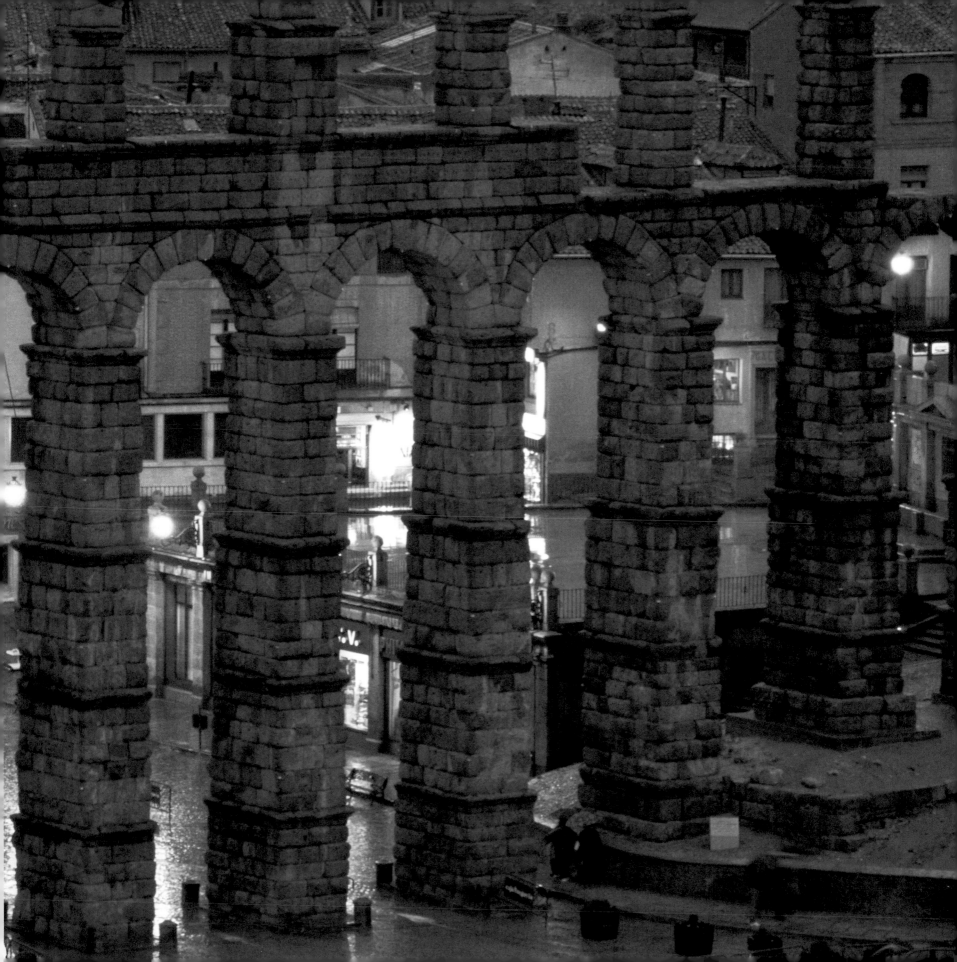

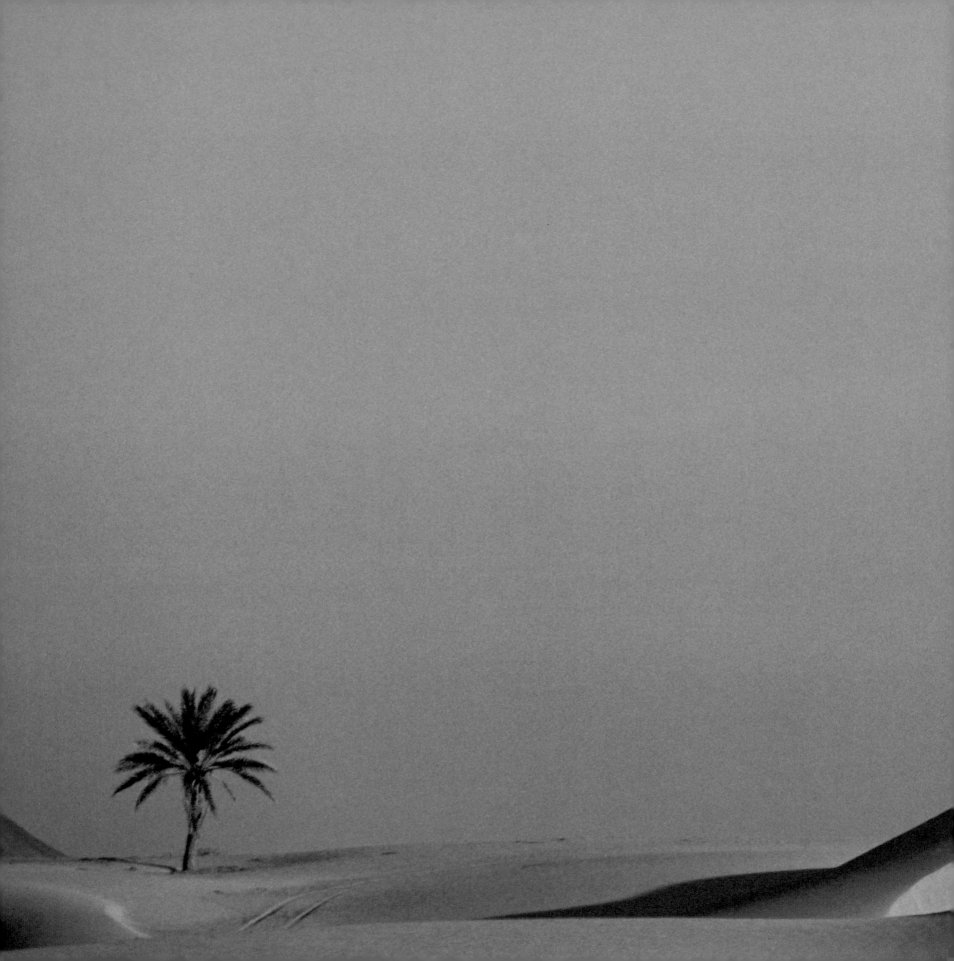

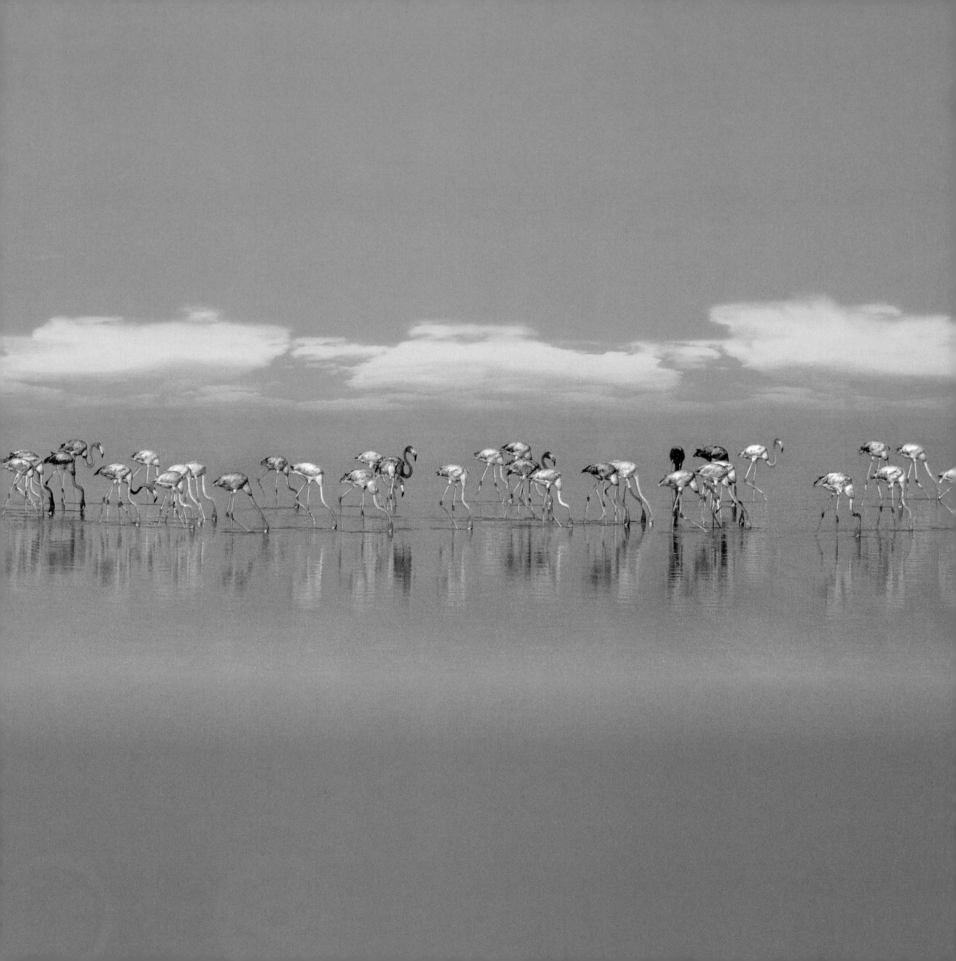

# WIDE ANGLE

## NATIONAL GEOGRAPHIC
## GREATEST PLACES

FERDINAND PROTZMAN

NATIONAL GEOGRAPHIC

WASHINGTON, D.C.

**32**
*East & Southeast Asia*

**78**
*Oceania*

**114**
*Central & South Asia*

**270**
*Western & Southern Europe*

**310**
*North Africa*

**348**
*Sub-Saharan Africa*

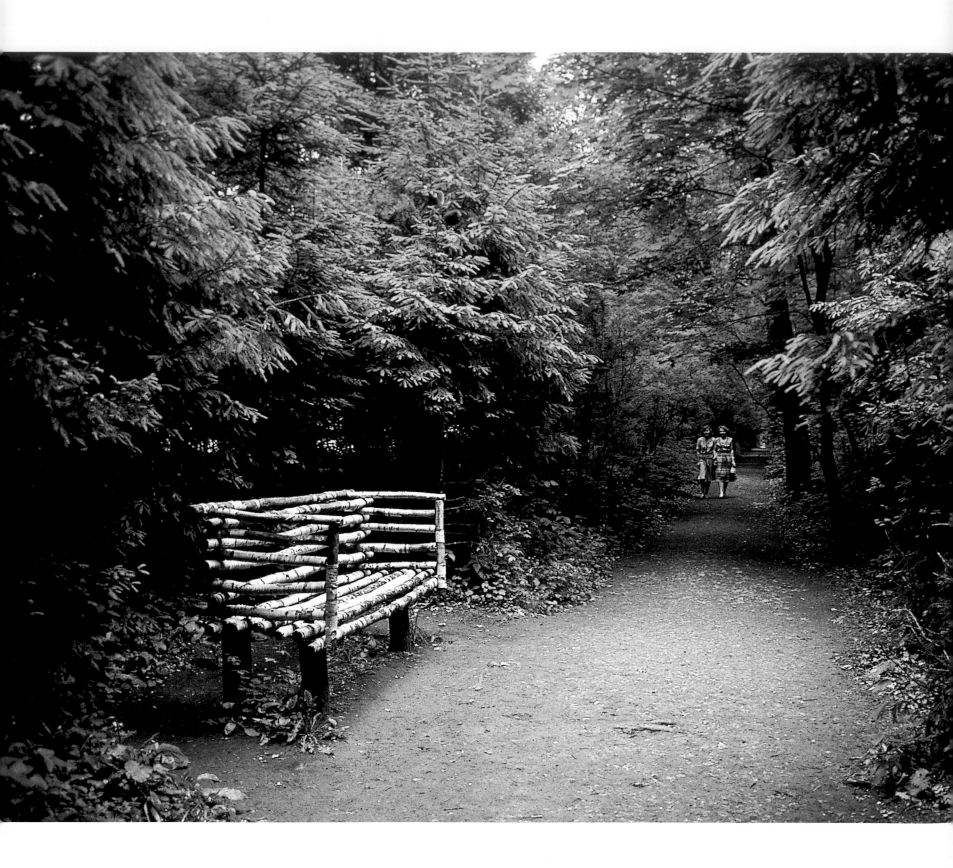

# INTRODUCTION

**S**am Abell's 1986 photograph of Leo Tolstoy's favorite path near the Russian literary genius's estate at Yasnaya Polyana suggests many things: hiking, sitting, observing, contemplating, and depicting. In this simple scene, two women stroll out of a black-hole vanishing point toward the camera, the forest is alive, and the presence of Tolstoy, taking a break, perhaps, from writing his masterpieces, *War and Peace* and *Anna Karenina*, occupies the bench.

Like this book, Abell's picture is a meditation on the many ways people experience and relate to places, pictures of places, and each other. These photos, many never before published, were selected from the National Geographic Society's archive of more than ten million images. All were taken somewhere along the path of life, where each of us finds our personal greatest places, which are not mere backdrops to our existence but active presences affecting who we are, what we believe, and how we live. In the great tradition of NATIONAL GEOGRAPHIC magazine, this photo and those that follow are an invitation to explore with a sense of wonder places exotic and ordinary but also to consider in fresh ways the meaning of place. Through these photographs we can circle the world without leaving the place called home.

—*Ferdinand Protzman*

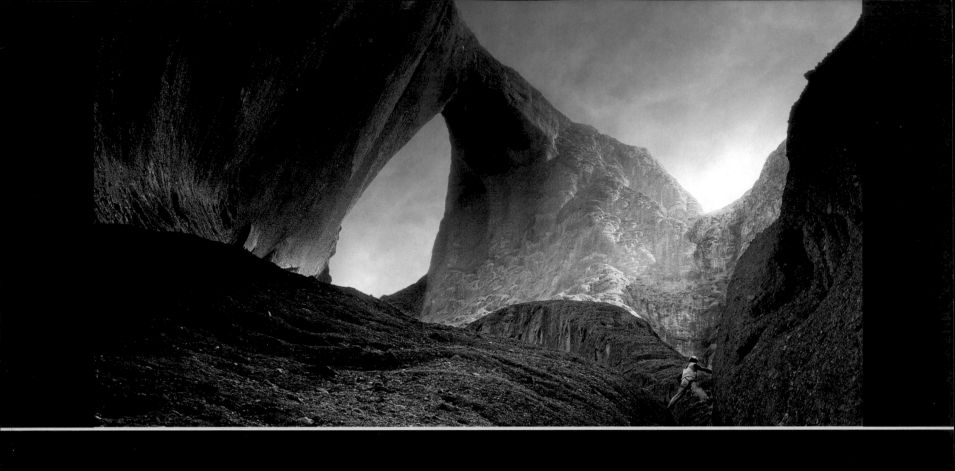
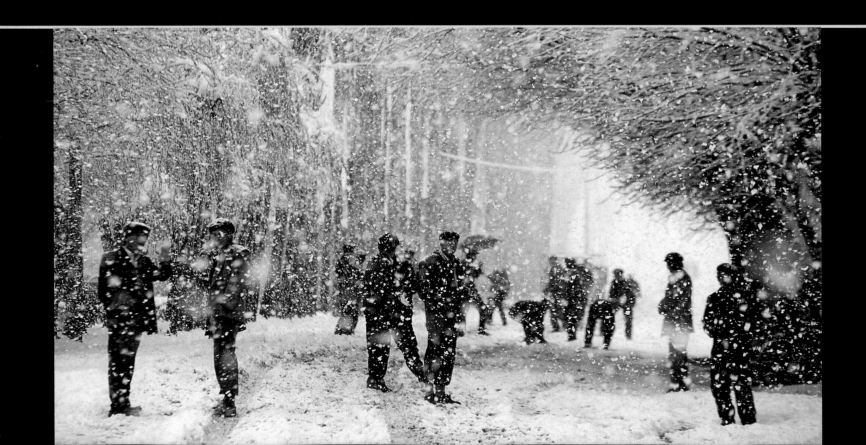

# 1 EAST & SOUTHEAST ASIA

PREVIOUS PAGE TOP: GORDON WILTSIE, 2000. SHIPTON'S ARCH IS NAMED AFTER ERIC SHIPTON, A BRITISH EXPLORER. IT IS ONE OF THE WORLD'S LARGEST KNOWN NATURAL ARCHES, SOARING HIGH ABOVE CHINA'S TAKLIMAKAN DESERT.

BOTTOM: MICHAEL YAMASHITA, 2001. BIG, LACY SNOWFLAKES CAN MAKE ANY PLACE BEAUTIFUL. FACTORY WORKERS ON BREAK IN KASHGAR, WESTERN CHINA, STEP OUTSIDE TO ENJOY THE MAGIC OF FALLING SNOW.

# EAST AND SOUTHEAST ASIA

I magining Southeast Asia as a place without people, as a landscape stripped of any evidence of human activity—social, political, or economic—accumulated over millennia, is difficult. What usually comes to mind is a mental slide-show of visual stereotypes: lush Borneo jungles; Mount Fuji capped with snow; vast tracts of Siberian forest; Mongolia's treeless plains; or the broad, muddy rivers of Indochina.

Those generic images of a depopulated Southeast Asia are, for those of us who have never traveled there, merely edited memories abstracted from photographs of China, Japan, Indonesia, Siberia, or Vietnam, photos seen in books, newspapers, magazines, or travel brochures. For millions of people the primary source of such pictures is NATIONAL GEOGRAPHIC magazine. Yet almost all of its photographs of the region include human beings or their works. Removing people from the frame and the place takes a willful act of imagination.

But doing so raises a number of intriguing questions about how we look at and think about not just Southeast Asia but our planet. What constitutes a "great" place? Do the specific, physical qualities of Mount Fuji, for example, exert some special influence on the people who live near or visit it? Is that dormant volcano's appeal simply visual, a function of how it looks? Does the landscape shape human beings, or do we shape the landscape by assigning greatness to a place for reasons that have little or nothing to do with its intrinsic qualities?

There are no easy answers. The landscape and people do not exist in a void. Both are an integral part of life, as we know it, on Earth, life vital and complex. The planet and its inhabitants change continually. Change in the physical landscape, from tectonic shifts to wind erosion, is often imperceptible. Viewed through the lens of human endeavor, change is often dramatic, as witness Southeast Asia, which has experienced over the past 50 years more political, economic, and social turmoil than any other region.

Even stripped of people as subjects, our pictures of Southeast Asia's geography are still the product of human subjectivity. In the case of National Geographic, its photographers were working for a society and a magazine dedicated to exploring, discovering, and analyzing the world's people and places for a predominantly American audience. Whether

professional photojournalists, artists, gifted amateurs, scientists, explorers, or adventurers, they took photographs that served to illustrate the magazine's articles and illuminate what the photographers saw and experienced. In Southeast Asia, as elsewhere, they usually were and are outsiders, approaching the landscape from an Anglo-Saxon cultural viewpoint.

Southeast Asia's indigenous people have a much different relationship to the landscape. They live in it. Where Europeans or Americans may see Marc Moritsch's photo of two Siberian tigers napping on the snowy floor of a Russian game reserve charming and peaceful, a local inhabitant may see only two dangerous beasts that he'd like to kill before they eat more of his livestock. One picture, one landscape, two divergent viewpoints, each with its own aesthetic and social conventions. Perhaps the greatest difference is that we, as viewers, can easily exert control over the landscape by closing our magazine or book. For the native Siberian, the tigers may be loose in the woods, not captive on the coffee table.

Each landscape photograph can be seen as the interface of cultures, the point where insider and outsider views of a specific place meet and interact. From that perspective, these photographs of Southeast Asia form a kind of composite picture of the place that tells us far more than any single image could. This composite was created, however, from a specific viewpoint, that of the Anglo-Saxon cultural tradition with its attendant aspects, ranging from aesthetics of landscape depiction featuring an elevated viewpoint and linear perspective to the intellectual emphasis on reason and empiricism. Historically, the culture's harsher qualities, such as racism, xenophobia, and economic exploitation have also been evident in its photographs.

But what sets this composite picture of Southeast Asia apart from that of any other region is its sheer dynamism. Unlike the relatively static composite image of Europe, for example, where photography was invented and where the landscape has been depicted and photographed ad nauseam, Southeast Asia's landscape keeps changing. Over the past decades, nations such as China, Japan, Malaysia, and South Korea have transformed themselves into industrial societies even as their populations exploded. These changes manifest themselves in many ways: rising living standards, densely crowded cities, sprawling factories, environmental degradation, intense pollution, and clashes between traditional cultural norms and the frenetic pace of modern life.

National Geographic's photographers have photographed these changes. More important, perhaps, the way they photograph Southeast Asia has also evolved significantly. Over the years, they have become far more attuned to the customs and aesthetic sense of indigenous cultures, in effect adopting elements of the insider's view. An example of this is Stuart Franklin's photograph, taken in January 2000, of Chinese mountains shrouded in fog, an image clearly descended from the expressive symbolism found in the Chinese brush-and-ink landscape paintings that first developed during the Yuan dynasty (1279-1368).

Because of these changes, we get a much more vital and nuanced picture of Southeast Asia's landscape and life than National Geographic readers did ten, twenty, or a hundred years ago. But do we know more about the region or any specific place in the sprawling reaches of land, sea, and islands?

Yes. Look at Karen Kasmauski's photograph of the fuzzy outline of Mount Fuji, rising in the hazy distance behind a field of sunflowers. At first glance, it looks very Western and very fake, like some hackneyed diorama painted on the wall of a down-market Japanese restaurant. Although some 102 million people live in Honshu province where the mountain lies; although 300,000 people, some 30 percent of them foreigners, climb its perfectly symmetrical cone each year; although it can be seen from Tokyo on a clear day, there are no people in the picture. The sunflowers seem to jump at the viewer's face like eager puppies, drawing attention away from the mountain.

A similarly distanced perspective can be found, however, in some of the ukiyo-e woodblock prints created by Japanese artist Hokusai Katsushika between 1823 and 1829, as part of his legendary "36 Views of Mount Fuji." The mountain, which the Japanese have viewed as sacred since ancient times, is little more than a pimple on the horizon in some of his pictures, yet its presence is always felt. Seasons and generations come and go. That two artists, separated by time, culture, language, and medium, an insider and an outsider, would depict a place named Mount Fuji in such similar ways suggests that no matter who makes the picture, the mountain has a magic all its own.

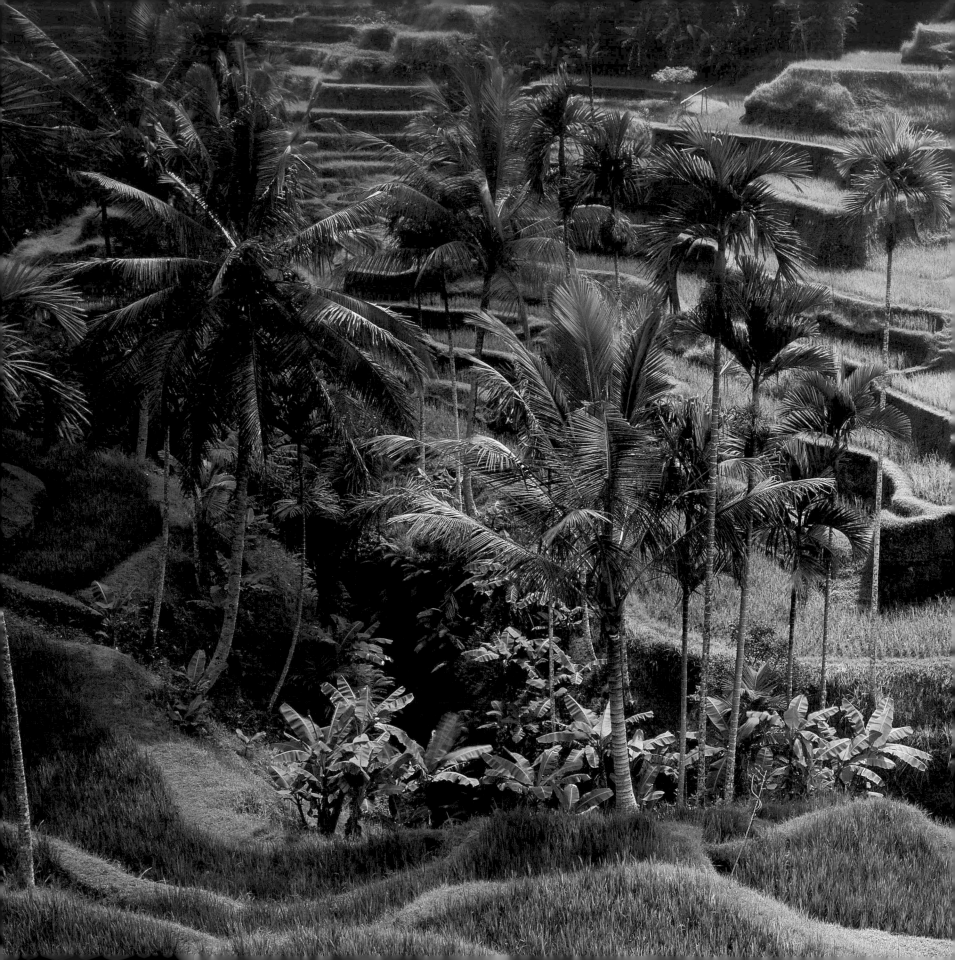

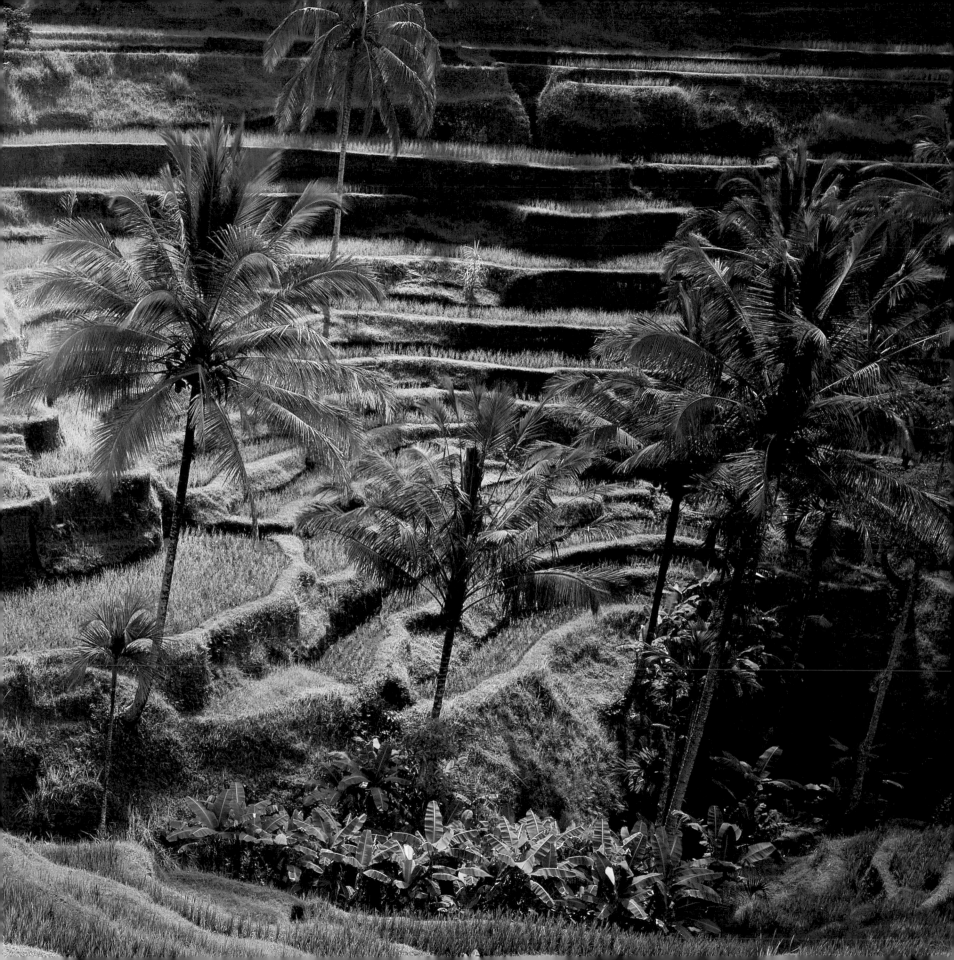

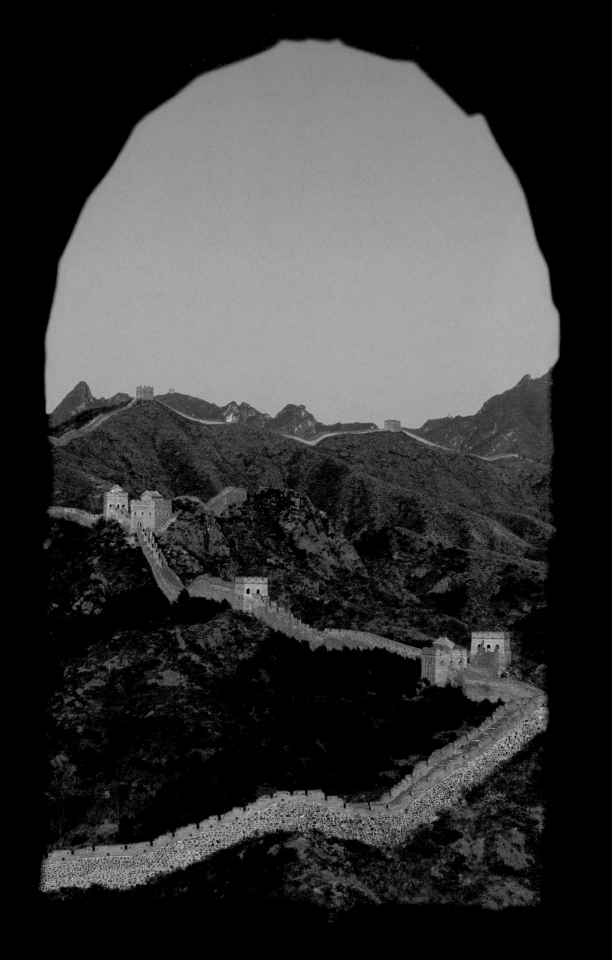

PREVIOUS PAGES: STUART FRANKLIN, 2000. MAN-MADE LANDSCAPES CAN BE BEAUTIFUL, TOO. ABOUT 2,000 YEARS AGO, FARMERS BEGAN CARVING THESE RICE TERRACES FROM HILLSIDES IN CENTRAL BALI, INDONESIA.

LEFT: RAYMOND GEHMAN, 2001. THE GREAT WALL OF CHINA IS ONE OF THE LARGEST CONSTRUCTION PROJECTS EVER BUILT, STRETCHING OVER 5,000 KILOMETERS.

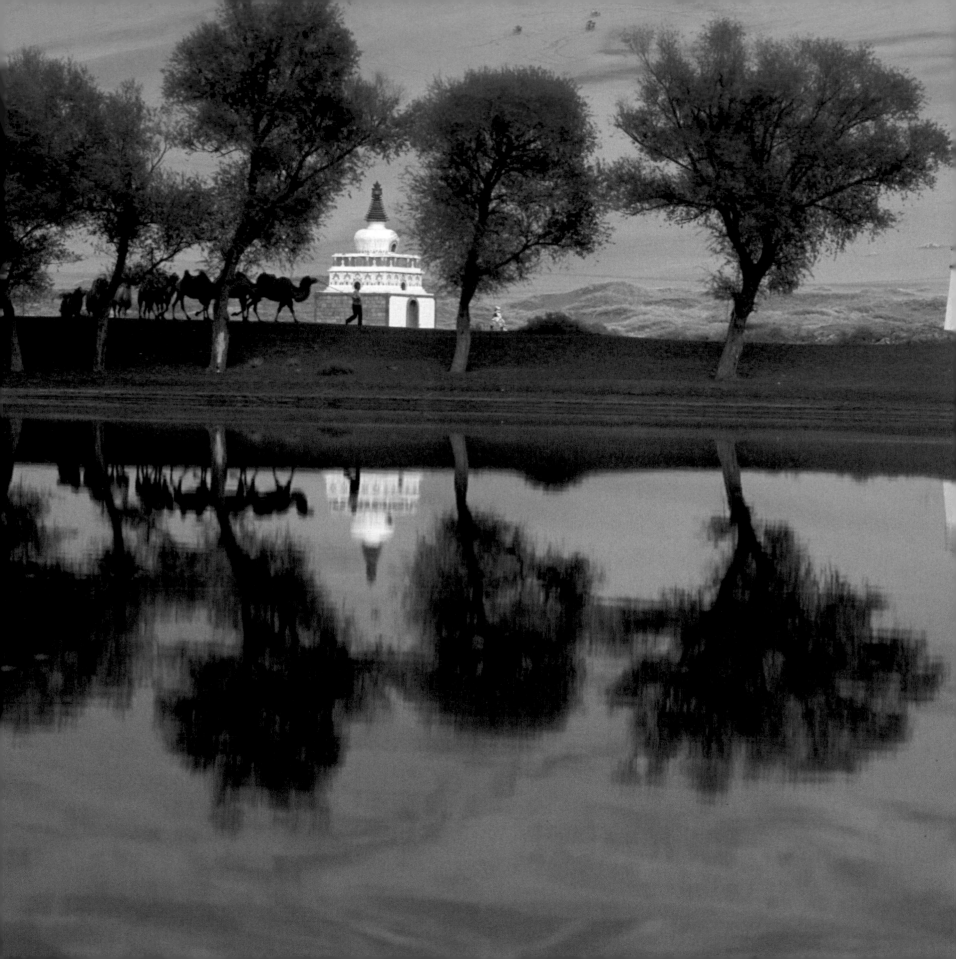

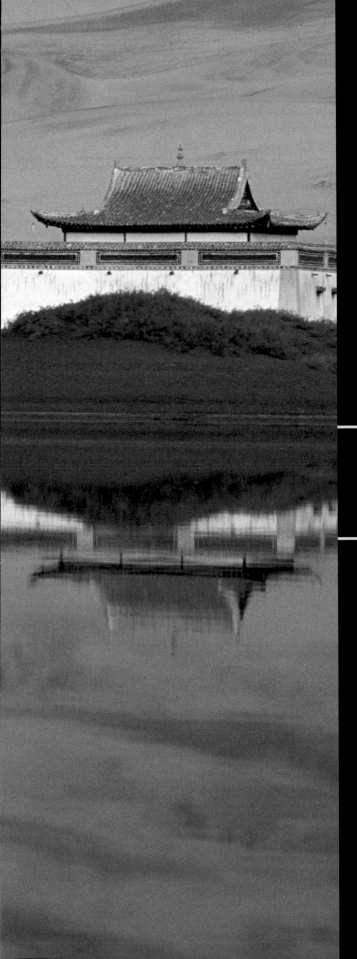

43

LEFT: GEORGE STEINMETZ, 2002. A BUDDHIST MONASTERY BETWEEN A LAKE AND A SAND DUNE IN CHINA'S BADAIN JARAN DESERT.

FOLLOWING PAGES: KAREN KASMAUSKI, 2004. PLACE AS AN INTERNATIONAL ICON: MOUNT FUJI WITH A PATCH OF SUNFLOWERS IN THE FOREGROUND.

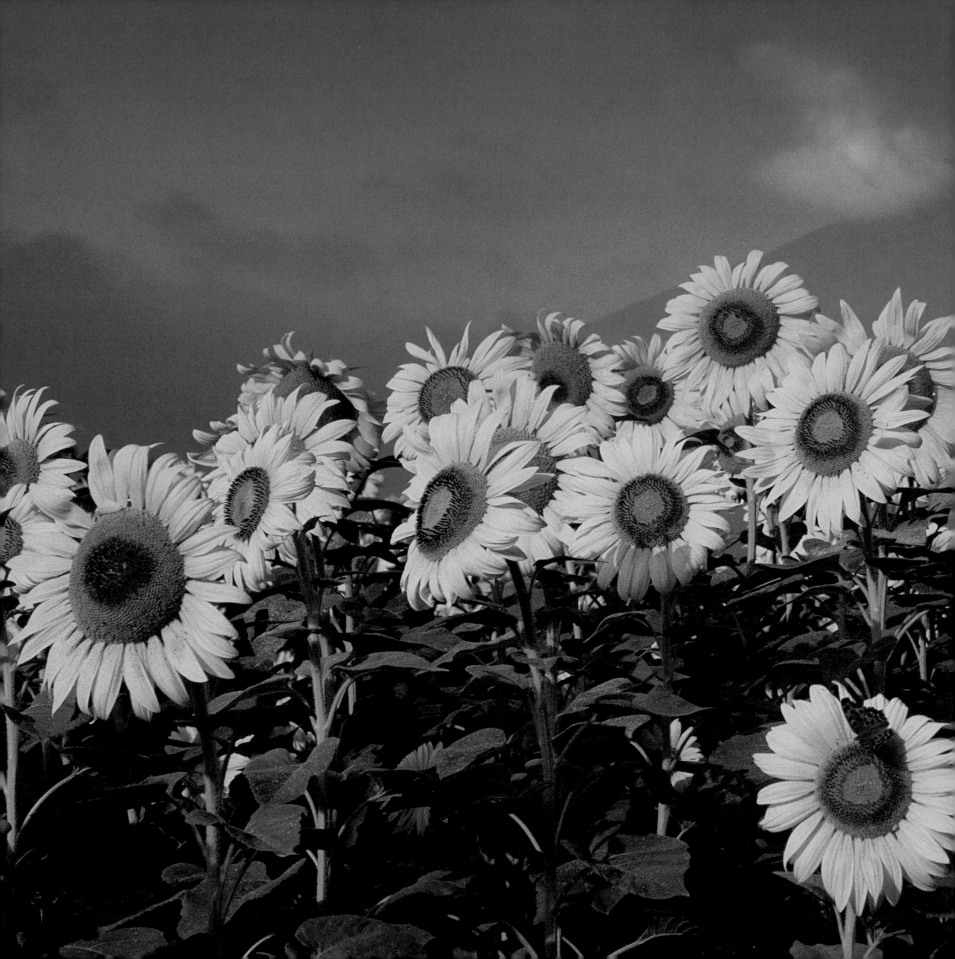

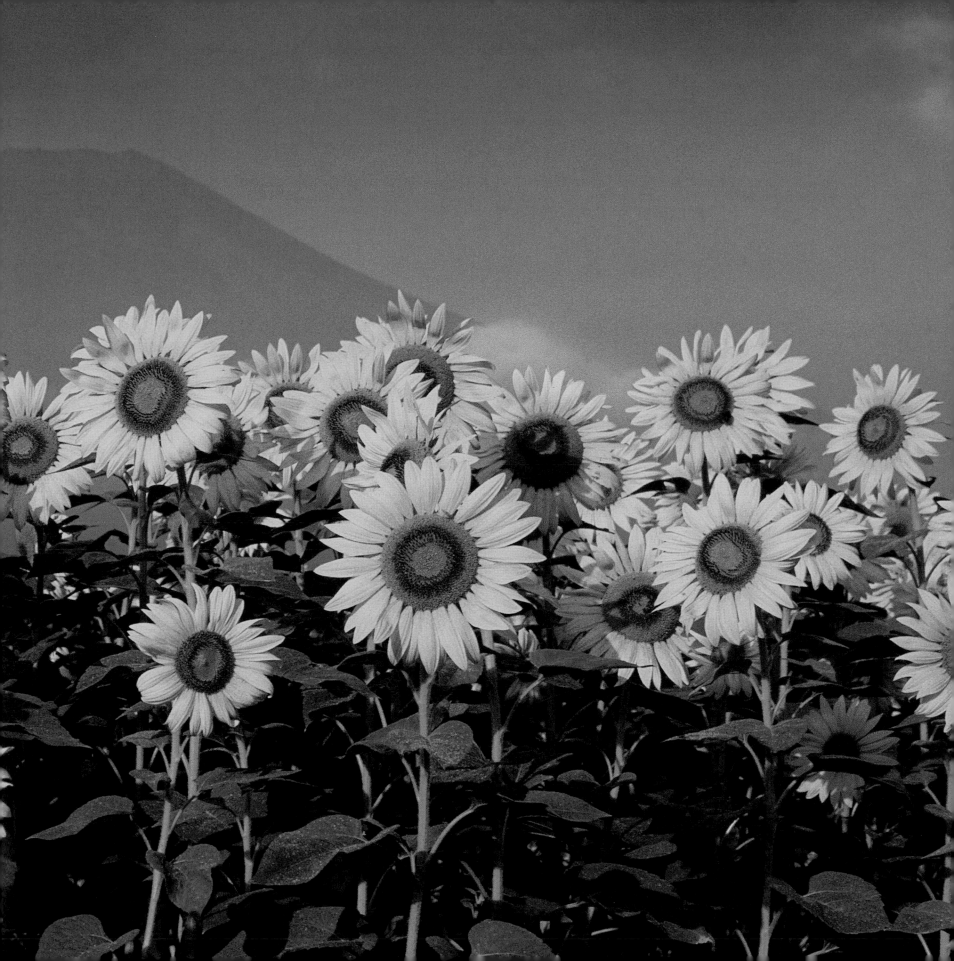

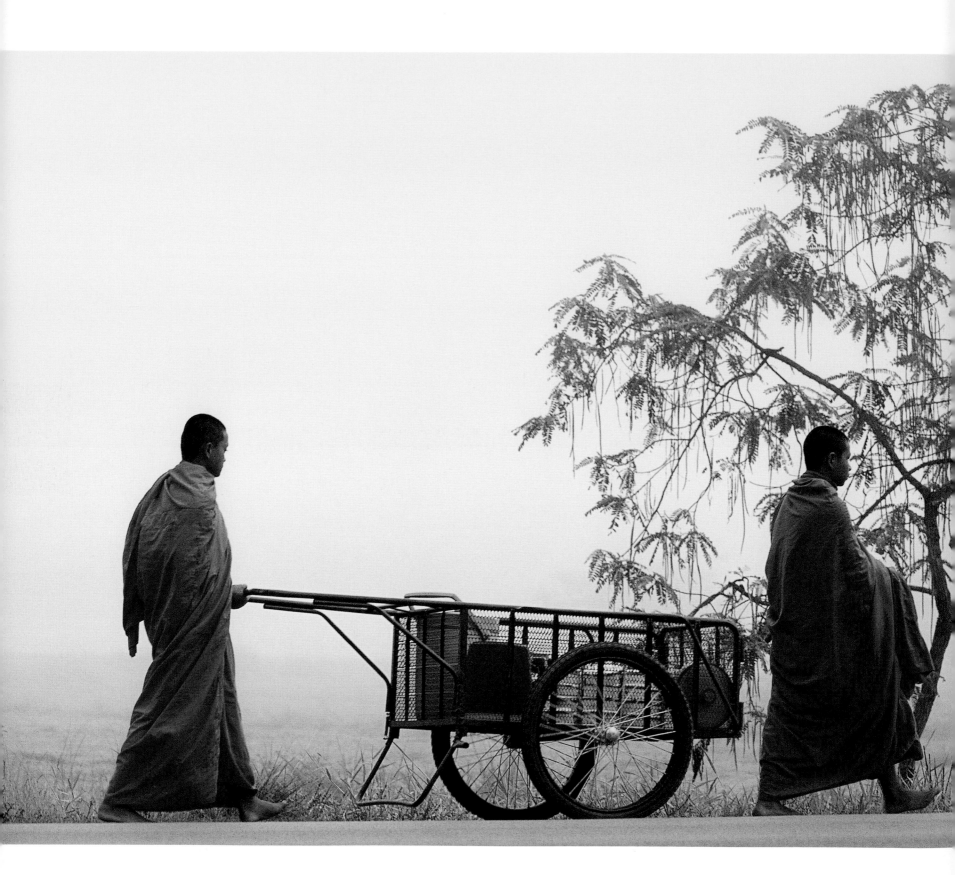

R. Ian Lloyd, 1987. Monks in northern Thailand collect food from villagers at sunrise on a misty morning.

47

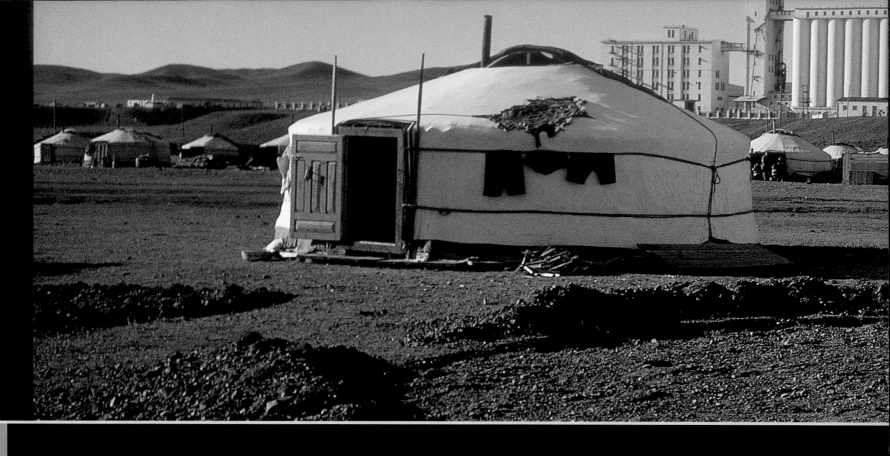

MERCEDES DOUGLAS, 1962. MANY MONGOLIAN CITY-DWELLERS PREFER TO LIVE IN A *GER*, A STURDY, ROUND STRUCTURE SIMILAR TO A YURT. THEY CAN WITHSTAND THE HARSH CLIMATE AND ARE ALSO EASILY MOVED. THESE GERS LOCATED NEXT TO A FLOUR MILL IN ULAN BATOR WERE MASS-PRODUCED.

IMAGINING MOST PLACES WITHOUT PEOPLE

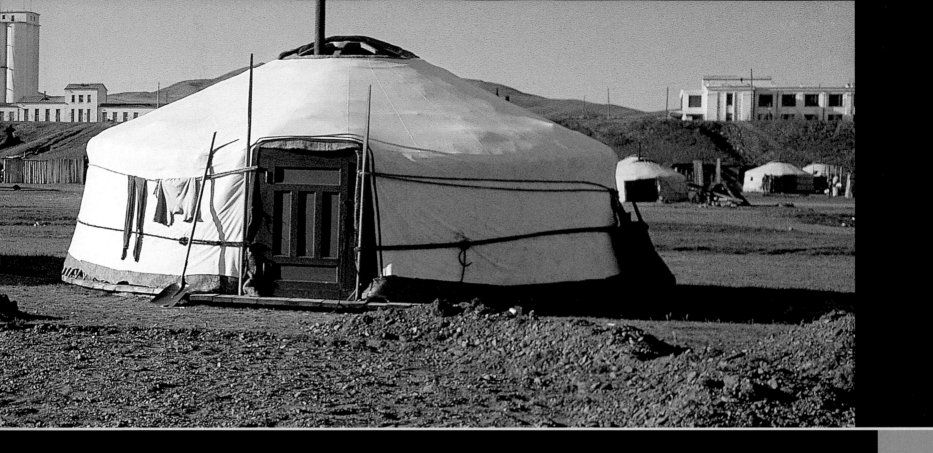

TAKES A WILLFUL ACT OF IMAGINATION. ℘

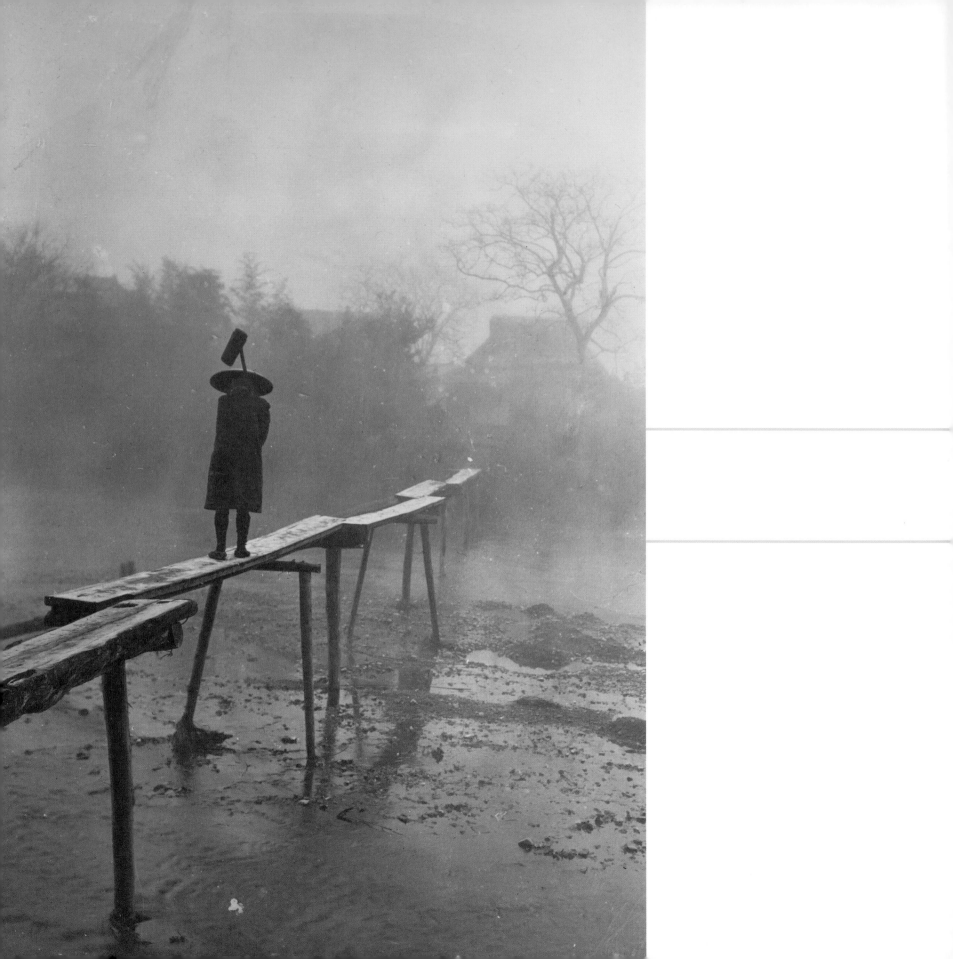

ELIZA R. SCIDMORE, 1914. PHOTOGRAPHY CAN TRANSFORM A MAN WITH A HOE CROSSING A SIMPLE WOODEN FOOTBRIDGE SOMEWHERE IN JAPAN INTO A PAINTERLY IMAGE EVOKING THE AUSTERE AESTHETIC AND LYRICAL GRACE OF THAT NATION'S TRADITIONAL VISUAL ARTS.

GORDON WILTSIE, 2004. BUDDHIST PILGRIMS
AT JOKHANG TEMPLE, LHASA, TIBET.

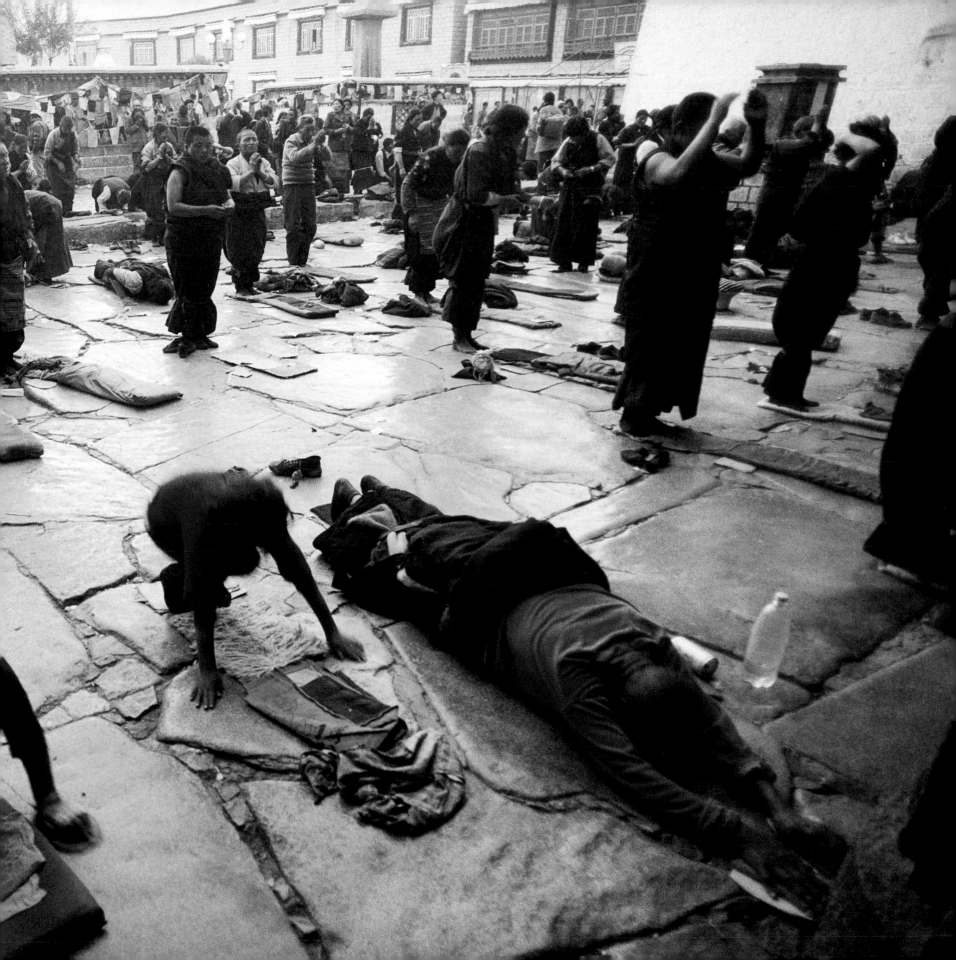

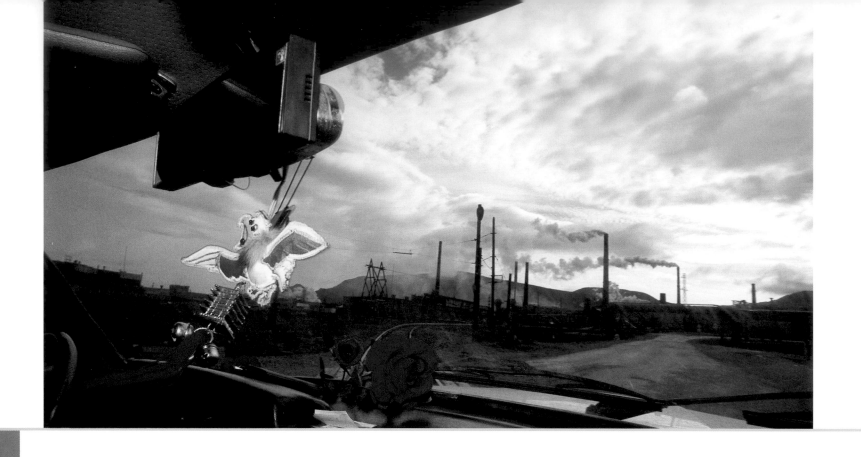

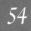

TOP: RANDY OLSON, 2000. THE FAKE BIRD ON THE MIRROR AND FAKE FLOWERS ON THE DASHBOARD OFFER A WHIMSICAL CONTRAST TO THE REAL SMOKE POURING FROM THE STACKS OF A SIBERIAN FACTORY.

BOTTOM: SIDNEY HASTINGS, 2004. A PLANET INHABITED BY PEOPLE IN MOTION: PEDESTRIANS PASS BY PARKED BICYCLES IN BEIJING, CHINA.

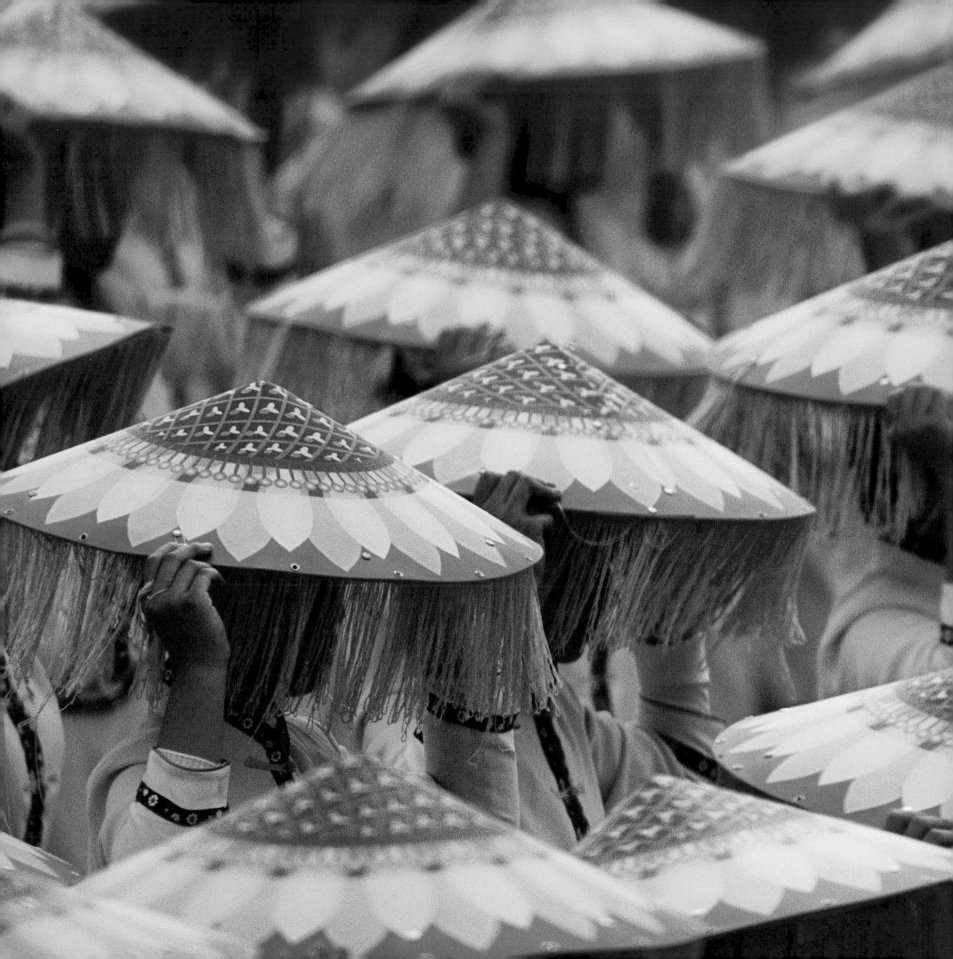

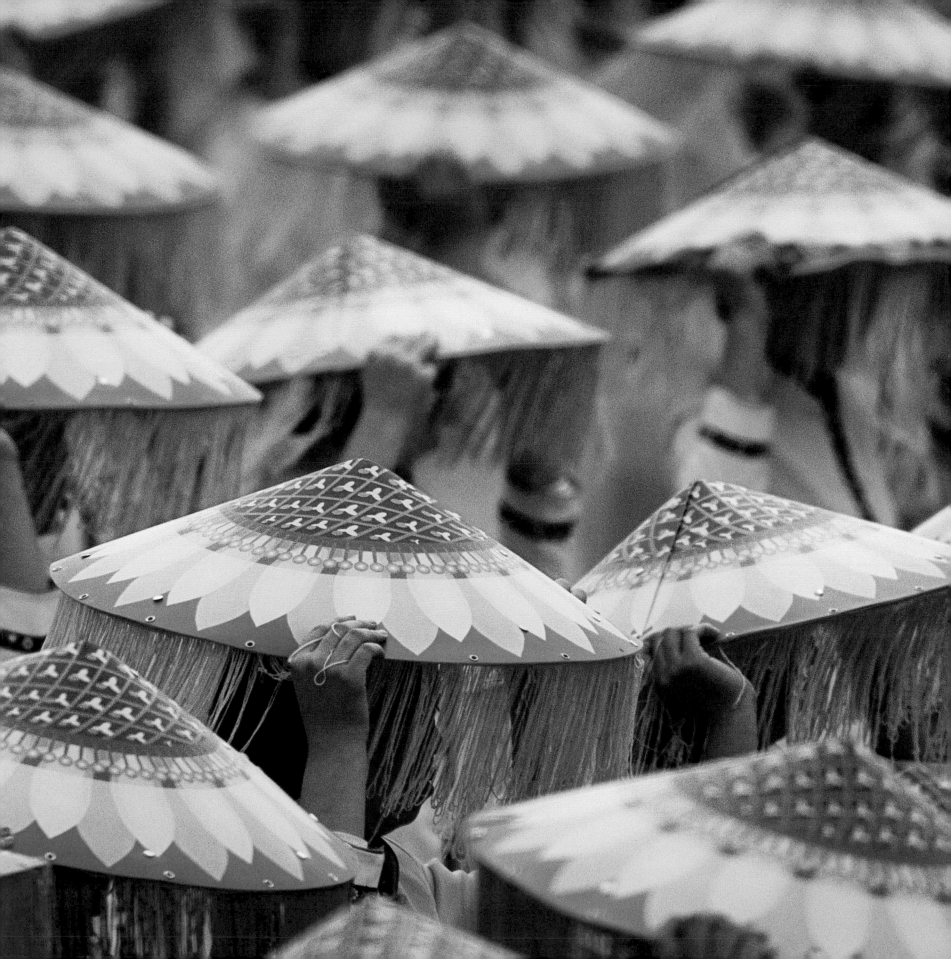

58

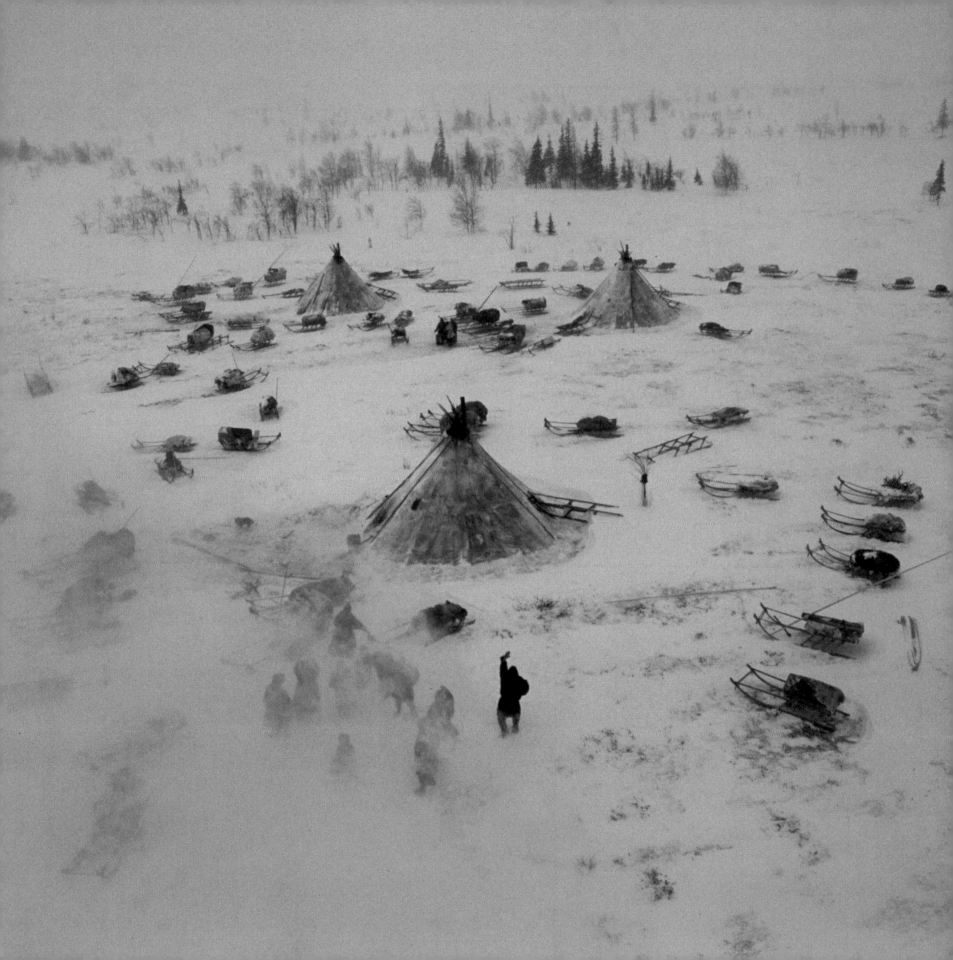

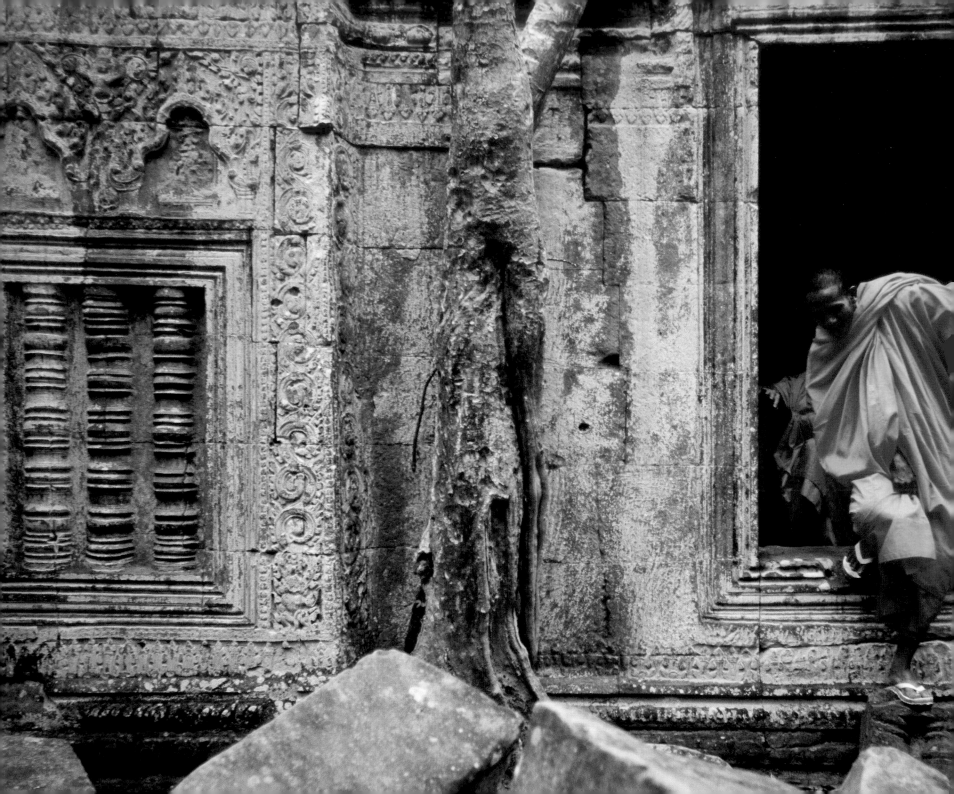

Steve Raymer, 2003. A Buddhist monk emerges from one of the temples at Angkor Wat, Cambodia.

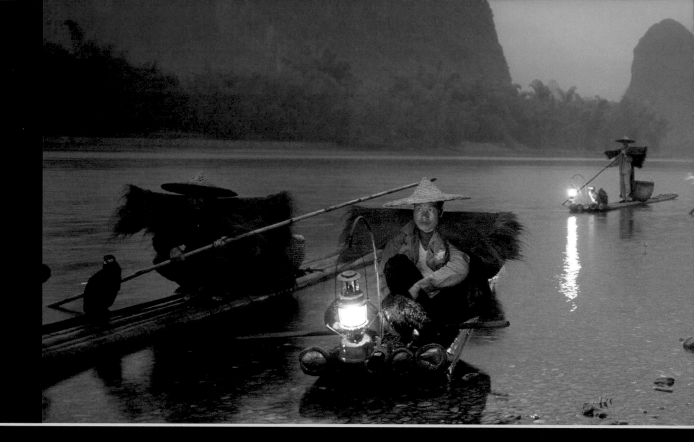

DAVID LAWRENCE, 2001. NIGHT CORMORANT FISHING ON THE LI RIVER IN GUANGXI PROVINCE, CHINA. THE FISHERMEN CONSTRICT THE BIRDS' THROATS SO THEY CANNOT SWALLOW THE FISH THEY CATCH ON THEIR DIVES.

WHAT CONSTITUTES

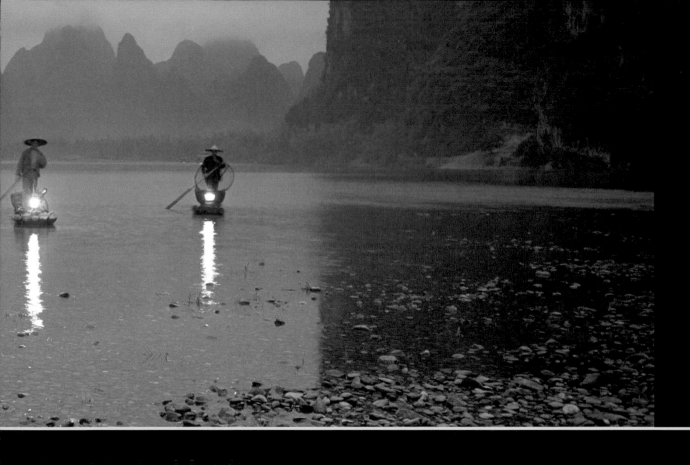

A GREAT PLACE?

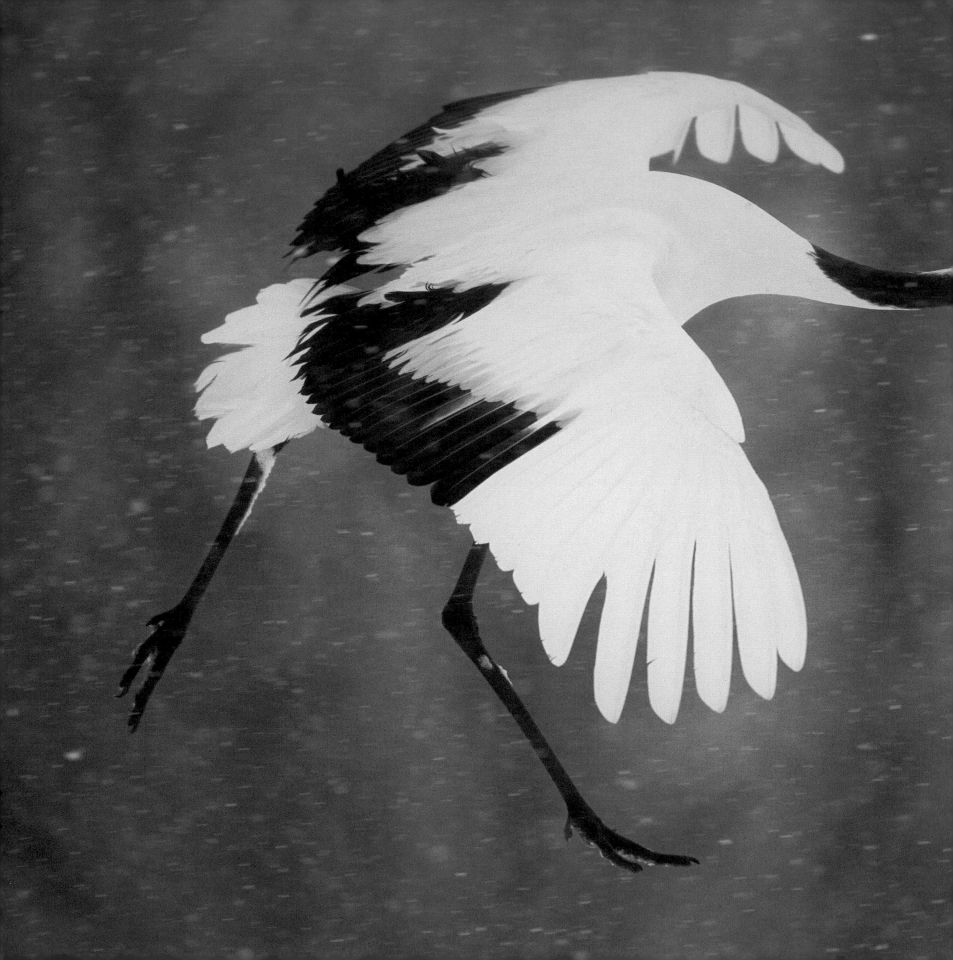

TIM LAMAN, 2003. A JAPANESE OR RED-CROWNED CRANE
LANDS DURING A SNOW SHOWER IN HOKKAIDO, JAPAN.

65

RAYMOND GEHMAN, 2004. A WOMAN IN A TRADITIONAL COOLIE HAT SITS BY HANDCARTS IN PINGXIANG, AN INDUSTRIAL CITY NEAR THE VIETNAMESE BORDER IN CHINA'S GUANGXI AUTONOMOUS REGION.

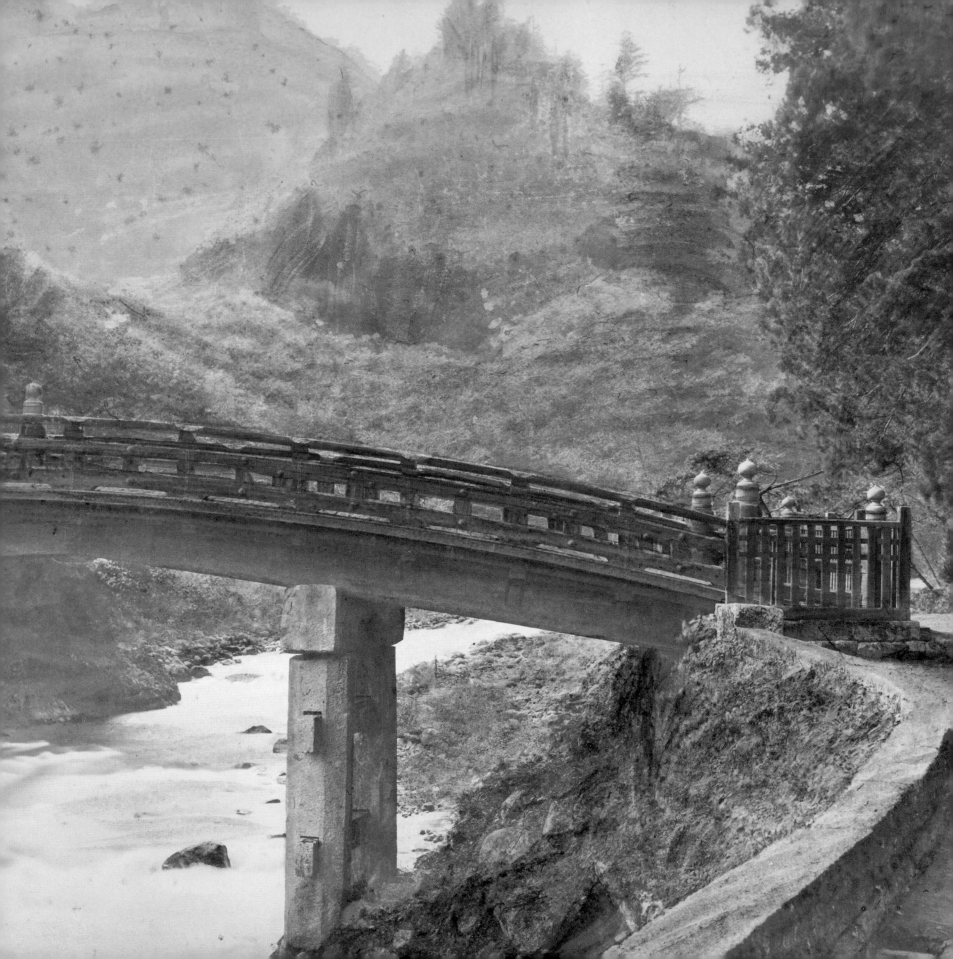

LEFT: CHARLES HARRIS PHELPS COLLECTION, 1878-1882.
RYOGOKU BRIDGE IN TOKYO, JAPAN.

FOLLOWING PAGES: JODI COBB, 1992. REHEARSING THE DRAGON FOR A
PARADE TO CELEBRATE DOUBLE TEN, TAIWAN'S NATIONAL DAY.

69

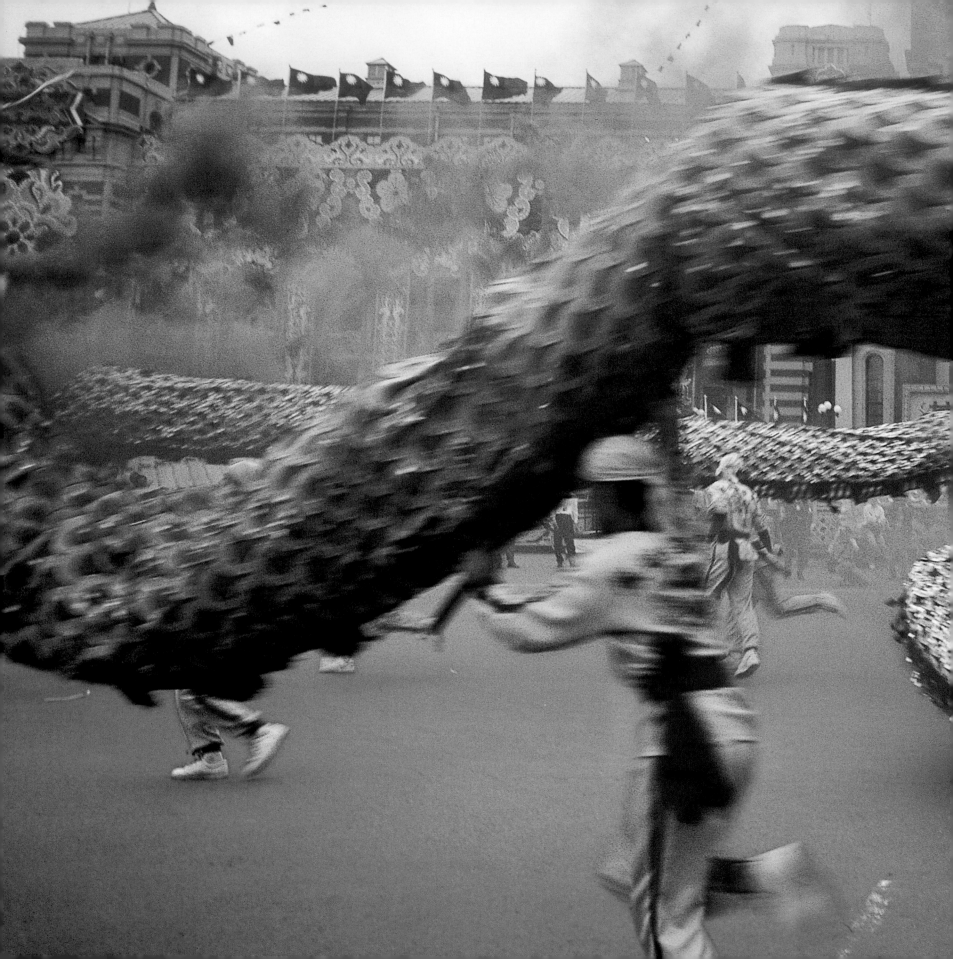

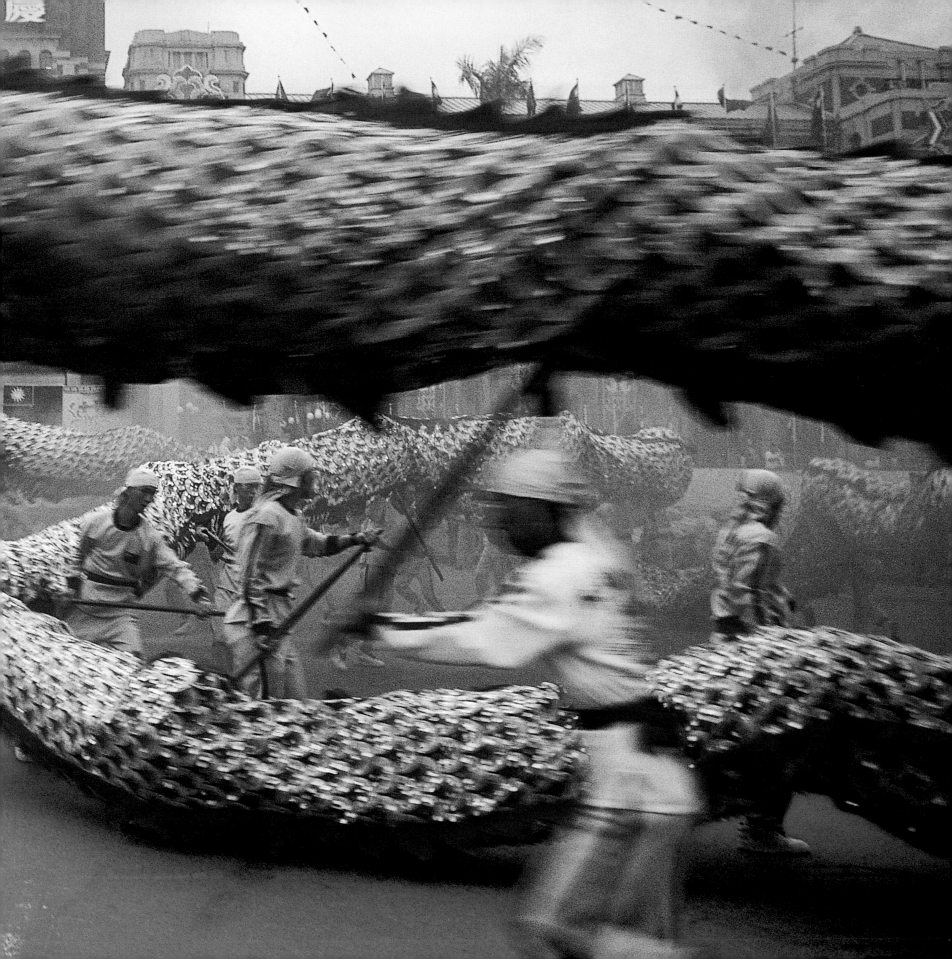

Marc Moritsch, 1997. Orphaned Siberian tigers nap at a preserve in Gayvoron, Siberia.

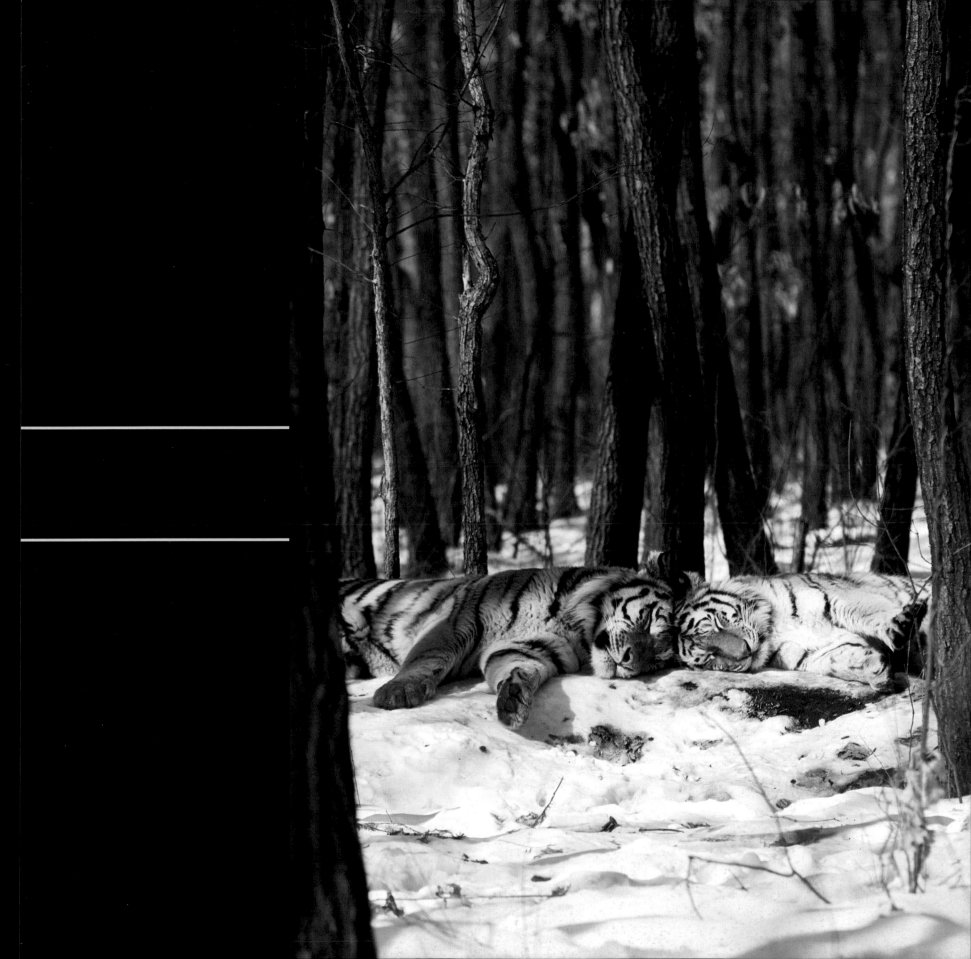

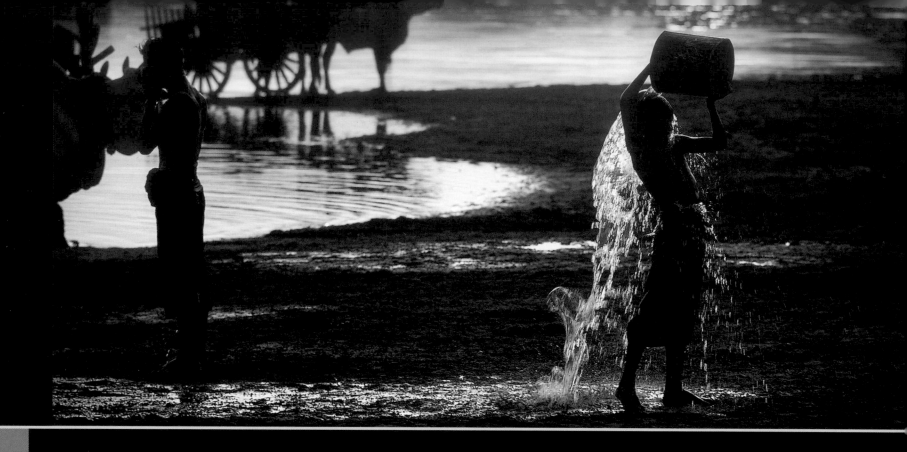

TOP LEFT: JAMES L. STANFIELD, 1983. A BOY IN MEIKTILA, MYANMAR (BURMA), DOUSES HIMSELF WITH A BUCKET OF WATER AT SUNSET.

TOP RIGHT: J. BAYLOR ROBERTS, 1955. MULTICOLORED CRATER LAKES IN INDONESIA.

LANDSCAPE PHOTOGRAPHS AS

THE INTERFACE OF CULTURES.

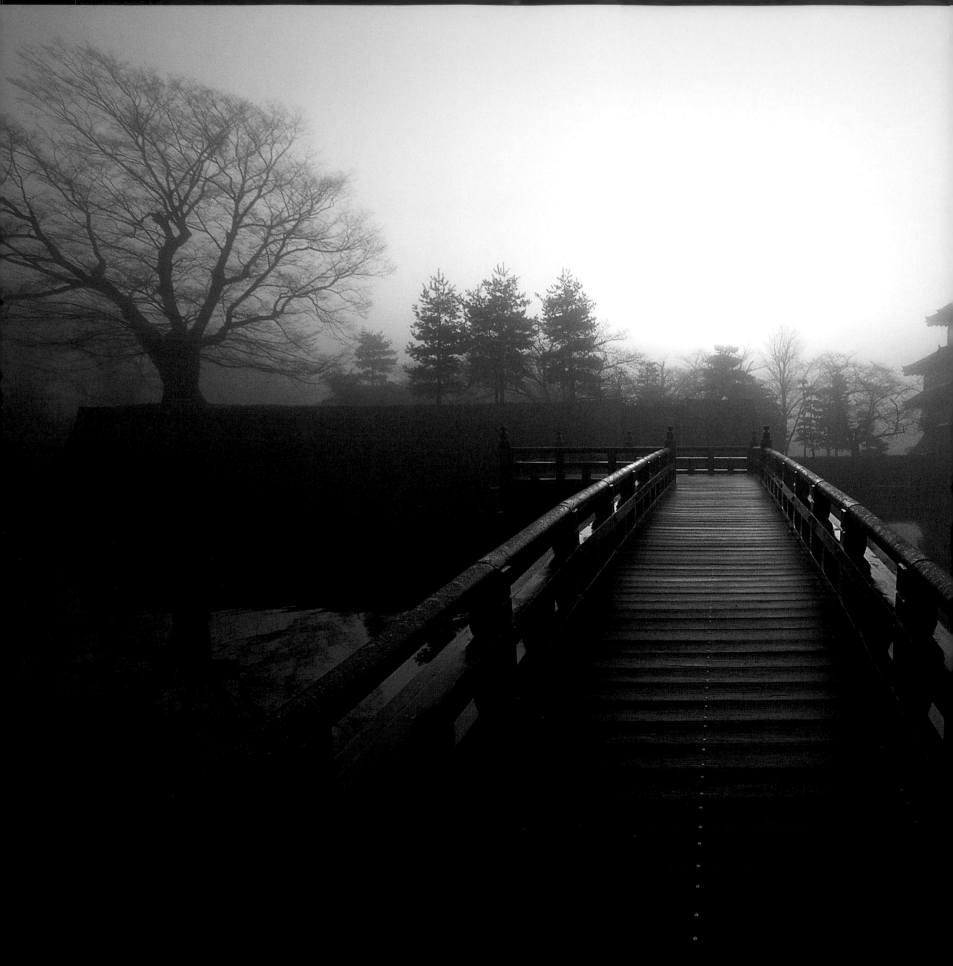

MICHAEL YAMASHITA, 2003. BRIDGE OVER THE MOAT OF MATSUMOTO
CASTLE, NAGANO PREFECTURE, HONSHU ISLAND, JAPAN.

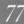

77

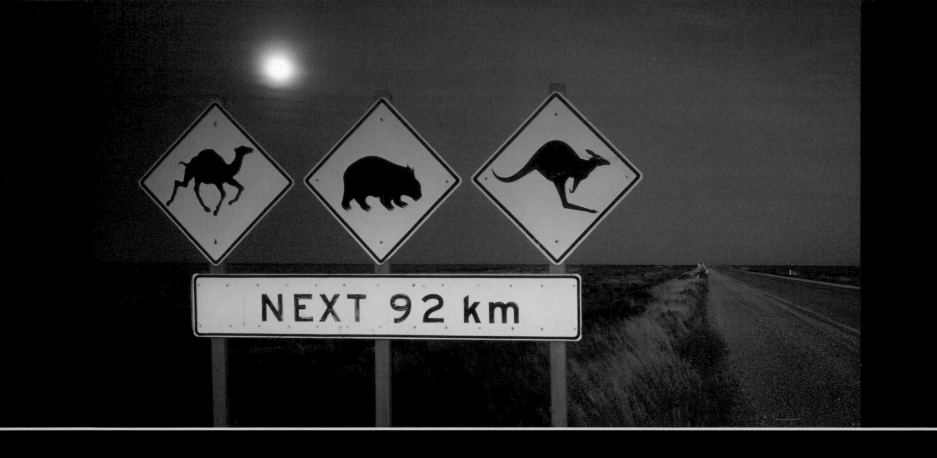

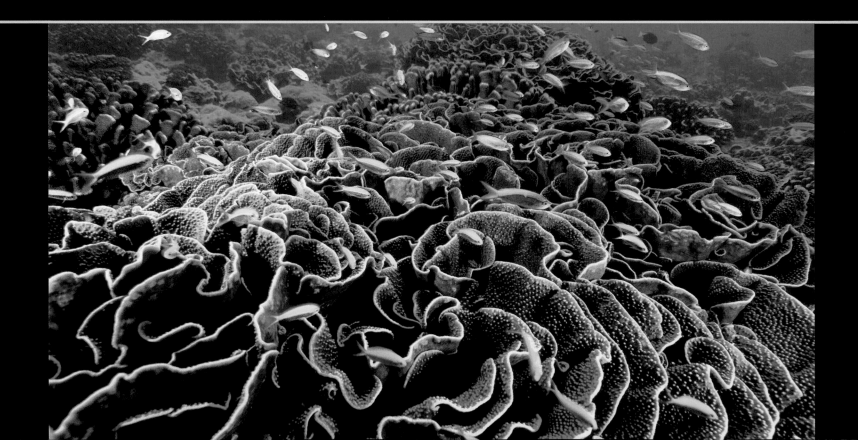

# 2 OCEANIA

PREVIOUS PAGE TOP: BILL BACHMAN, 1999. AUSTRALIAN OUTBACK SIGNS WARN OF CAMEL, WOMBAT, AND KANGAROO CROSSING.

BOTTOM: PAUL NICKLEN , 2004. THE ART OF UNDERWATER LIFE AND PHOTOGRAPHY: FAIRY BASSLET FISH AMIDST BLOOMS OF LETTUCE CORAL IN THE PHOENIX ISLANDS, KIRIBATI, POLYNESIA.

# OCEANIA

Traveling via photographs from NATIONAL GEOGRAPHIC magazine, a typical day in the South Pacific might look something like this: Breakfast on a Tahitian beach; scuba exploration of Fiji's reefs; tour downtown Sydney; drive through the Australian outback, lunching with several thousand sheep; visit Papua New Guinea's Asaro mudmen for their annual tribal sing-sing; hike in the highlands of American Samoa, then a quick flyover of Palau before returning to Hawaii for a windsurfing competition followed by a *hukilau* and a luau.

In reality, of course, that schedule is impossible. But this imaginary agenda of island-hopping mixed with tourist outings and more scientific activities bears reasonable semblance to the somewhat schizophrenic way National Geographic has depicted the region over the years.

Photographs published in the Society's magazine have played a significant role in promoting and perpetuating the stereotype of the South Pacific islands as paradise. In one lush color shot after another, readers see perfect weather and an impossibly blue ocean caressing pristine, empty beaches while handsome, friendly inhabitants perform ceremonial rituals and dances. We cast our nets into this sea of imagery and, in the words of Jack Owens's 1948 ditty, "...all the *amaama* come a-swimming to me." Pass the poi, please.

Before we feast on Hawaiian delights, however, consider the sheep. Packed cheek-by-woolly jowl into huge pens that nearly fill the frame in Winfield Parks's photograph from Queensland, Australia, their presence and our knowledge that they exist only to provide flesh, wool, or bedroom slippers demonstrate how National Geographic photographers have also been debunking the South Sea island stereotype. The flock of Christmas Day revelers soaking up sun, sand, and beverages in Annie Griffiths Belt's photo of Sydney's Bondi Beach takes considerable high-culture wind out of the local opera house's sails.

There are many reasons for this dichotomous approach. The most fundamental is that the photographers shot what was there. Even their most clichéd pictures, such as Paul Chesley's photo of native musicians and dancers ranked behind a garish Hawaii sign, came from real life.

So did the elements underlying the stereotype. The sun, the sea, the sand, the flora, the fauna, and the indigenous

cultures of Australia, New Caledonia, Papua New Guinea, New Zealand, Palau, the Fiji Islands, and Hawaii are unique and fascinating. The Pacific Ocean is indeed full of amazing marine life and remarkable geophysical formations such as Australia's Great Barrier Reef, the world's largest collection of coral reefs, home to 400 types of coral and 1,500 species of fish.

These places and their peoples have been dazzling Western eyes since the Southern Hemisphere was first explored in detail by Captain James Cook and others during the 18th century. The appeal of the islands also translated very well to the written word and pictures. To Cook's contemporaries, accustomed to Europe's gray skies and damp, chilly climate, his written descriptions of Tahiti, Australia, and Hawaii must have sounded like heaven on earth.

Artists' renderings of the place amplified that impression. When photography came along, so did photos. With the development of photo-mechanical reproduction, four-color printing, and color photography, the wonders of the South Pacific looked better still and were seen by a broad and growing audience. After World War II, jet aircraft dramatically reduced the time it took Americans or Europeans to travel to places like Palau, while the rising tide of post-war prosperity afforded them the means and the opportunity.

NATIONAL GEOGRAPHIC magazine's photographs were not intended to lure masses of tourists to the region. Over the past century, many of its photos have documented in detail the plant, animal, geological, and cultural life of the Pacific isles. But other pictures were highly subjective and focused solely on how lovely the islands look. Luis Marden's classically beautiful picture of a placid Tahitian lagoon, which ran in the July, 1962, issue as part of a story titled, "Tahiti, 'Finest Island in the World,'" is the stuff of a travel marketer's dreams.

That is no indictment of Marden. He is said to have truly loved the place and he saw what he saw. Ever since the first Europeans arrived, visitors have been smitten with Tahiti and other South Pacific islands. That love obviously comes in part from the region's proven allure. Powerful as that is, the pictures of the islands also touch something deeply rooted in Western thought, as well as in religions such as Islam and Buddhism, namely the notion of paradise. It may not exist, but we all want to go there.

Paradise, in a sense, is landscape viewed as an expression of human conscience. It is a place where mankind can still live in harmony with nature, a place primitive, pure, and unchanging, a place without want, where needs are filled effort-

lessly. Simple, uncomplicated people dwell there in amity and happiness. The goodness of the place provides the antidote to humanity's failings. The longing for paradise has prompted countless people to travel to the islands. That longing has been fueled in large measure by words and pictures, such as those created by the artist Paul Gauguin, who returned to France in 1893 from his first trip to Tahiti and began work with the critic Charles Morice on a book about his experiences, titled *Noa Noa.* That story ends with the narrator, Gauguin, summarizing his experience. "Farewell, hospitable land, delicious land, home of freedom and beauty! I leave after two years, twenty years younger, more uncouth therefore than on arrival and yet more educated. Yes, the savages have taught many things to the old civilized man—many things, those illiterates, about the science of living and the art of being happy."

If we overlook his slurs, Gauguin's description of the place has the same universal appeal as paradise. Yet, even Gauguin's paradise was not immune to trouble. He returned to Tahiti in 1895, and attempted suicide there in January 1898, shortly after completing his mural-like painting, "Where Do We Come From? What Are We? Where Are We Going?"

Those are the same questions many children the world over ask their parents. The answers vary widely because adults hate to admit that they don't really know. Unfortunately, as Gauguin perhaps discovered, the idea of paradise and pictures of it raise as many existential questions as they answer. Paradise and photographs share certain characteristics. They are abstractions, removed from their place of origin. They can alter our emotional state and sometimes overwhelm rational thought. And they are reminders that we could be someplace other than where we are. That is why we put photographs of places like Hawaii or New Caledonia on the walls of our homes, workplaces, and public buildings.

The photographs in this chapter show the South Pacific as it was when Luis Marden and his colleagues saw it. If some of their pictures seem quaint or stilted now, well, time moves on and tastes and ideas change, sometimes even before the picture is developed. Even though in recent years National Geographic's photographers haven't shied away from the grittier, less pleasant aspects of life in the region, such as environmental degradation and cultural clashes between inhabitants and visitors, the lure of paradise remains strong. But as Medford Taylor's photograph of Australia's Dog Fence reminds us, even in paradise there are always dingoes who consider the sheep to be just another moveable feast.

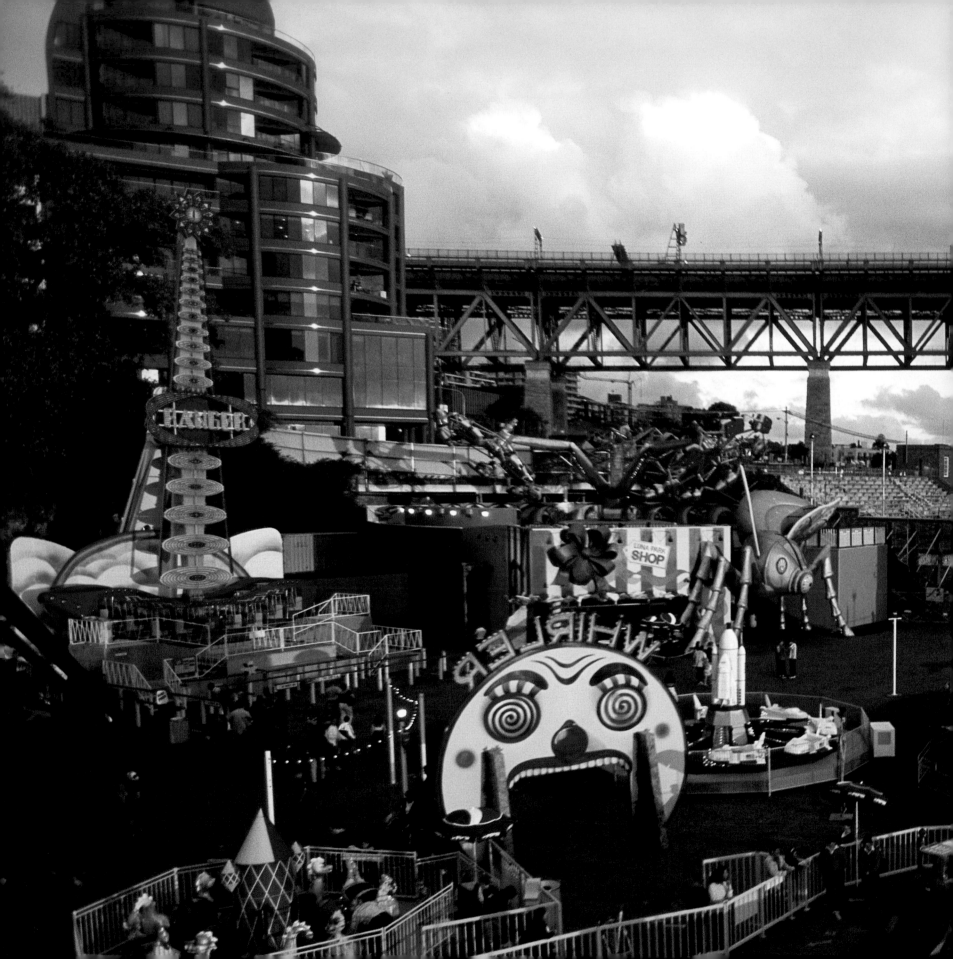

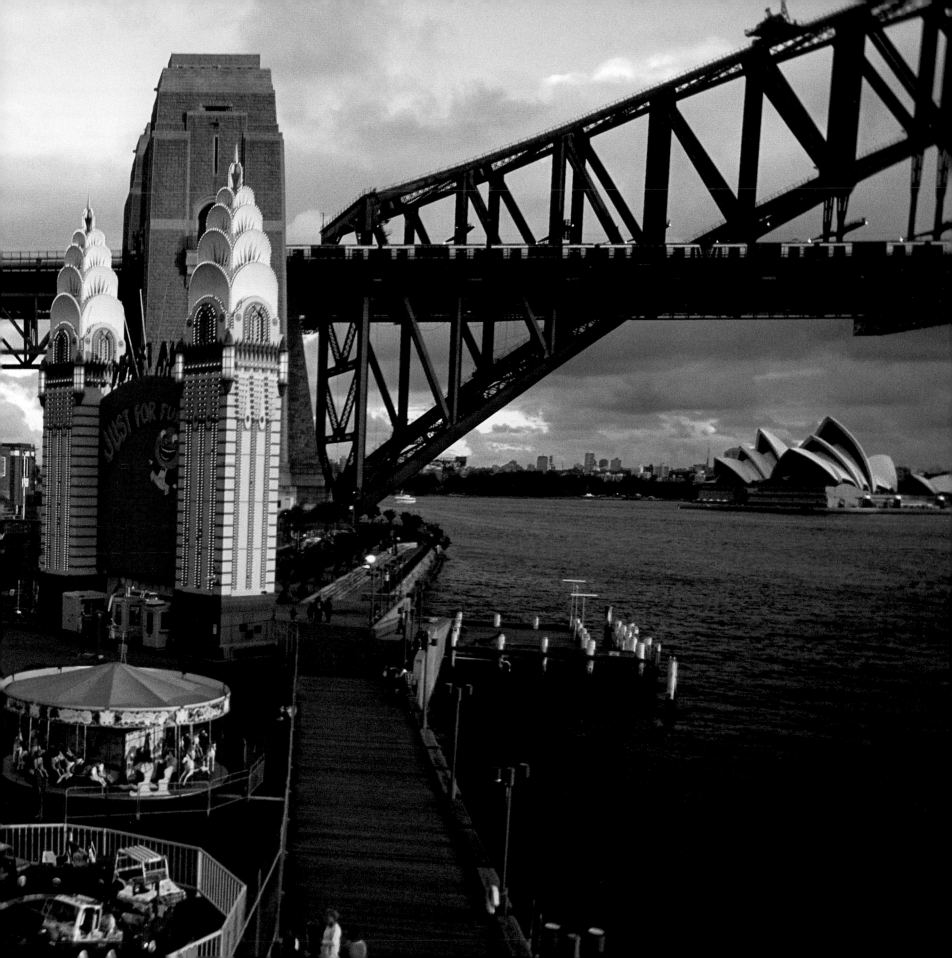

87

FRANS LANTING, 1999. THE FLORA OF PARADISE: LOBELIAS AND GREENSWORDS FLOURISH IN MAUI'S PU'U KUKUI WATERSHED PRESERVE.

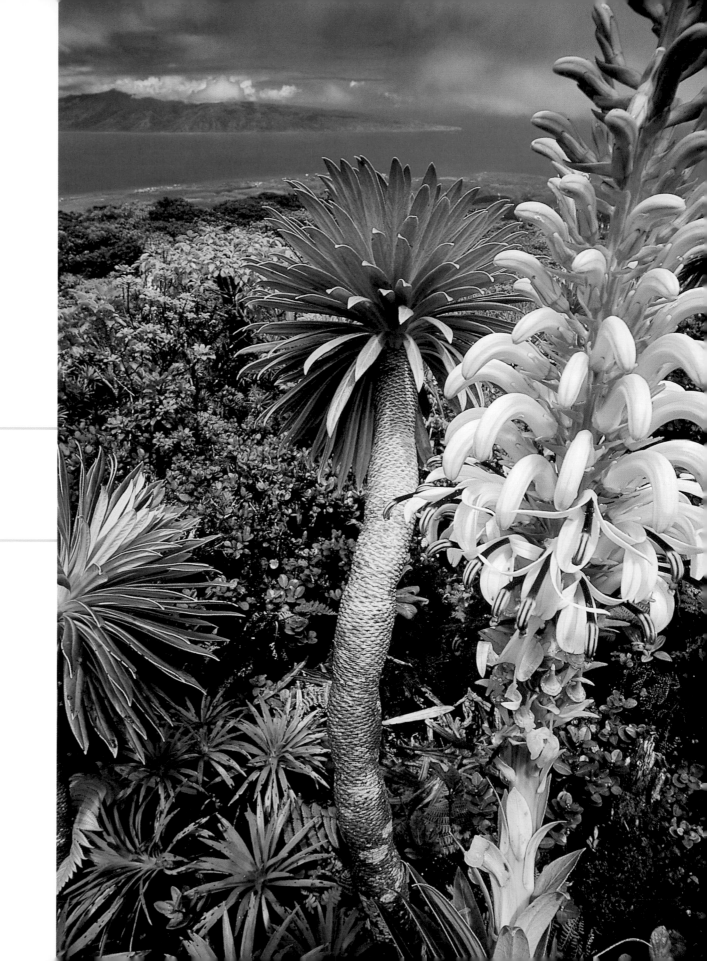

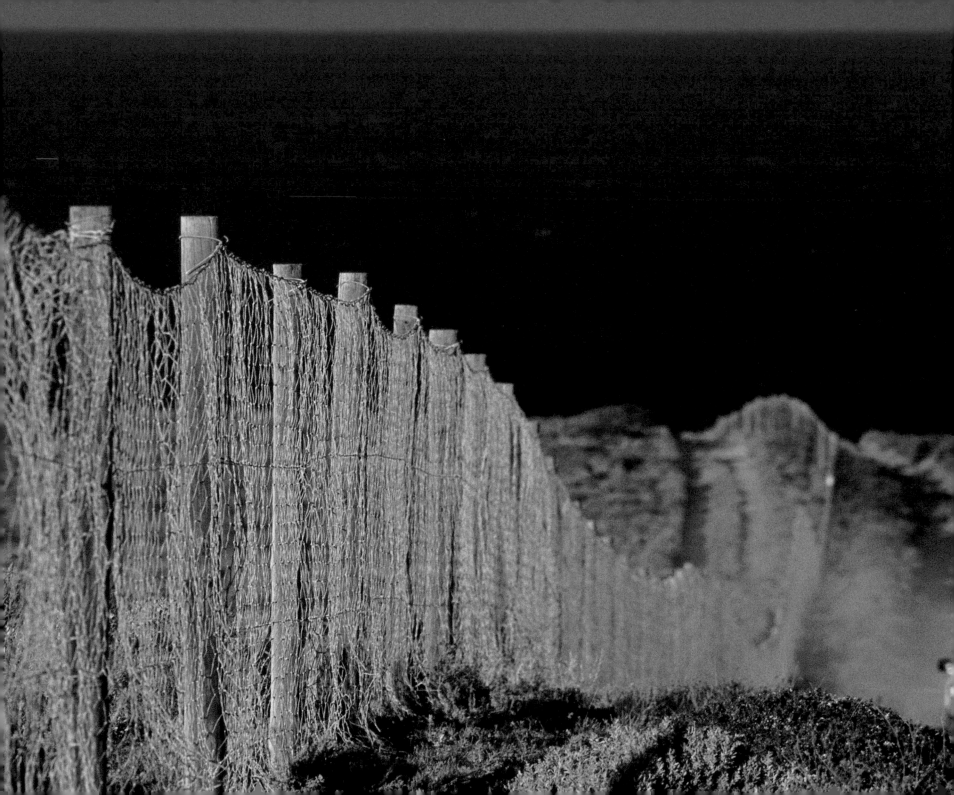

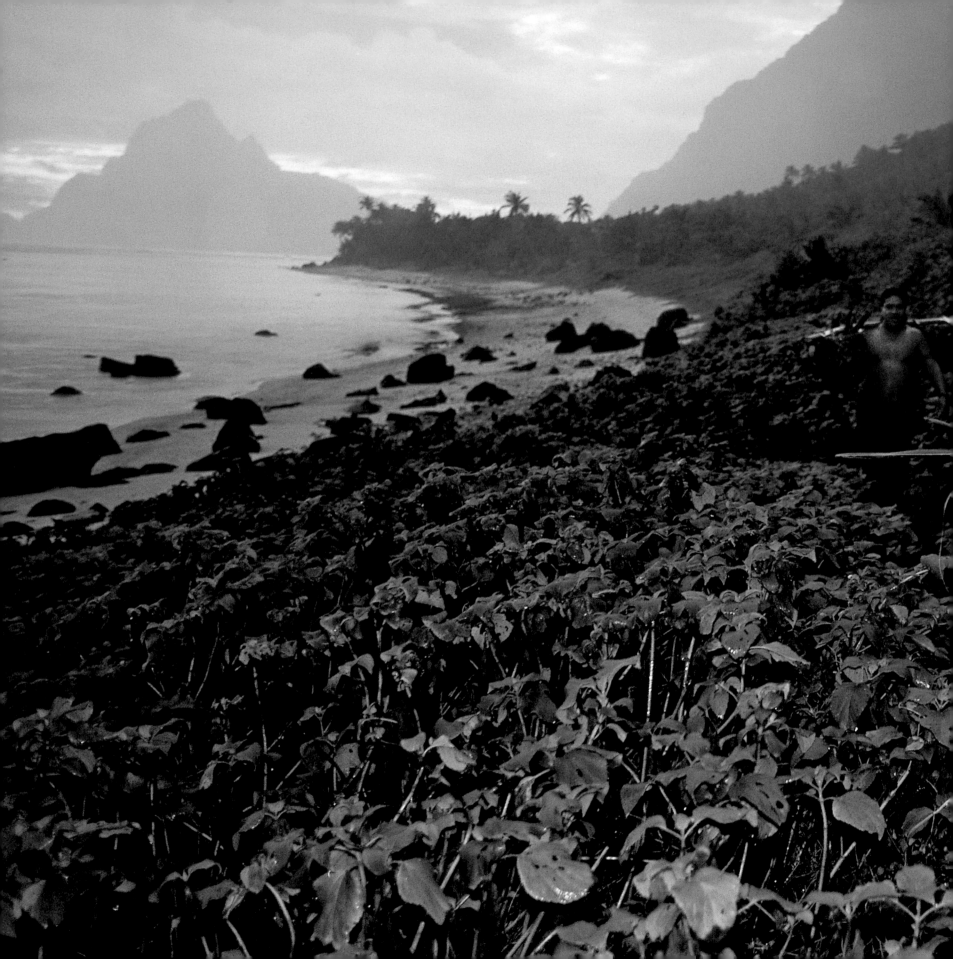

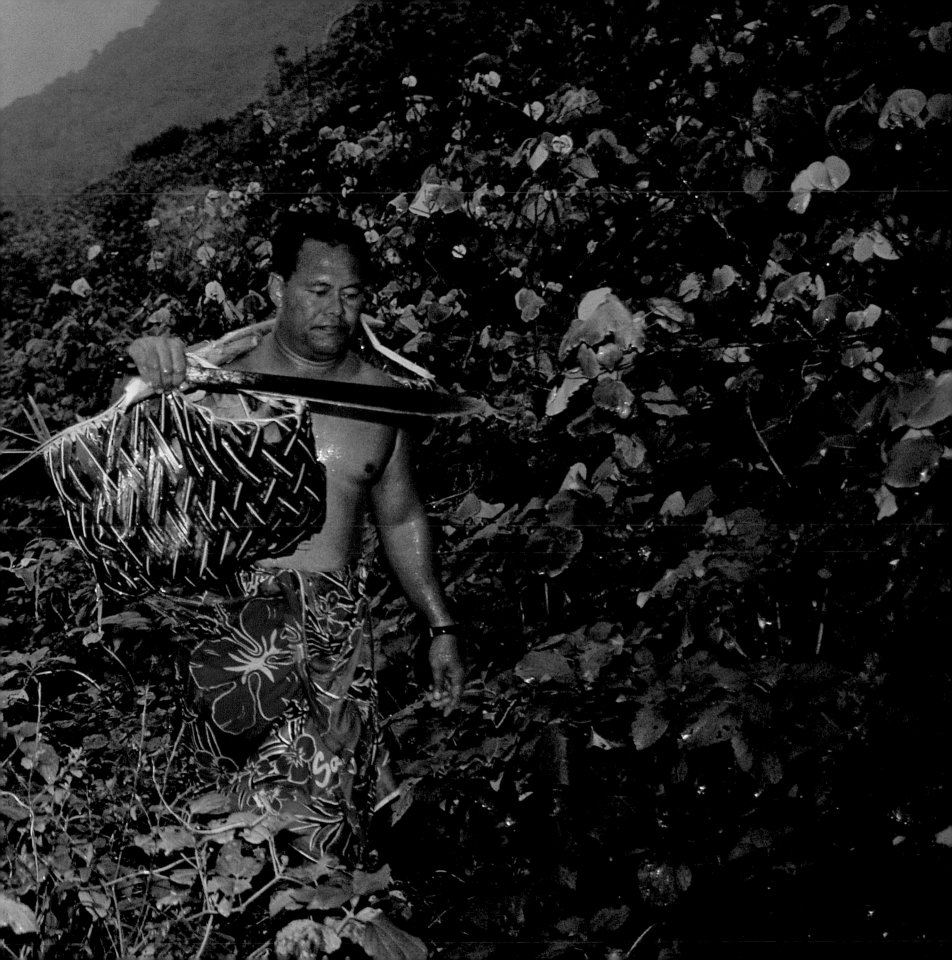

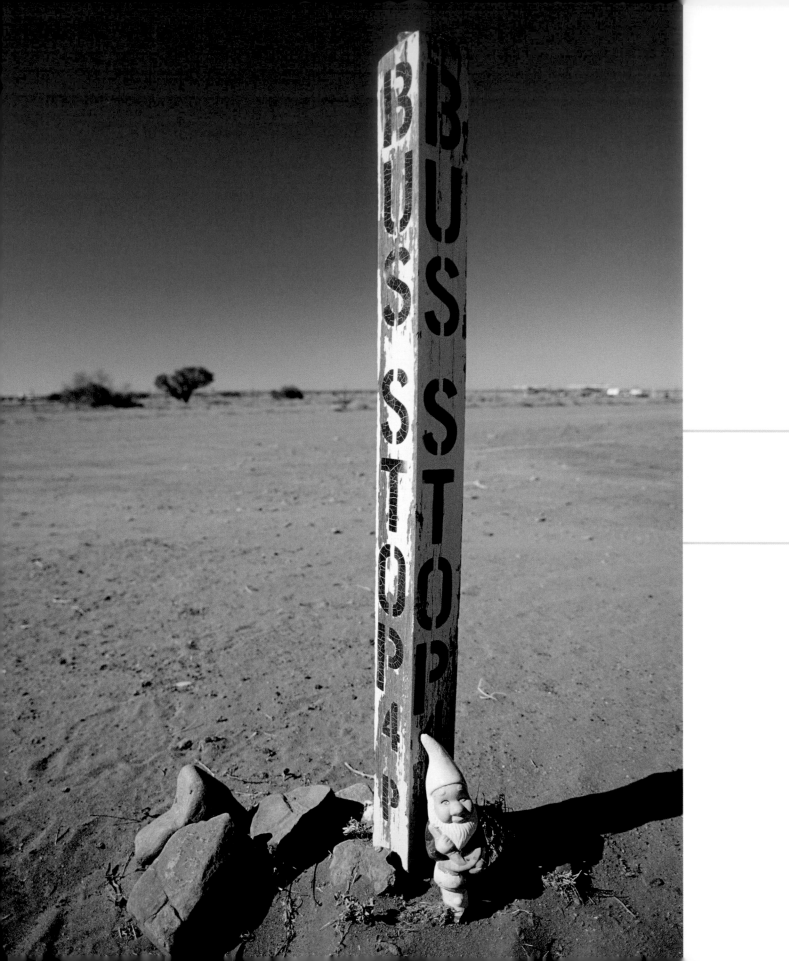

LEFT: WINFIELD PARKS, 1968. MERINO SHEEP AT BAXTER'S SHED, A SHEEP STATION IN QUEENSLAND, AUSTRALIA.

RIGHT: KEVIN DILETTI, 1988. EUCALYPTUS AND ACACIA ON THE SOUTHERN REACHES OF THE NULLARBOR PLAIN, WESTERN AUSTRALIA.

BEFORE WE FEAST ON HAWAIIAN

DELIGHTS, CONSIDER THE SHEEP. ❧

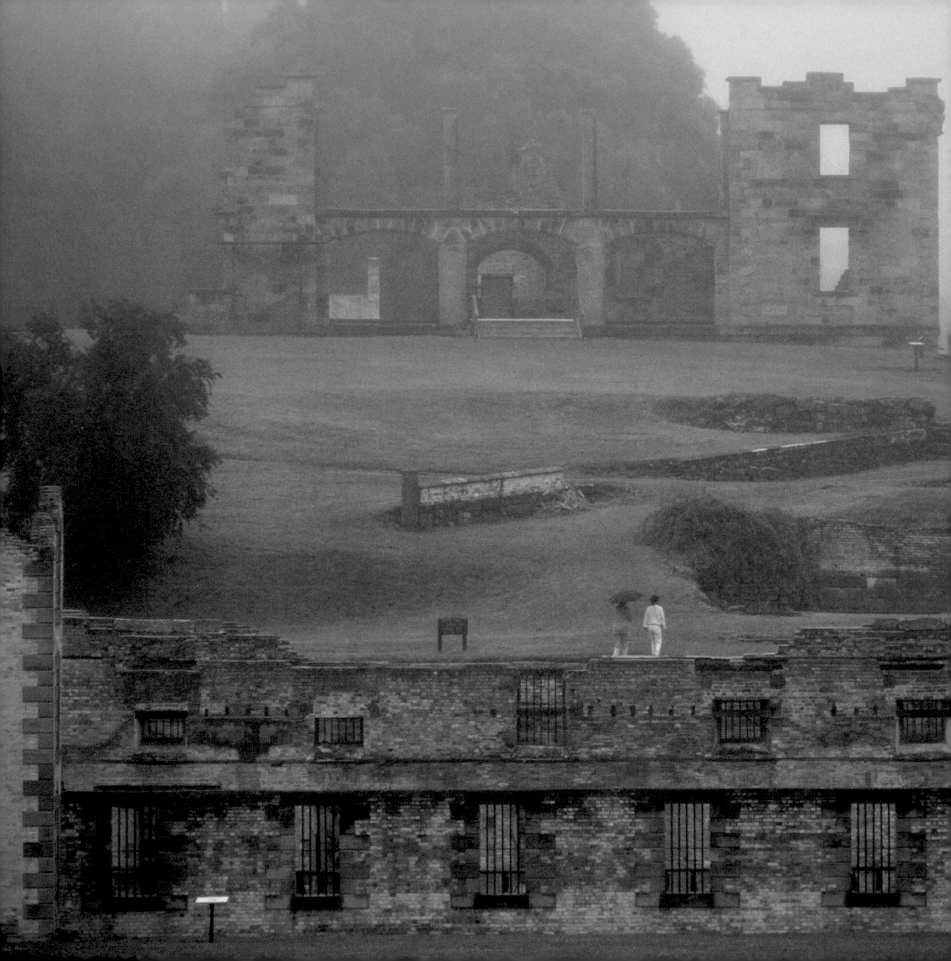

SAM ABELL, 1996. PARADISE AS A PLACE OF EXILE AND INCARCERA-
TION: RUINS OF PORT ARTHUR PENITENTIARY, TASMANIA.

99

PETER ESSICK, 2000. KANAK TOTEMS ON THE ISLAND OF NEW CALEDONIA SYMBOLIZE THE INDIGENOUS CULTURE OF FRANCE'S TERRITORY IN THE SOUTH PACIFIC.

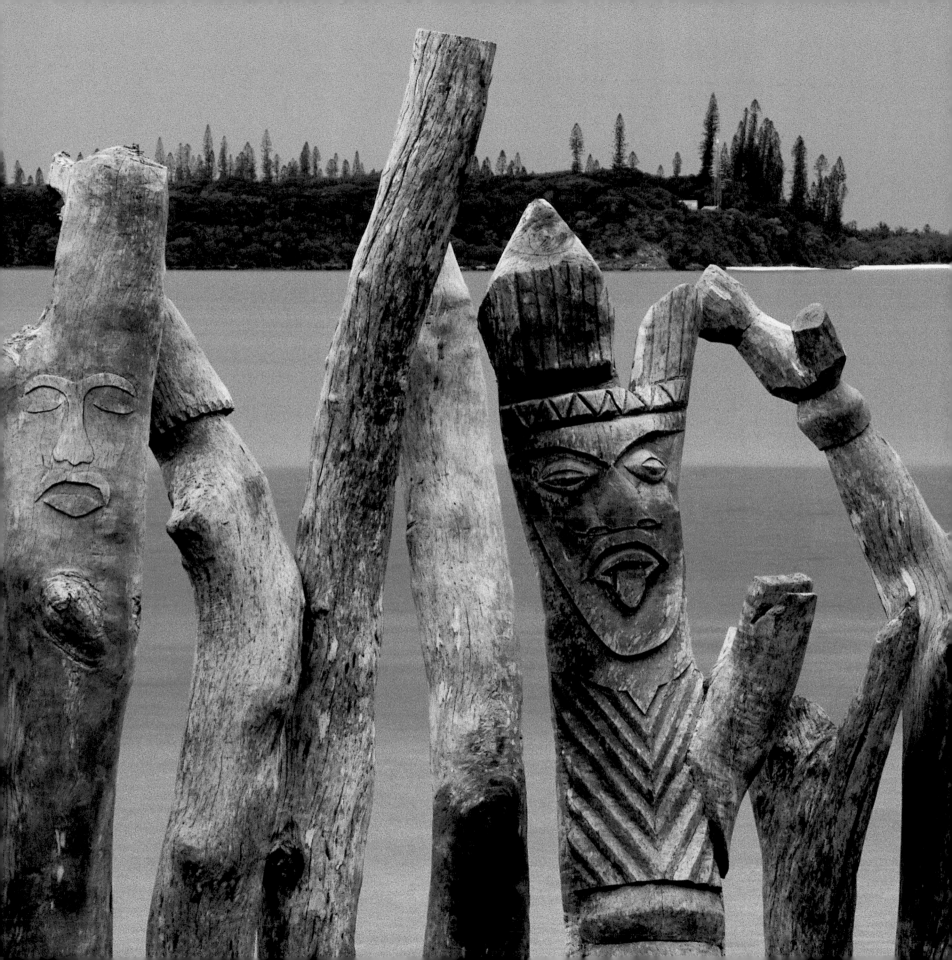

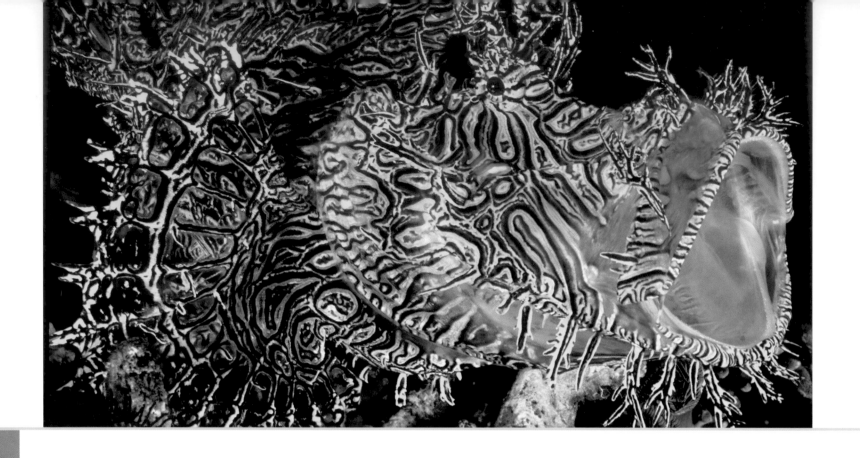

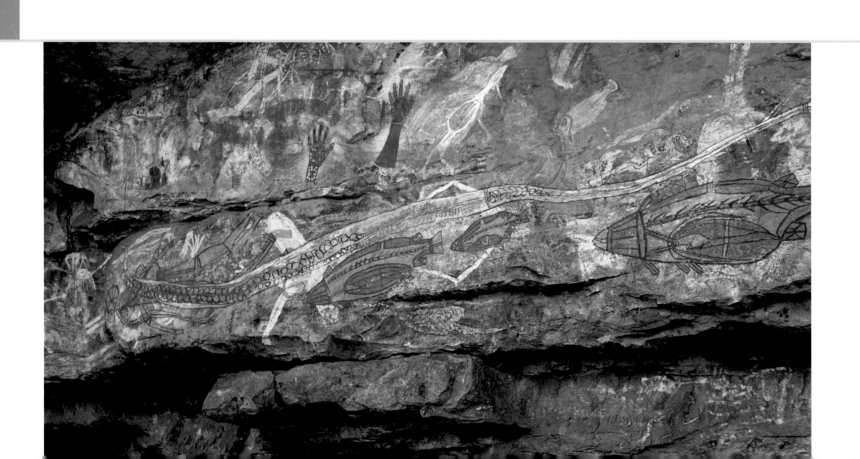

TOP LEFT: DAVID DOUBILET, 1999. A MERLET'S SCORPIONFISH, CAMOUFLAGED IN THE NEON COLORS OF THE SOUTH PACIFIC, INHALES ITS PREY OFF PAPUA NEW GUINEA.

BOTTOM LEFT: BELINDA WRIGHT, 1988. LANDSCAPE AS A FORUM AND FOUNDATION FOR INDIGENOUS ART: THE ABORIGINAL VIEW OF CREATION PAINTED ON THE ROCK WALLS OF AUSTRALIA'S KAKADU NATIONAL PARK.

PREVIOUS PAGES: JODI COBB, 2001. SITTING ON A HAWAIIAN BEACH, LIVING THE DREAM OF A PACIFIC ISLAND ESCAPE.

RIGHT: MIGUEL LUIS FAIRBANKS, 1995. AN ORPHANED KOALA RIDES WITH FOSTER PARENT MIRIAM GRAHAM IN NEW SOUTH WALES, AUSTRALIA.

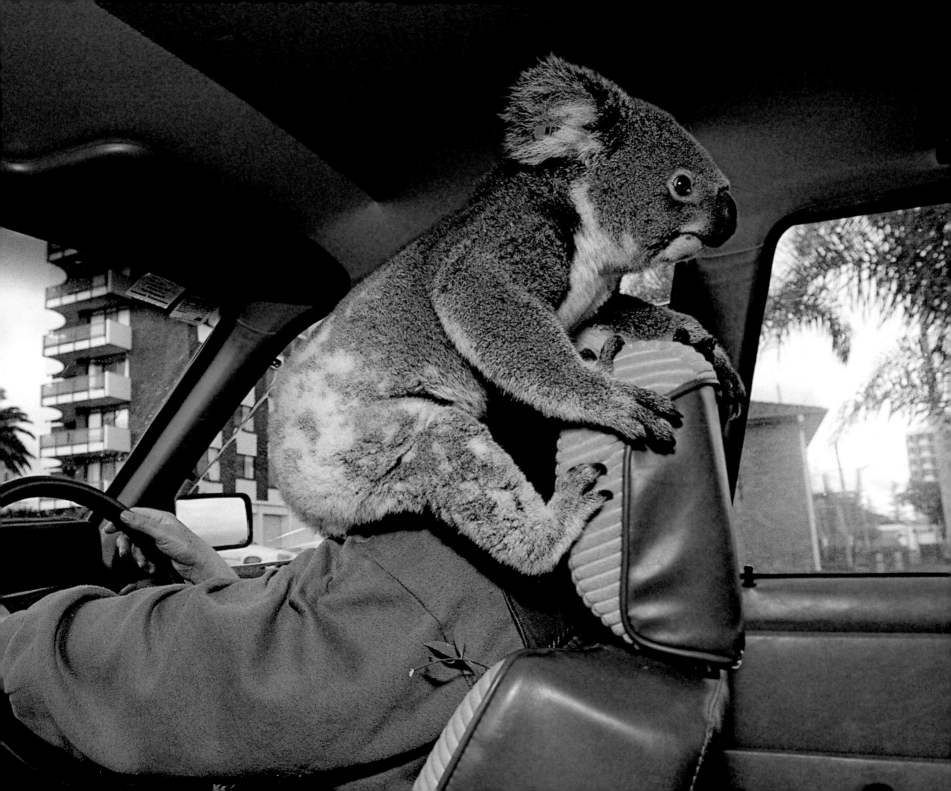

TOP RIGHT: PAUL CHESLEY, 1997. THE CLICHÉS OF PARADISE COME FROM REAL LIFE, AS WITH THESE HAWAIIAN DANCERS AND MUSICIANS.

BOTTTOM RIGHT: ANNIE GRIFFITHS BELT, 2000. SANTA, SUN, AND SUDS: CHRISTMAS DAY REVELERS PACK BONDI BEACH IN SYDNEY, AUSTRALIA.

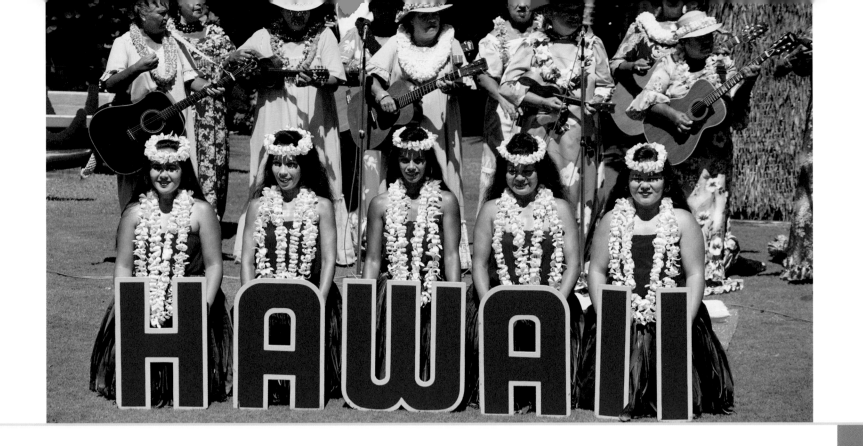

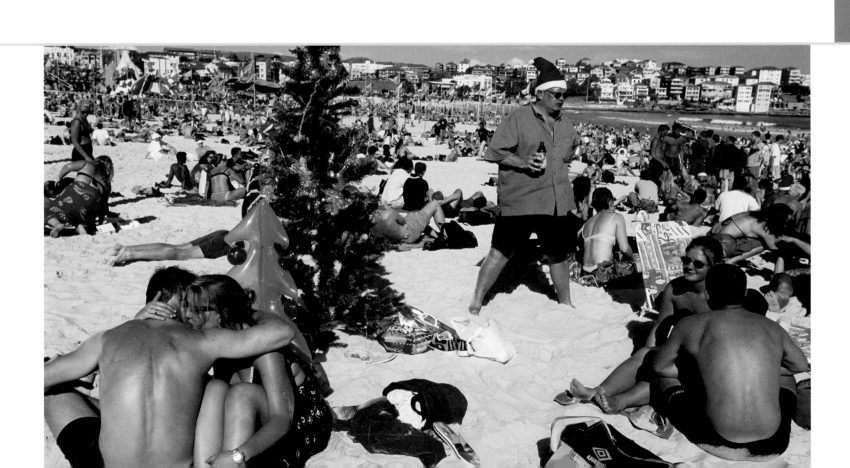

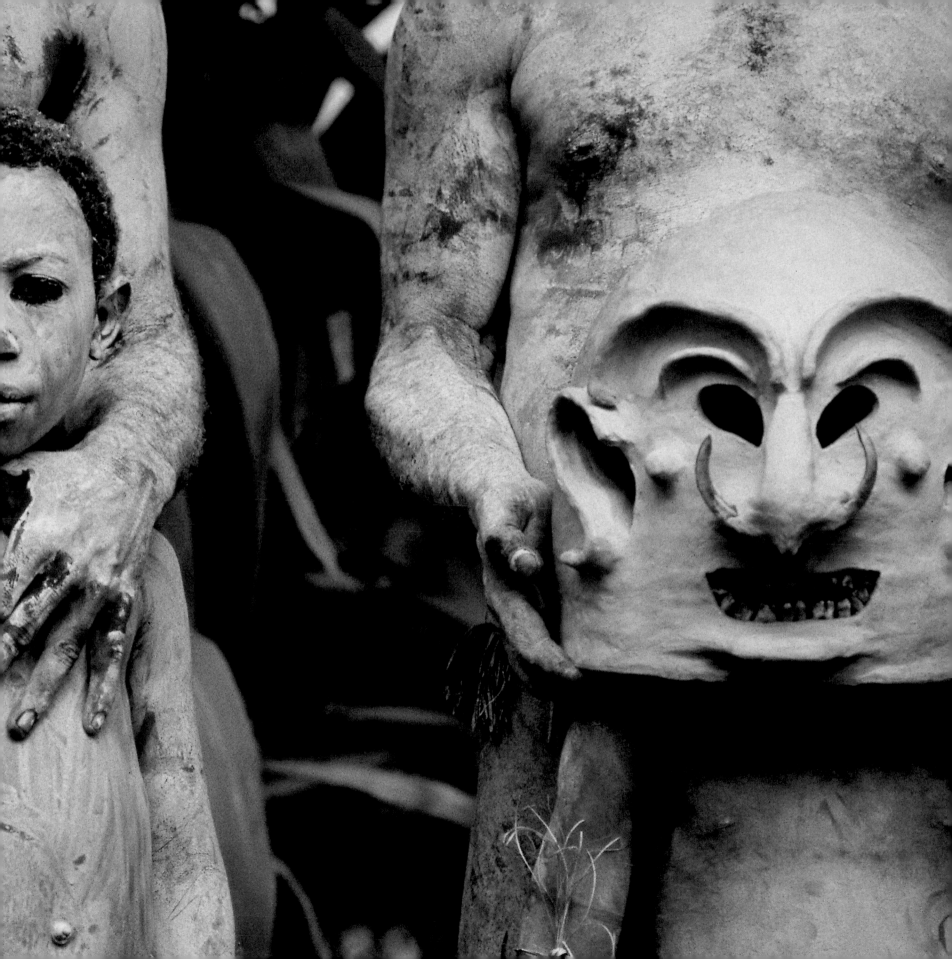

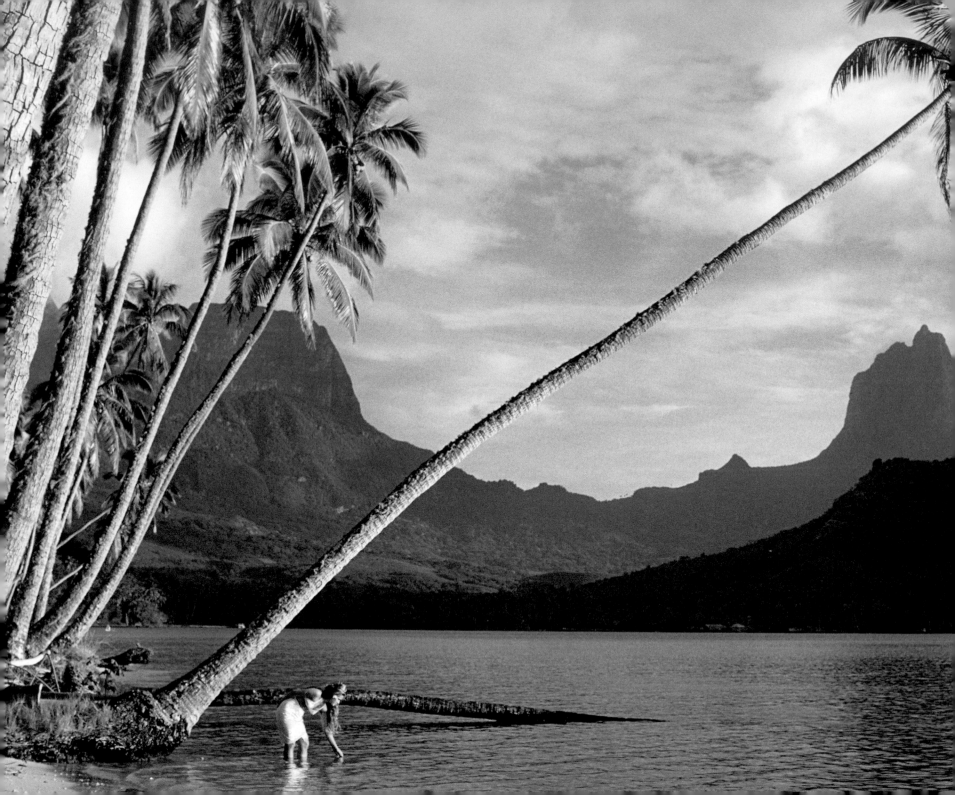

PREVIOUS PAGES: JODI COBB, 2001. YOUNG ASARO MUDMEN AT THE ANNUAL TRIBAL SING-SING AT GAROKA, PAPUA NEW GUINEA.

LEFT: LUIS MARDEN, 1962. TAHITI AS THE IDEAL IMAGE OF AN ISLAND PARADISE, PERFECT IN EVERY WAY, AT LEAST AS A PHOTOGRAPHIC SUBJECT.

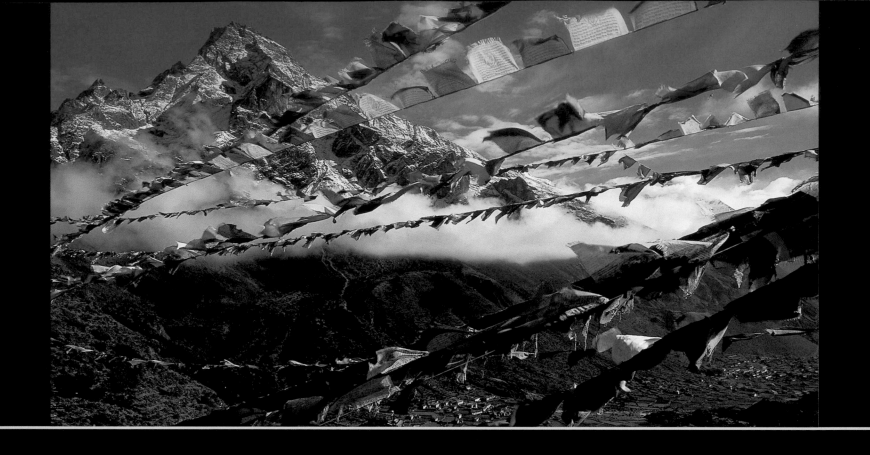
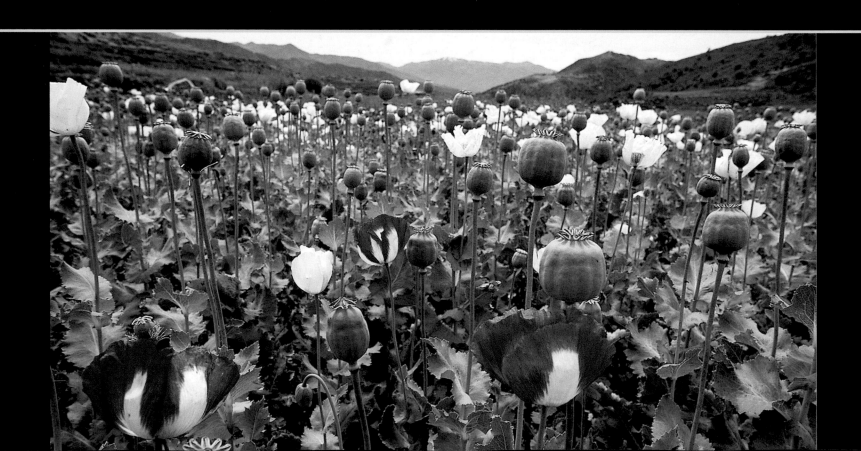

# 3 CENTRAL & SOUTH ASIA

116

PREVIOUS PAGE TOP: ROBB KENDRICK, 2003. BUDDHIST PRAYER FLAGS, SAID TO BRING HAPPINESS, LONG LIFE, AND PROSPERITY, FLUTTER OVER THE VILLAGE OF KHUNDE, NEPAL.

BOTTOM: STEVE RAYMER, 1983. BRIGHTLY COLORED OPIUM POPPIES AND THEIR EGG-SHAPED SEED PODS, THE SOURCE OF HEROIN, BLANKET PAKISTAN'S KHANPUR VALLEY.

# CENTRAL AND SOUTH ASIA

**A**photograph is an image transmitted by light through a relatively tiny spy glass held, in the case of published pictures, by a person we will likely never know. That photographer is a subjective filter, choosing what to include in the photo. Regardless of that person's inclinations, skill, and equipment, the picture taken always shows just a fragment of a place at a certain point in time.

Photos published in NATIONAL GEOGRAPHIC magazine or other publications go through a further selection process presided over by editors whose job is to see that the pictures illustrate a text or tell a story on their own. After this winnowing, viewers see an even smaller portion of the fragments of the picture's place of origin. The wider scene it was culled from can only be inferred, if it is considered at all.

Sometimes, however, the qualities of a place—the landscape, the elements, the people, and the culture—are so vibrant that the inherent limitations of the medium and the selection process are overcome. The fragments coalesce into an expansive, more telling vision, as with these pictures taken in Russia, Kazakhstan, Uzbekistan, Afghanistan, Pakistan, Bhutan, Nepal, and India.

The physical landscape—often treated in photographs of a place as either a postcard cliché or a quiescent backdrop—has a primal force that seems to pour through the lens and out of the images, making them seem bigger and more animated than any photo can be.

That is a tribute first of all to the photographers working for National Geographic and the extraordinary subjects they chose. The pictures in this chapter are a visually compelling sampling of life in this vast swath of territory at the heart of the largest land mass on Earth, a place marked by extremes of geography, geology, biology, climate, population density, economic and social organization, beauty, and ugliness.

But the resonance of this group of photos comes not just from the extremes shown—the deserts, the glaciers, the Taj Mahal, the brutal poverty—but from those only inferred: the sheer immensity of Central and South Asia and their distance from the Western world and worldview.

From the taiga of Siberia, down through the peaks and valleys of the Hindu Kush, across the undulating hills of India's Deccan plateau, south to the jungles of Sri Lanka, the physical environment depicted here, even where fertile and temperate, appears to tolerate rather than welcome human presence. In the heart of Asia, where the elements and elevation range from monsoons and tsunamis pounding the Indian coast to the thin, frigid air atop Mount Everest, the landscape is often inhospitable and indomitable, so enormous and rugged that mankind can occupy but never subdue it. Africa may be the cradle of civilization. Central Asia is where empires die.

The power of the landscape can often be felt literally, as in the Hindu Kush, where the Eurasian and Indo-Australian tectonic plates collide causing an average of four major earthquakes annually, each measuring at least 5.0 on the Richter scale. Sometimes the heavens also shake. Violent Himalayan storms caused the Bhutanese people to refer to their nation as "Druk Yul," which translates as "Land of the Thunder Dragon."

Photographs cannot convey such sound and fury as those natural occurrences. But James L. Stanfield's photo of Chomolhari mountain, Bhutan's second-highest peak, looming over a crumbling fortress, gives a powerful sense of the scale of the region and the physical forces at play there.

The spiritual power that Buddhists and Hindus assign to the physical landscape is also evident. The people of the Paro Valley worship the Buddhist mountain goddess Tsheringma, who the Bhutanese believe is embodied in Chomolhari. In India, James P. Blair photographed Hindu pilgrims bathing in the Kapil Dhara waterfall at the headwaters of the Narmada River. Hindus believe the river descended from the sky by the order of Lord Shiva, and its divinity is so strong that merely gazing upon it will absolve them of their sins and make them pure.

Some may see such beliefs as examples of how distanced these places are from the West, not just physically, but culturally. But the more I look at Blair's photo, the closer I feel to those pilgrims. Every day, millions of people the world over experience the commonplace miracle of a shower. Many of us come away feeling, if only briefly, cleansed in body and spirit.

The Buddhist prayer flags Robb Kendrick shot as they fluttered high above the Nepalese village of Khunde may look, from a different cultural context, like nothing more than laundry drying. But the flags in Nepal and bedclothes flapping in

Genoa are cut from the same spiritual cloth. Both symbolize belief in the wind's power to spread blessings, whether they are Buddhist conceptions of enlightenment and prosperity or the breath of spring in fresh sheets.

Given the time to look and consider, it is relatively easy to find common cultural ground in photographs of a place. Whether convergences would be as evident in the actual scenes shown is another question. Central and South Asia is a huge stretch of land inhabited by many ethnic groups. Some came as conquerors, like the Persians, the Greeks under Alexander the Great, the Turks, and the Arabs. They brought with them cultural influences, such as Islam and Buddhism, which still dominate the region. Yet no empire held sway for very long. The history, particularly of Central Asia, is one of almost steady-state ethnic and religious turmoil.

All of the region's nations are struggling to reconcile their traditional values with the influx of global culture. The Silk Road was the information superhighway of its time. Now Samarqand and Tashkent are linked by the Internet, and cultures can cross paths at the click of a mouse. The new, post-Soviet nations—Kazakhstan, Uzbekistan, Turkmenistan, Kyrgyzstan, and Tajikistan—which get lumped together in the West as "the Stans," as if they were clones of some beleaguered blue-collar worker, find themselves laboring to develop economic and political stability and establish national identities.

Even the meaning of an icon like Mount Everest has changed. In my lifetime, the world's tallest mountain has been transformed from an unclimbed legend into a place where climbers need reservations and expedition litter lines the climbing routes.

Despite those changes, its power as a place endures. In Wally Berg's photo, sunrise sets a peak near Mount Everest aglow and the highest mountain's shadow links heaven and Earth. The picture makes it immediately understandable why people who live near Mount Everest worship it and why others come from afar to risk their lives trying to reach its summit, a place where, as with life, no one stays for long. Even in photographs, its majesty is so overwhelming that it feels almost as though something unfathomably immense is peering through the other end of the spy glass, marveling at our smallness and our tiny images.

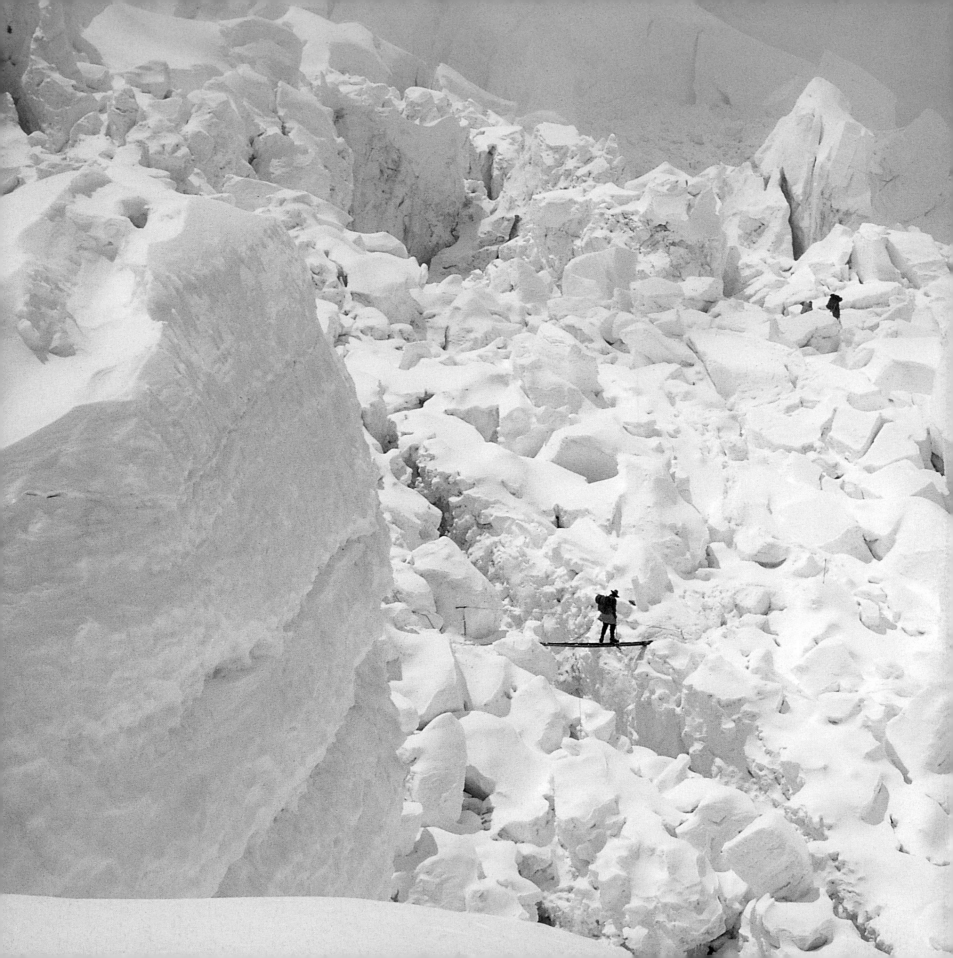

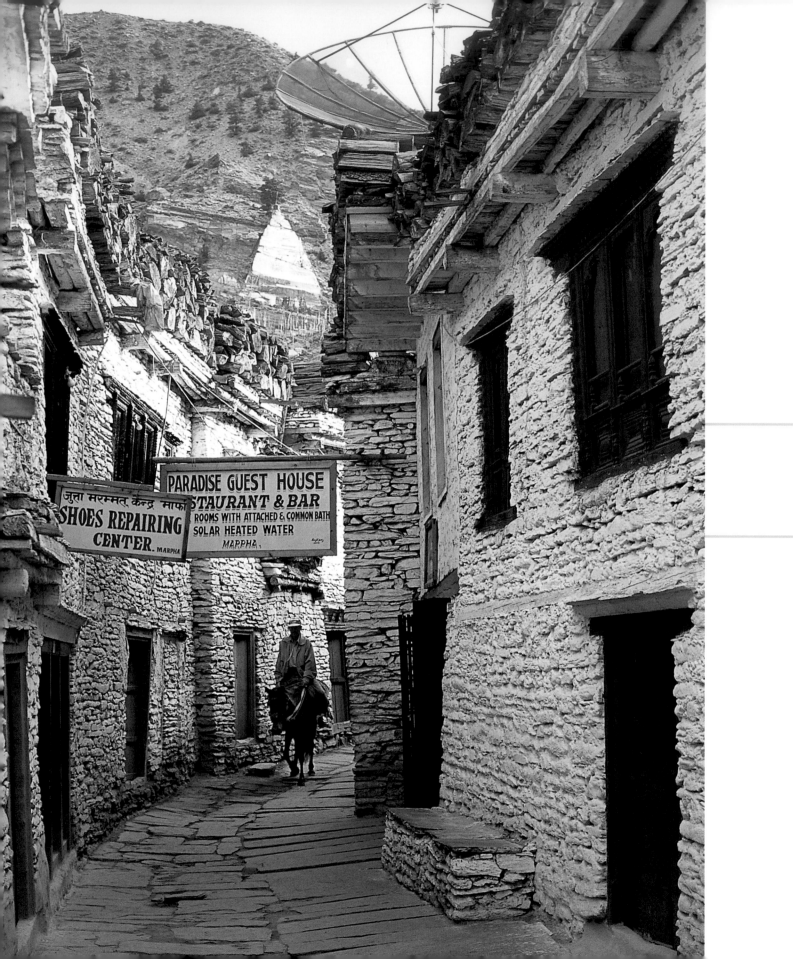

PREVIOUS PAGES: BARRY BISHOP, 1963. CLIMBERS NEGOTIATING PASSAGE ACROSS THE MASSIVE CHUNKS OF THE KHUMBU ICEFALL, HIMALAYA MOUNTAINS, NEPAL.

LEFT: STEVE MCCURRY, 1999. GUEST SERVICES LINE THE STONY STREETS OF MARPHA, NEPAL, CATERING TO HIMALAYAN TOURISTS.

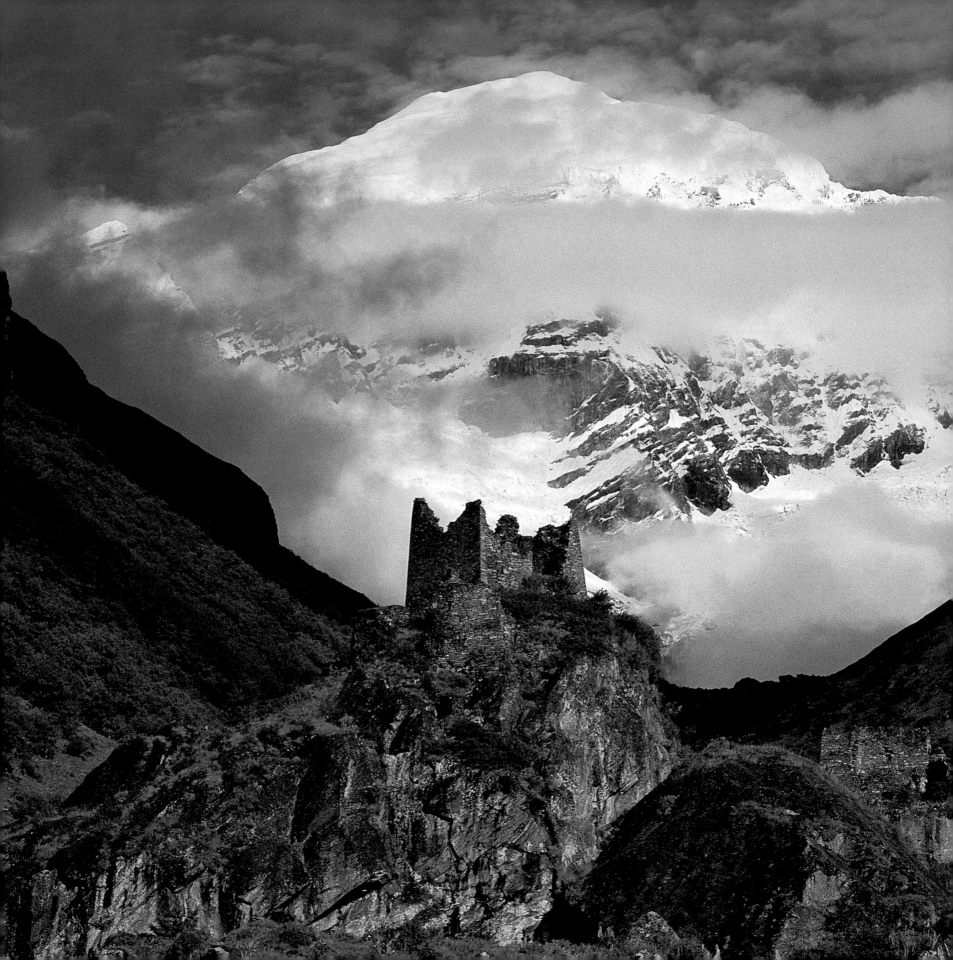

JAMES L. STANFIELD, 1991. A CRUMBLING FORTRESS, DWARFED BY
CHOMOLHARI MOUNTAIN, BHUTAN'S SECOND-HIGHEST PEAK.

125

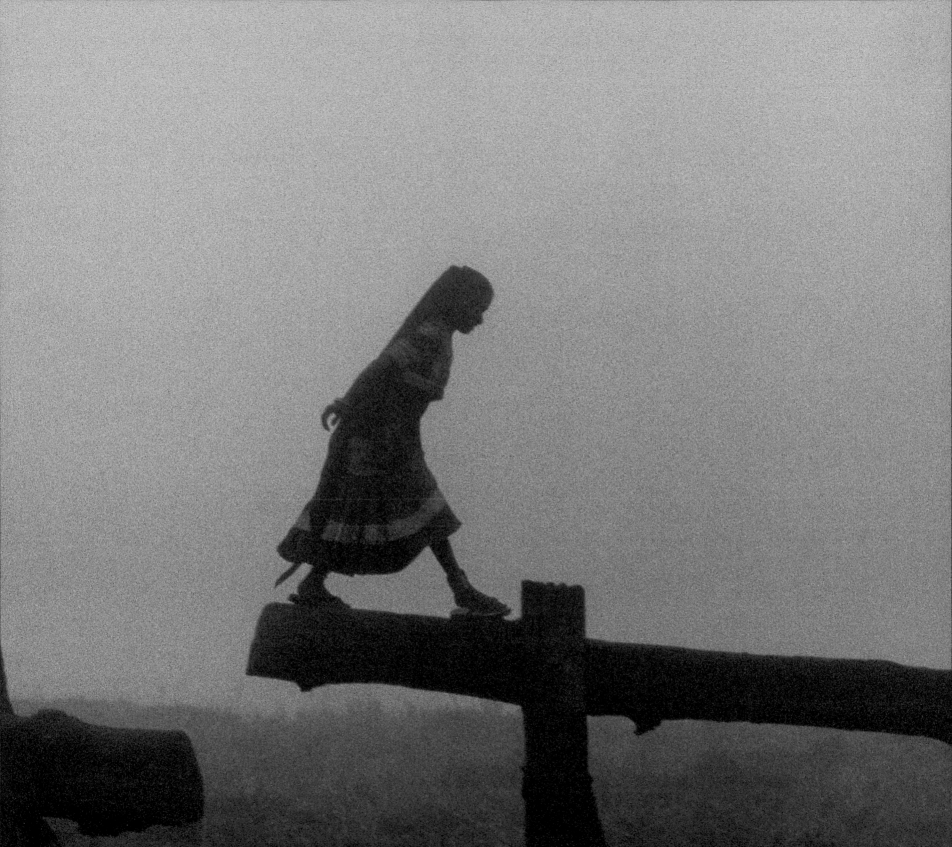

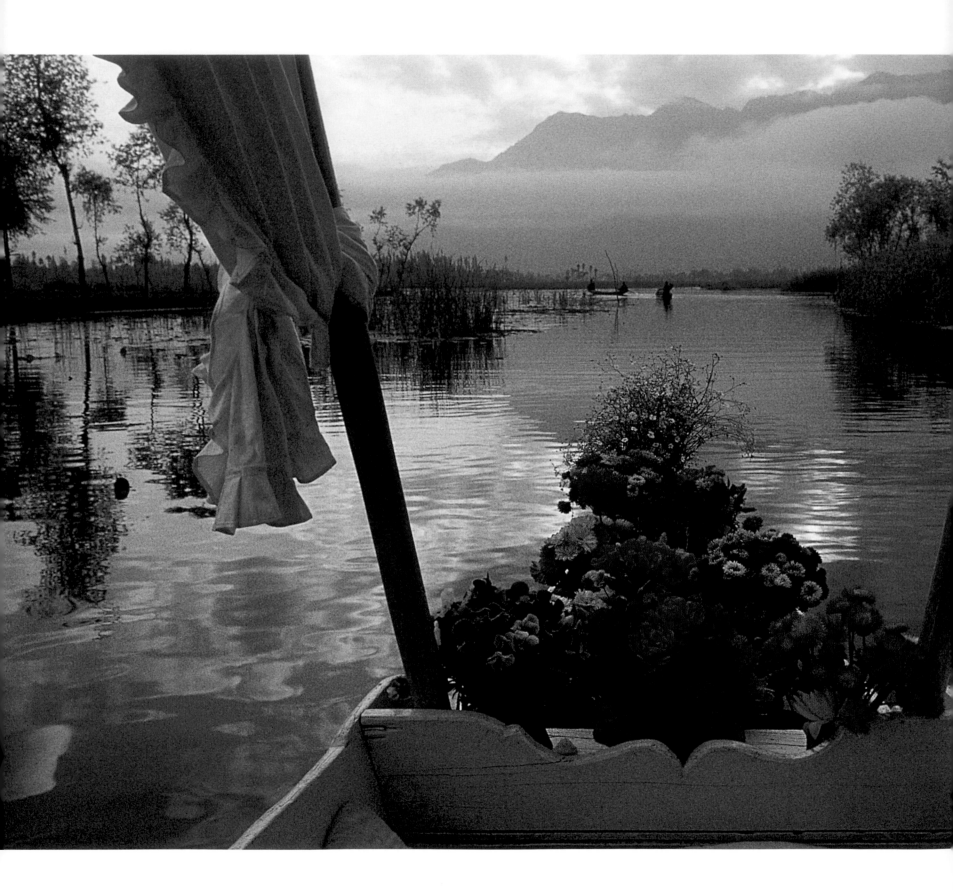

PREVIOUS PAGES: DEBRA KELLNER, 2000. RANA THARU WOMAN, NEPAL.

LEFT: SAM ABELL, 2000. BOAT WITH FLOWERS, LAKE DAL, KASHMIR, INDIA.

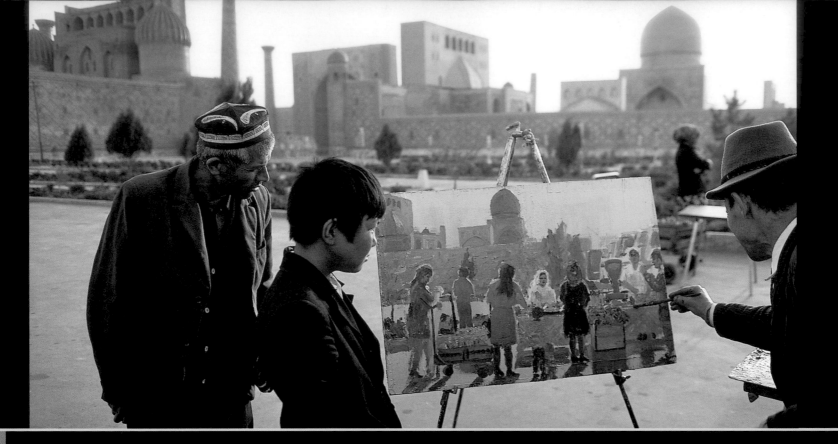

LEFT: GORDON GAHAN, DATE UNKNOWN. PICTURE WITHIN A PICTURE. SPECTATORS WATCH AN ARTIST PAINT-
ING REGISTAN SQUARE IN SAMARKAND, UZBEKISTAN.

RIGHT: GERD LUDWIG, 1991. A WOMAN SELLING GEESE FROM THE TRUNK OF A CAR AT THE CENTRAL FLEA
MARKET PAUSES FOR LIQUID REFRESHMENT ON A SUNDAY MORNING IN ALMA-ATA, KAZAKHSTAN.

& THE PICTURE TAKEN ALWAYS SHOWS

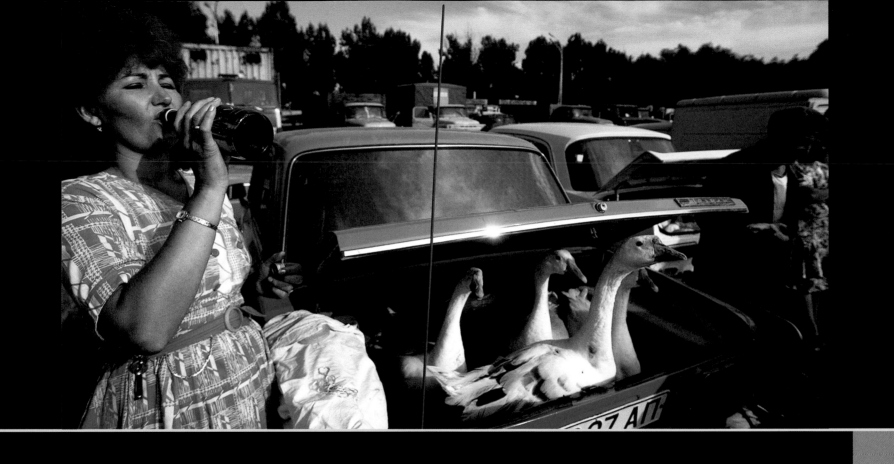

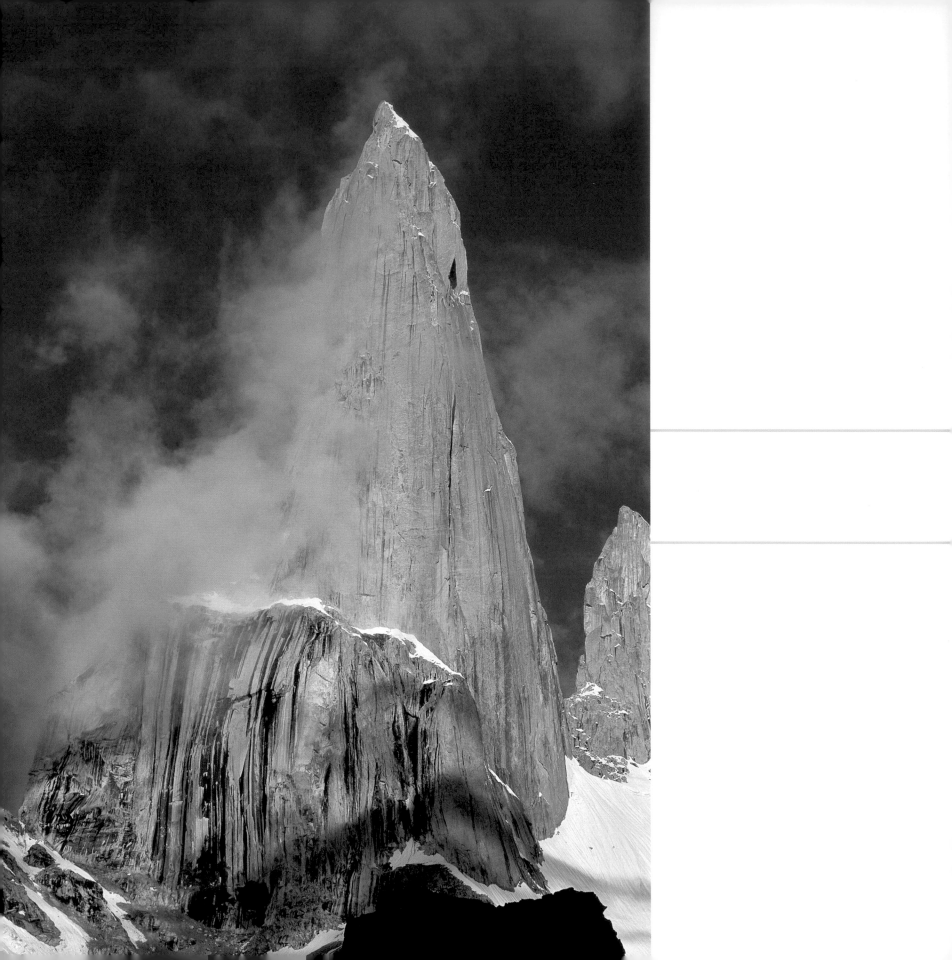

BILL HATCHER, 1996. THE PRIMAL POWER AND BEAUTY OF CENTRAL ASIA SEEN ON THE RUGGED EAST FACE OF NAMELESS TOWER IN PAKISTAN'S KARAKORAM MOUNTAINS.

JAMES P. BLAIR, 1988. HINDU PILGRIMS IN THE KAPIL
DHARA WATERFALL OF THE NARMADA RIVER, INDIA.

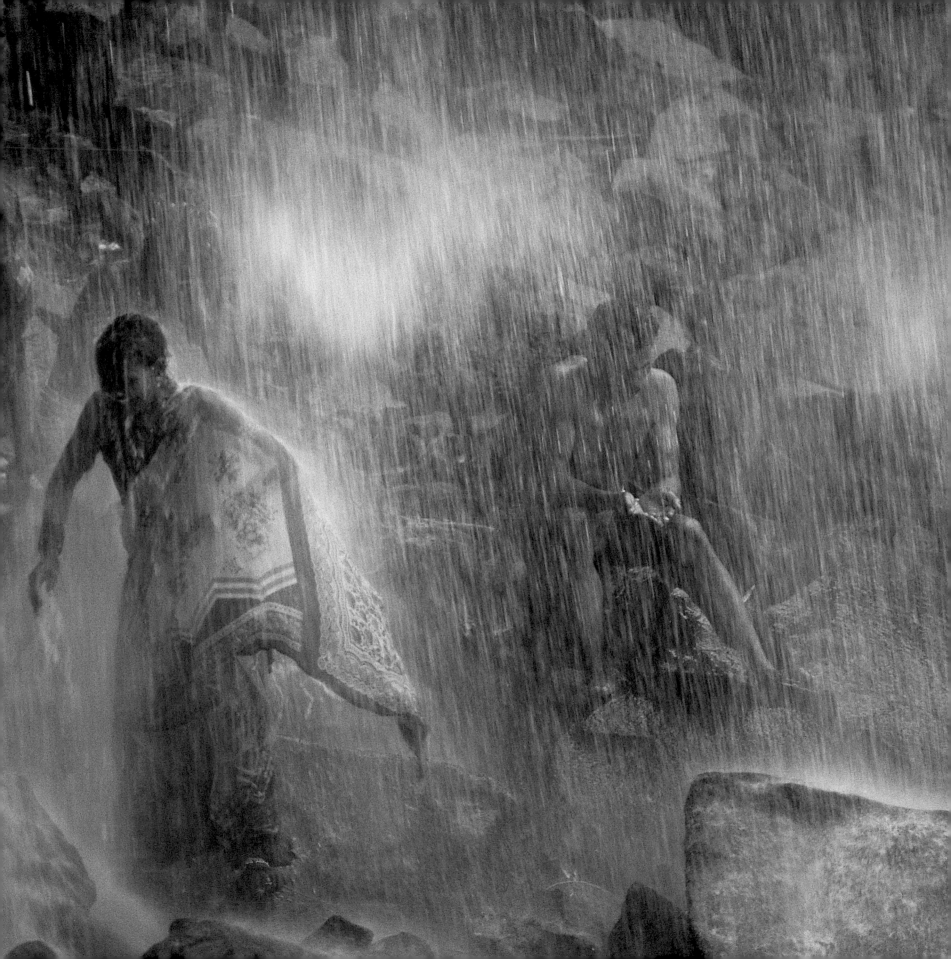

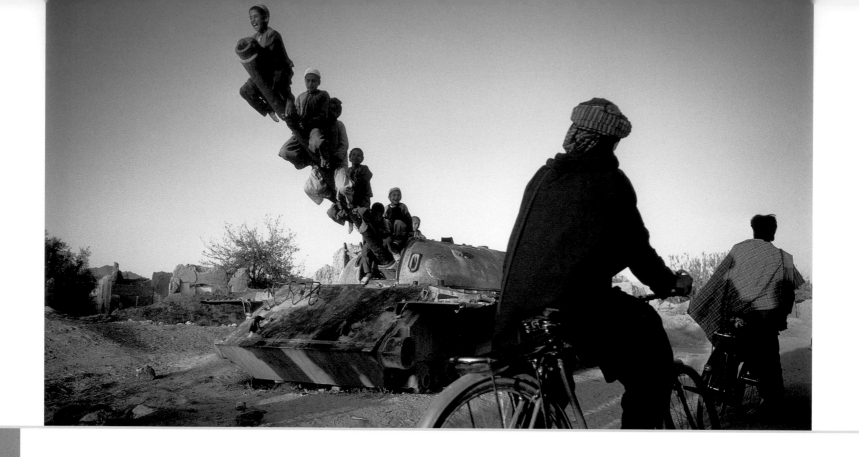

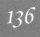

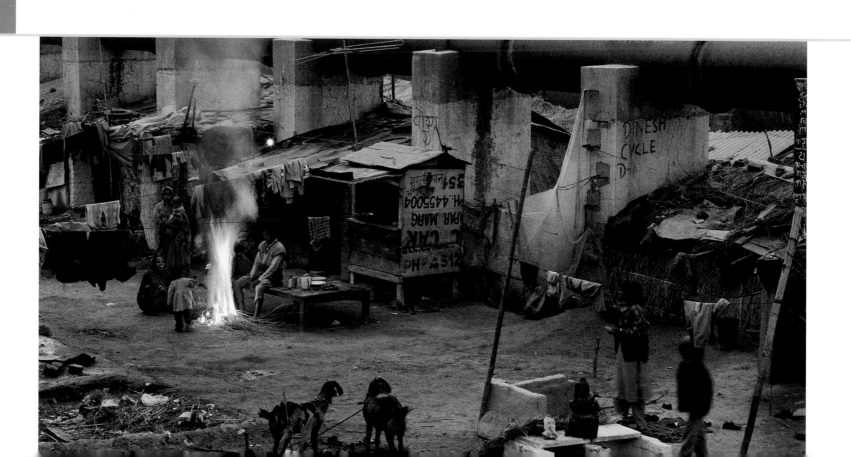

Top Left: Steve McCurry, 1993. Afghan children play on the barrel of a tank in the city of Kandahar.

Bottom Left: Peter Essick, 2002. Squatters living under a water pipe that carries fresh water to the city of Delhi, India.

PREVIOUS PAGES: NICOLE BENGIVENO, 1988. CENTRAL ASIA'S LANDSCAPE SEEMS TO TOLERATE RATHER THAN WELCOME HUMAN PRESENCE. A 12TH-CENTURY MUSLIM MAUSOLEUM AMID THE RUINS OF THE ANCIENT CITY OF MERV IN RUSSIA.

RIGHT: FRANS LANTING, 2002. A MAGNIFICENT PEACOCK RESTING IN A TREE IN BANDIPUR, INDIA.

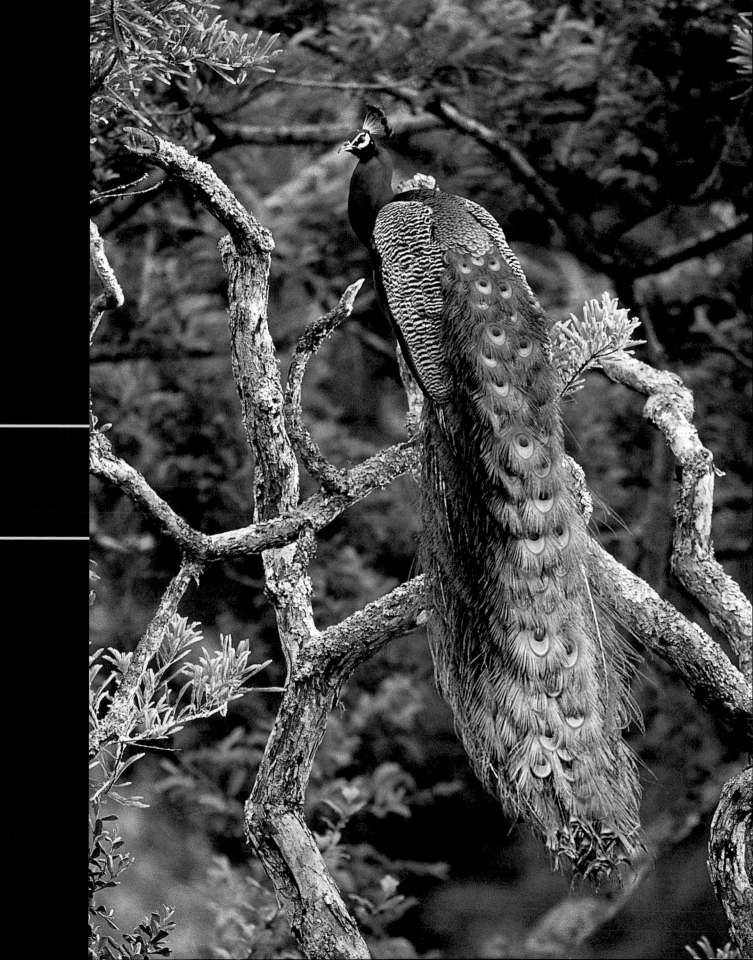

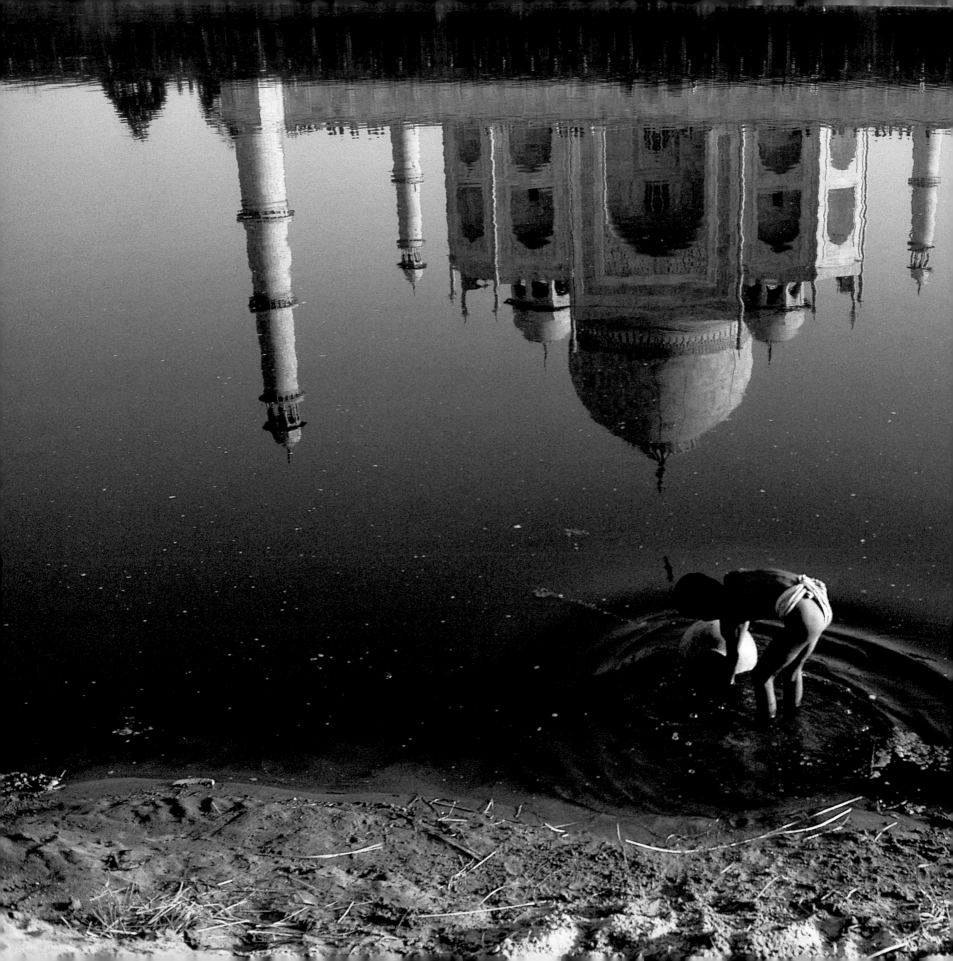

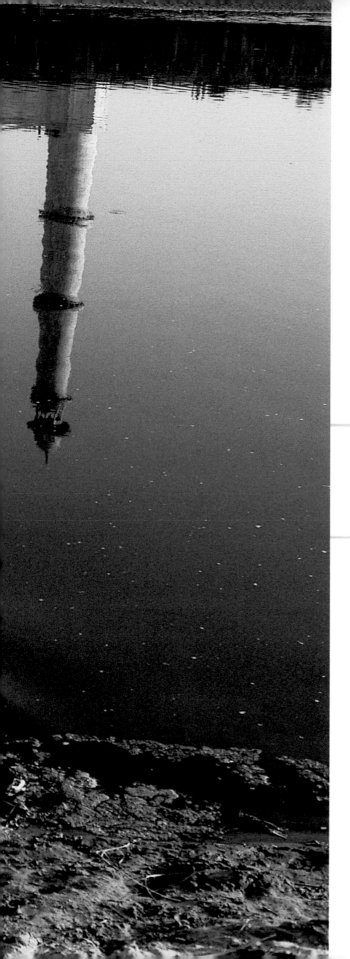

STEVE MCCURRY, 1997. A BOY COLLECTING RIVER WATER BY THE TAJ MAHAL, AGRA, UTTAR PRADESH STATE, INDIA.

143

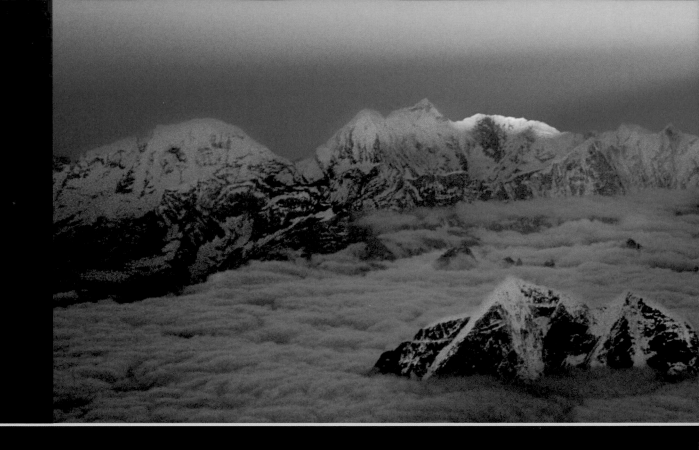

WALLY BERG, 2003. FIRST LIGHT OF DAWN STRIKES A PEAK WEST OF EVEREST, WHOSE PYRAMID-SHAPED SHADOW REACHES TOWARD THE HEAVENS.

*Ω* WHY PEOPLE WHO LIVE NEAR

MOUNT EVEREST WORSHIP IT. ✺

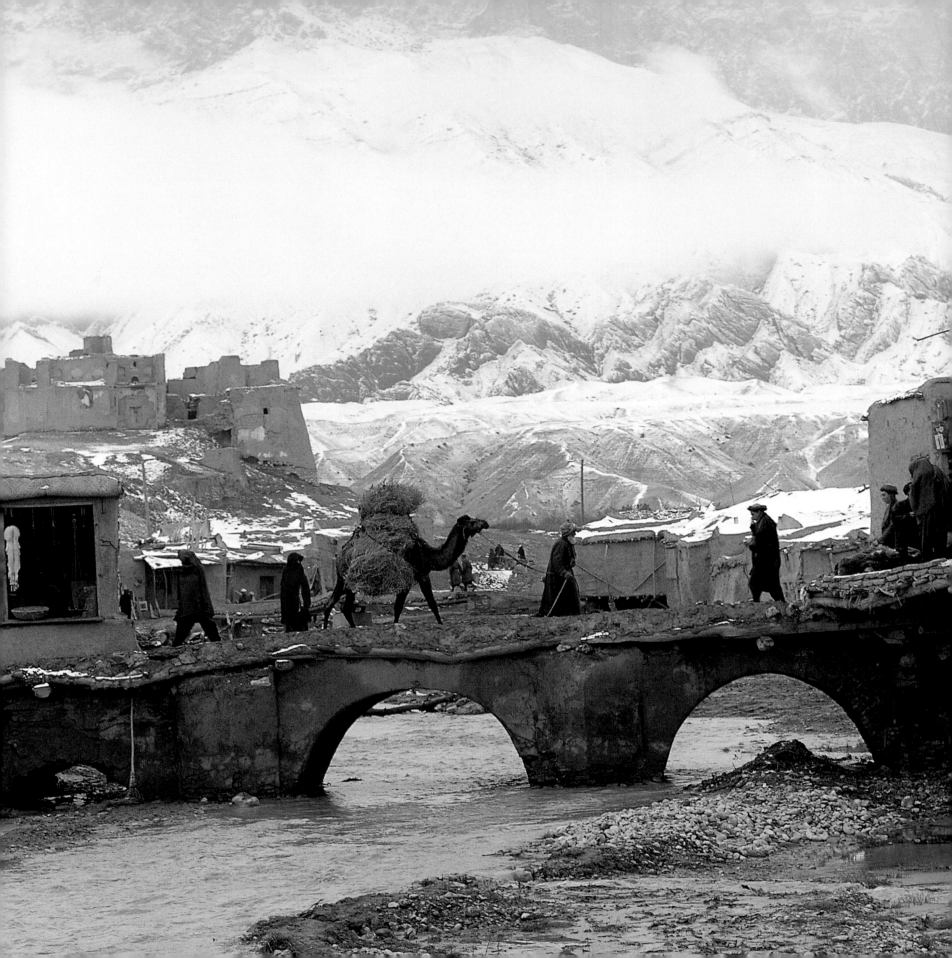

ROLAND AND SABRINA MICHAUD, 1973. HILLTOP FORT AND BRIDGE IN KHOLM, AFGHANISTAN, AN ANCIENT CROSSROADS TOWN CONNECTING THE HINDU KUSH WITH THE LOWLAND RIVER VALLEYS.

James P. Blair, 2004. Small stupas, called chaityas, surround the Swayambhunath Stupa in Swayambhu, Nepal.

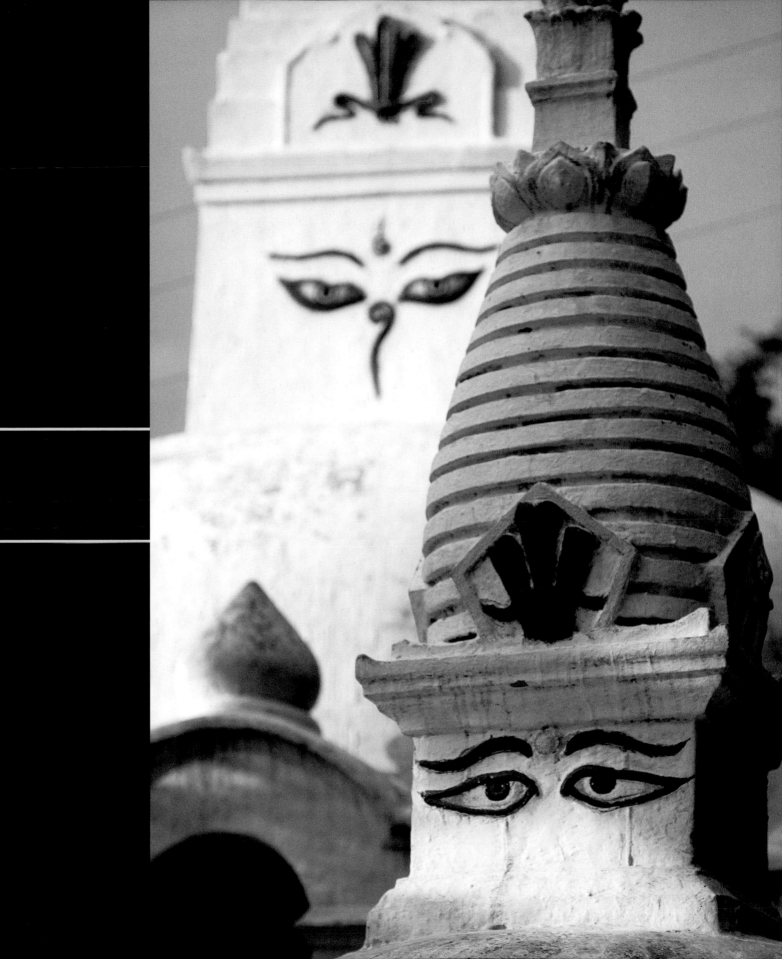

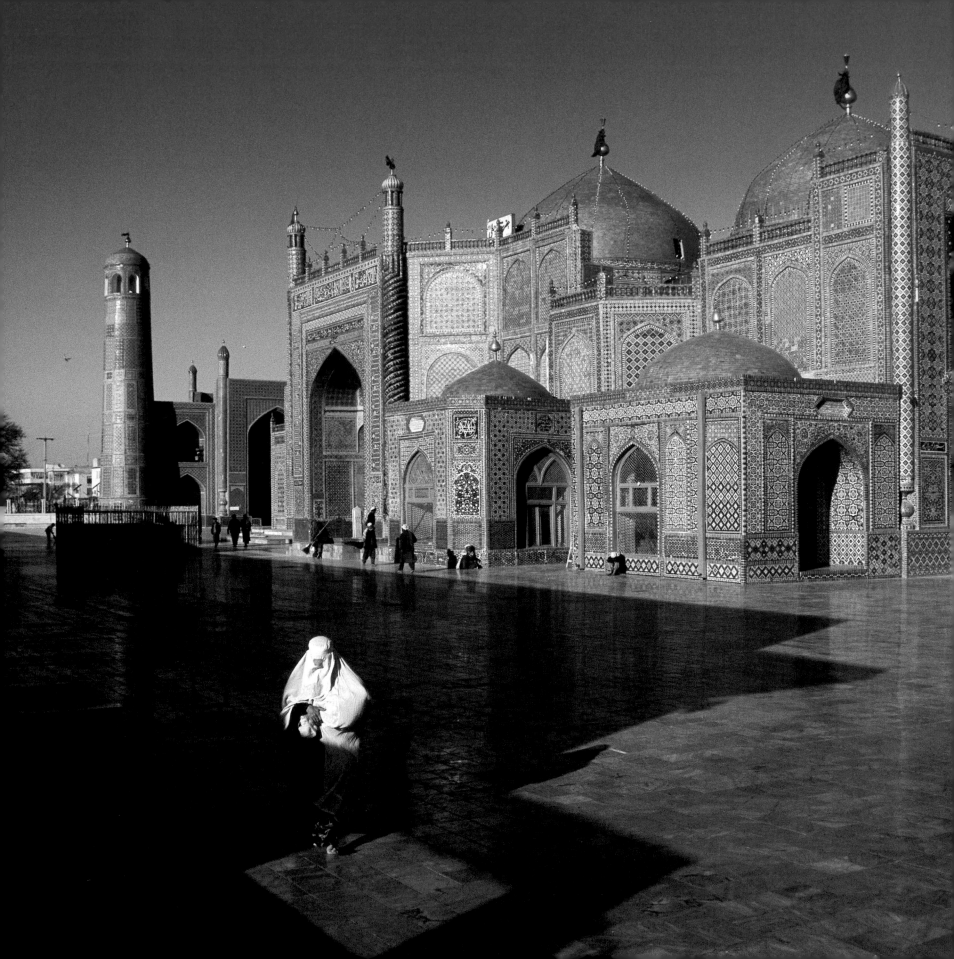

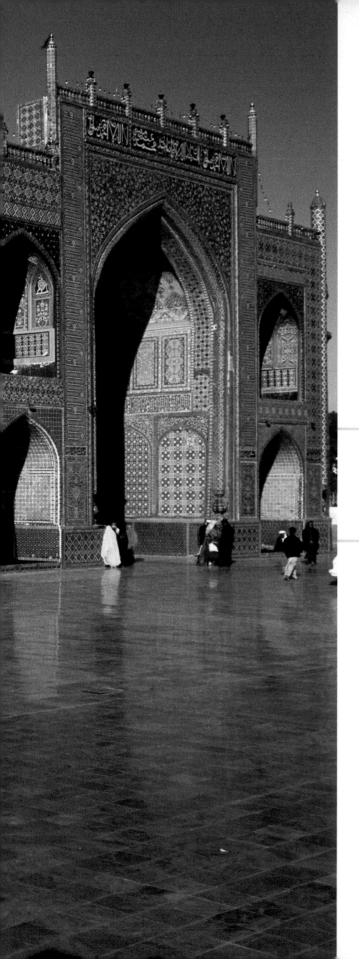

LEFT: STEVE MCCURRY, 2003. THE SHRINE OF HAZRAT ALI AT MAZAR-E-SHARIF, AFGHANISTAN.

FOLLOWING PAGES: STEVE MCCURRY, 2002. RUG MERCHANT, KABUL, AFGHANISTAN.

151

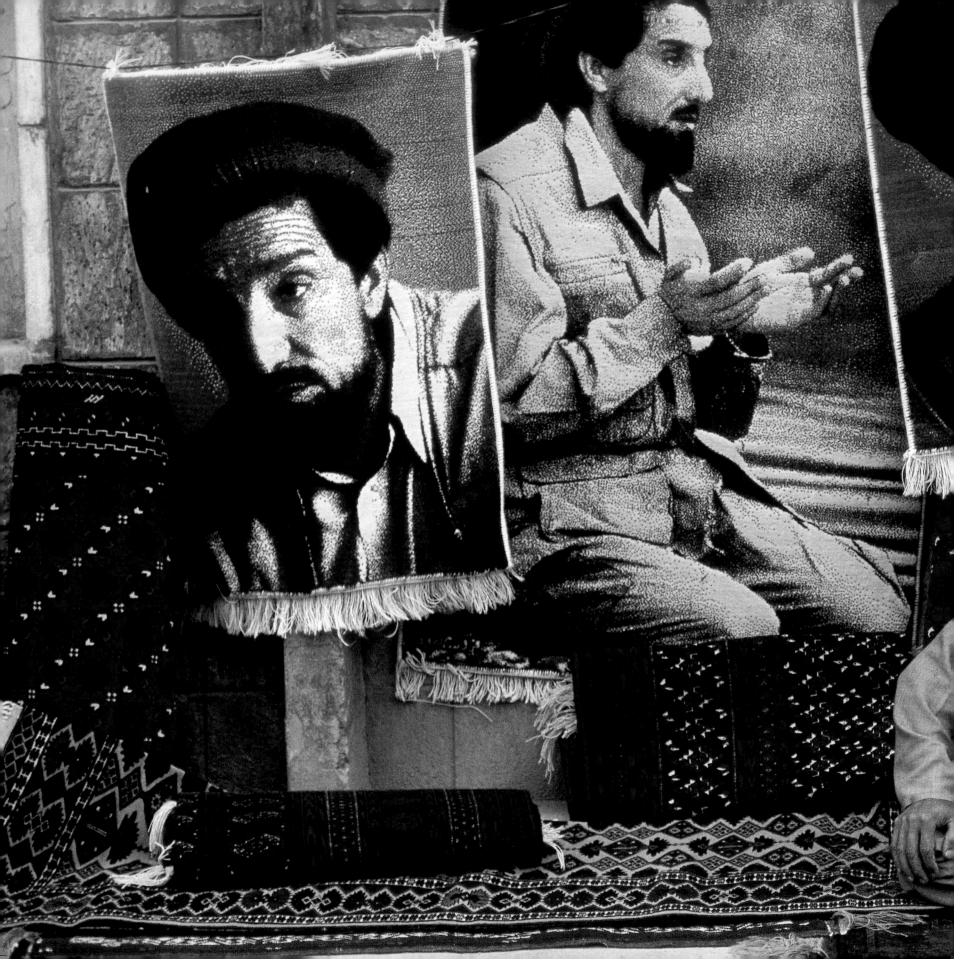

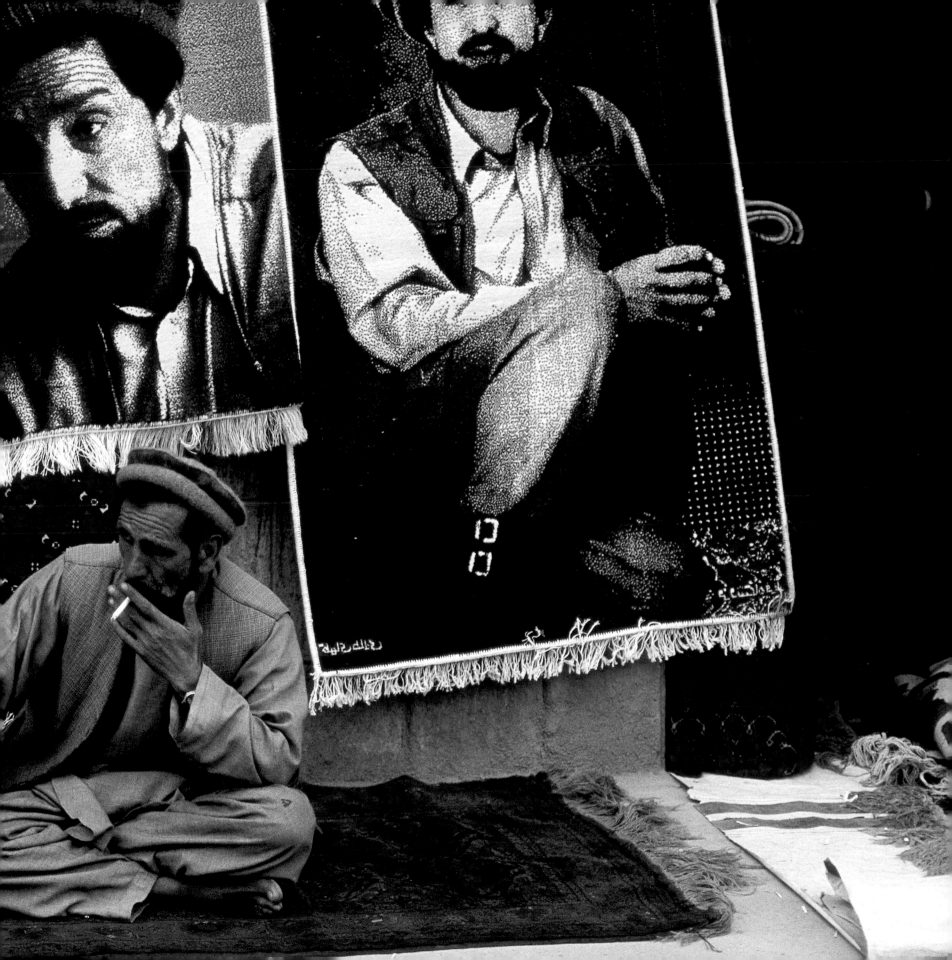

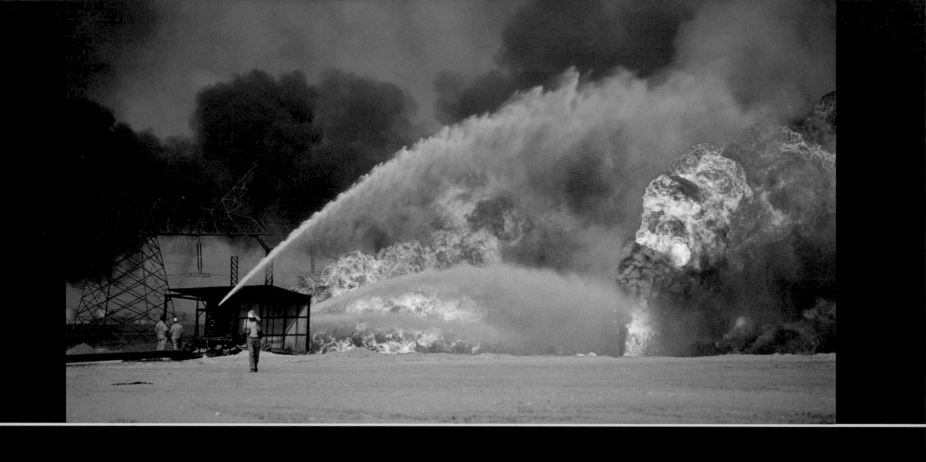

# 4 MIDDLE EAST

PREVIOUS PAGE TOP: Sisse Brimberg, 1991. Contrasting images of the Middle East. An oil field burning after the 1991 Gulf War in Kuwait.

BOTTOM: Annie Griffiths Belt, 1998. Wildflowers growing in the desert land near Petra, Jordan, once a thriving city on the Silk Road.

# MIDDLE EAST

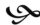

Through the centuries, the Middle East has come to be defined as a place not by its landscape, wildlife, or climate but by individuals, ideas, events, and emotions. So heavy is the region's weight on the scales of world history and news that any photographs of it, regardless of what they show or when, where, and how they were taken, cannot escape being viewed as symbols and metaphors.

No other place on Earth can equal the Middle East's evocative power. Yet that power is highly ambiguous, depending largely on what one believes in every sense of the word. Because the world's three major, monotheistic religions—Islam, Judaism, and Christianity—were founded in the Middle East, because their patriarchs lived and died there, and because they have billions of followers around the world, the place carries an emotional charge only distantly connected to its geophysical properties. That Mecca is an oasis town in the sands of western Arabia or that Bethlehem lies amid the rocky hills and olive groves of Judea is irrelevant compared to their significance as the respective birthplaces of Muhammad and Jesus.

The power of the Middle East as a symbol can be seen in the earliest photographs of the region, taken in the 1850s by John Beasley Greene, Auguste Salzmann, and others. Since they were first published, those pictures have thrilled viewers by transforming Nile vistas, Roman ruins, and Jerusalem religious sites into visual images that bring the past into contemporary life, enlivening and enriching history, science, and religion. By contrast, many contemporary photographs of the Middle East feature the symbols of death and destruction, such as Alexandra Boulat's picture of a sandstorm slowing the fighting in Baghdad during the invasion of Iraq or Sisse Brimberg's picture of an oil field burning one year after the end of the Gulf War.

In old or new photographs of the Middle East, place, time, people, and events conflate into a potent mass of symbols and metaphors to which each viewer assigns meaning. This conflation is most noticeable in terms of time. Maynard Owen Williams's photograph of the ruins of the Temple of Jupiter in Baalbek, Lebanon, for example, could have been taken yesterday, today, tomorrow, or centuries ago. Aside from their color, the same can be said of Reza's photograph of millions of Muslims prostrating themselves at the Grand Mosque in Mecca during their hajj or Anne Keiser's picture of a Jewish man standing at the Western Wall in Jerusalem, a wall believed to be a part of the temple built by Solomon in 970 B.C.

The meaning of those photographs is tied, of course, to the cultural context in which they are viewed, what the viewers know about the Middle East, and, to some extent, their religious persuasion.

In the Western world, knowledge of contemporary Middle Eastern life and of its ancient Arab, Turkish, and Persian cultures is quite limited. Many Middle Eastern societies are essentially closed to outsiders. Qatar, considered accessible compared to some Arab countries, didn't begin issuing tourist visas until 1989. Relatively few Westerners travel in the region; fewer still speak or read its languages or make the effort to understand its rich history or its seminal contributions to world culture. Those include the first alphabet, which was devised by the Phoenicians. The Latin, Greek, Hebrew, and Arabic alphabets are all derived from it.

Israel is the sole exception. Its governmental and social structures are, in essence, Western transplants, and its history as a modern state dates back just over 50 years. Israeli society is relatively open, and Jews, Christians, and Muslims from around the world travel there to visit the holy sites of their faiths, as do secular tourists from many lands.

Because of linguistic and cultural barriers, it is impossible to say what most inhabitants of the Middle East know of their region's history and culture or what meaning they would assign to the photographs of Kuwait, Israel, Saudi Arabia, Jordan, Lebanon, Turkey, Iran, United Arab Emirates, Oman, Iraq, Palestine, and Qatar that are shown here. Their reaction is bound to be affected by the pictorial traditions of Islam, which differ from those of Judeo-Christian culture in that they discourage the representation of people. What is clear, however, is that many people in those countries view Western culture as a threat to their age-old ways of life and to their overwhelmingly Islamic religious beliefs. In practical terms, that means any photograph taken by an outsider is likely viewed with the same suspicion one sees in the eyes of the Cepni girls walking down a street in Salpazari, Turkey, in Randy Olson's photograph.

These cultural factors can be a severe handicap for photographers. NATIONAL GEOGRAPHIC magazine is one of the only mainstream American publications to have shown a continued interest in the Middle East over the years. For much of the past century, its photographers have documented what the region's cities, countryside, and people looked like. Only in recent years has the magazine succeeded in providing its readers with a more intimate look at how people in the region live and who they are.

Reza's photos of the Great Mosque in Mecca or of Bedouin tribal leaders gathered around a campfire, as well as Robb

Kendrick's stunning shot of a Qatari mother and daughter at home, demonstrate how far the magazine's photography has come in terms of content, picture quality, and sensitivity to the local cultures.

Those pictures also highlight the difficulties of photographing a place so freighted with history and polarized by politics and religion. The photographer's intent and ability are subjected to viewers' highly divergent perceptions. To a Westerner, the veiled face of the Qatari woman in Kendrick's photo may symbolize a societal attitude toward women that seems feudal, oppressive, and abhorrent. A Muslim viewer, however, may regard her garb and the fact that her face is covered as a sign of piousness and propriety, even while disapproving of the very idea of depicting her.

The daughter, hamming for the camera as children everywhere do, seems like the only point of cultural convergence. But no kids grow up in a vacuum. They learn from their parents and peers, their circumstances and societies. Although the cliché about children being our hope for the future has universal appeal, in the context of the Middle East at the beginning of the 21st century, the picture of the girl and her mother can be seen, depending on one's viewpoint, as symbolizing two diametrically opposed hopes: for change and for no change.

Whether and how that dichotomy should or can be resolved depends on what one believes. In the meantime, strife prevails in the Middle East, despite the fact that Islam, Judaism, and Christianity condemn the taking of innocent life. The three religions are alike in other ways. All look to the past to explain and give meaning to the present and the future. All promise rewards in this life and afterward if their believers adhere strictly to the faith's tenets. Those rewards are also similar, consisting primarily of a closer, more intimate relationship with the Supreme Being, allowing the individual to know the face, mind, and heart of the Maker, in effect becoming part of the Godhead and dwelling forever in the garden of paradise.

It's tempting to offer Annie Griffiths Belt's poetic study of wildflowers growing in the desert near Petra—once a thriving city on the Silk Road, now an archaeological site and tourist attraction—as a lovely if stereotypical metaphor for peace, beauty, and nature's resurgent power. Or we can think of it as a reminder that we live in the only known garden in the universe. If peace doesn't grow here, can anyone truly expect to be rewarded at the next stop in time?

But that would be too much weight for any picture to bear.

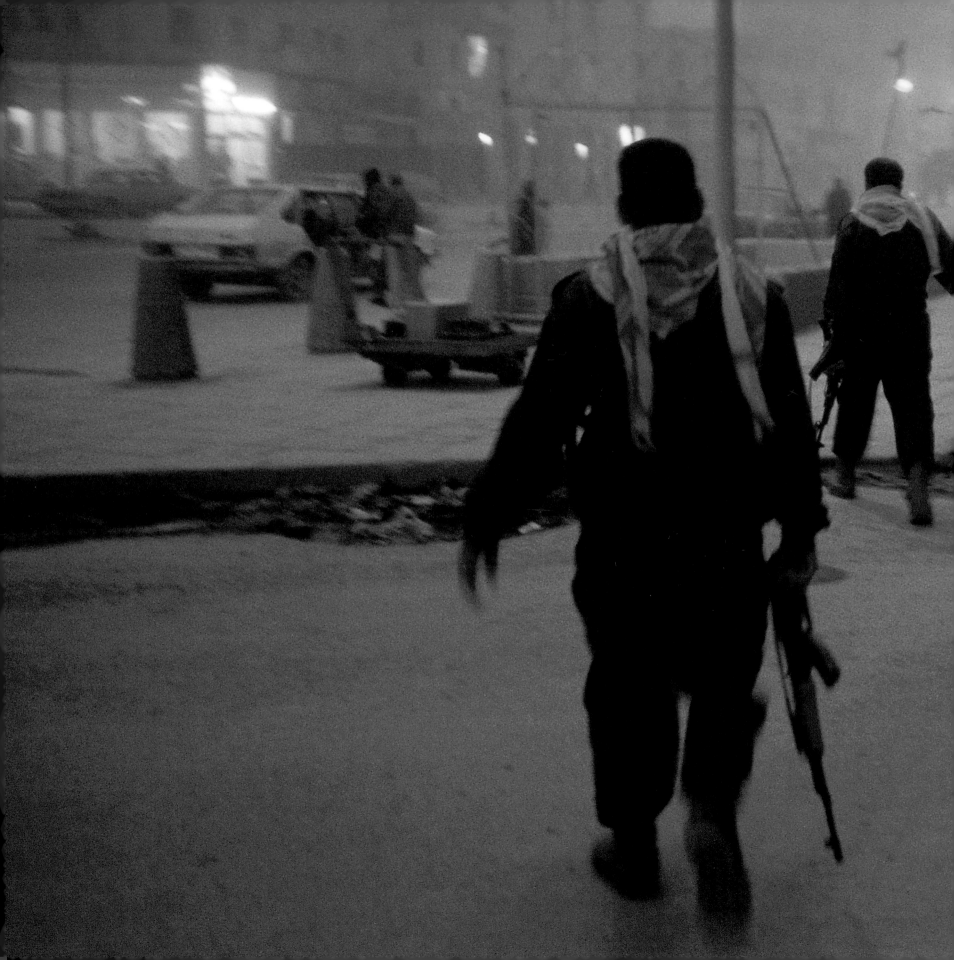

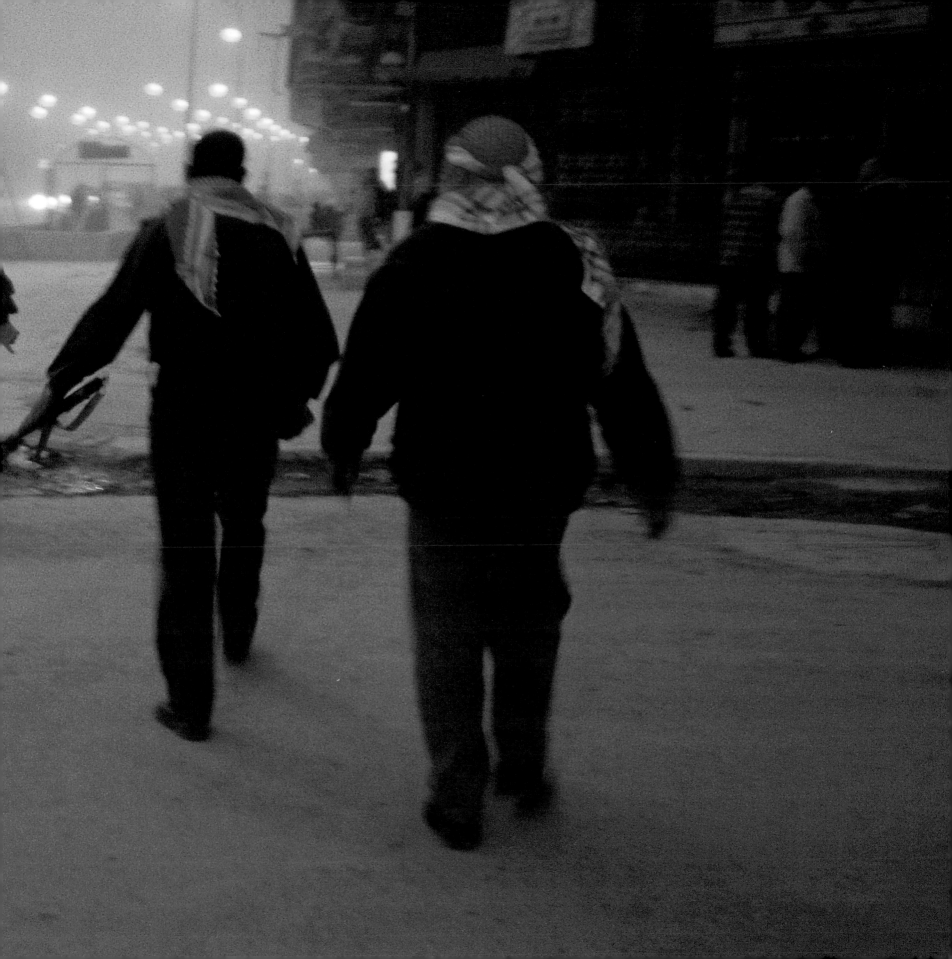

PREVIOUS PAGES: ALEXANDRA BOULAT, 2003. A SANDSTORM IN BAGHDAD SLOWS THE BOMBING AND THE ADVANCE OF U.S.-LED TROOPS DURING THE INVASION OF IRAQ.

LEFT: ANNIE GRIFFITHS BELT, 1997. THE RUINS OF PALMYRA, ONCE CONSIDERED ONE OF THE GREATEST CITIES OF THE ROMAN EMPIRE, IN THE SYRIAN DESERT.

163

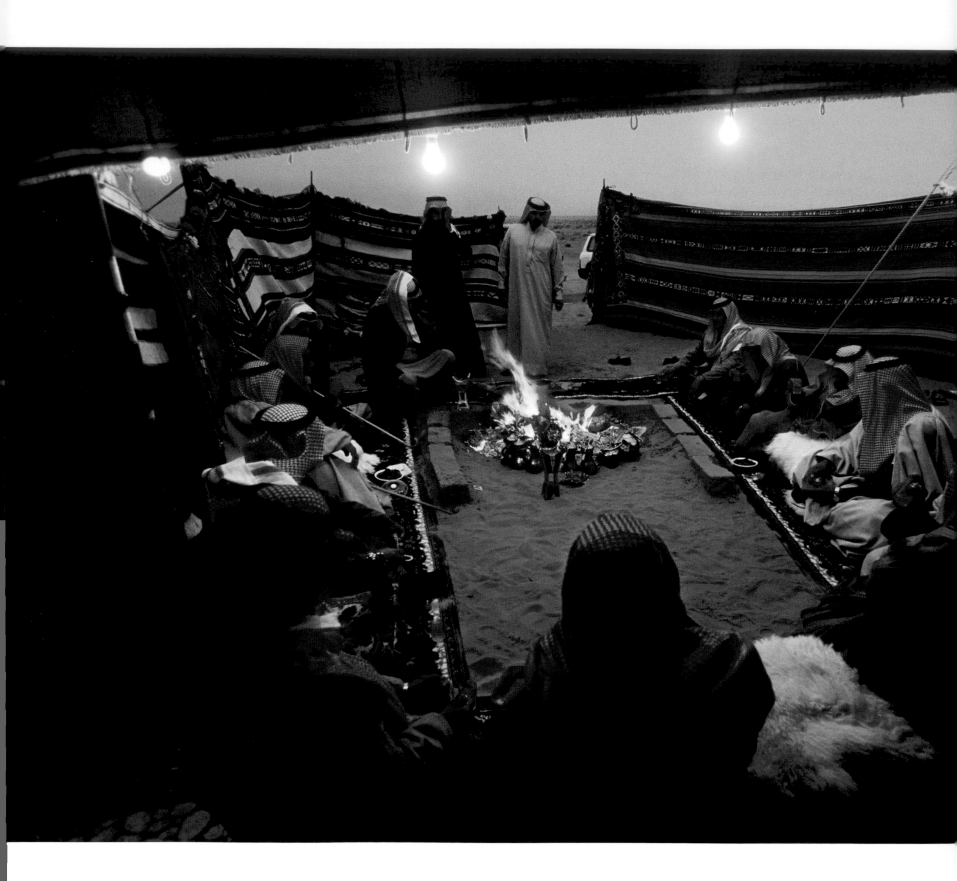

REZA, 2003. BEDOUIN TRIBAL LEADERS MEET AROUND A FIRE AT A PROMINENT SHEIK'S TENT IN SAUDI ARABIA.

165

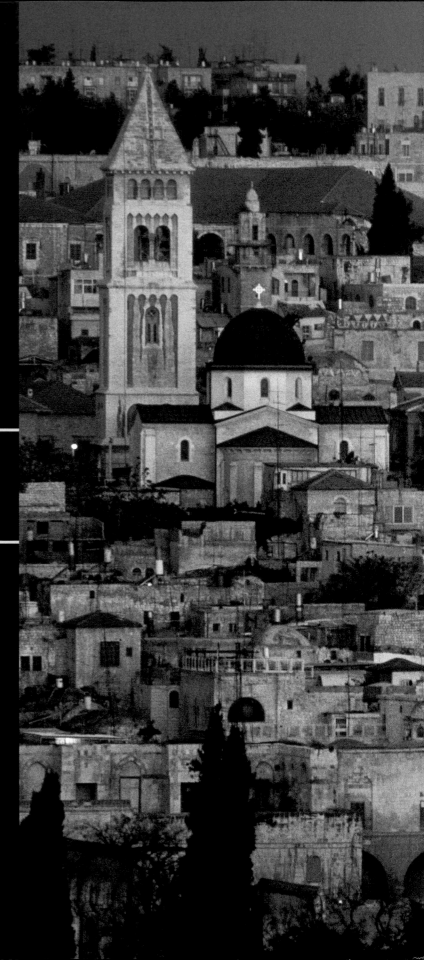

ANNIE GRIFFITHS BELT, 2004. JERUSALEM PANORAMA WITH
DOME OF THE ROCK AND CHURCH OF THE HOLY SEPULCHRE.

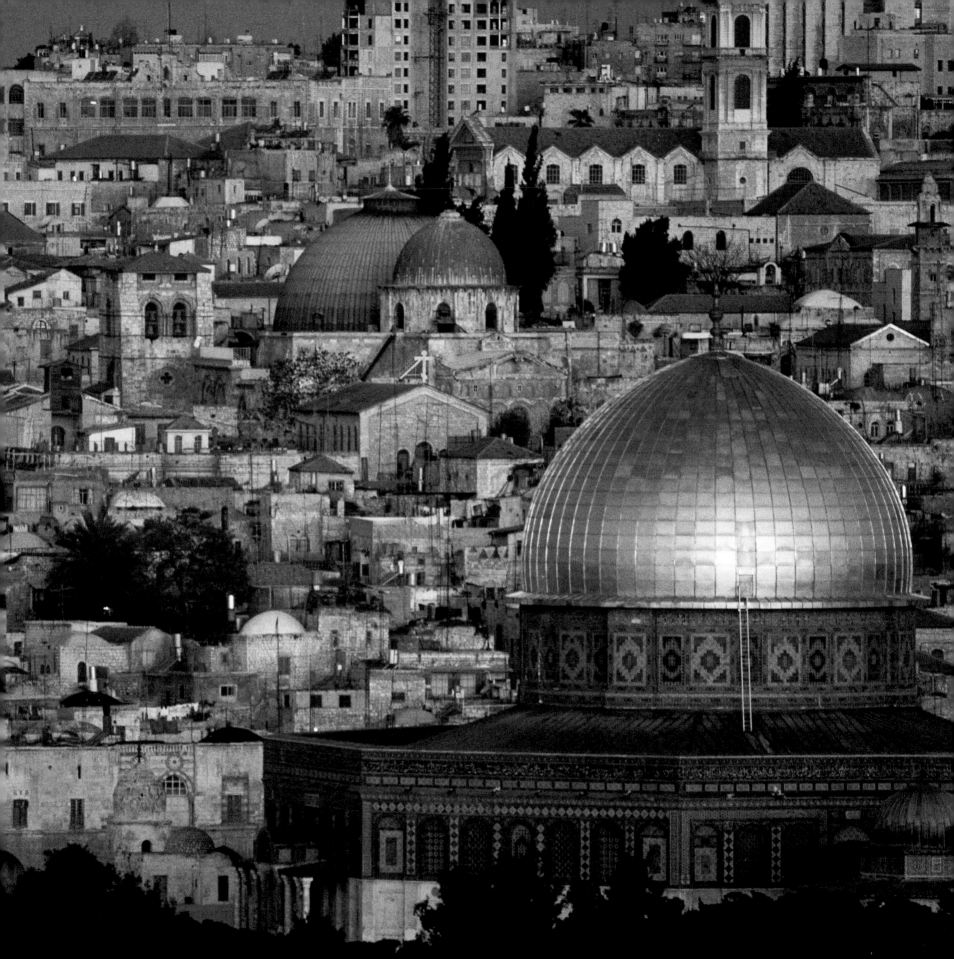

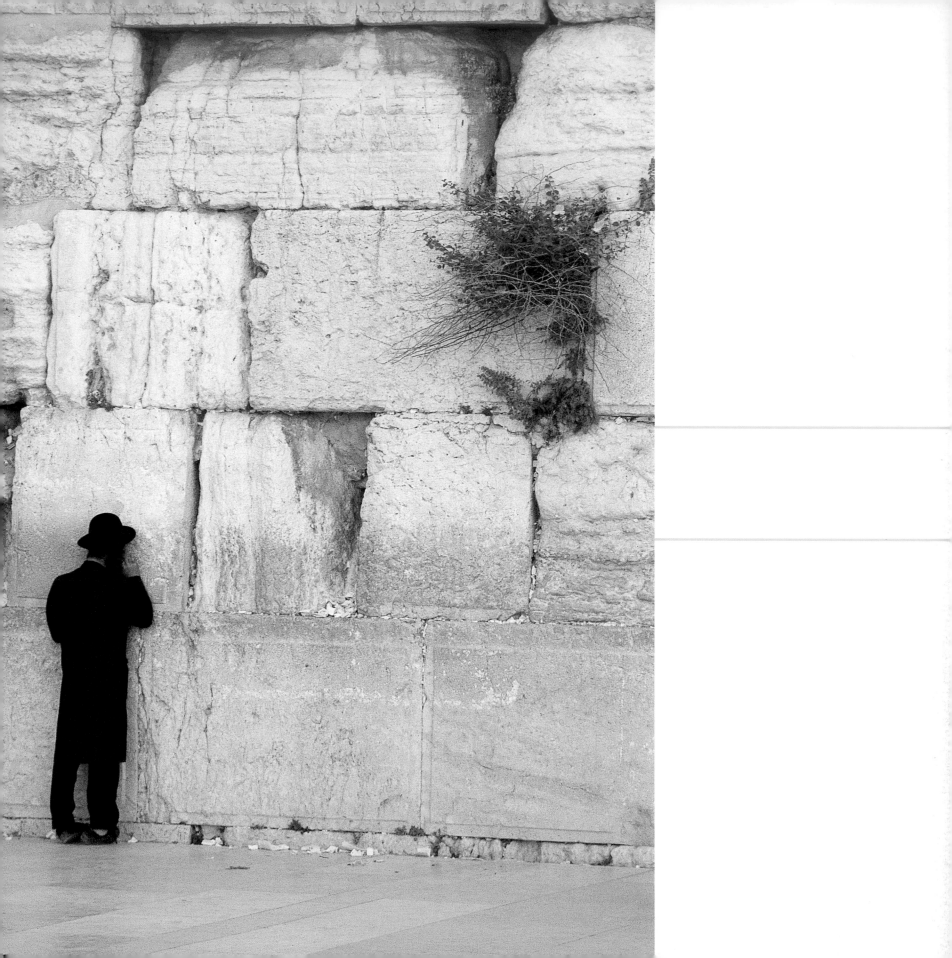

ANNE KEISER, 2001. IN JERUSALEM, A JEWISH MAN STANDS AT A SECTION OF THE WESTERN WALL, BELIEVED TO BE A PART OF THE ORIGINAL TEMPLE WALL BUILT BY SOLOMON IN 970 B.C. SINCE THE MIDDLE AGES, JEWS HAVE COME TO THIS WALL TO BEWAIL THE FALL OF THE CITY AND DESTRUCTION OF SOLOMON'S TEMPLE.

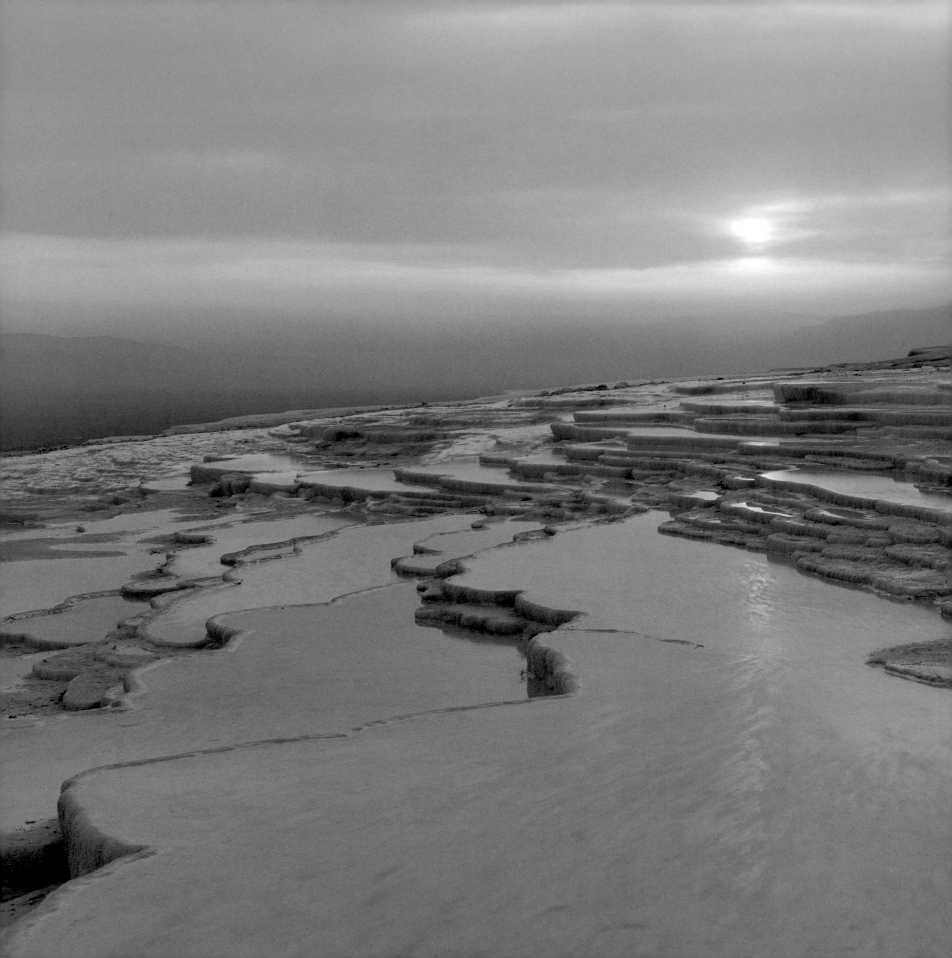

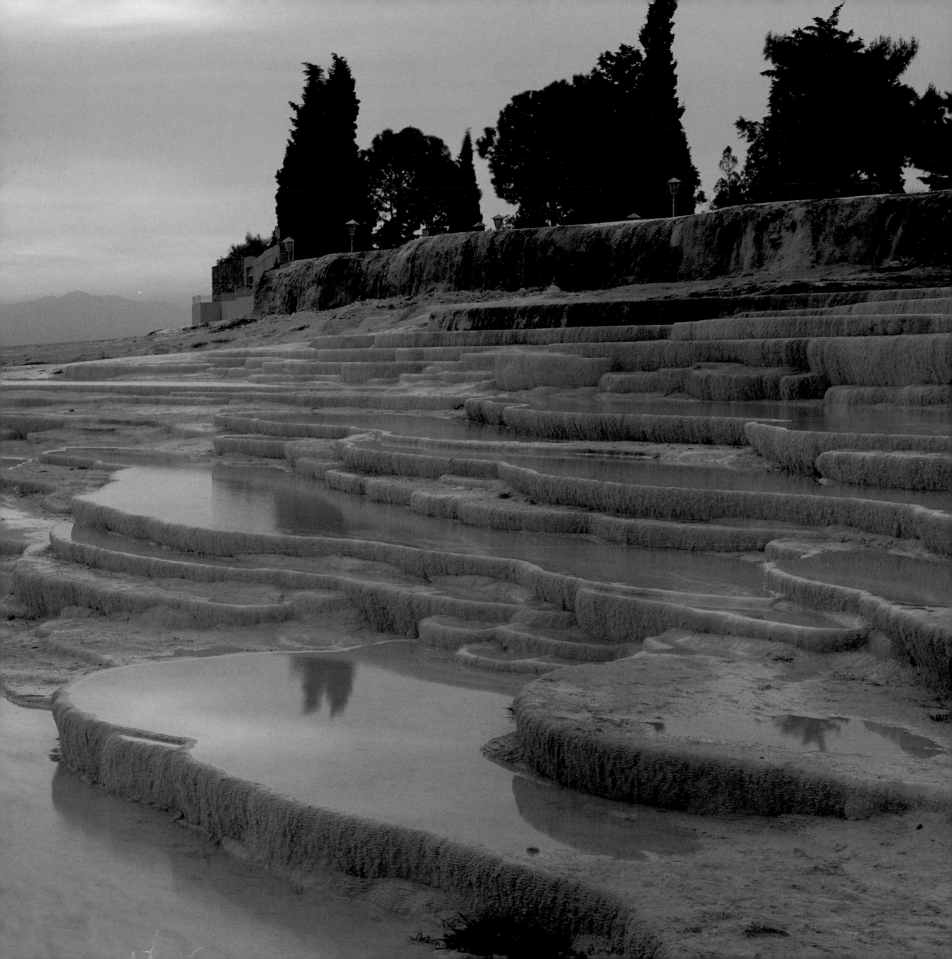

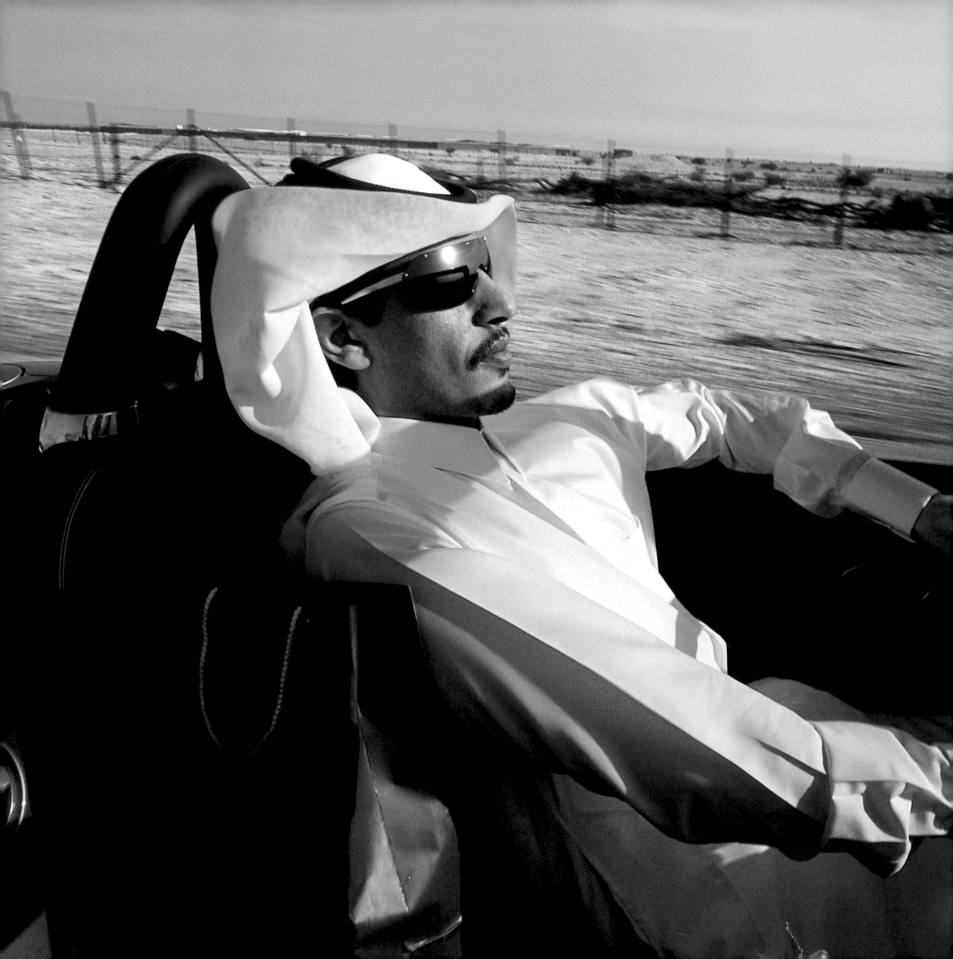

173

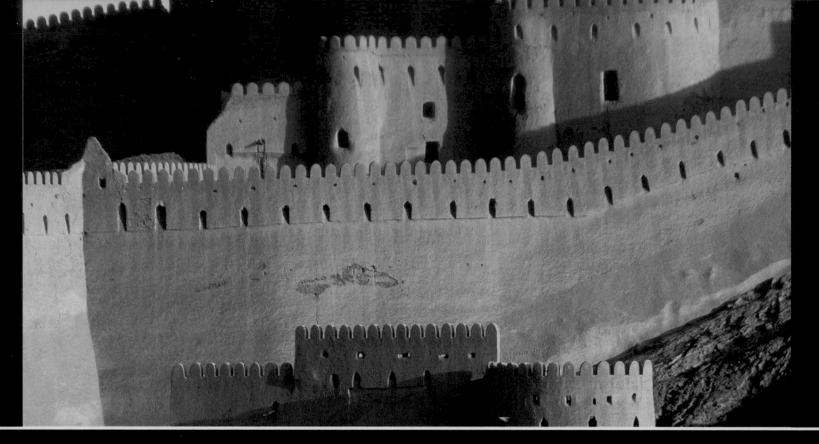

LEFT: MICHAEL YAMASHITA, 2001. A VIEW OF THE EARTHEN WALLS CIRCLING THE MEDIEVAL CITADEL OF BAM IN IRAN. THE CITADEL WAS DESTROYED BY AN EARTHQUAKE IN DECEMBER 2003.

RIGHT: MAYNARD OWEN WILLIAMS, 1927. RUINS OF THE TEMPLE OF JUPITER TAKEN NEAR THE TEMPLE OF BACCHUS IN BAALBEK, SYRIA, NOW LEBANON.

⅃ NO OTHER PLACE ON EARTH CAN EQUAL

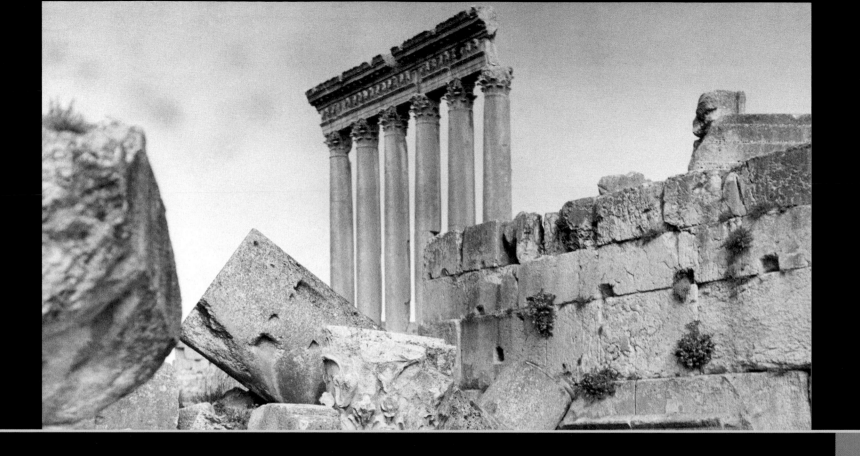

THE MIDDLE EAST'S EVOCATIVE POWER. ❧

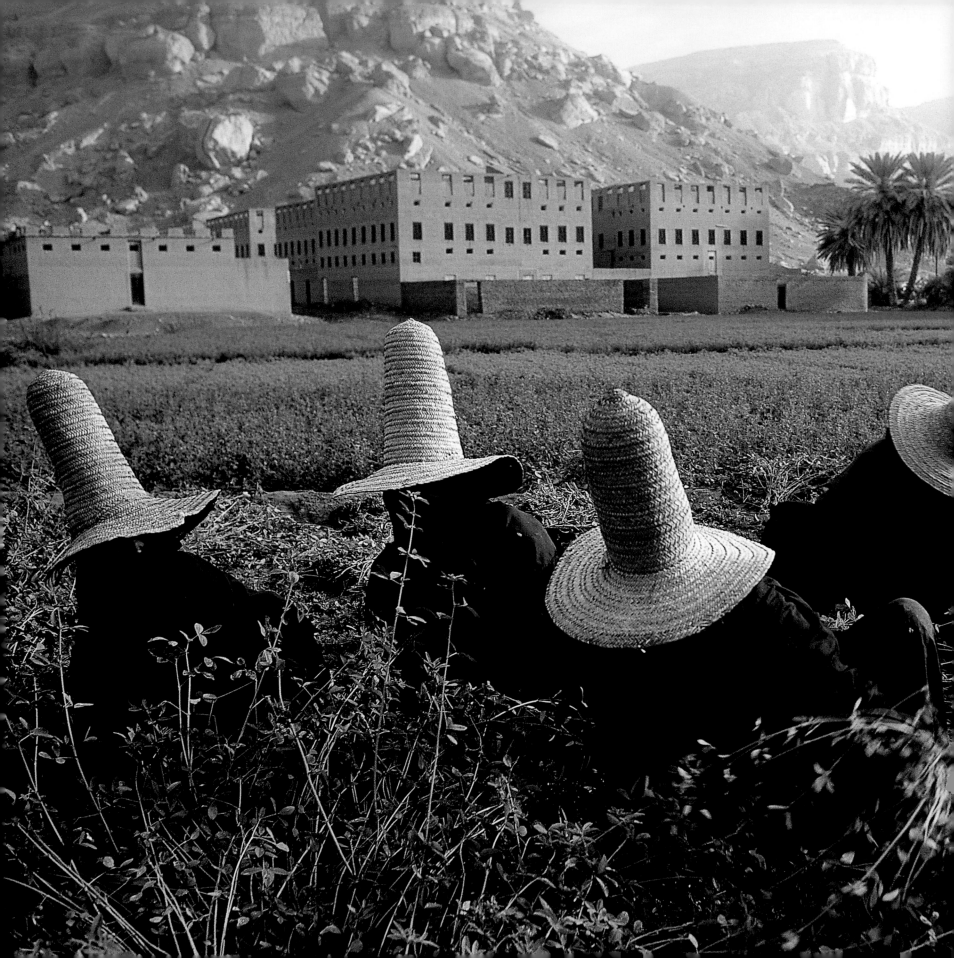

STEVE McCURRY, 2000. WOMEN IN STRAW HATS IN A
CLOVER FIELD, REPUBLIC OF YEMEN.

178 REZA, 2004. FIREWORKS ON THE BEACH FOR THE START OF THE EID-AL-FITR HOLIDAY BREAKING THE FAST OF RAMADAN, JEDDAH, SAUDI ARABIA.

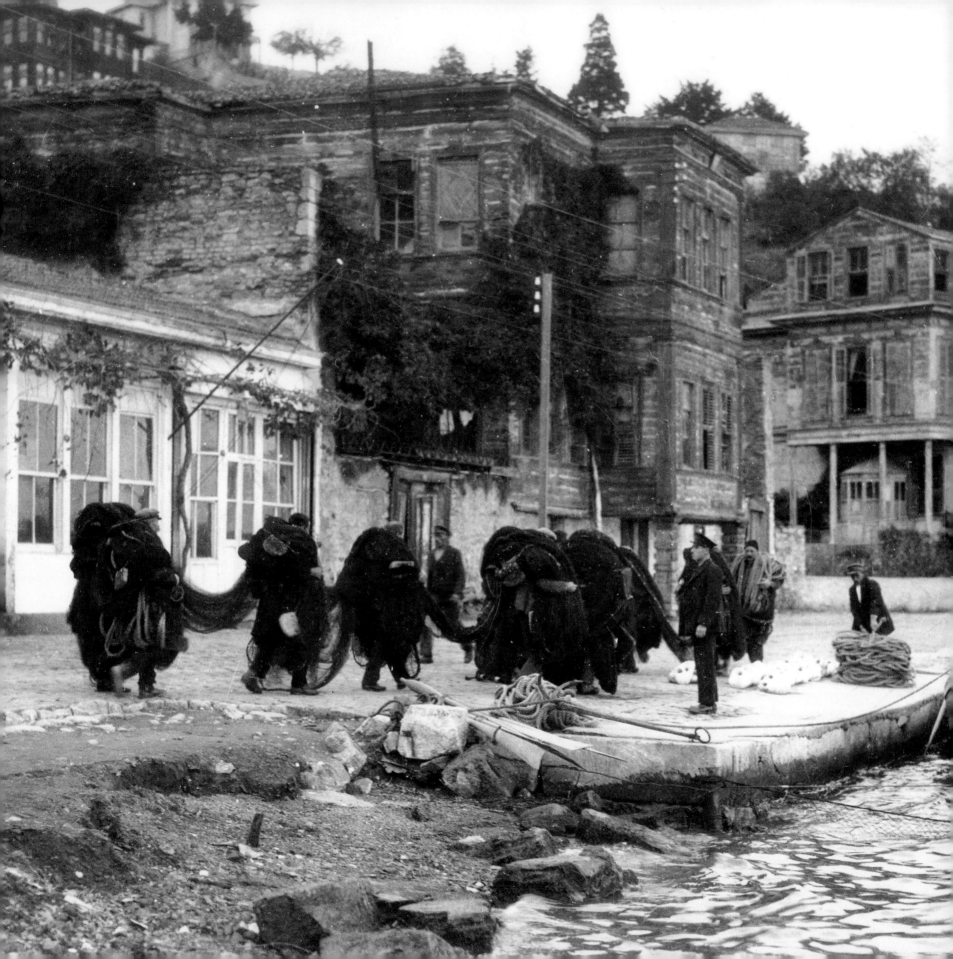

MAYNARD OWEN WILLIAMS, 1911. TURKISH FISHERMAN CARRY BUNDLES OF NETS TO THEIR BOATS.

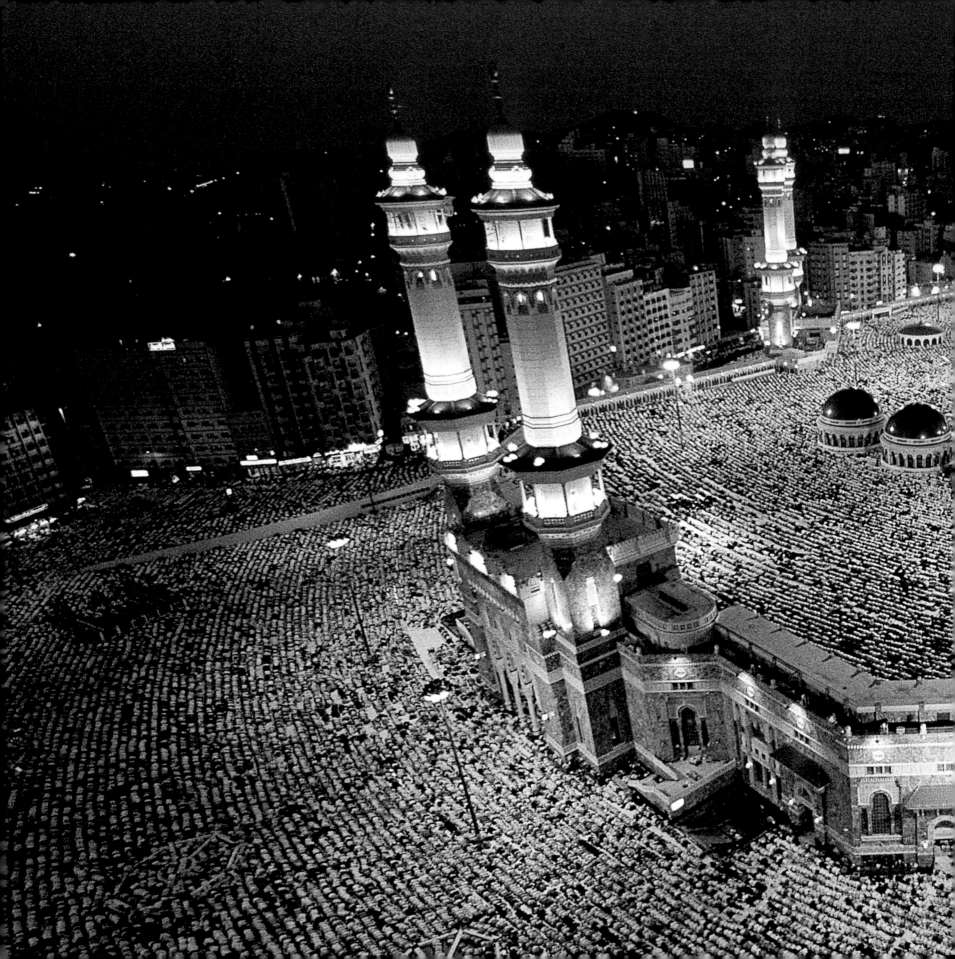

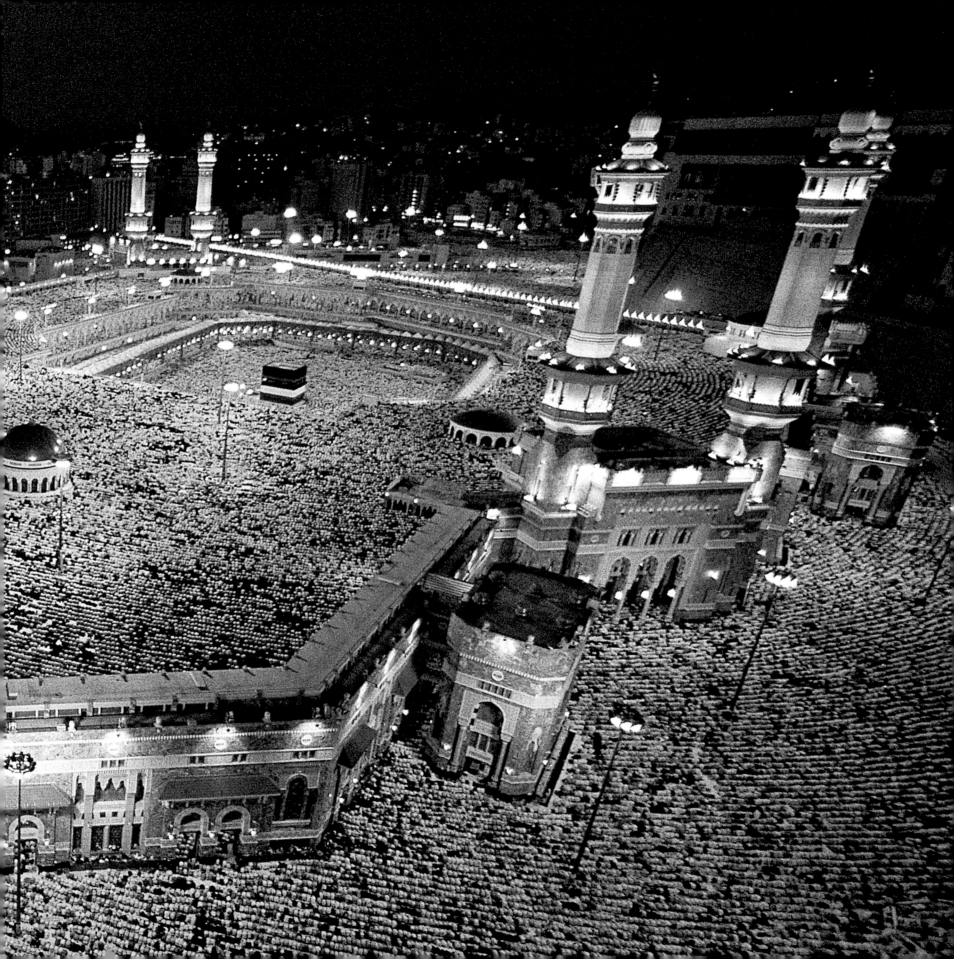

PREVIOUS PAGES: REZA, 2001. MILLIONS OF MUSLIMS PROSTRATE THEM-SELVES AT THE GRAND MOSQUE IN MECCA EACH YEAR DURING THE HAJJ.

RIGHT: ROBB KENDRICK, 2003. A QATARI MOTHER AND HER DAUGHTER AT HOME.

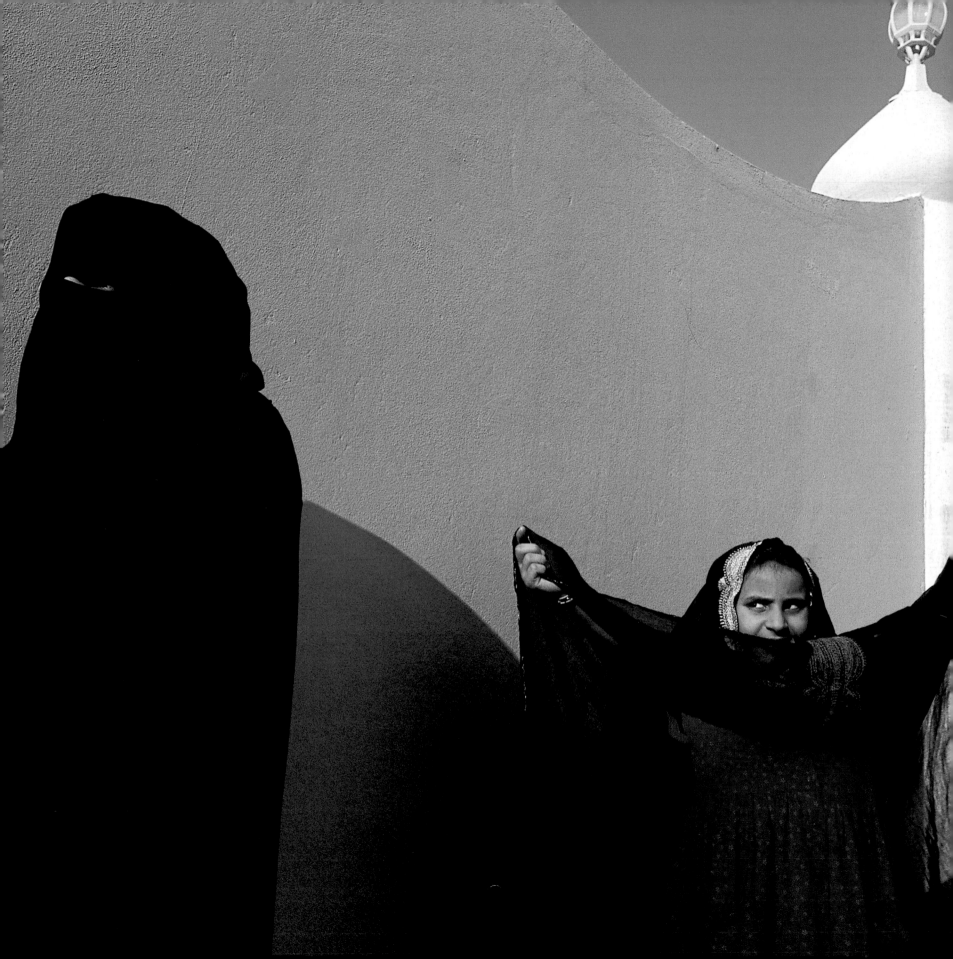

TOP LEFT: PETER ESSICK, 2001. THE UNIVERSAL TRAPPINGS OF WEALTH AND LUXURY: BURJ-AL-ARAB HOTEL, DUBAI, UNITED ARAB EMIRATES.

BOTTOM LEFT: RANDY OLSON, 2002. IN MUCH OF THE MIDDLE EAST, ANY PHOTOGRAPH TAKEN BY AN OUTSIDER IS LIKELY VIEWED WITH THE SAME SUSPICION: CEPNI WOMEN IN TRADITIONAL GARB, SALPAZARI, TURKEY.

George Steinmetz, 2005. Empty Quarter, Saudi Arabia, One of the world's largest sand deserts and driest places.

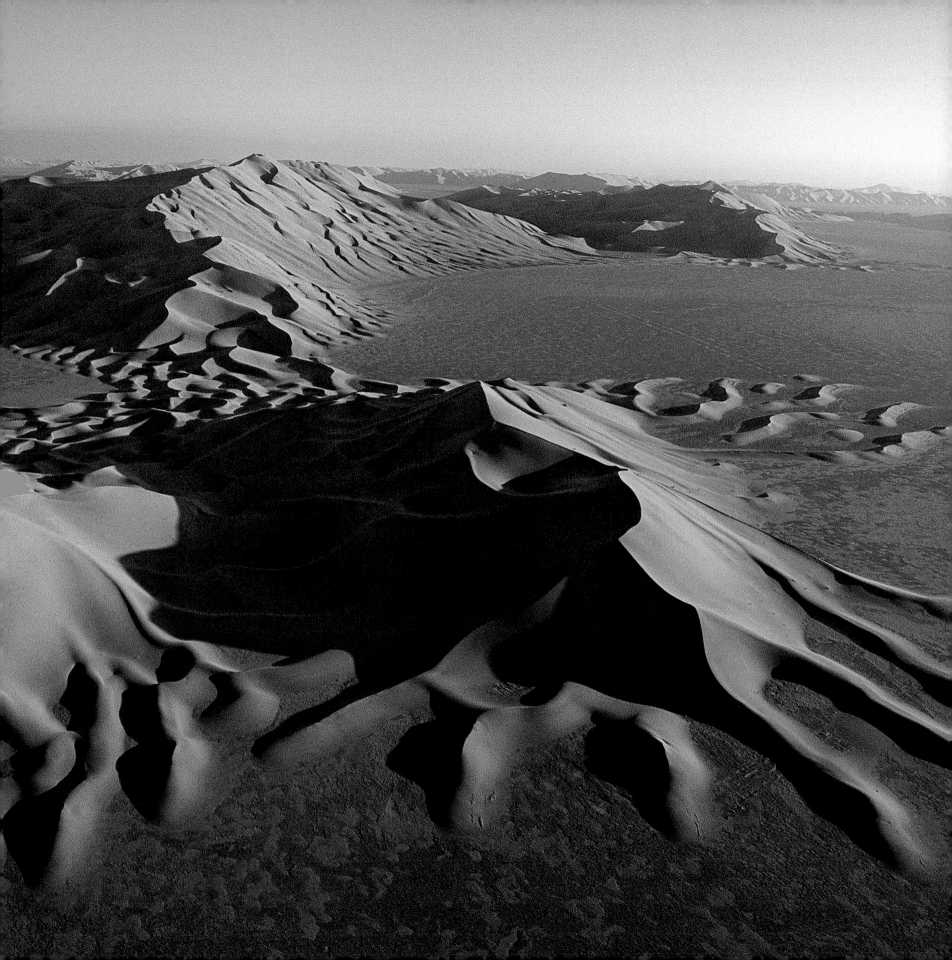

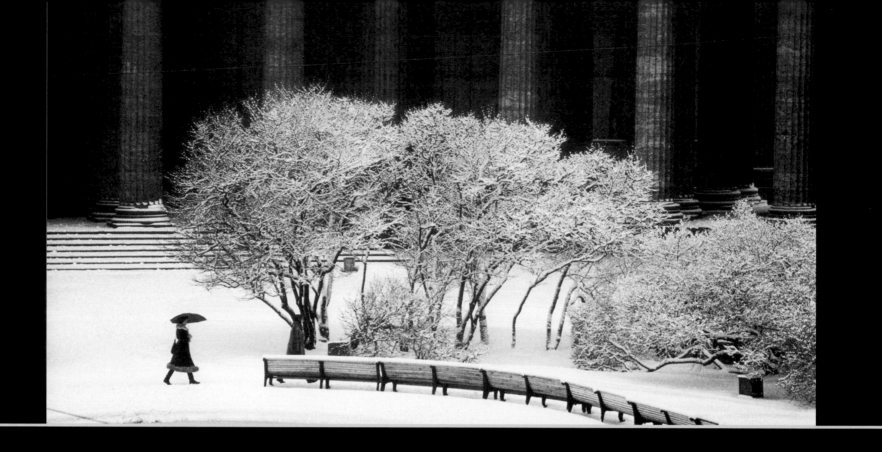

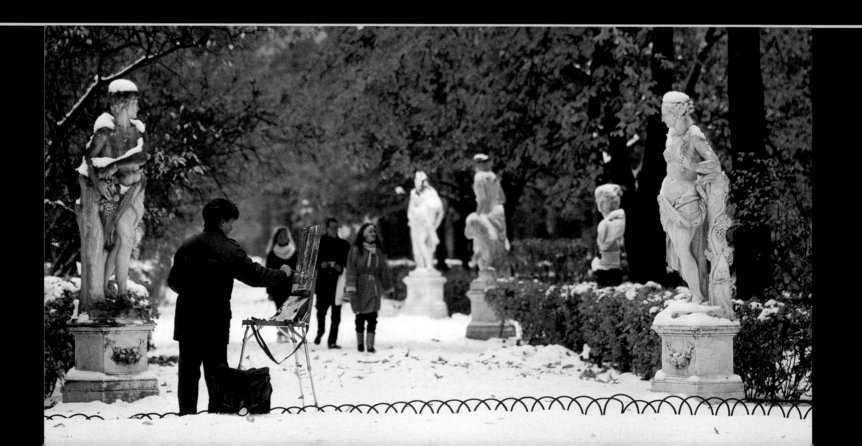

# 5 CENTRAL & EASTERN EUROPE

# CENTRAL AND EASTERN EUROPE

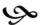

Places experienced directly or as pictures can be deceptive. The stream flowing from a swampy pond turns out to have been created by human hands. Farmland that looks dark and rich as espresso is contaminated by industrial pollution. A vibrant urban square glowing in the sunset becomes a no-man's land after nightfall. The postcard-perfect image of an Austrian alpine village provides no clue that the place first flourished in the Iron Age as a Celtic settlement whose economy was based on salt mining.

This gap between the visual surface of a place and the interwoven layers of contemporary life, history, and culture underlying it exists everywhere to some degree. But in Central and Eastern Europe it is particularly pronounced. Whether one is in the region or just looking at photographs of its diverse, often wondrous landscape and life, what meets the eye can seldom be taken at face value.

As a journalist covering German reunification in 1990, for example, I asked a village mayor in eastern Germany if the collapse of communism was the most significant event his town had experienced. No, he replied, occupation by the Swedes was. Then he described in vivid detail how some villagers were murdered and robbed while others hid themselves and their valuables in the forest when Swedish troops under King Gustavus Adolphus seized the place during the Thirty Years' War in the 17th century. He spoke as if it had happened just days before.

Because of the region's long history of war, social upheaval, and political instability, similar tales in which the privations of the past live on in the present can be heard in cities, towns, and farmsteads from the steppes of Russia to the Tyrolean Alps. In all these stories a collective sense of place, particularly of landscape, is a central theme. Whether the storyteller is a Serb, a Sorb, or a Saxon, a visual image of their native landscape is a key component of their identity.

Nowhere else have the meanings human beings assign to landscape and depictions of landscape had more glorious and more disastrous consequences than in Central and Eastern Europe. The beauty of the region's mountains, forests, plains, and waters has inspired some of the world's greatest works of visual art, literature, and music. The same landscape

has also been exploited by politicians and propagandists to promote nationalist movements that created nation-states ultimately responsible for killing and displacing millions of people over the past century.

The glory and the gore stem from ideas and emotions human beings project on the landscape rather than the specific physical qualities of a given piece of land or stretch of water. Artists and politicians feed off the emotional response people have to the landscape's unique combination of universal visual appeal and vast metaphorical possibilities. Landscape pictures are the most popular form of art worldwide. Looking at them, many people obviously feel a connection to something greater and more enduring than themselves, whether it is the divine or a collective vision of home and hearth. Regardless of the meaning attributed to it, landscape imagery has strong evocative power.

Yet no landscape, real or depicted, ever returns our feelings. Where there are no border markings to tell us where Germany ends and France, Poland, Austria, Switzerland, Denmark, the Netherlands, and Belgium begin, the landscape of one country is indistinguishable from the next. Still, millions have died for *das Vaterland,* Mother Russia, Greater Serbia, and other carefully delineated chunks of claimed terrain.

At the other end of the landscape spectrum is Leo Tolstoy, who wrote, "The earth is the general and equal possession of all humanity and therefore cannot be the property of individuals." Another Central European writer and thinker named Karl Marx had somewhat similar thoughts about property and place.

That such notions regarding place arose in Central and Eastern Europe is no surprise. Appearance and reality were dancing a strangely distanced pas de deux there long before photography was invented. Tolstoy, for instance, often wrote at Yasnaya Polyana, his family's sprawling slice of rural Russian real estate. Marx put his thoughts to paper in the urban grime of North London, far from his familial roots.

One can, of course, view the photographs in this chapter mainly in aesthetic terms, appreciating them for their clarity, color, and meticulous composition. Or they can be seen as high-level tourist photos depicting the beauty of the Alps, the tranquility of Tolstoy's favorite path at Yasnaya Polyana, the charm of children in a version of traditional Hessian dress.

Some of these pictures show truly lovely places such as Hallstatt in Austria's Salzkammergut district, the picturesque

former Celtic salt-mining village that is now on the UNESCO World Heritage list of protected sites. The visual poetry of Gerd Ludwig's shot of Moscow's Red Square or Ed Kashi's photo of white pelicans taking off from Lake Rosca in Romania has universal appeal.

So does James P. Blair's picture of Mount Triglav in Slovenia's Vrata Valley. It is a classic landscape, a photographic descendant of an Albrecht Altdorfer painting, the kind of scene—sun shining, valley in blossom, rugged, stony mountain rising in the distance—holding what anyone would want from the place they call home or homeland: brightness, beauty, safety, and solidity, all looking impervious to change.

A similar valley is painted on a piece of canvas in the photograph of a portrait photographer waiting for clients in downtown Warsaw in 1947. It is one of several backdrops in the picture. Behind the faux landscape is the wan sky and ruined city, destroyed on Adolph Hitler's orders after the 1944 Warsaw uprising. Pinned to the painting is a square, white cloth, like a blank wall against which the photographer sits.

Whether or not he knew his picture was being taken, the photo is a layered and subtle portrait of the artist, the city, and the society as survivors and of life persevering through death and devastation. That the photographer sitting in front of his camera is selling appearances rather than reality is completely understandable.

Such a scene might seem like ancient history. Ed Kashi's picture of a woman walking in a Croatian town along a street lined with houses ravaged by artillery and gunfire suggests otherwise. We can tell ourselves that in Central and Eastern Europe religious and ethnic conflicts, nationalistic antagonisms, and authoritarian regimes are things of the past, that democracy and free markets are bringing peace, stability, and prosperity to the region. Sometimes neither place nor pictures deceive us. We do it ourselves.

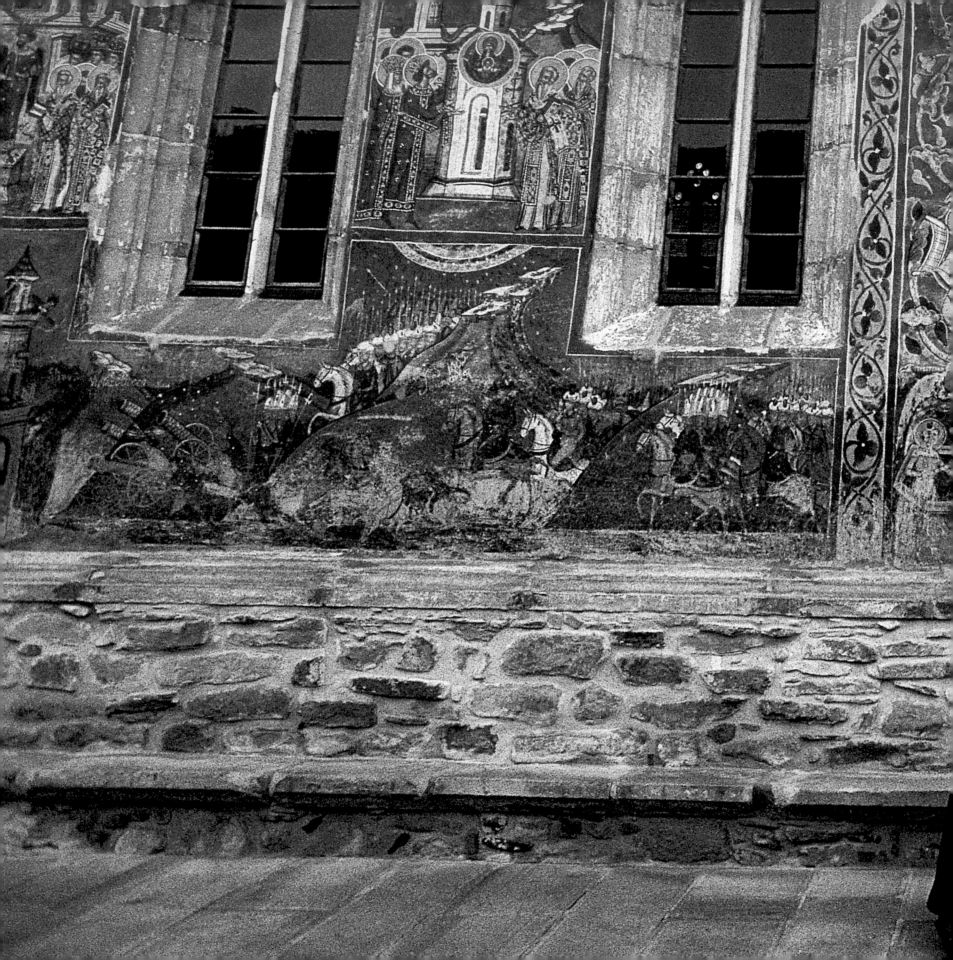

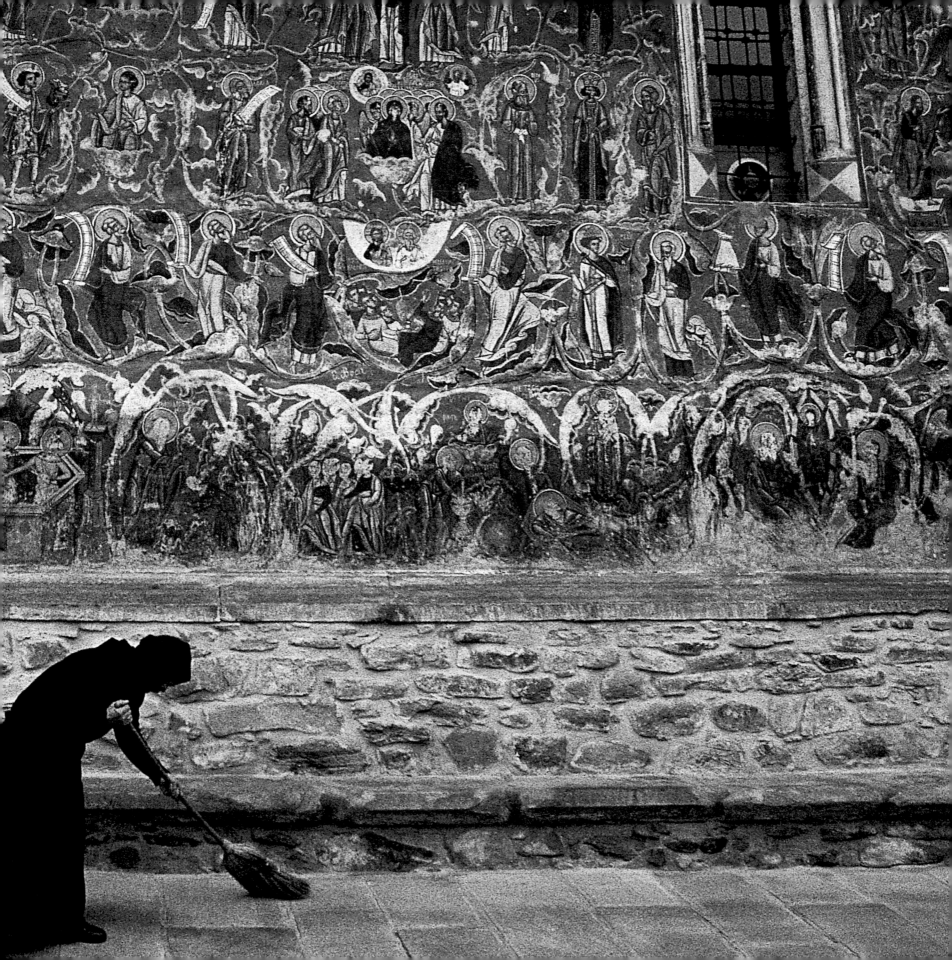

198

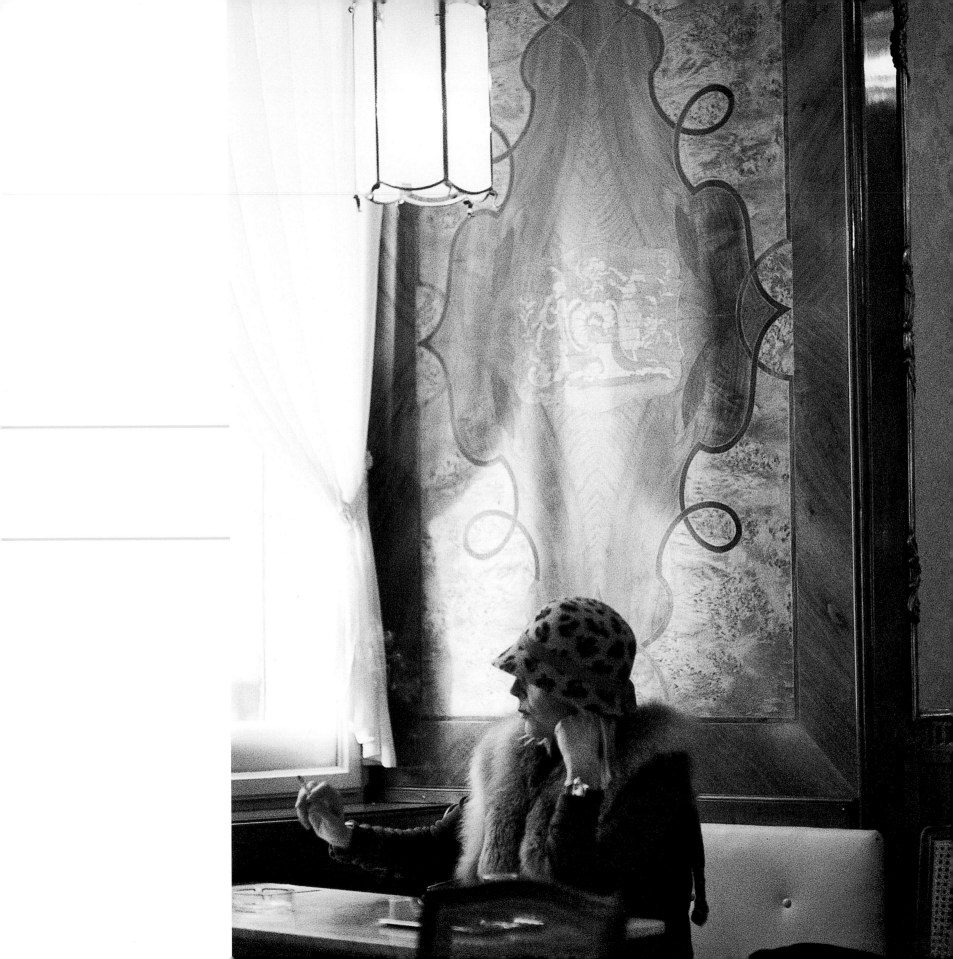

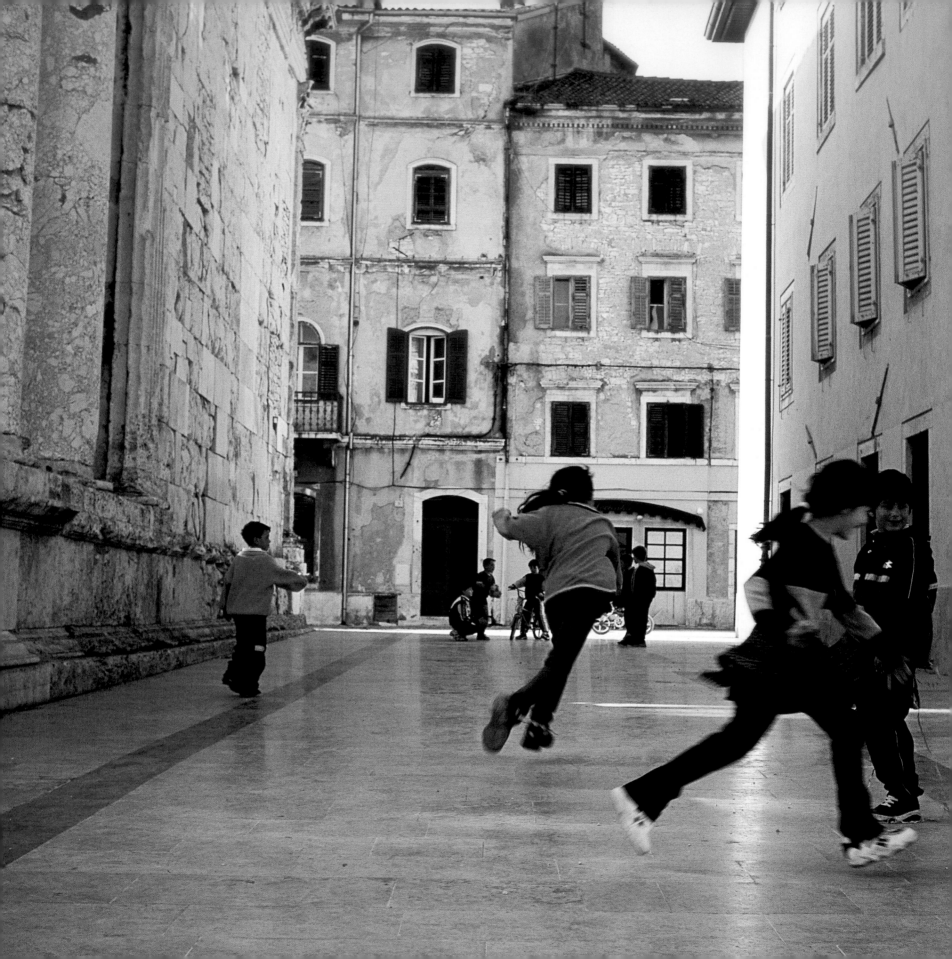

VINCENT J. MUSI, 2001. KIDS PLAYING IN THE STREET, ISTRIAN PENINSULA, CROATIA.

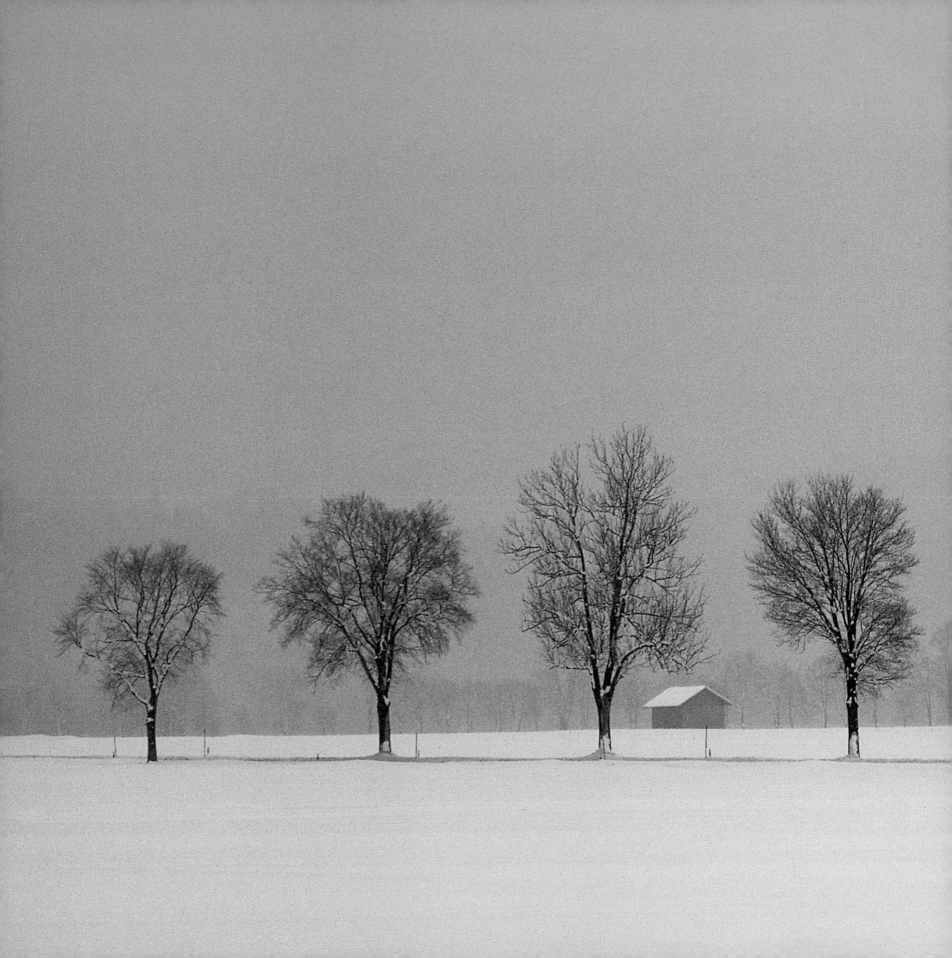

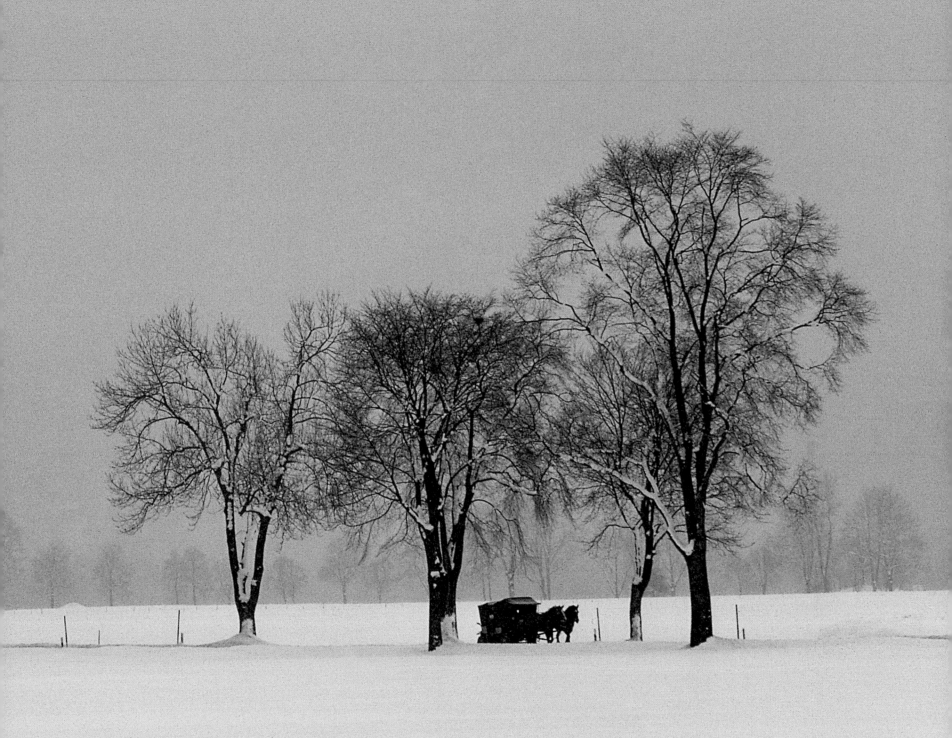

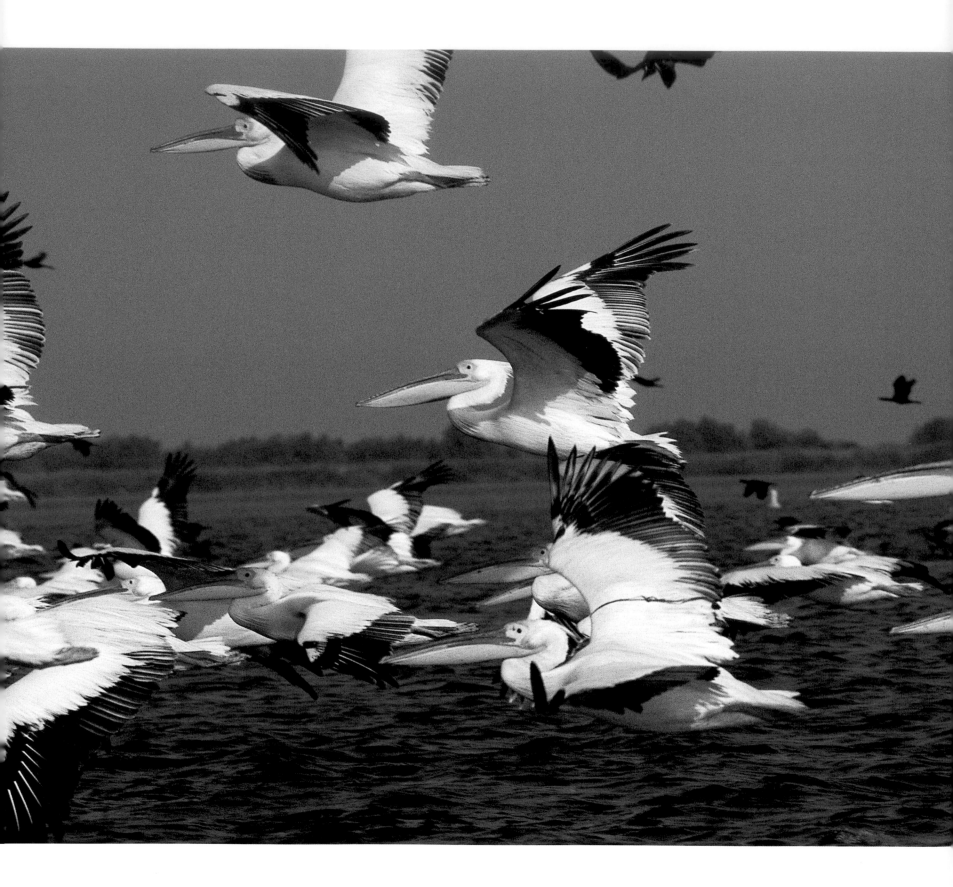

PREVIOUS PAGES: GEORGE F. MOBLEY, 2004. HORSE AND WAGON ON A SNOWY DAY IN BAVARIA.

LEFT: ED KASHI, 2002. WHITE PELICANS TAKING OFF FROM LAKE ROSCA, ROMANIA, HOME TO EUROPE'S LARGEST GREAT WHITE PELICAN COLONY.

205

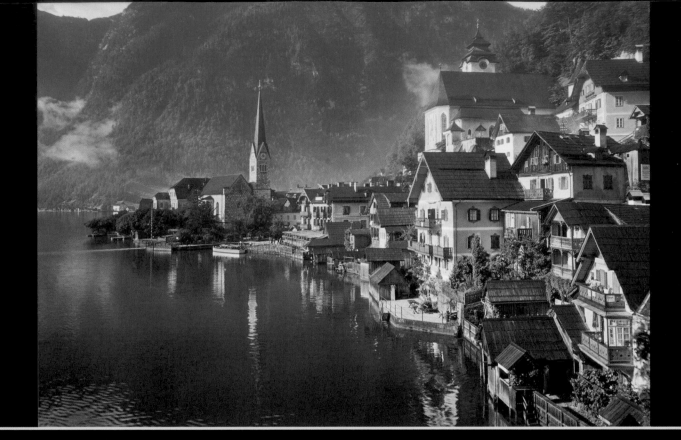

LEFT: W. ROBERT MOORE, 1937. SCENIC VIEW OF HALLSTATT, AUSTRIA, AN ALPINE VILLAGE THAT FIRST FLOUR-
ISHED IN THE IRON AGE AS A CELTIC SETTLEMENT WHOSE ECONOMY WAS BASED ON THE NEARBY SALT MINES.

RIGHT: IFF FROM THREE LIONS, 1947. LAYERS OF LANDSCAPE, FAKE AND REAL, BEHIND A LONELY PORTRAIT
PHOTOGRAPHER IN THE POST-WAR RUINS OF DOWNTOWN WARSAW, POLAND.

PLACES EXPERIENCED DIRECTLY OR

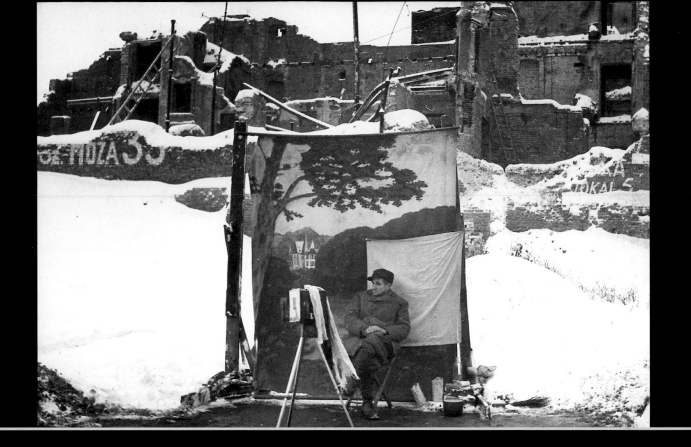

AS PICTURES CAN BE DECEPTIVE. ℘

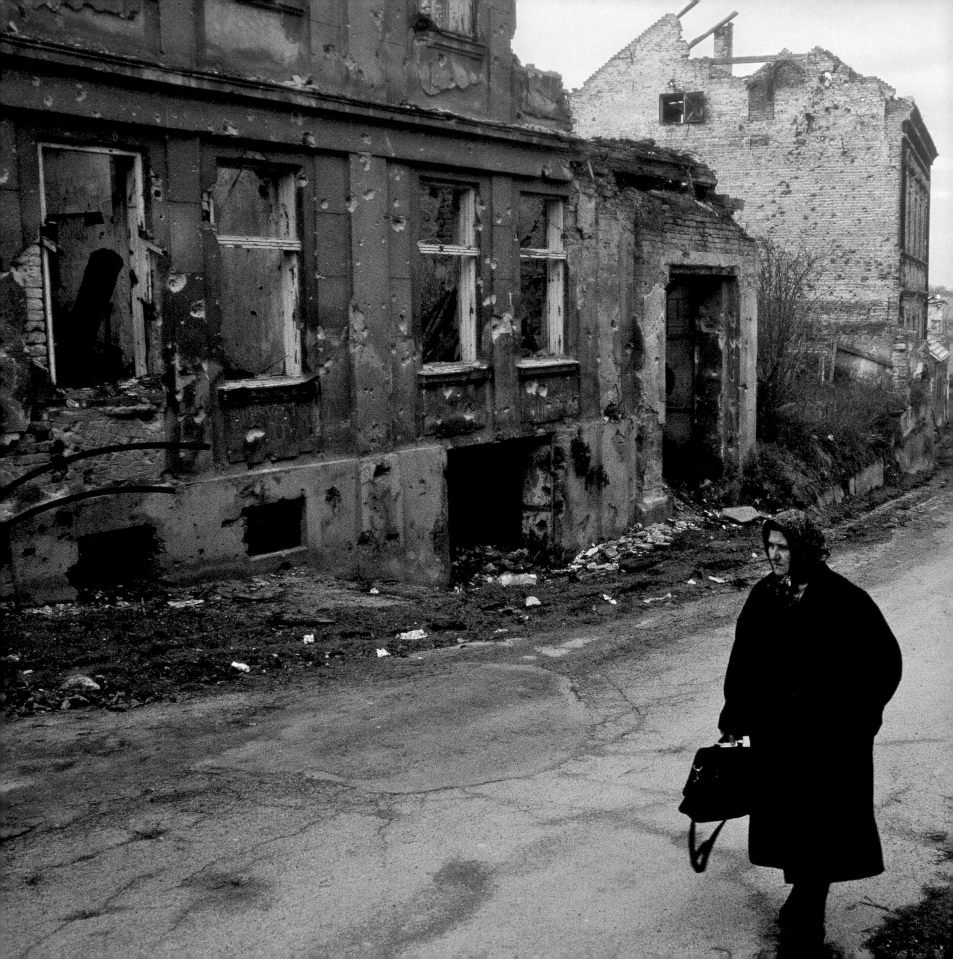

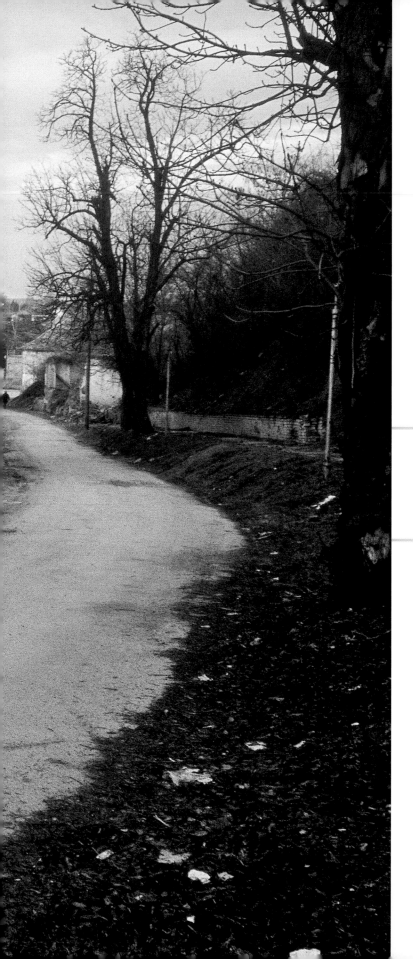

ED KASHI, 2002. A WOMAN WALKING PAST WAR-RAVAGED
BUILDINGS IN CROATIA.

209

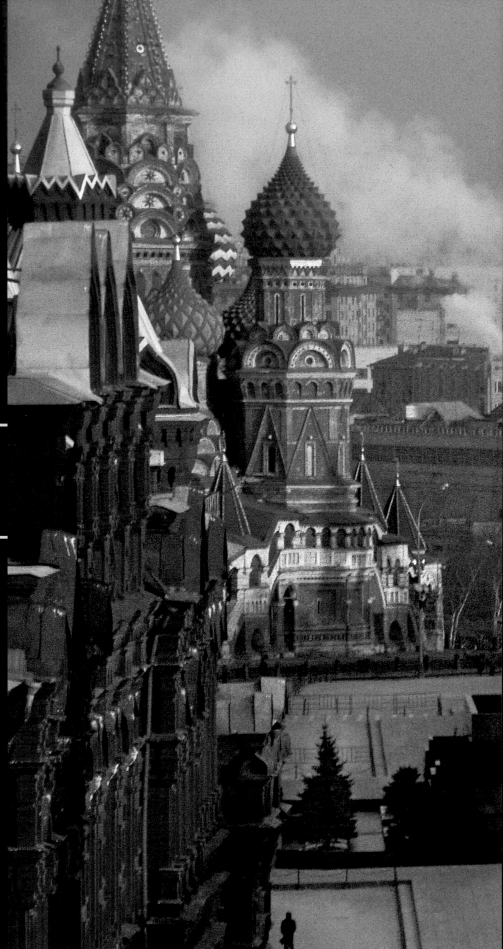

GERD LUDWIG, 1997. RED SQUARE IN MOSCOW,
RUSSIA.

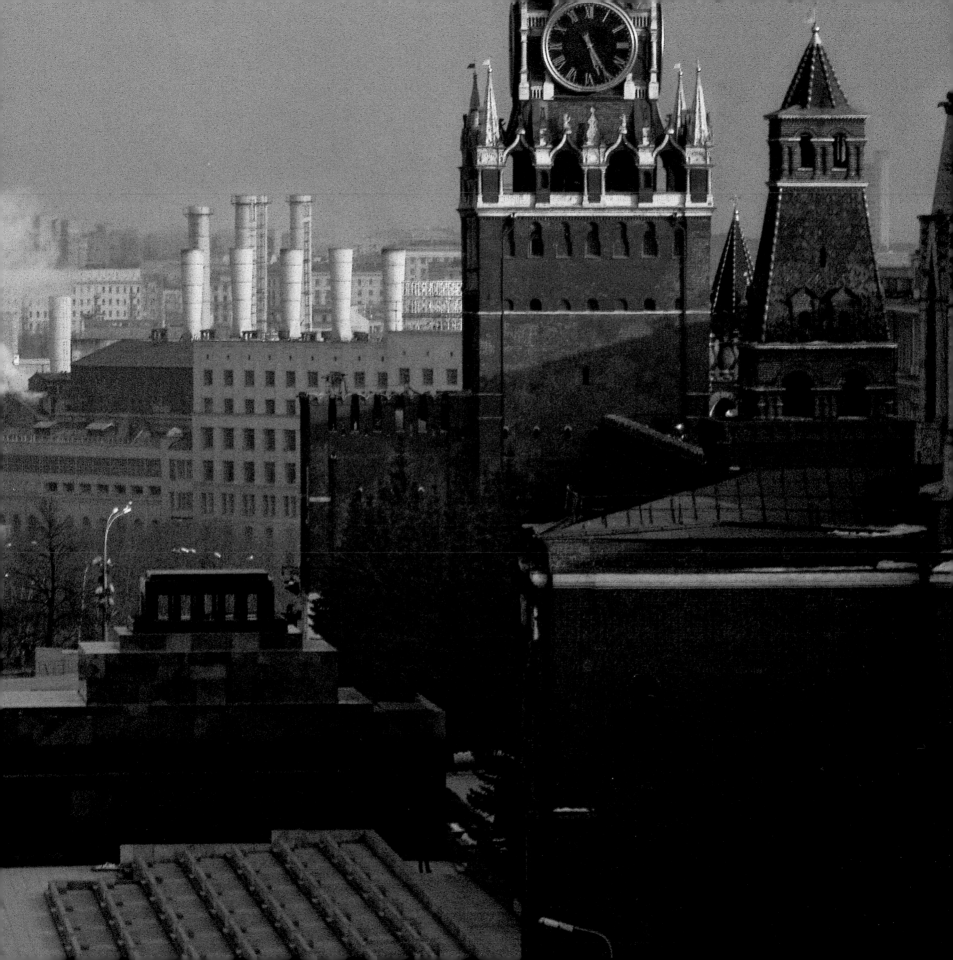

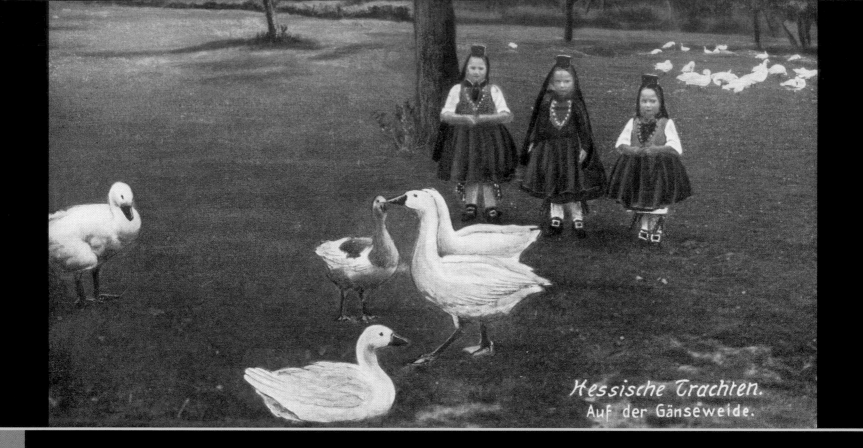

Hessische Trachten.
Auf der Gänseweide.

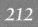

TOP: CHARLES HARRIS PHELPS COLLECTION, 1878-1882. CHILDREN DRESSED IN SCHWÄLMER TRACHT, ONE OF MANY TYPES OF TRADITIONAL FOLK DRESS FOUND IN THE GERMAN STATE OF HESSE.

BOTTOM: JAMES L. STANFIELD, 1992. TURN-OF-THE-CENTURY BEEHIVES AT AN ETHNOGRAPHIC MUSEUM IN ROZNOV, CZECH REPUBLIC.

213

PREVIOUS PAGES: JOHN EASTCOTT AND YVA MOMATIUK, 1987. COMMUNIST-ERA SLOVAKIA. RURAL VILLAGERS SUCH AS KATARÍNA MISUROVÁ OF PÁRNICA RAISED LIVESTOCK AND VEGETABLES TO SUPPLEMENT THEIR DIET BECAUSE OF ERRATIC AVAILABILITY OF FOOD IN STORES.

RIGHT: CHARLES HARRIS PHELPS COLLECTION, 1878-1882. LIECHTENSTEIN CASTLE IN GERMANY.

STEVE RAYMER, 1993. LAVISH MOSAICS ON THE CHURCH OF THE
RESURRECTION, BUILT WHERE TSAR ALEXANDER II WAS ASSASSINATED
IN 1881, IN ST. PETERSBURG, RUSSIA.

219

RANDY OLSON, 2002. CLOUDS DRIFT ACROSS THE CAUCASUS MOUNTAINS IN RUSSIA.

🔗 LANDSCAPE IS OFTEN USED AS A KEY

COMPONENT OF NATIONAL IDENTITY.❧

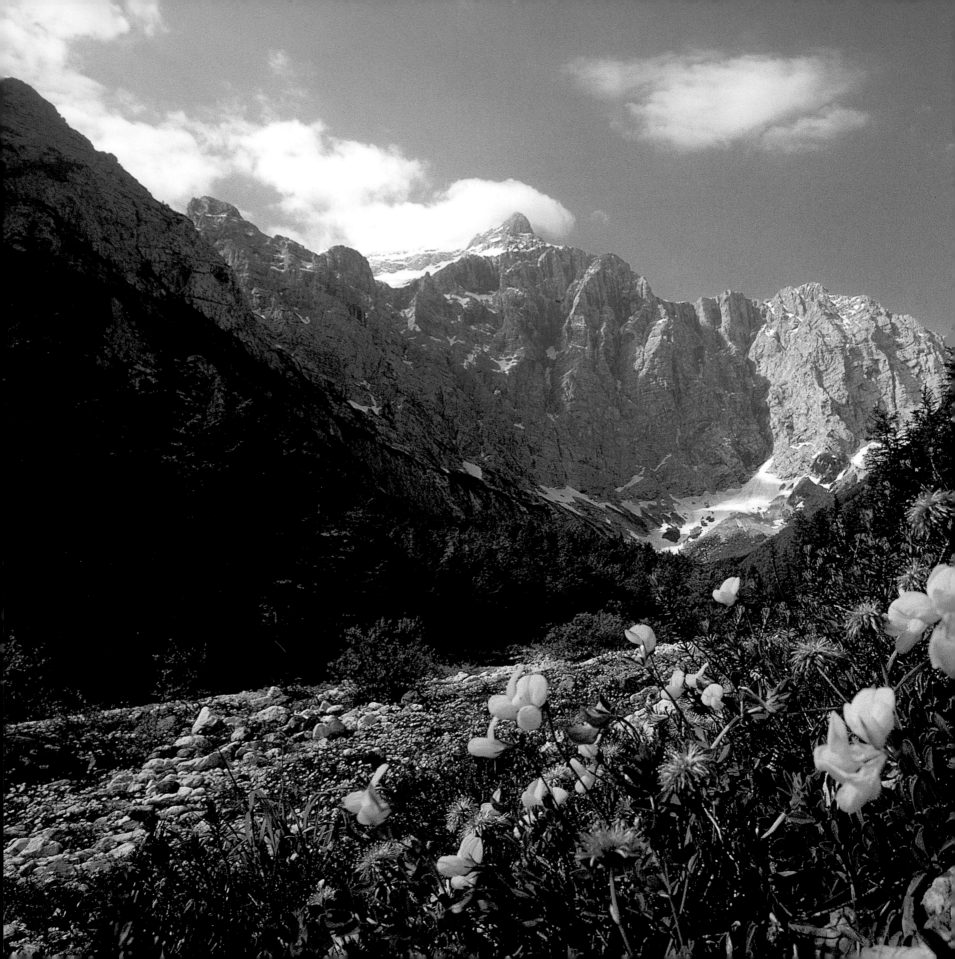

JAMES P. BLAIR, 1973. THE NORTH WALL OF MOUNT TRIGLAV,
RISING 9,393 FEET ABOVE THE VRATA VALLEY, SLOVENIA, IS
A CLASSIC LANDSCAPE, A PHOTOGRAPHIC DESCENDANT OF AN
ALBRECHT ALTDORFER PAINTING.

223

RAYMOND GEHMAN, 1992. BIALOWIEZA, POLAND. FOR INSIDERS, PLACE IS NOT JUST GEOGRAPHIC, BUT PERSONAL, PROVIDING THE SETTING FOR THEIR LIVES.

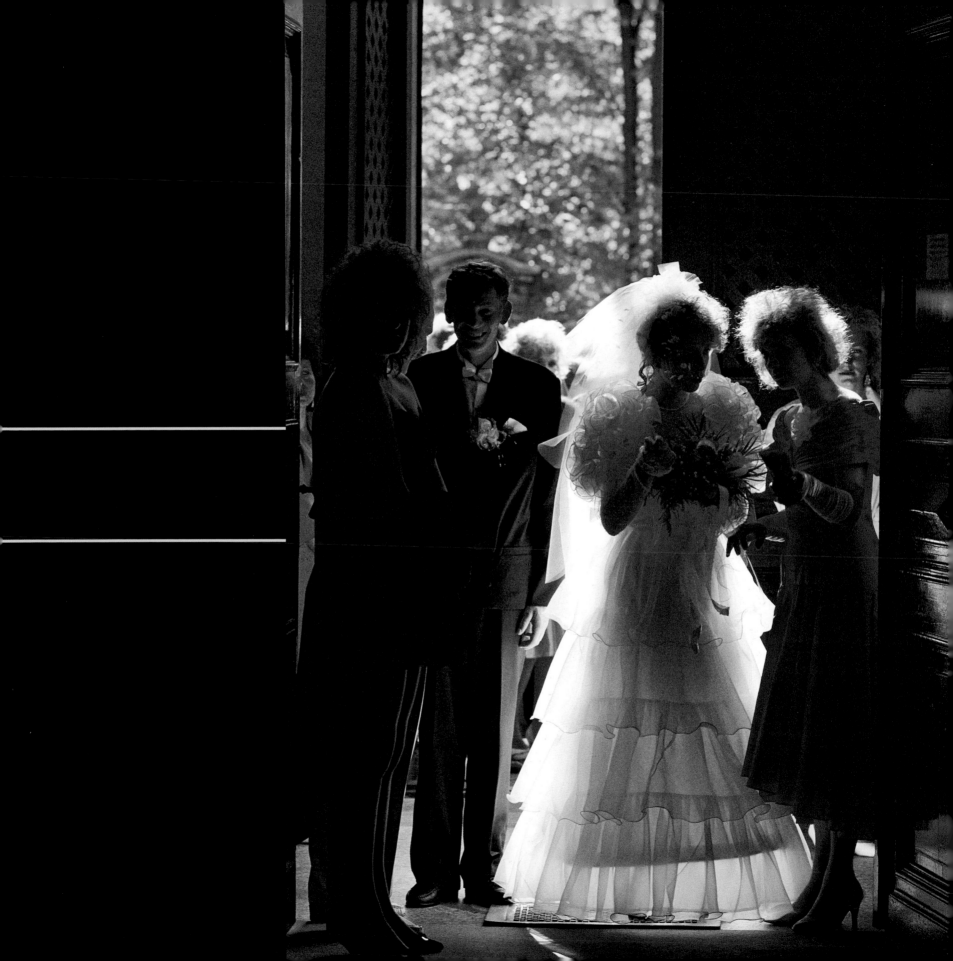

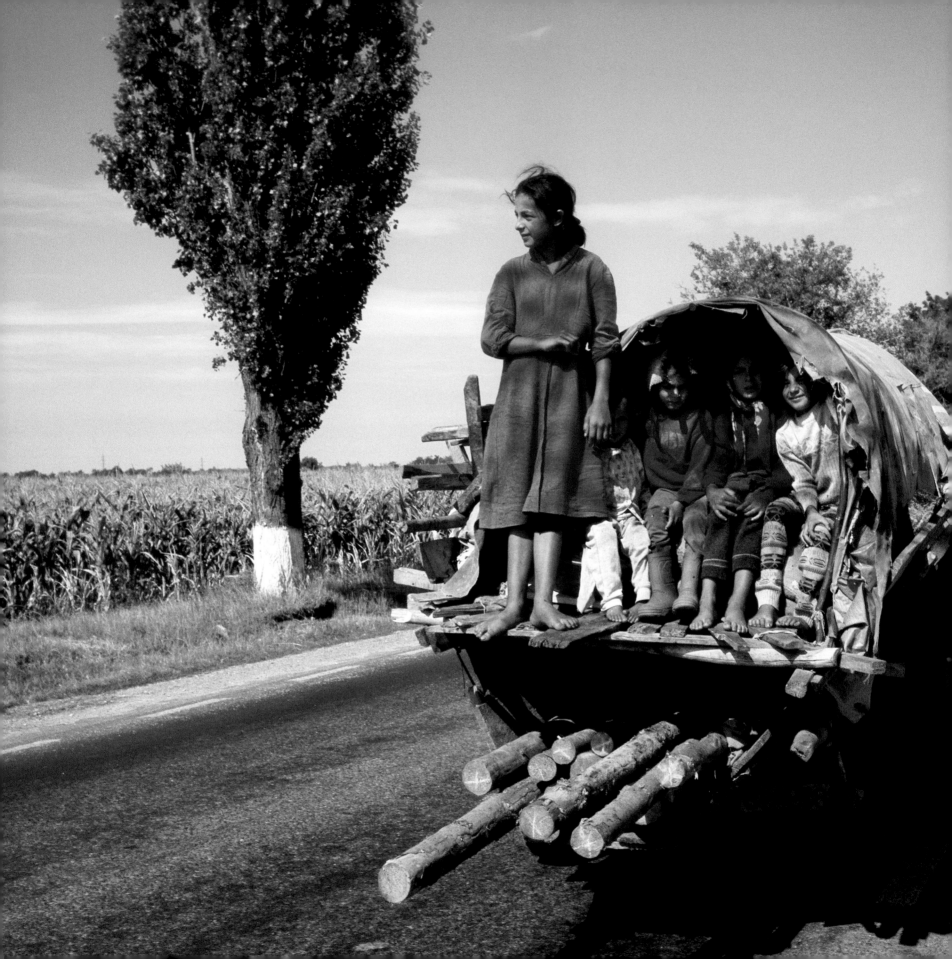

Left: Tomasz Tomaszewski, 2001. A wagon carrying a Gypsy family in Buzescu, Romania.

Following Pages: Alexandra Avakian, 1998. Mist shrouding Vlad Dracula's castle in the region of Walachia, Romania.

227

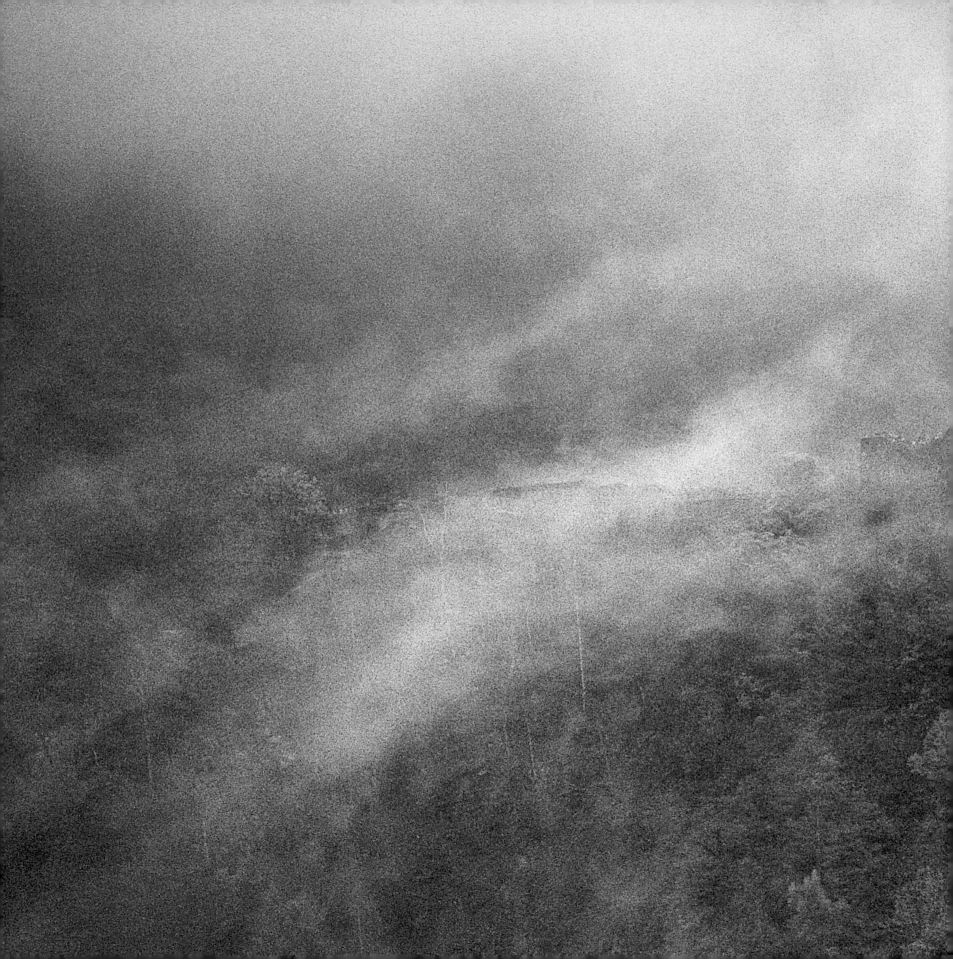

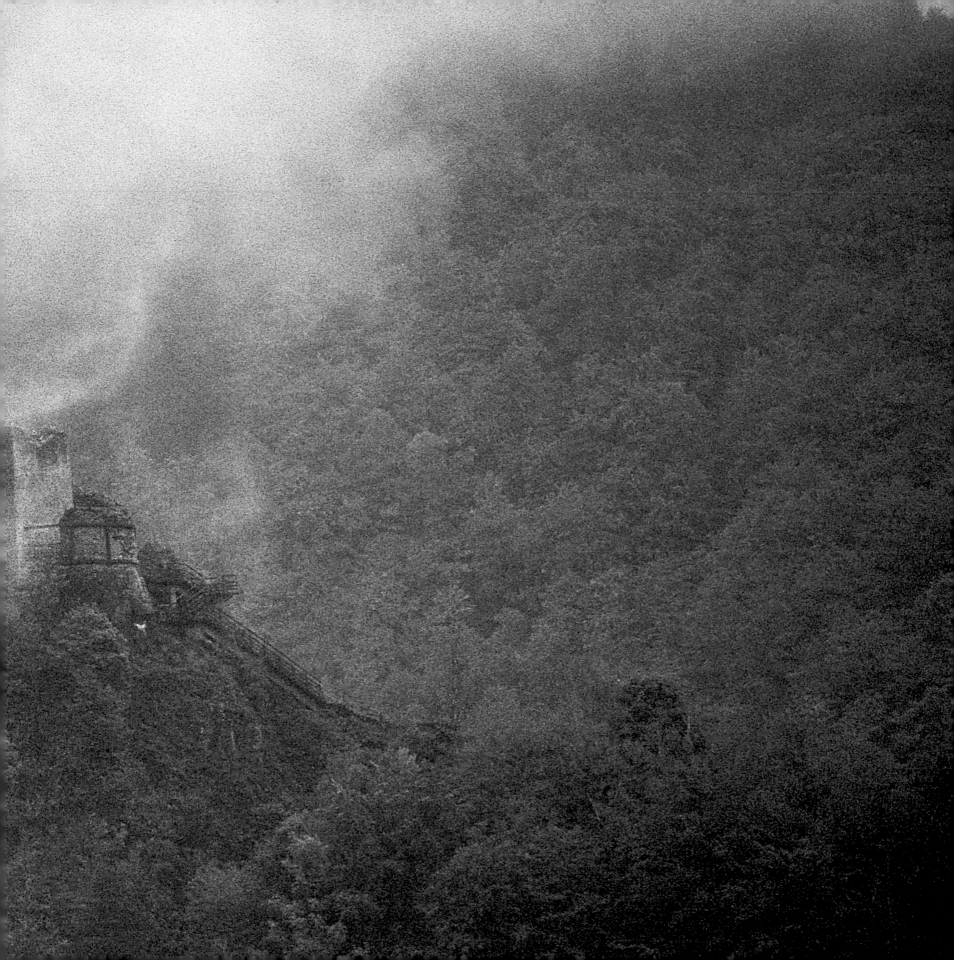

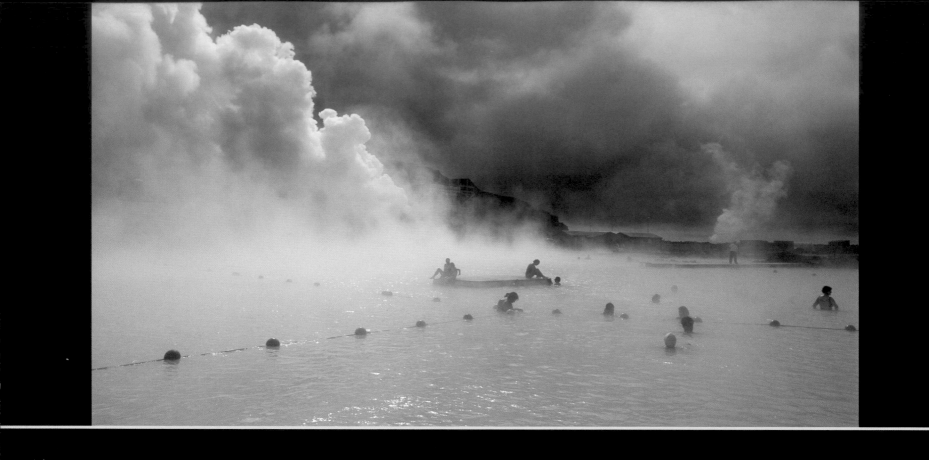

# 6 NORTHERN EUROPE

PREVIOUS PAGE TOP: SISSE BRIMBERG, 1998. PEOPLE ENJOY SWIMMING IN THE WARM WATERS OF THE BLUE LAGOON, A GEOTHERMAL SPA THAT IS ONE OF ICELAND'S MOST POPULAR ATTRACTIONS.

BOTTOM: MATTIAS KLUM, 2001. NATURE AS A COMMERCIAL ENTERPRISE: STRAIGHT AND WELL-SPACED, THESE TREES IN SWEDEN ARE TYPICAL OF NORTHERN EUROPE'S FORESTRY INDUSTRY.

# NORTHERN EUROPE

To Western eyes, these photographs of Northern Europe may seem familiar, like pictures in a family album. That feeling of familiarity is obviously rooted in the powerful historical and cultural bonds between the region and the rest of the world, especially North America. Millions of Americans are descended from the peoples of the British Isles or Scandinavia. Many have visited their "ould sod," be it Ireland, Iceland, Scotland, or Sweden. They have also seen countless pictures and heard innumerable tales of their ancestral lands.

Such close links would seem to ensure that any photographs of Northern Europe come tinged with triteness. Yet these aren't because the same collective familiarity that can spawn banality also opens the way to intimacy. That does not mean all photos of Northern Europe automatically possess deep layers of meaning. My tourist shots of London and Helsinki, for example, are simple, visual mementoes, nothing more. But this intimacy enables gifted photographers, such as those working for National Geographic, to see the profound in the prosaic and create pictures that communicate their insights on multiple levels.

Some of the photographers featured here had little or no knowledge of these specific spots in Northern Europe before they shot them. But in a broader sense, they knew them as insiders raised in the culture, fluent in its visual language, versed in its history. This knowledge allowed them to probe their subjects in greater depth and detail. Beyond showing how these places in Finland, Sweden, Scotland, Wales, England, Ireland, and Iceland looked at a given point in time, their pictures examine how Western society assigns meaning to places and to depictions of those places. This can be seen most clearly in their photographs of Britain, the birthplace of time, place, and photography as we know them.

Every photo in this book is produced by the interaction of place, time, light, chemicals, and the photographer, just as photos were in 1839, when William Henry Fox Talbot introduced his negative-to-positive paper process, the photographic technique still widely used today. Talbot's early pictures, taken in and around his family estate at Lacock Abbey in England, demonstrated the efficacy and efficiency of his discovery. They also demonstrated his place in England's social order.

Talbot was born into a family of landed gentry, received an excellent education, and traveled extensively. He was a brilliant and energetic man with strong knowledge of art and art history, including the traditions of European painting. Talbot's

aesthetic sensibility shines from his photographs in their linear perspective, meticulously balanced composition, and lyrical interplay of light and shadow. His photographs are art, classical paintings, and drawings taken straight from life by his camera. Talbot summarized his belief in photography as an art form in the title of his book, *The Pencil of Nature.* Published in 1844, it was the first commercial book to be illustrated with photographs.

The country house, with its prospect and surrounds, was a primary motif of British landscape painting long before Talbot invented modern photography. Such places were designed in the Palladian tradition to be living landscape paintings, art turned to architecture in which one could dwell. With his camera, Talbot gave viewers a sense of what it was like to live in and look out from that scene, to be lord of the manor. It was, in a word, sweet.

Sam Abell's remarkable photograph of the Hampton Court Palace and its Privy Garden offers a different view, literally and figuratively. Taken from a raised path at the far end of the elaborate formal garden, the picture seems to have the hallmarks of traditional landscape depiction: an elevated viewpoint; distanced perspective; symmetrical composition featuring a centered subject framed by nature; green hues dominating the foreground, blue the background.

The scene reflects Abell's refined aesthetic sensibility, his knowledge of history, and the subject's design. It also shows that unlike Talbot or the royal family, Abell was not born to the manor. He is an outsider, peering into this corseted landscape of shrubs, flowers, grass, and gravel bound tightly together by gardeners to form a pre-determined figure meant to provide viewing pleasure for the owner and guests. The garden also demonstrates that the owners had the economic and political clout to wall off a major chunk of London real estate for their private purposes, in effect creating a social space demarcating the top of the heap from the hoi polloi.

Through its composition and color, Abell's photograph pays homage to Talbot and the tradition of landscape depiction in Western art, while subtly subverting the social, economic, and political foundations of that tradition. This is the sweet life seen from a poacher's perspective. The palace and grounds are diminished, squeezed between the trees in the foreground and dark clouds on the horizon. The flip side of place, which Adam Smith wrote about in his treatise, "The Theory of Moral Sentiments," is made visible. "And thus, Place, that great object which divides the wives of aldermen, is the end

of half the labours of human life; and is the cause of all the tumult and bustle, all the rapine and injustice, which avarice and ambition have introduced into this world."

That striving for place also contributed to the creation of standardized global time, which was officially established in the United States but begins each day in the London suburb of Greenwich. Pressure from commercial interests, such as railroads looking to synchronize their watches and schedules, prompted American President Chester A. Arthur to invite delegates from 25 nations to a conference in Washington, D.C., in October 1884.

The conferees established the meridian passing through the principal Transit Instrument at the Observatory at Greenwich as the "initial meridian," the benchmark from which all countries would adopt a universal, solar day counted on a 24-hour clock beginning at mean midnight in Greenwich. President Arthur, it's worth noting, was the son of a Protestant preacher who had emigrated from northern Ireland to New England.

A brass strip cemented amidst cobblestones marks zero longitude in Greenwich, where the Universal Day begins. There are many ways that Bruce Dale could have photographed that strip that would have shown us the urban context in which it exists, the hustle-bustle of London with its trademark double-decker buses bearing, as in Jodi Cobb's photo, the latest in fashion-advertising attitude. Or he could have concentrated on the historic character of the observatory building.

Instead he made a photograph that defies virtually all the pictorial conventions of fine art and photojournalism. There is no horizon, the few colors are minimally modulated, all we see of the people are their feet and shadows, one of which points to and just crosses the meridian. Dale zeroes in on that line, which zooms across his picture like an express train bound for the heart of the Western psyche.

This transient regularity is the essence of the relationship between human beings, place, and time. In Greenwich, the latter two form a line running to infinity. Every day, we follow it, looking for our place in the immensity of the universe. If we're lucky, we find a good spot, at least for a time. Even if we can't stay there forever, we can picture it in our minds and photographs until the light fades away toward another new day.

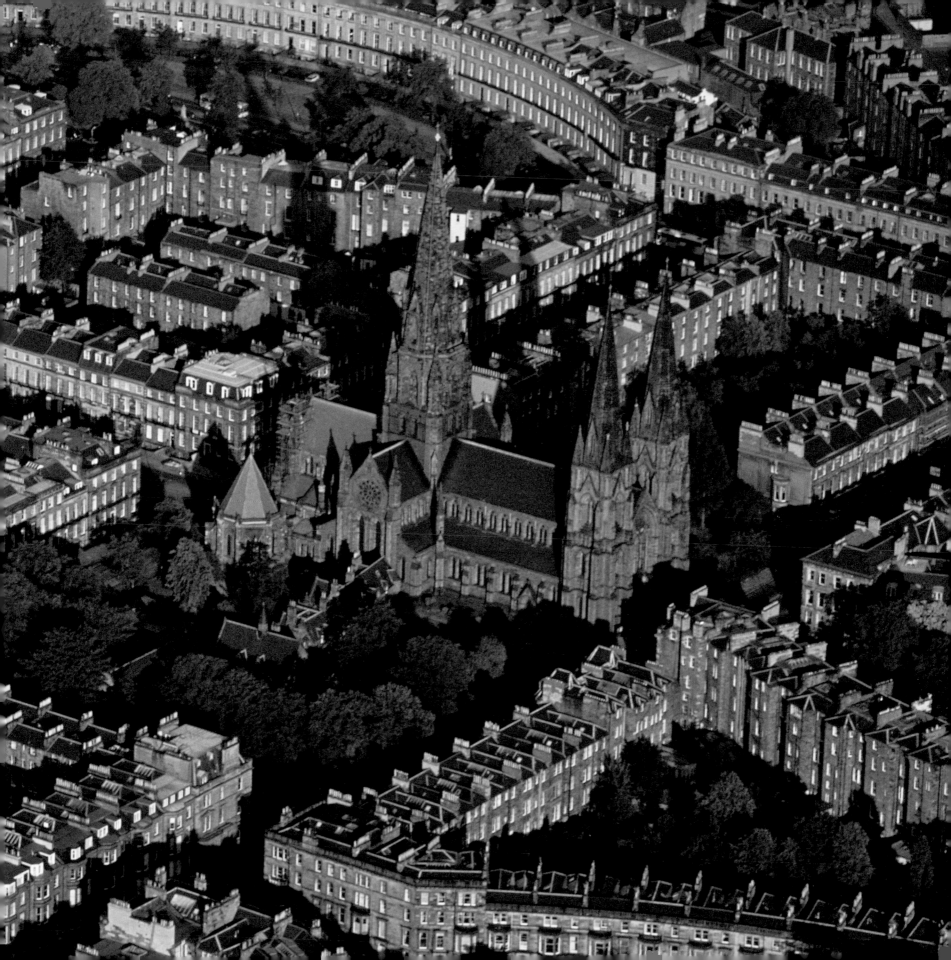

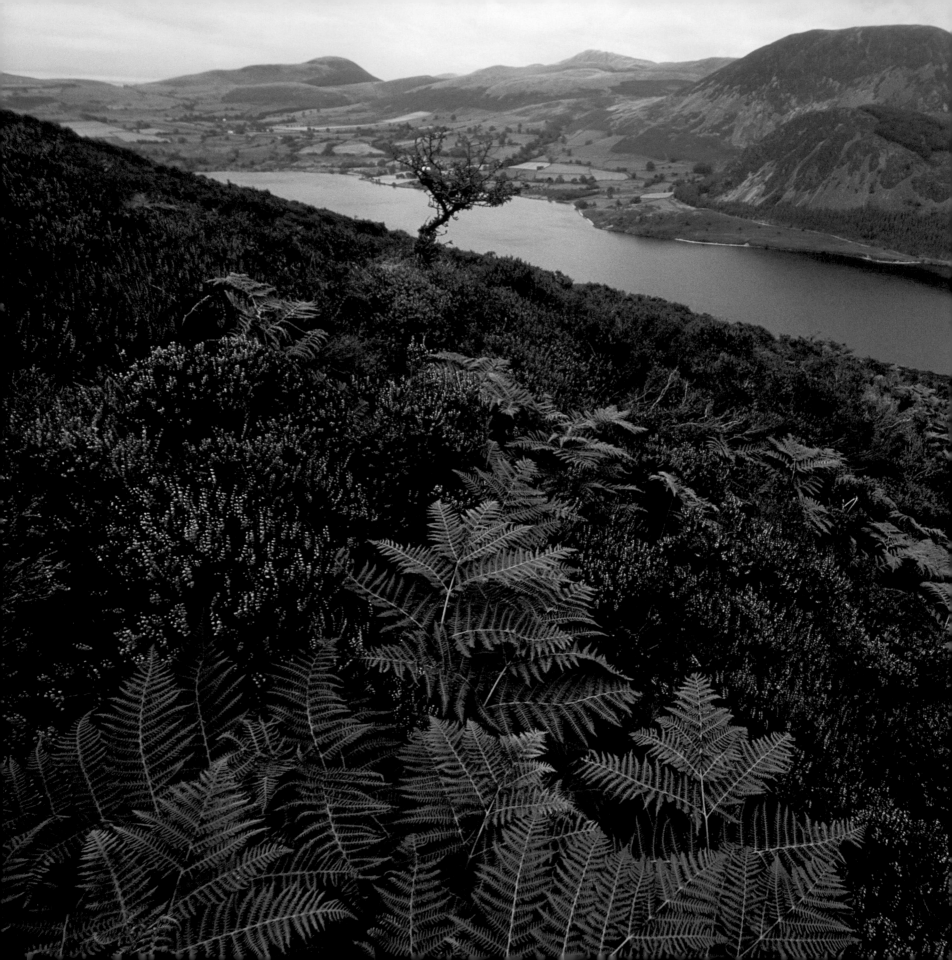

GAIL MOONEY, 1995. A BLUE BULL'S HEAD KEEPS WATCH OVER
DIRECTIONAL SIGNS AND A RESTAURANT IN IRELAND.

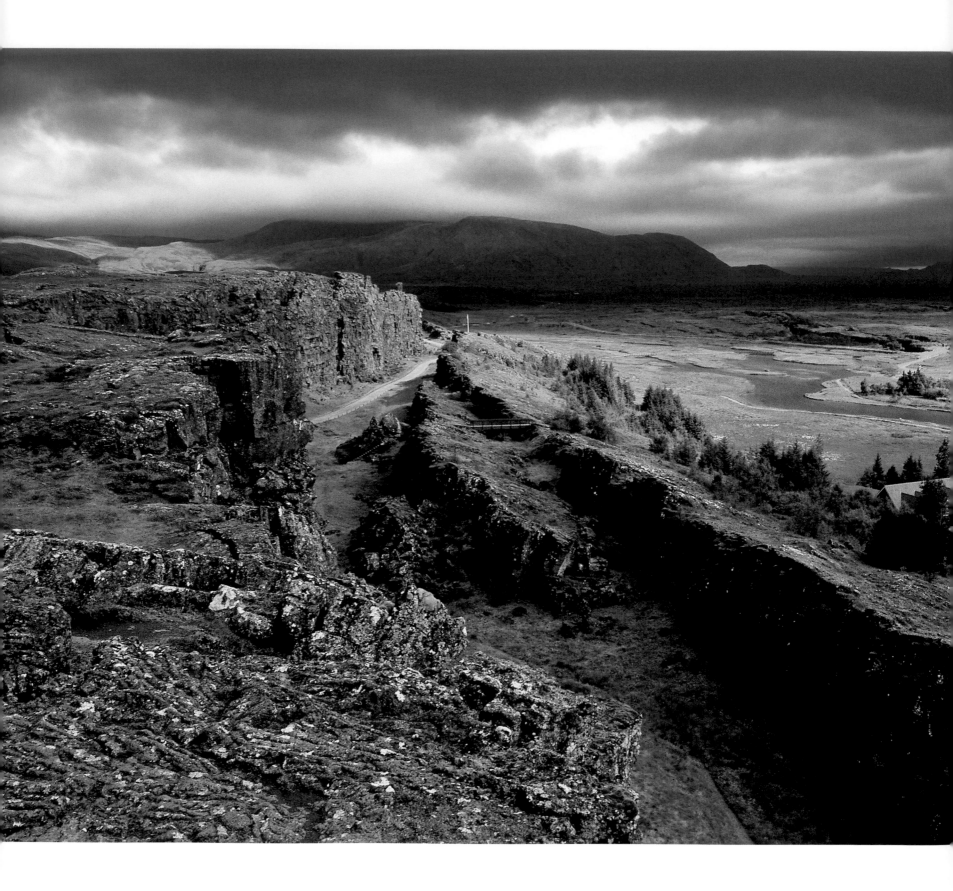

PREVIOUS PAGES: BOB KRIST, 1997. SHOPS AND CAFES ALONG THE STREETS OF GAMLA STAN, MEDIEVAL CENTER OF STOCKHOLM.

LEFT: SISSE BRIMBERG, 2000. THE ALTHING, WHERE ICELAND'S LEADERS HAVE MET EACH YEAR SINCE 930 A.D., THINGVELLIR NATIONAL PARK.

245

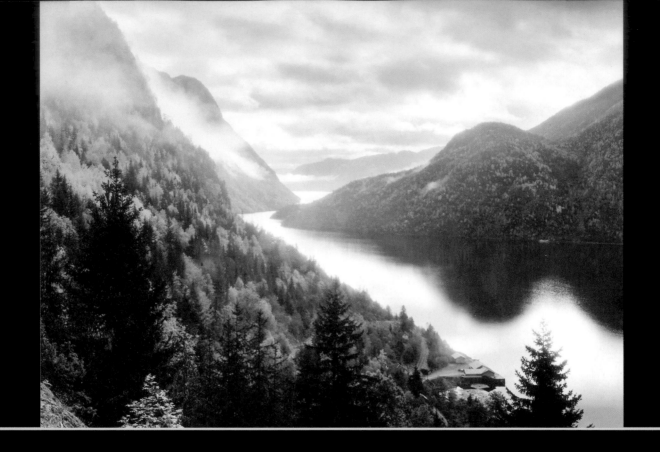

LEFT: A.B. WILSE, 1935. LAKE BANDAK IN TELEMARK, NORWAY.

RIGHT: A.B. WILSE, 1939. HAY DRIES ON RACKS OF POLES AND WIRES IN NORWAY.

SEEING THE PROFOUND IN THE PROSAIC

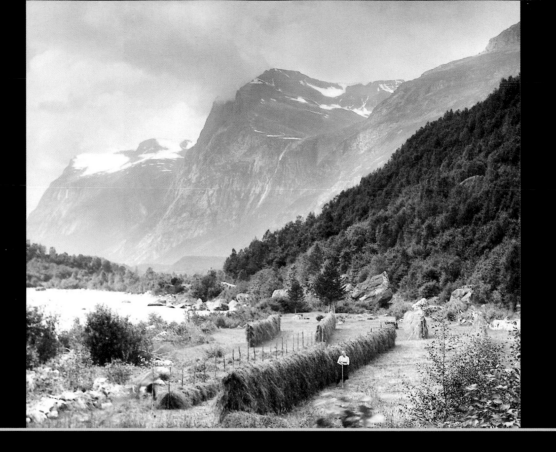

AND CREATING INSIGHTFUL PHOTOGRAPHS. ❧

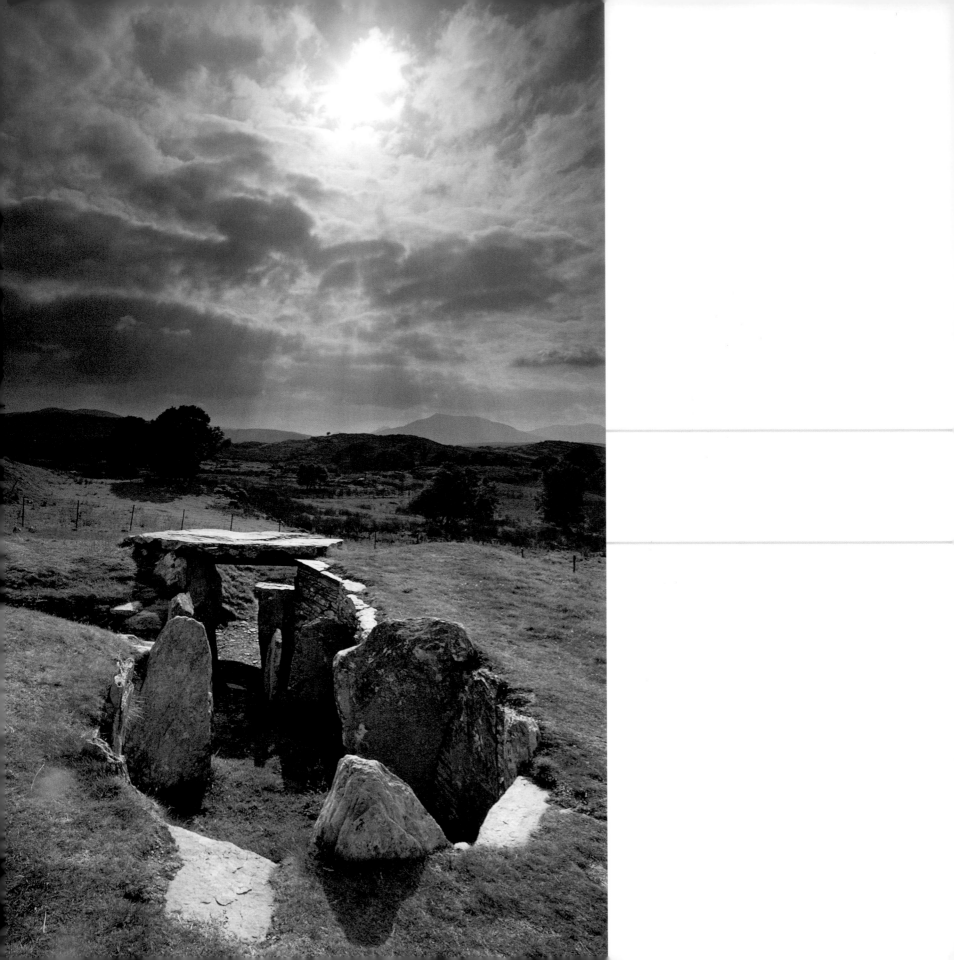

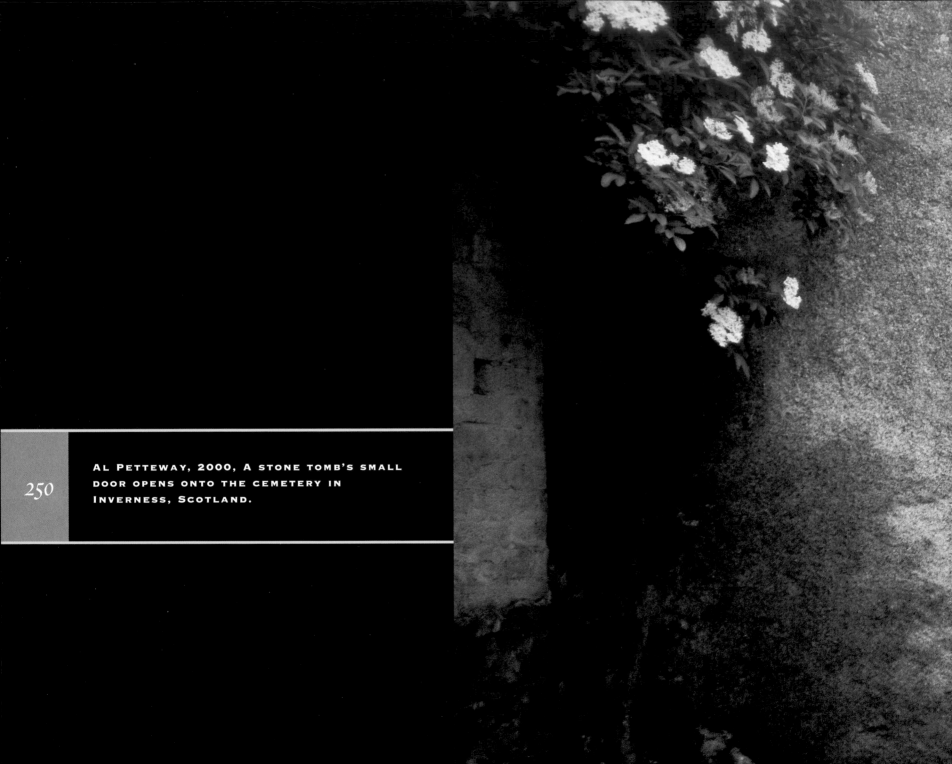

250

AL PETTEWAY, 2000, A STONE TOMB'S SMALL DOOR OPENS ONTO THE CEMETERY IN INVERNESS, SCOTLAND.

TOP: BRUCE DALE, 1989. DALE'S SHOT OF THE BRASS STRIP MARKING ZERO LONGITUDE AT GREENWICH, ENGLAND DEFIES VIRTUALLY ALL THE PICTORIAL CONVENTIONS OF FINE ART AND PHOTOJOURNALISM.

BOTTOM: VINCENT J. MUSI, 2001. ONCE A WORKING COAL MINE, NOW A POPULAR MUSEUM, BIG PIT IN BLAENAVON, WALES, ILLUSTRATES HOW ECONOMIC FORCES CAN ALTER THE CHARACTER OF A PLACE.

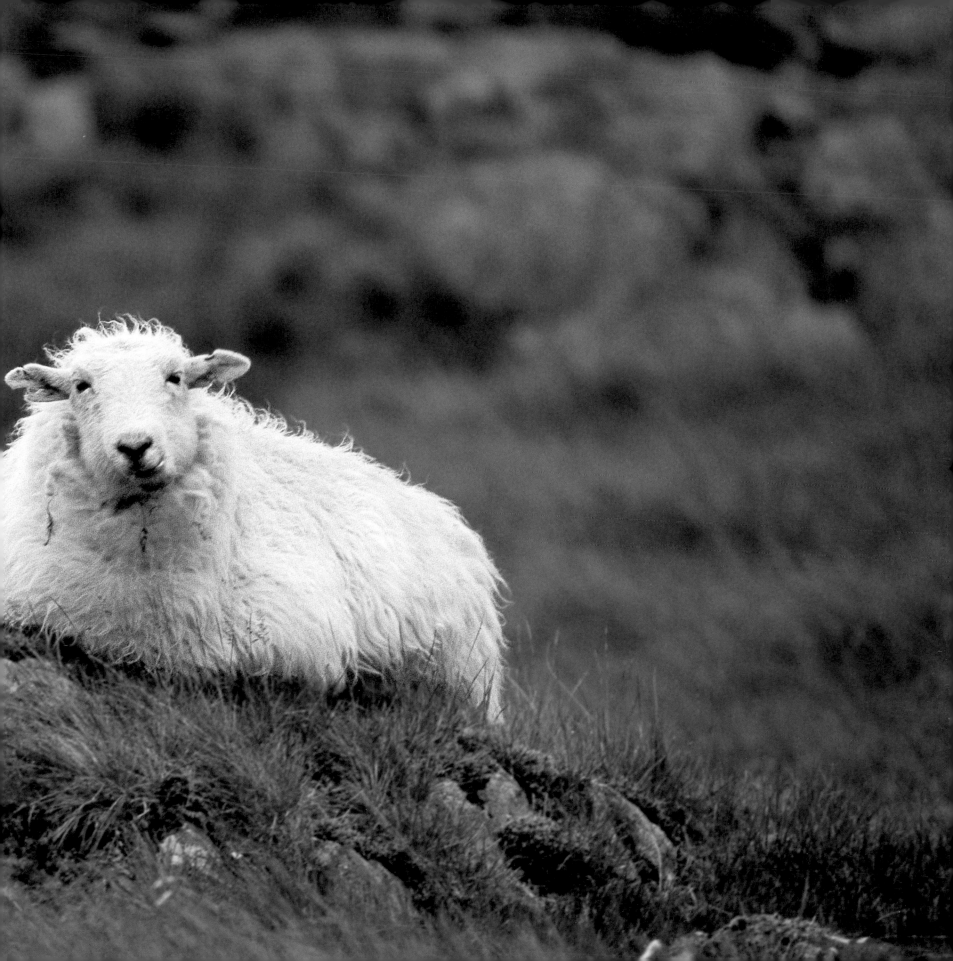

257

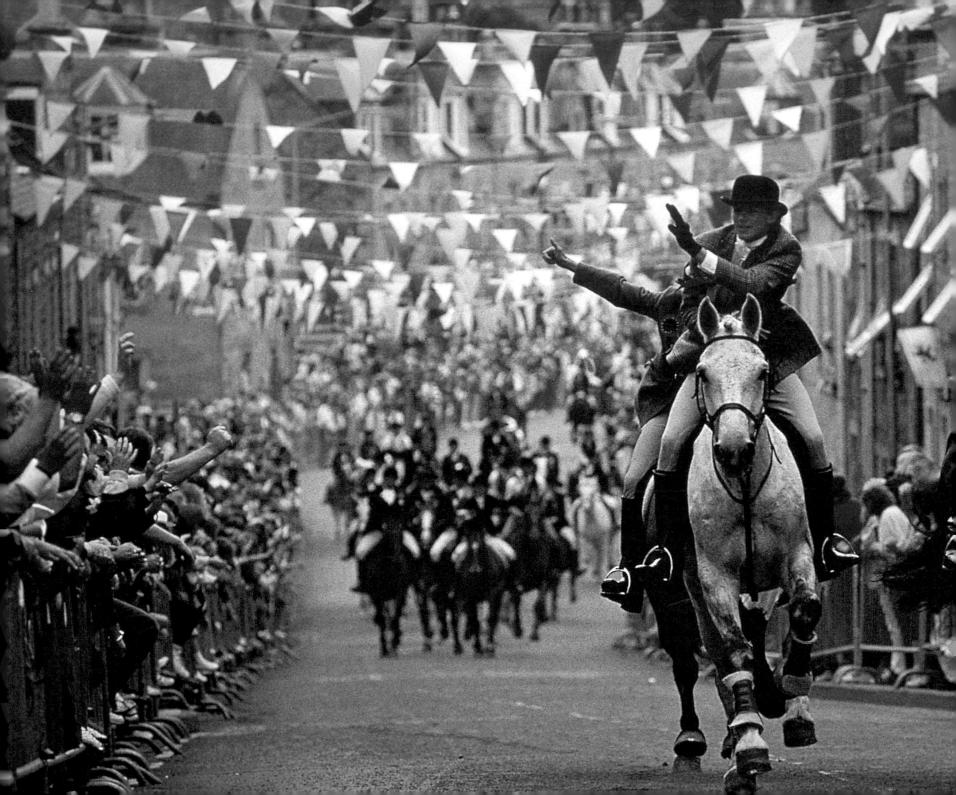

JIM RICHARDSON, 1995. THE ANNUAL BRAW LADS GATHERING, A "BORDER RIDING" EVENT IN GALASHIELS, SCOTLAND.

THE TOPICAL PRESS AGENCY, LTD., 1932. TEA O'ER THE THAMES: LONDON LADIES PICNIC ON THE ROOF OF ADELAIDE HOUSE, WHICH THEN HAD A FRUIT AND FLOWER GARDEN AND AN 18-HOLE PUTTING GREEN.

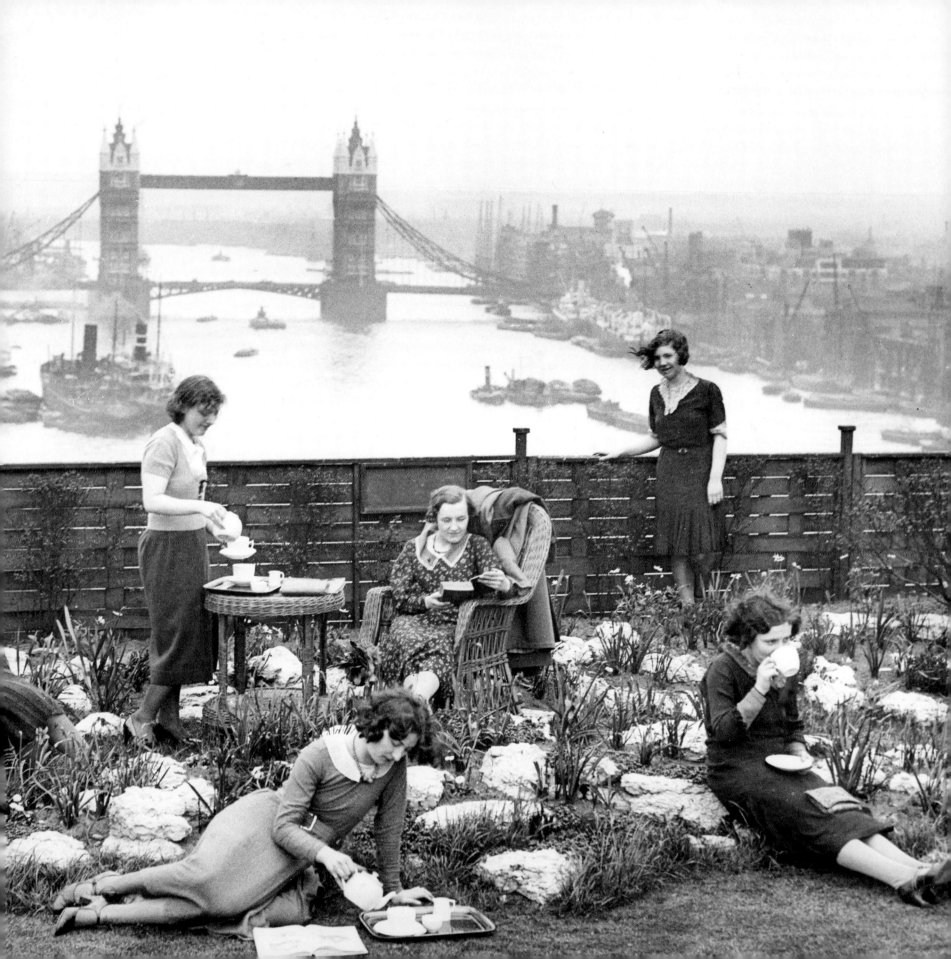

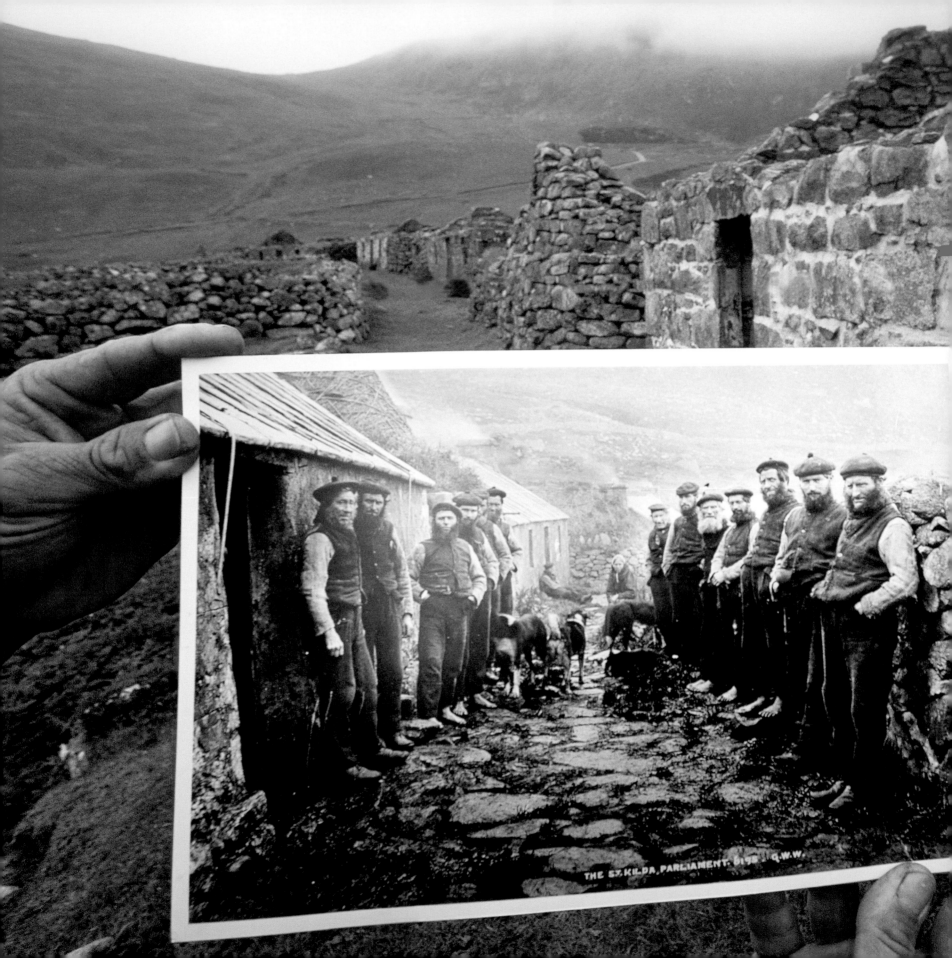

THE ST. KILDA, PARLIAMENT. 8195. G.W.W.

Frans Lanting, 1996. An old photograph shows the Fowlers of St. Kilda, home to Britain's largest puffin colony.

Vincent J. Musi, 2000. Gray clouds and Welsh slate seem to merge in this shot of Machynlleth, Wales.

THE
AGA SHOP

LEFT: PRITT VESILIND, 1988. A BONFIRE OF FISHING BOATS SENDS SPIRITS OF THE DEAD TO HEAVEN ON FINLAND'S SEURASAARI ISLAND.

FOLLOWING PAGES: SAM ABELL, 2004. HAMPTON COURT, GREATER LONDON, ENGLAND.

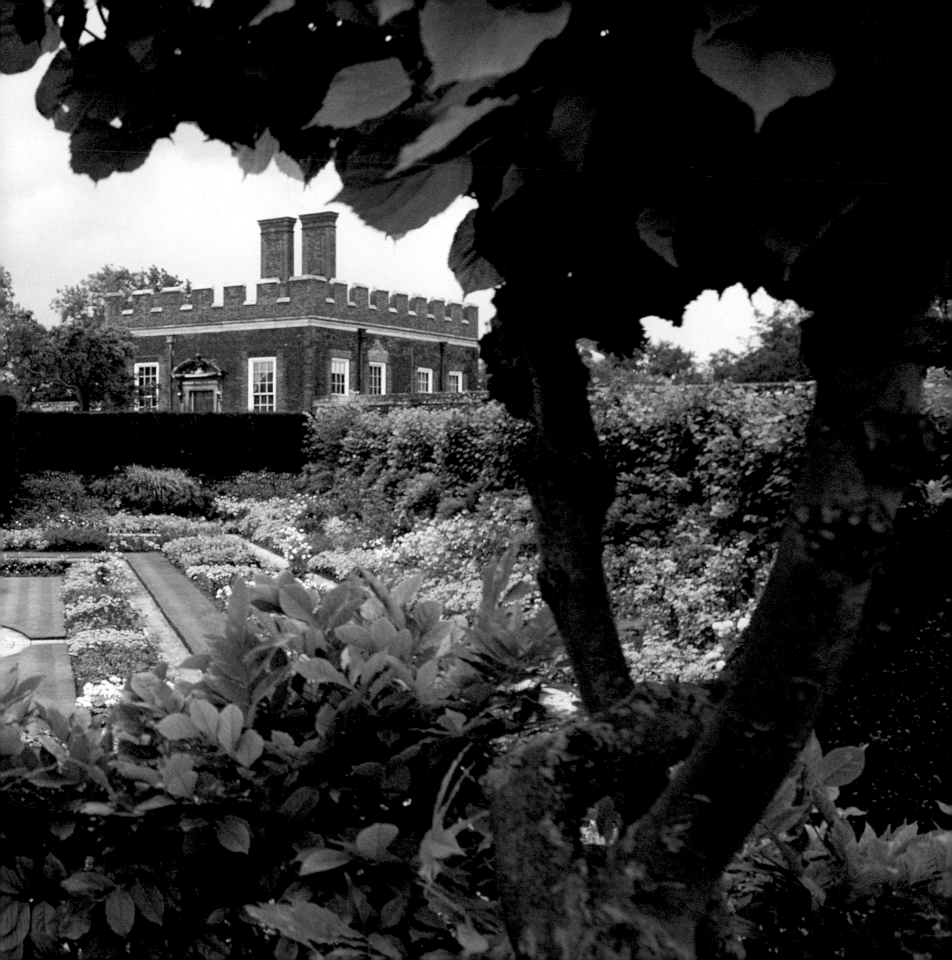

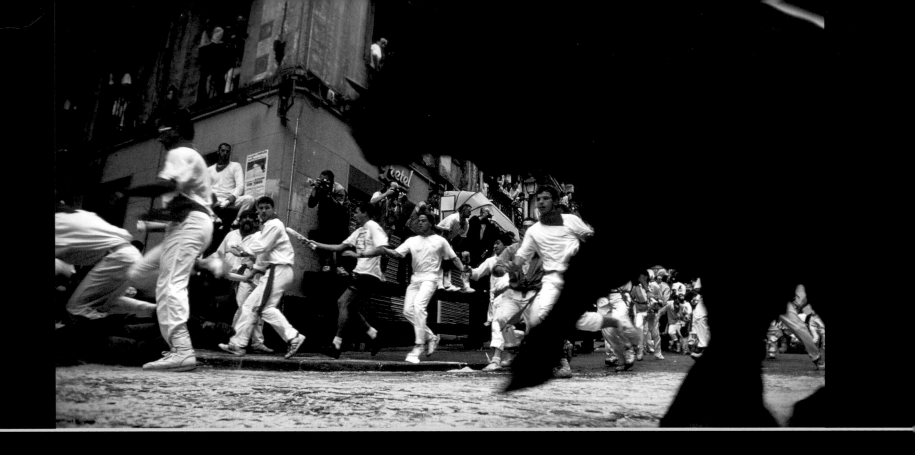
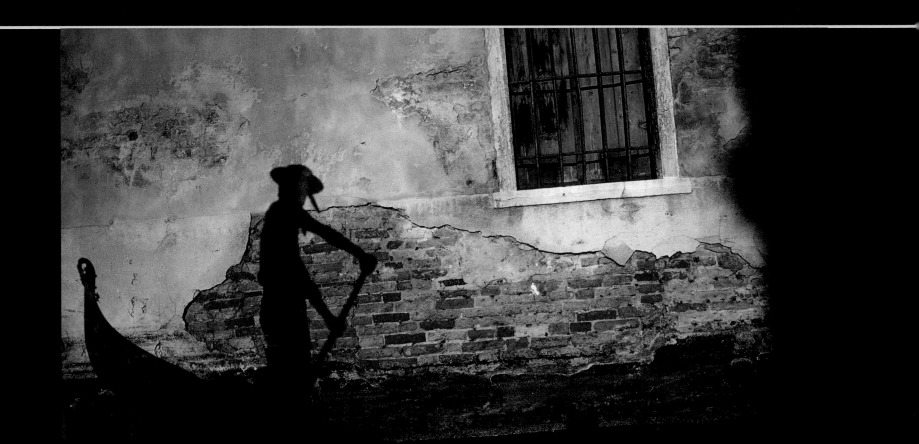

# 7 WESTERN & SOUTHERN EUROPE

PREVIOUS PAGE TOP: JOANNA B. PINNEO, 1994. RUNNING OF THE BULLS IN PAMPLONA: EUROPE'S HISTORY, BEAUTY, AND CULTURE ARE NOT JUST POSTCARD FODDER BUT FACTS OF EVERYDAY LIFE FOR EUROPEANS.

BOTTOM: WILLIAM ALBERT ALLARD, 2001. FOR A MOMENT, LIFE, HISTORY, AND ART CONVERGED IN ALLARD'S PICTURE OF A GONDOLIER'S SHADOW ON A WALL IN VENICE, ITALY.

# WESTERN AND SOUTHERN EUROPE

Even though there is snow on the ground outside my home in Maryland, I'm sitting with Claude Monet on a sunny terrace behind a cottage set amidst a panoply of greenery along the Canal du Nivernais in France. No matter that the impressionist master is long dead or that I'm separated from summer in France by an ocean, two seasons, and a slew of logistical and financial issues. Thanks to Anne Keiser's photograph of that ivy-covered cottage, I'm seated in a white, wrought-iron chair on a waterside terrace in the middle of a Monet painting.

Every time I look at her photo that ornate piece of garden furniture transfixes me. The chair is what French writer Roland Barthes, in his book *Camera Lucida,* called the "punctum" of a photograph, an element "which rises from the scene, shoots out of it like an arrow, and pierces me." The punctum is something we add to the photograph that is nonetheless already there.

The chair opens up an imaginary space, which I fill with my desire to be sitting there, enjoying the sunlight and the scenery of a summer day in France, occupying a place in a living artwork. This being Burgundy, I'm also imagining a delicious dinner accompanied by a bottle of Vosne-Romanée.

On a broader cultural level, Keiser's picture is a prime example of the experiential immediacy that is one of the great and enduring strengths of the photographs published in NATIONAL GEOGRAPHIC magazine. Looking at her picture, you feel as if you were simultaneously in the frame and standing beside her as it was taken. You are in and of that place.

This sense of being there begins with the photojournalistic way of seeing and its emphasis on highly descriptive pictures that tell a story. National Geographic has practiced that approach with varying degrees of success since the magazine was founded.

Over the past 30 years, photographers with refined, artistic sensibilities and highly personal visions have given the magazine's pictures far greater visual and socio-political presence, heightening that feeling of immediacy and, in some cases, producing photojournalism that ranks as art.

Making artful photographs of any place, let alone the French countryside with its exalted position in art history, is tricky. When a place is represented as a photograph, certain changes occur. The three-dimensional world loses one dimension and

the remaining two are radically diminished. Life's living colors are mimicked and frozen in chemical-soaked paper, for better or worse. A unique and immovable physical place is transformed into a likeness that can be reproduced exponentially in books, magazines, postcards, or on advertisements gracing the sides of beer trucks. All too easily, the place can be reduced to a commercial cliché.

Since Western and Southern Europe have been depicted in various media for centuries, clichés are hard to avoid. On a purely aesthetic level, perhaps, Keiser's photo of the cottage could be viewed as a cliché based on the cliché of the impressionistic landscape. A harsher critic might call it derivative, a superficial piece of eye candy devoid of socio-political significance and aimed at the same mass-market, bourgeois consciousness that has produced blockbuster Monet exhibitions and gift shops crammed with impressionist posters and tchotchkes in museums around the world.

To which I reply: welcome to France; now please get off my terrace.

Repetition has always been part of art. If we're going to dismiss photographs of a place simply because they show beauty or show it in ways that resemble paintings, then our culture is in deep trouble. As for socio-political content, all depictions of place conceal more than they reveal. No image truly re-creates reality. There may, in fact, be a cement factory hidden behind the trees in Keiser's picture, although I doubt it. But by seeing and photographing the beauty that is undeniably there, Keiser and the other photographers in this chapter reveal some basic truths about Western and Southern Europe: it is the mother lode of Western culture; its past is inextricably and visibly part of its present and future and it is often picturesque.

If you live in Europe, its history, beauty and culture are not just postcard fodder but facts of everyday life. Each July, the bulls rumble through the the streets of Pamplona. When the canals freeze in the Netherlands, large numbers of Dutch people go skating. Each day, thousands of people scarcely glance at the Roman aqueduct in Segovia or the Place des Vosges in Paris as they hurry past.

Yet even the most jaded European will admit there are moments when life becomes art. In James L. Stanfield's photo of Segovia, the light of a drizzly evening turns dull pavements into reflecting pools that fill the viaduct's ancient arches with slices of life glowing in gold, yellow, green, and blue hues. History becomes a mottled stone matrix supporting the present. But old

stones don't make a place special or a picture of it art. It is their physical and cultural context—the light, the air, the life going on around them—and the abilities of the person trying to capture that atmosphere—that provides those distinctions.

The trick is seeing that atmosphere. Seeing is the common denominator of art and photography. The Place des Vosges has been depicted countless times for the obvious reason that's it is a beautiful, lively place. But William Albert Allard's photograph of it isn't a cliché. From the shade of the trees, he turns the park into a long, receding strip of silhouettes, vignettes, and urban brightness in a composition reminiscent of Georges Seurat's "Sunday Afternoon on the Island of La Grande Jatte." Whether Allard consciously played to that resemblance doesn't matter. His picture is nonetheless original and arresting.

George Steinmetz's photograph of a contemporary fashion billboard in Milan might appear to bear little connection to high culture or history. It is just a slick sign, an advertisement, all image and attitude created to sell products. By photographing it at dusk from a distance, however, Steinmetz alters the message. The tram catenaries slash the image even as they suggest connections, tension, and electricity, all characteristics of life in Milan. Thus the commercial sign serves, like the motifs of patron saints or classical gods that Renaissance cartographers put on their intricate and exacting city maps, to tell us something about the socio-political topography of the place. Art mirrors life mirrors art. That's not new. But it's so.

From the topography of my French terrace, I'm disconnecting from the socio-political grid. For the moment, all I care about is enjoying the living picture where my punctum is parked. As Monet once said, "People discuss my art and pretend to understand as if it were necessary to understand, when it's simply necessary to love."

Thanks, Claude. More burgundy?

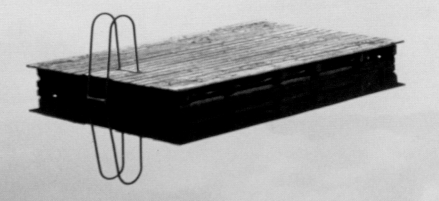

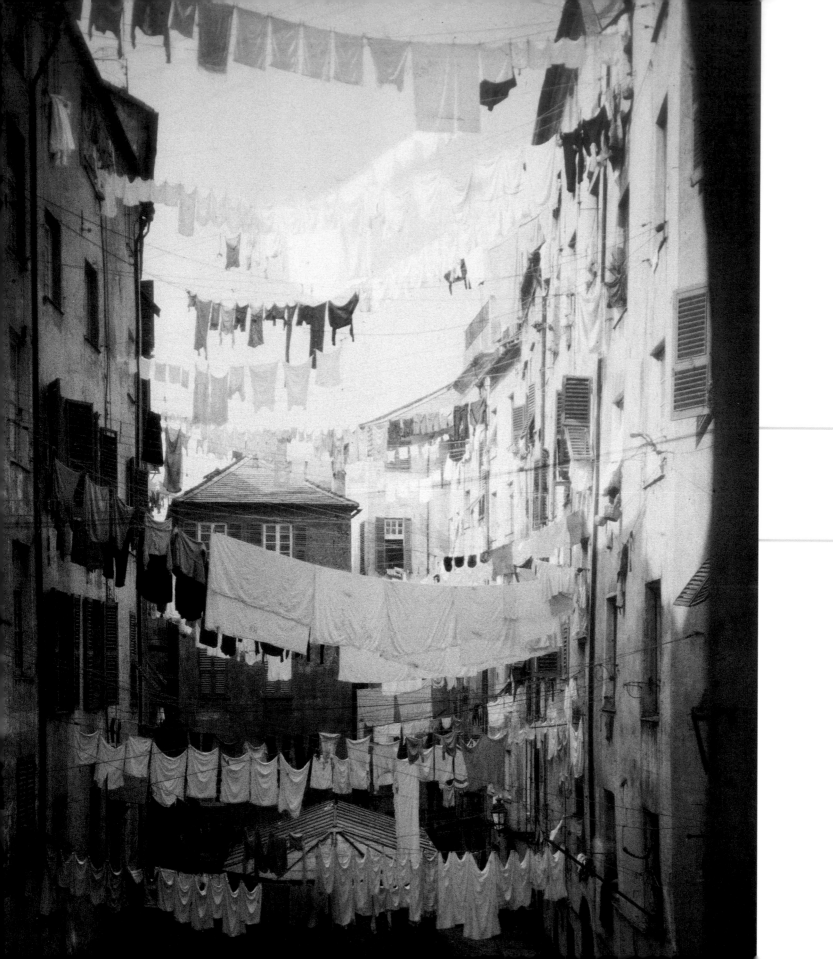

PREVIOUS PAGES: JODI COBB, 2004. A SWIMMING DOCK APPEARS TO HOVER IN MID-AIR ON LAKE THUN, SWITZERLAND.

LEFT: HANS HILDENBRAND, 1928. LAUNDRY DRIES ABOVE A STREET IN GENOA, ITALY.

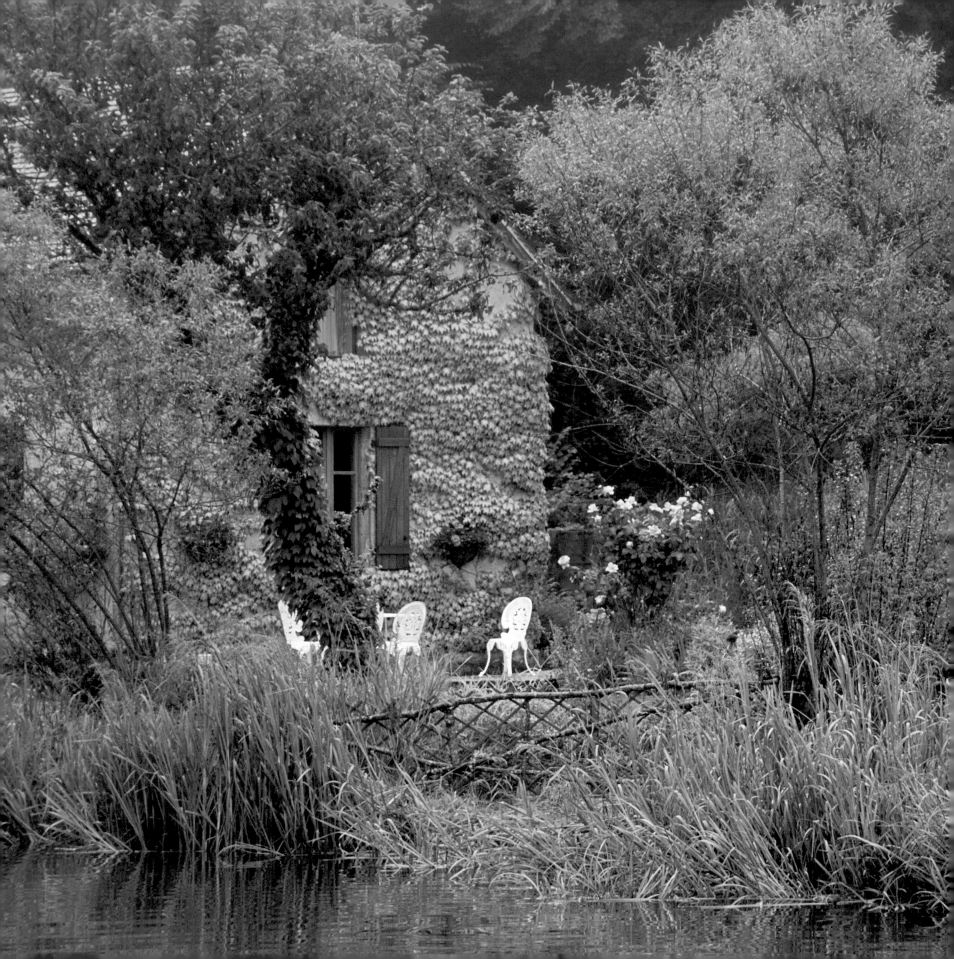

Anne Keiser, 2001. A cottage along France's Canal du Nivernais. "People discuss my art and pretend to understand as if it were necessary to understand, when it's simply necessary to love," said Claude Monet.

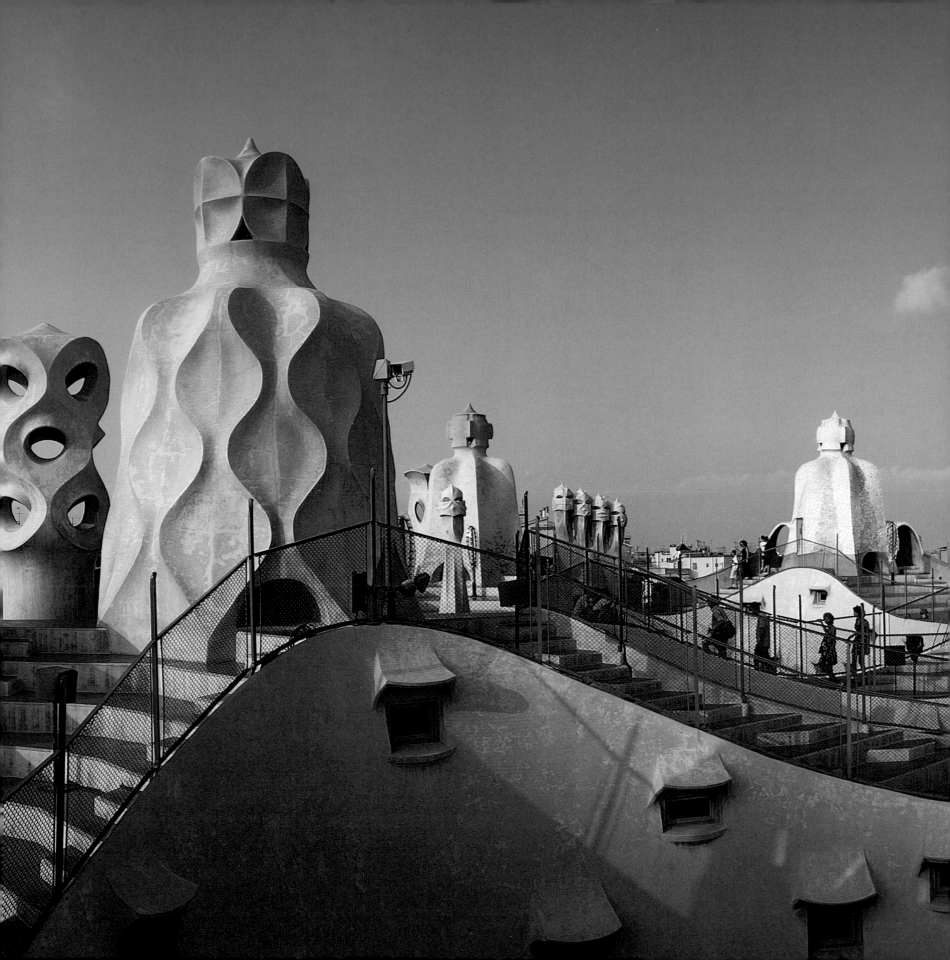

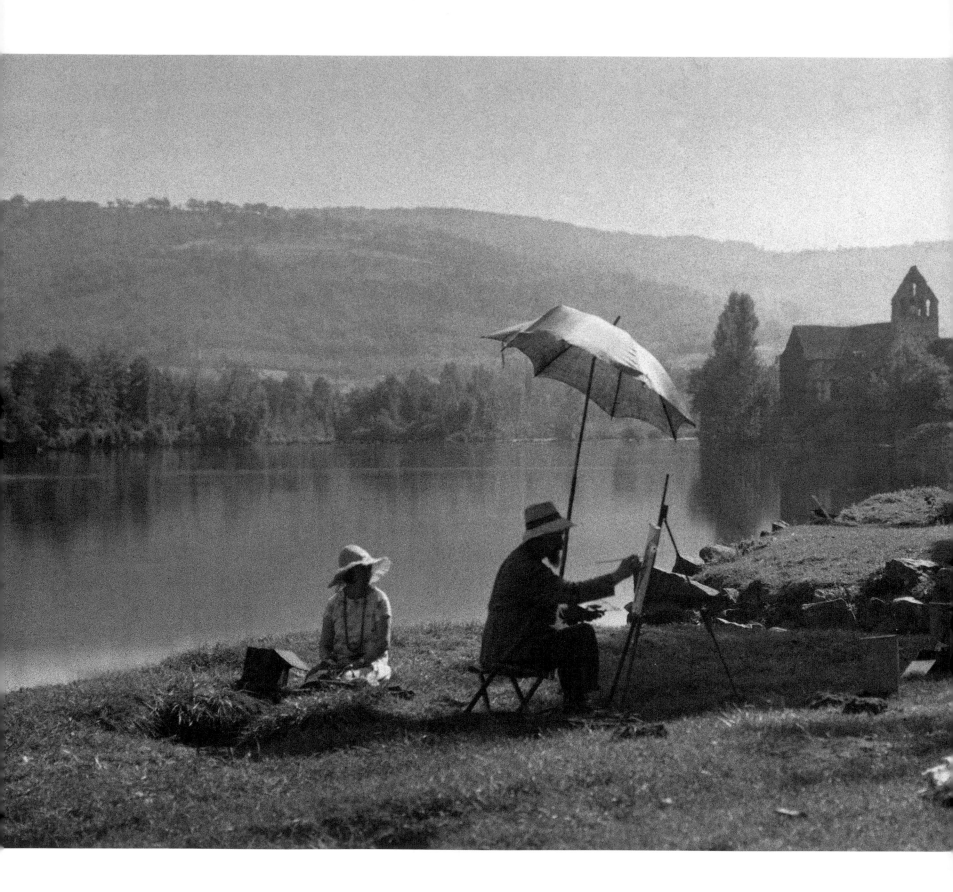

PREVIOUS PAGES: MARK SEGAL, 1999. CASA MILA, BARCELONA, SPAIN.

LEFT: GERVAIS COURTELLEMONT, CIRCA 1925. FRANCE.

285

WILLIAM ALBERT ALLARD, 2003. PEOPLE RELAX ON PARK BENCHES IN THE PLACE DES VOSGES. SEEN FROM THE SHADE OF THE TREES, THE PARK BECOMES A LONG, RECEDING STRIP OF SILHOUETTES AND SUN-SPLASHED VIGNETTES IN A COMPOSITION REMINISCENT OF GEORGES SEURAT'S "SUNDAY AFTERNOON ON THE ISLAND OF LA GRANDE JATTE."

HISTORY, BEAUTY, AND CULTURE ARE

# FACTS OF EVERYDAY LIFE IN EUROPE. ❧

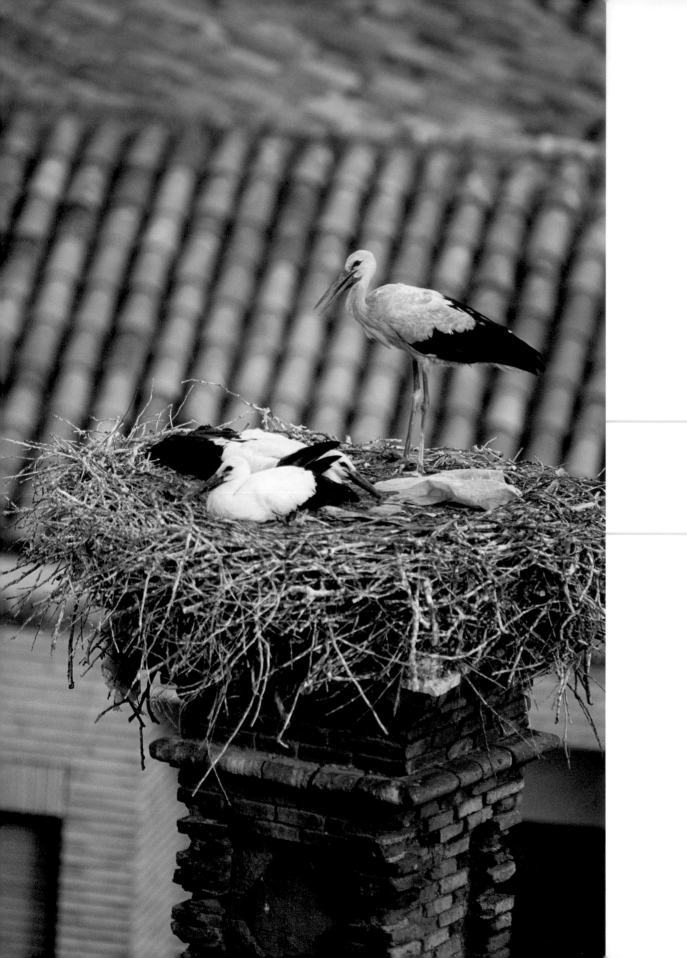

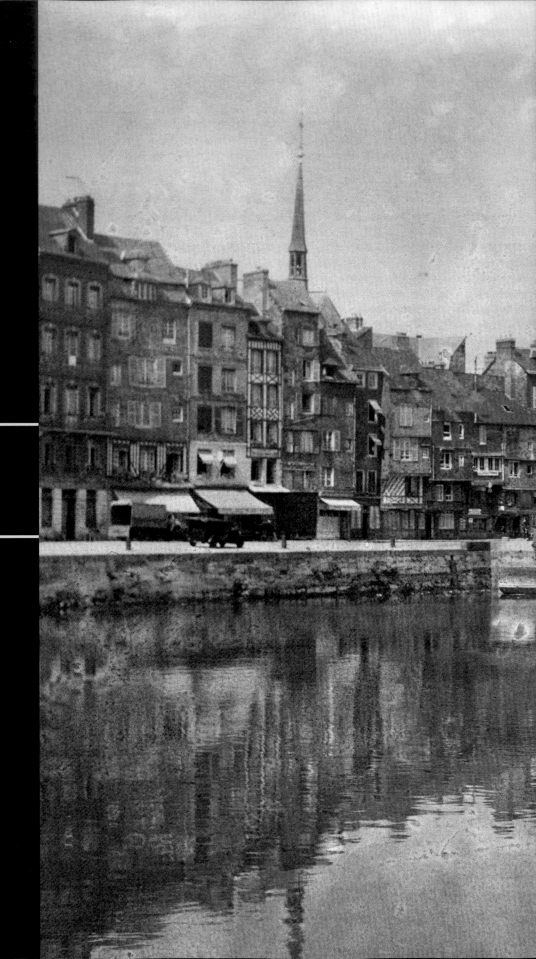

W. Robert Moore, 1936. Old boats are left to rot in the harbor of Honfleur, in Normandy, France.

CHARLES O'REAR, 1989. FITTING NICELY INTO THE BUILDING'S PAINTED FLORAL FAÇADE, A WOMAN GAZES FROM A WINDOW IN LISBON, PORTUGAL.

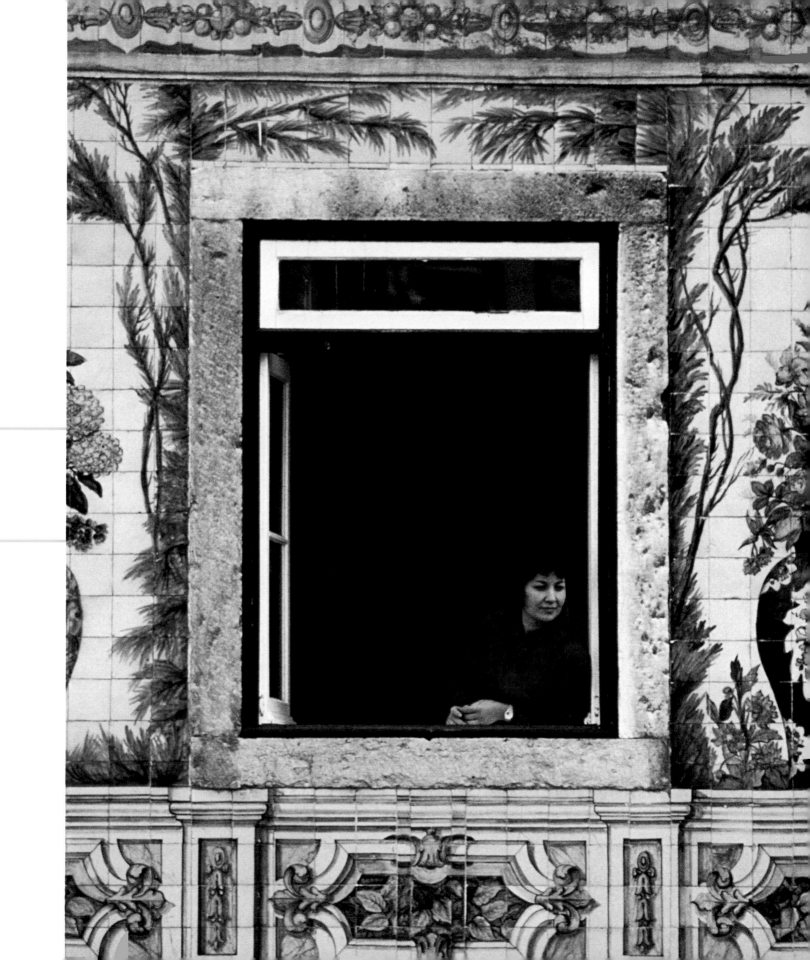

PREVIOUS PAGES: SISSE BRIMBERG, 2001. DUTCH FLOWER POWER: A MAN AMIDST SIX MILLION TULIPS AT KEUKENHOF, THE NETHERLANDS.

RIGHT: JODI COBB, 2001. VIEW OF SWITZERLAND'S BERNESE ALPS.

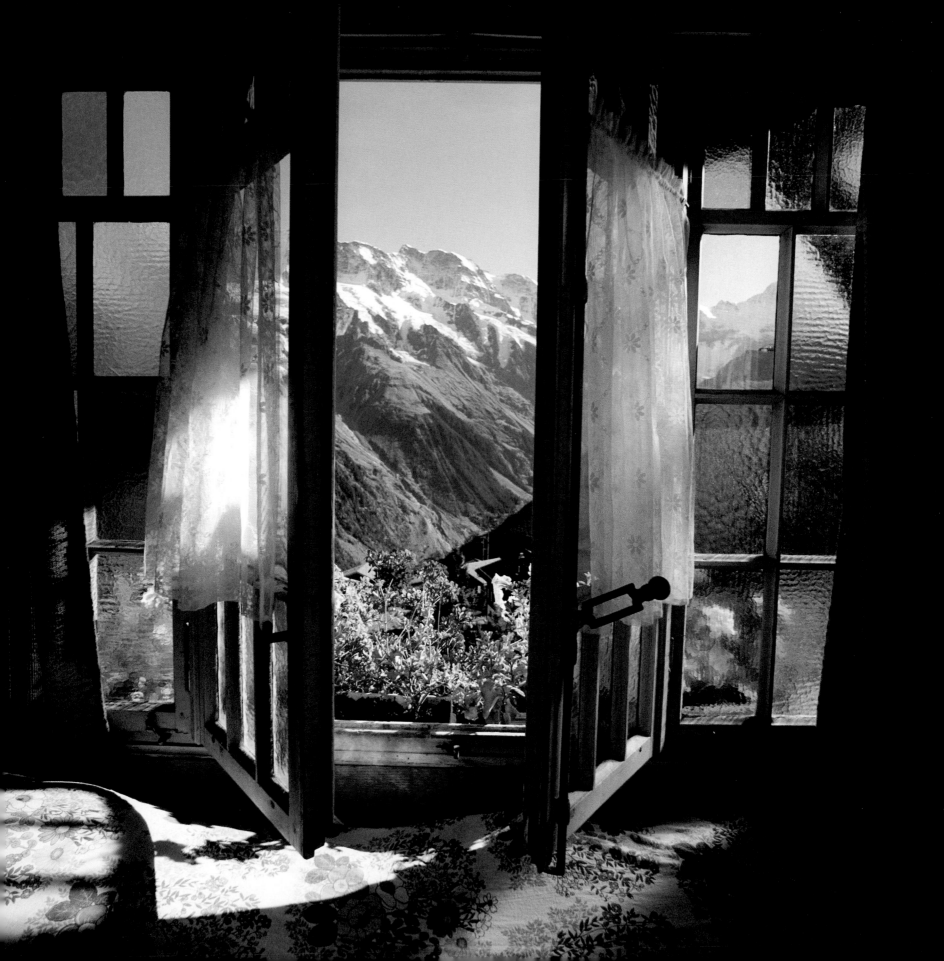

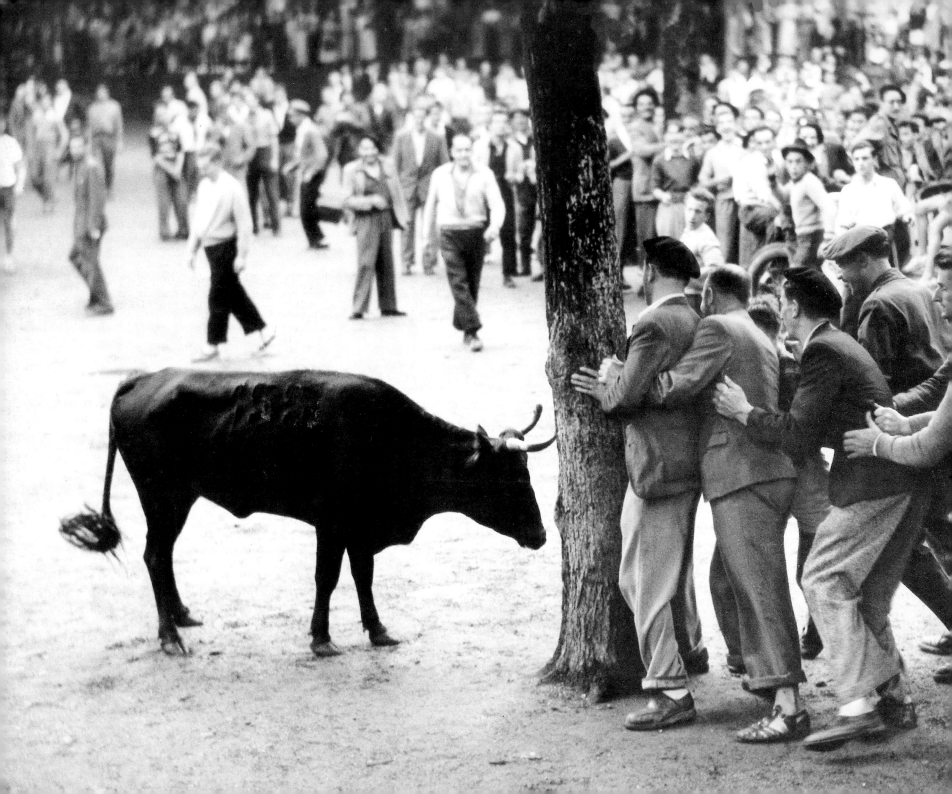

JUSTIN LOCKE, 1956. BASQUE FESTIVAL IN BAYONNE, PYRÉNÉES-ATLANTIQUES DEPARTMENT, AQUITAINE REGION, FRANCE.

299

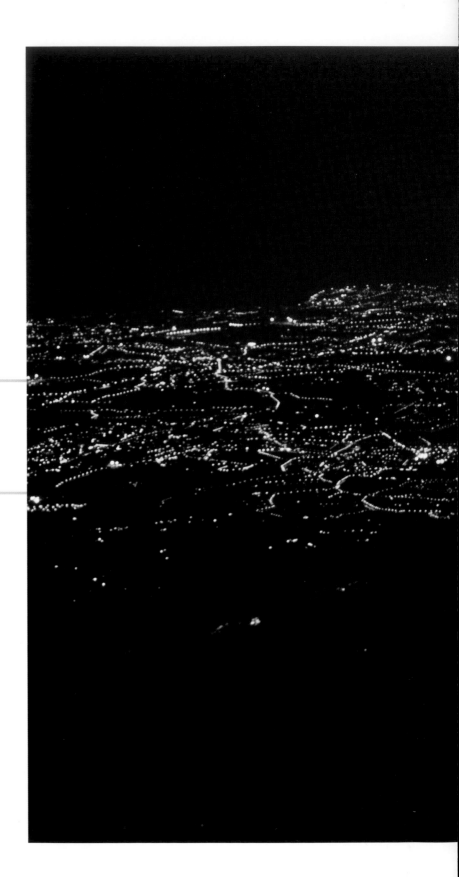

300 CARSTEN PETER, 2002. LIGHTS OF CATANIA BENEATH AN ERUPTING PIANO DEL LAGO, MOUNT ETNA, SICILY, ITALY.

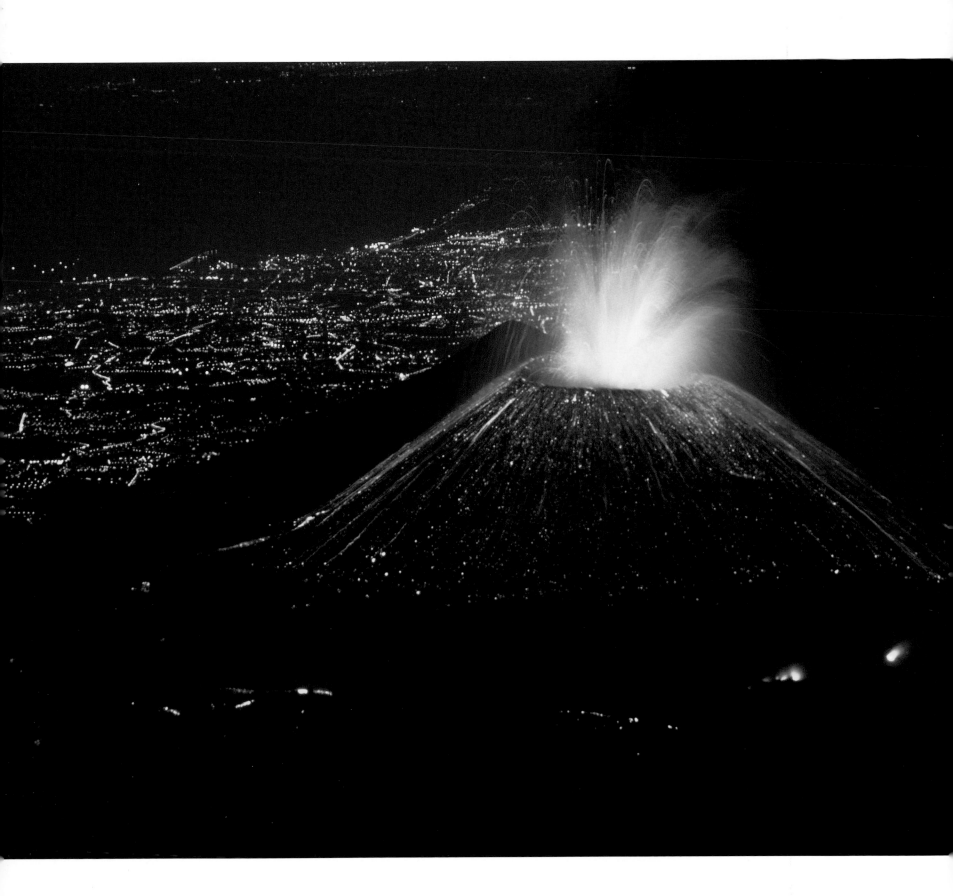

George Steinmetz, 1992. A Billboard towers over a street in the trendy Brera district of Milan, Italy.

303

BOB KRIST, 1999. THE LIGHT OF A TUSCAN AFTERNOON TURNS A COUNTRY ROAD INTO A MAGIC CARPET WOVEN OF GOLD AND SHADOWS.

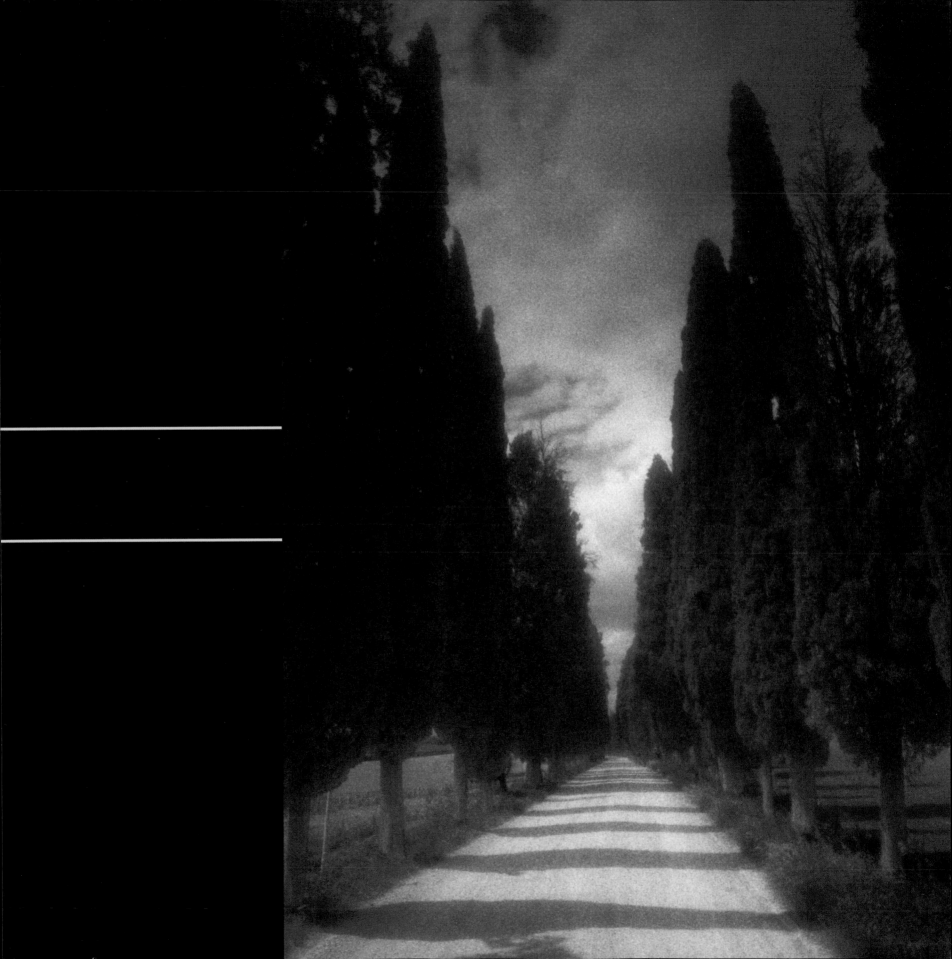

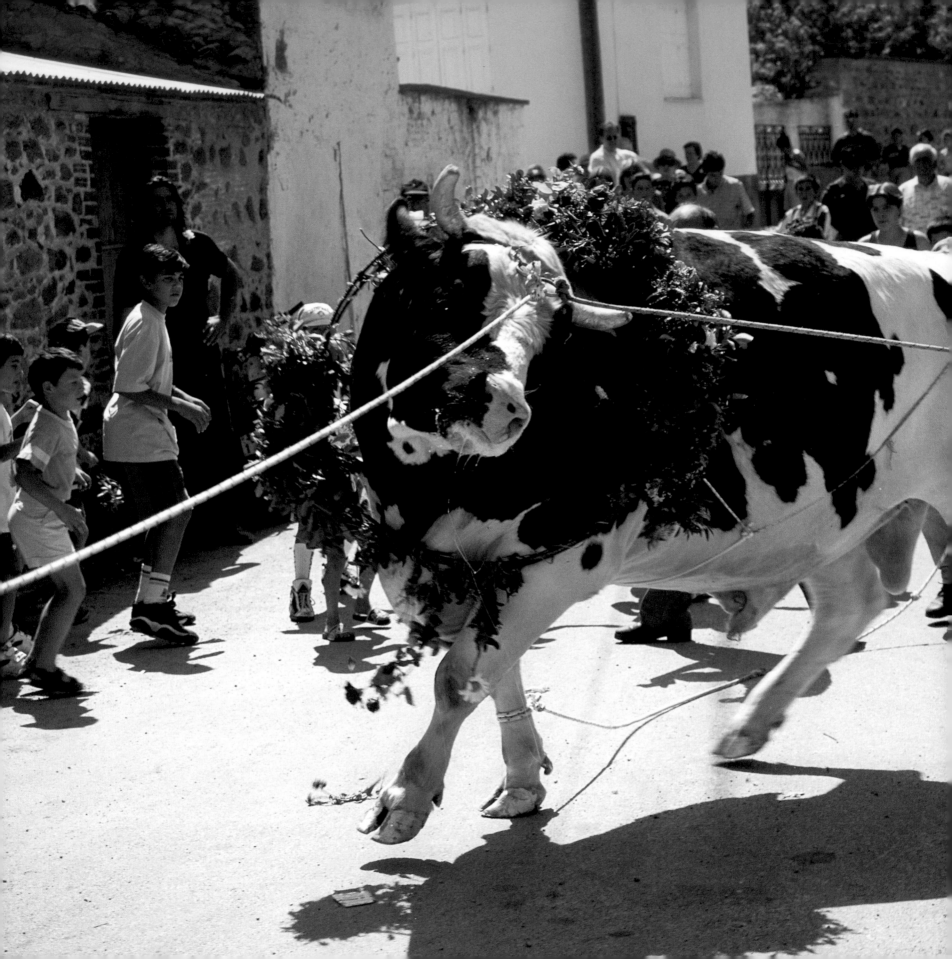

LEFT: JAMES L. STANFIELD, 2000. A GARLANDED BULL, AGIA PARASKEVI, LESBOS, GREECE.

FOLLOWING PAGES: JOANNA B. PINNEO, 1995. BASQUE SHEPHERD'S COTTAGE.

*307*

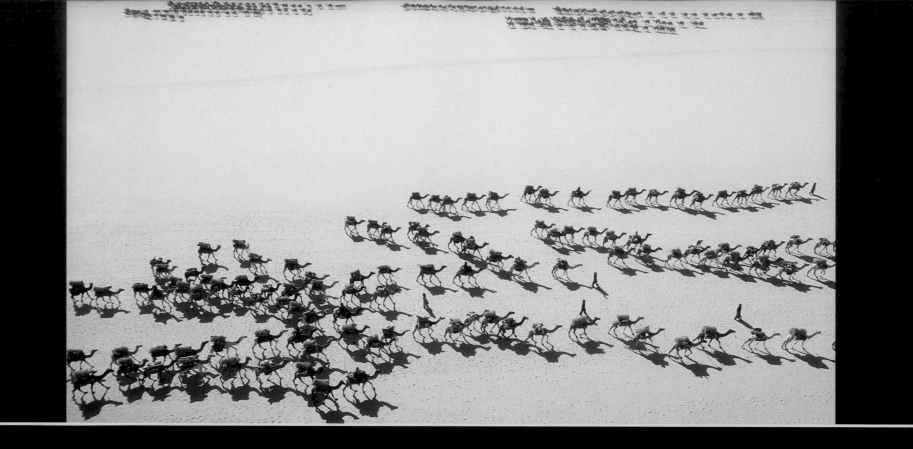

# 8 NORTH AFRICA

PREVIOUS PAGE TOP: GEORGE STEINMETZ, 1999. CAMEL TRAINS IN SAHARAN NIGER FOLLOW ANCIENT TRADE ROUTES THAT ARE CENTRAL ARTERIES OF THE DESERT NOMADS' WAY OF LIFE.

BOTTOM: RICHARD NOWITZ, 1998. AN ALABASTER FACTORY IN LUXOR, EGYPT, WHICH SELLS CARVED VASES AND ORNAMENTS.

# NORTH AFRICA

In North Africa, most of the landscape isn't obscured beneath layers of human activity or perception. The earth's surface is naked and plainly visible, covering millions of square miles, impervious to delineation, impregnable in its raw physical power. The Sahara Desert dominates the northern third of the African continent. The Sahara's size, climate, and geological conditions make it an extraordinarily difficult place for human beings to survive, let alone take photographs. It is the world's largest desert, stretching eastward from the Atlantic Ocean to the Red Sea, spreading across an area roughly the size of the United States. Average annual rainfall is about three inches. Daytime temperatures can reach 130°F. Nights are chilly. Depending on the season, darkness can bring frost. The land consists mainly of various forms and hues of sand, gravel, rock, and minerals arrayed in topography from flat to mountainous. Vast and empty are the adjectives most commonly used to describe the place.

Those qualities clearly affected how National Geographic's photographers approached North Africa. Responding to the unusual demands of the place, they relied more heavily than usual on putting people in their pictures. Almost every picture in this chapter features human beings in a prominent role. In images from towns and cities in Egypt, Niger, Morocco, and Sudan, people are shown because they are central to the life, look, and feel of the place, just as they are in urban areas the world over. Although photographs such as Kenneth Garrett's shot of merchants swirling through a marketplace in Saqqâra, Egypt, are colorful and unique, they fall well within Western pictorial traditions.

Not so the desert shots. The Sahara's immense, open space, straight-edge horizons, and expanses of terrain barely modulated in terms of color or form are not the stuff of Western landscape conventions. Pictorially, the desert landscape is more akin to American postwar abstract art, particularly the color-field paintings by artists such as Mark Rothko, than to traditional landscape pictures by the likes of Jacob van Ruisdael or Claude Lorrain.

Faced with the Sahara, the photographers quite understandably included people, as well as camels, to give a sense of the ancient cultures that live in the desert's harsh light and arid heat. But they present their human and animal subjects in ways that address the desert's size and scale, while nudging its abstract visual appearance a bit closer to the mainstream

of photojournalistic and fine-art landscape photography, genres descended from European landscape painting. This was done partly by substituting aerial shots or low angles for the elevated perspective typical of more traditional landscape pictures and by shooting pictures in the morning and the evening when the angled sunlight softens the desert's shapes and ignites its colors.

The result is a hybrid photographic form dictated by the desert, a vigorous blend of art, photojournalism, documentation, and mystery. The desert's other-worldly power and beauty radiate from these pictures. Of all places on Earth, the Sahara most closely resembles what we have seen, courtesy of space exploration, of the surface of other planets in our solar system. From the air, caravans look like clusters of ants traversing the Martian wastes.

What doesn't appear in these photographs tells much about the place. There is no water, another staple of Western landscapes. Only the Nile and Niger Rivers cross the Sahara. They support most of the desert's human population. The paucity of water creates a mesmerizing dramatic tension. Consciously or subconsciously, one's eyes search for water. This tension was expressed by Antoine de St. Exupéry, the French writer, pilot, and adventurer who wrote in *Wind, Sand and Stars,* his 1939 book about the Sahara: "What makes the desert beautiful is that somewhere it hides a well."

Water isn't the only notable absence. Nowhere in this chapter does one see the familiar web of lines—electricity, telephone, cable TV, streets, and rails—that are a fact of life almost everywhere else in the world, lines transmitting and transporting people, goods, communications, money, and power of every ilk.

Such lines exist in the Sahara, of course. But they are invisible to outsiders. In George Steinmetz's photograph, caravans going to and from the town of Bilma in Saharan Niger move across a featureless plain of sand. As viewers, we assume the men and camels know where they are going, that they are following some ancient route with landmarks and coordinates. Otherwise, given the unforgiving, disorienting nature of the place, they are walking to their deaths.

More than people and beasts bearing goods travel those routes. They are the arteries that have borne the culture, history, and way of life of the desert's nomadic inhabitants for centuries. Like the desert in which they dwell, the nomads seem well-positioned to resist the encroaching forces of global culture. They are the embodiment of living off the grid and in harmony with nature.

What would the desert-dwellers think of these pictures of their homes and homeland? I don't know, but I suspect not much. The majority of them are Muslims, and Islam places little value on pictorial images that do not relate directly to the faith. Their aesthetic sense is expressed primarily in textiles, such as rugs, blankets, and garments. Hanging a picture on a tent wall poses a problem, as does the need to transport such a nonessential item. And who needs pictures when you can step out of your tent into one of the most compelling landscapes on Earth?

The desert's size and beauty make mankind's wonders look small. Gervais Courtellemont photographed the Pyramids of Giza in low-light conditions from a distance, diminishing them. There is a pond in the foreground of his picture, and the tip of one pyramid is reflected in it. The graceful curve of the bank and the dark, vertical lines of the palm trunks form a geometric counterpoint to the pyramids. Instead of monumental tombs, the pharaohs' pyramids could be tidy piles of gravel at some quarry. Courtellemont reminds us that people live among such wonders and that mankind's greatest structures are insignificant seen against the vastness of the sky and the universe.

Antoine de St. Exupéry felt something similar one night in the Sahara: "When I opened my eyes I saw nothing but the pool of nocturnal sky, for I was lying on my back with outstretched arms, face to face with that hatchery of stars. Only half awake, still unaware that those depths were sky, having no roof between those depths and me, no branches to screen them, no root to cling to, I was seized with vertigo and felt myself as if flung forth and plunging downward like a diver."

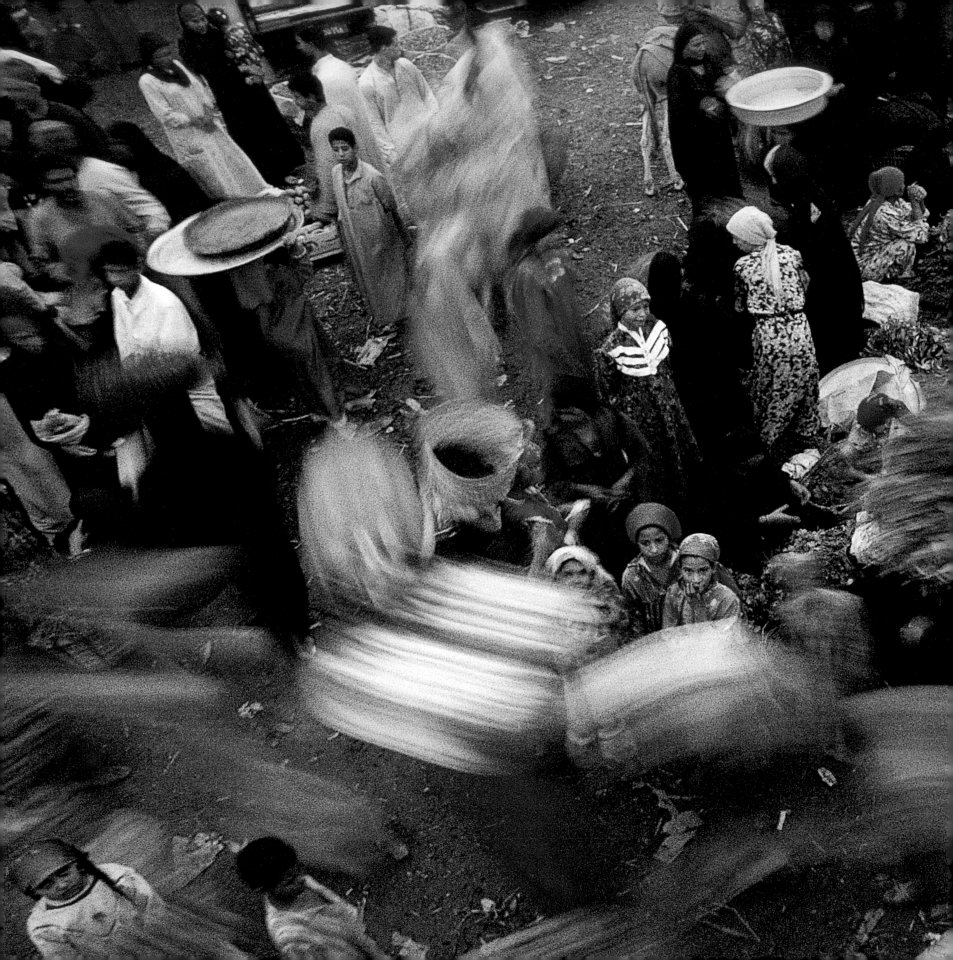

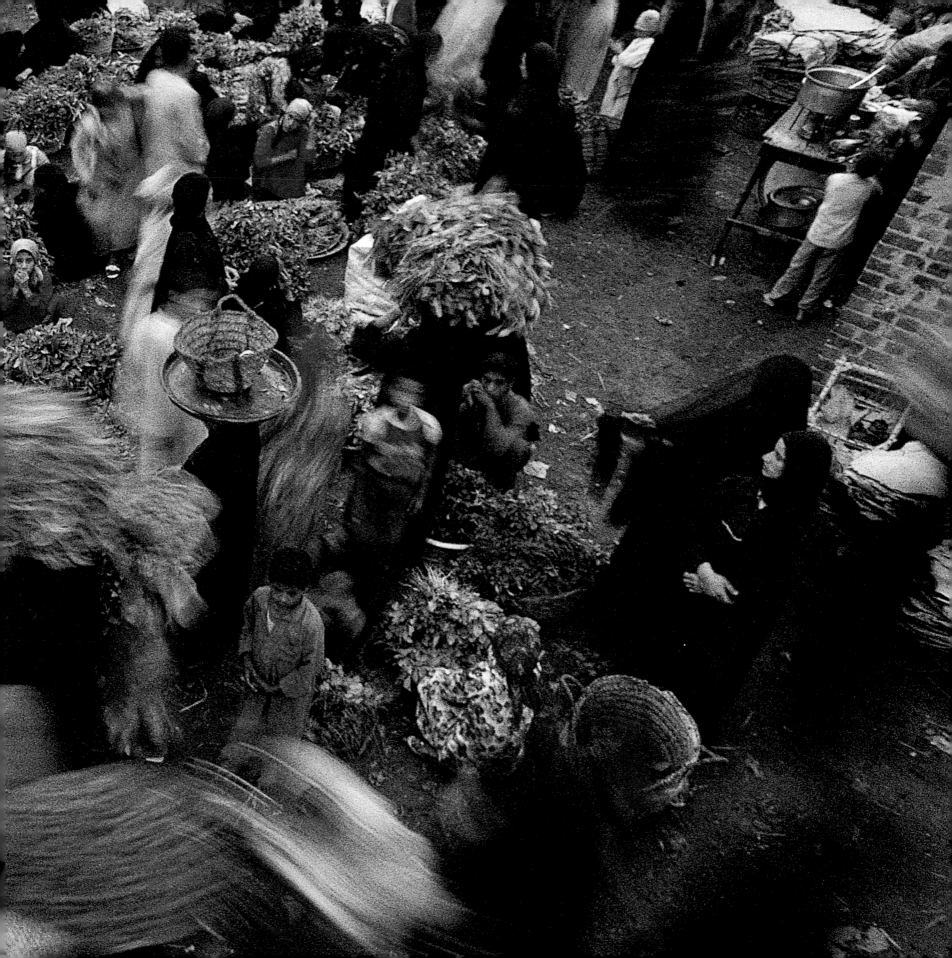

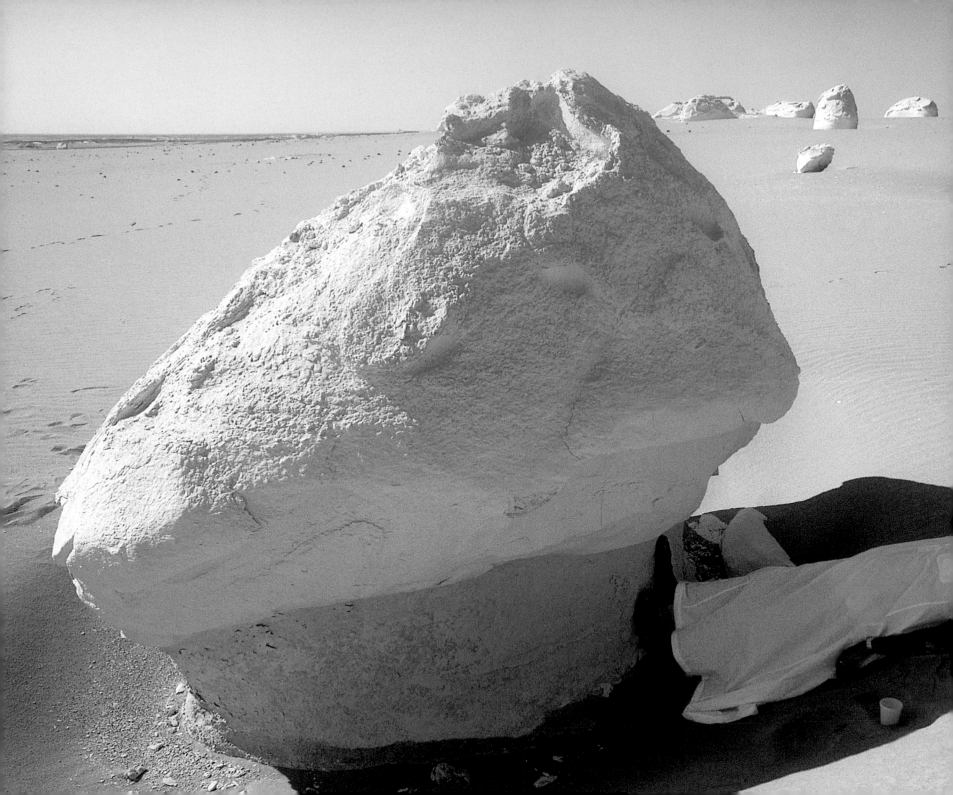

*319*

320    BRUNO BARBEY, 1996. VISITORS PERFORM ABLUTIONS AT A COURTYARD FOUNTAIN IN FEZ, MOROCCO.

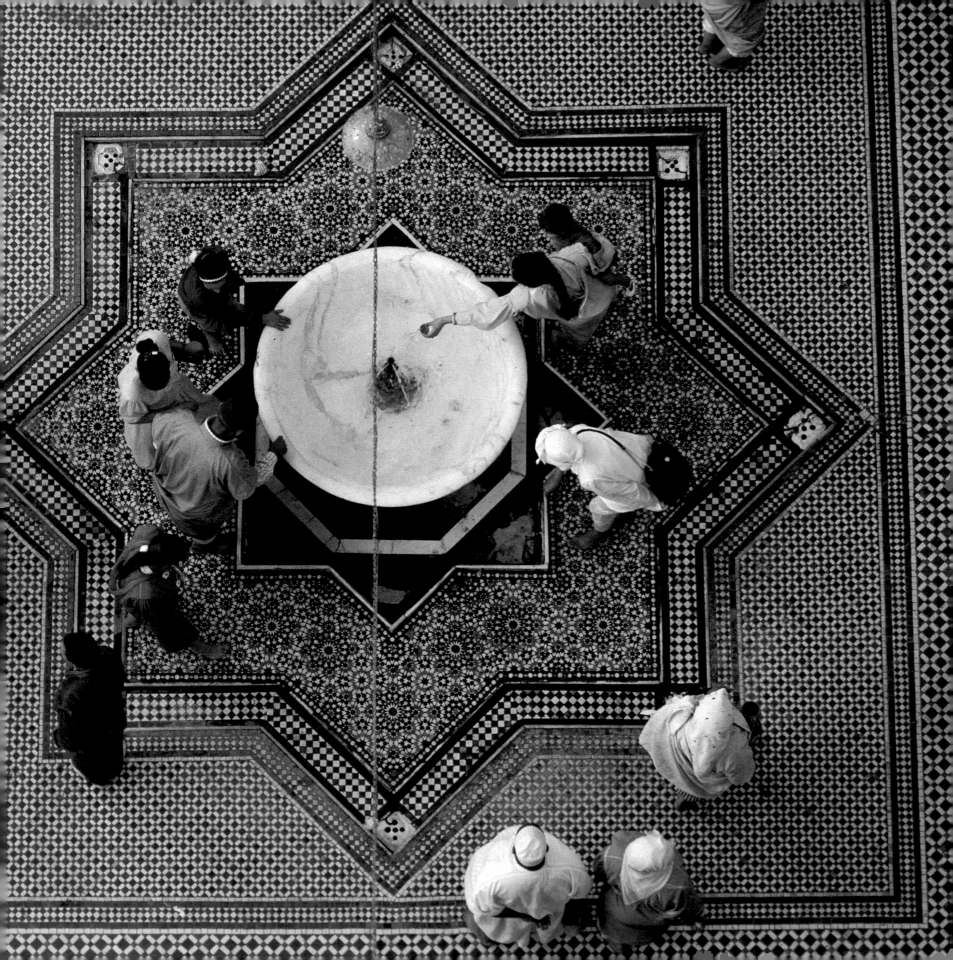

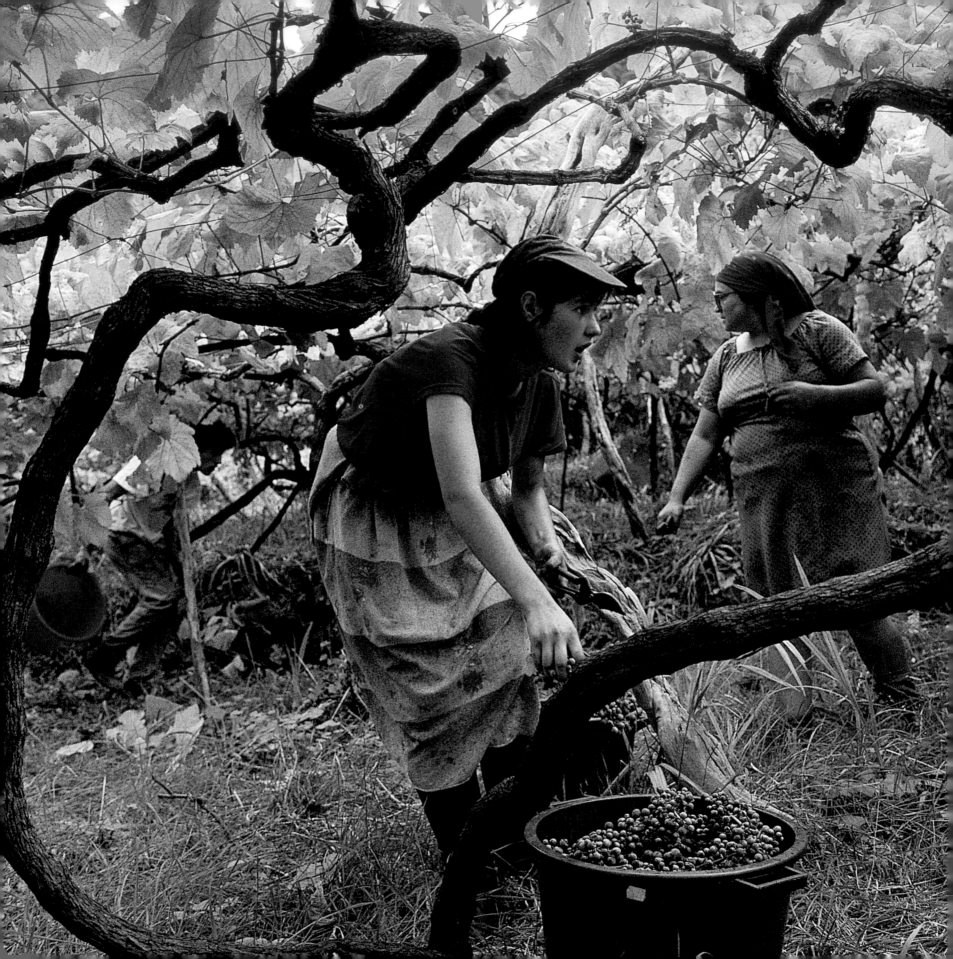

LEFT: MEDFORD TAYLOR, 1993. GRAPE-PICKERS ON MADEIRA, FAMED FOR ITS WINES.

FOLLOWING PAGES: GEORGE STEINMETZ, 2001. EVAPORATION PONDS FOR SALT PRODUCTION IN TEGUIDDA-N-TESSOUMT, NIGER.

323

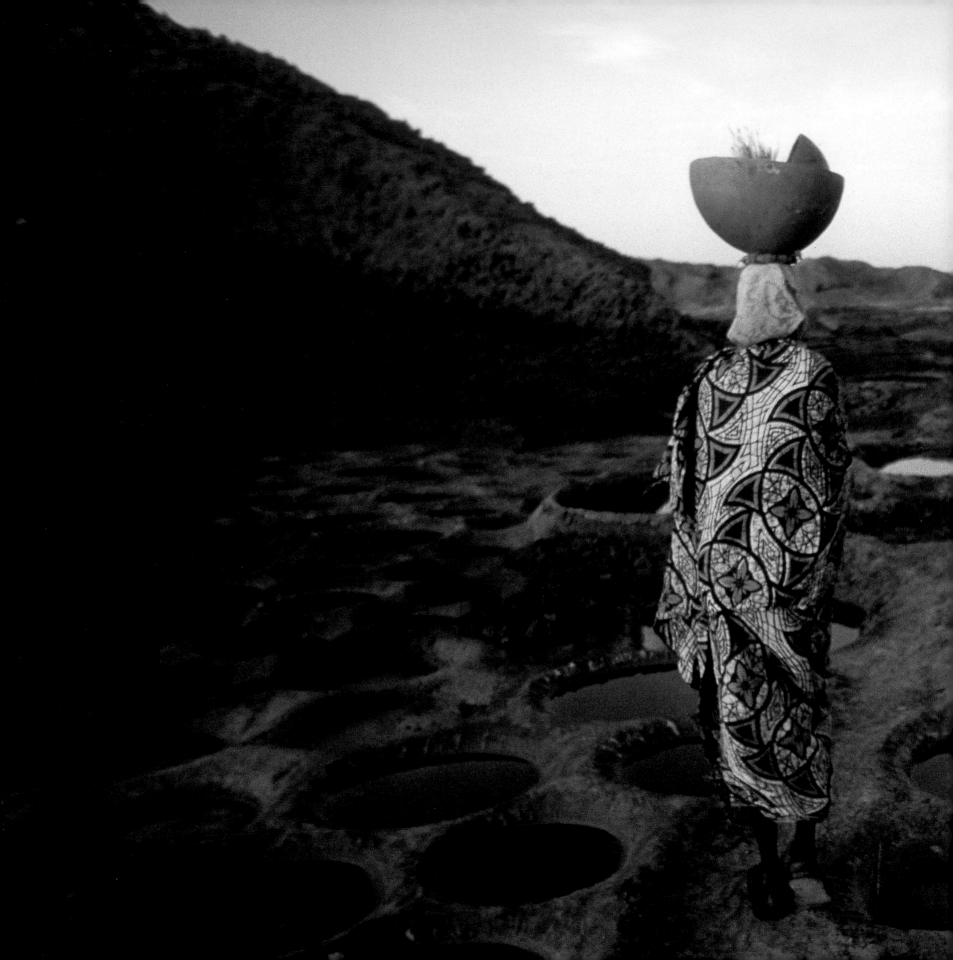

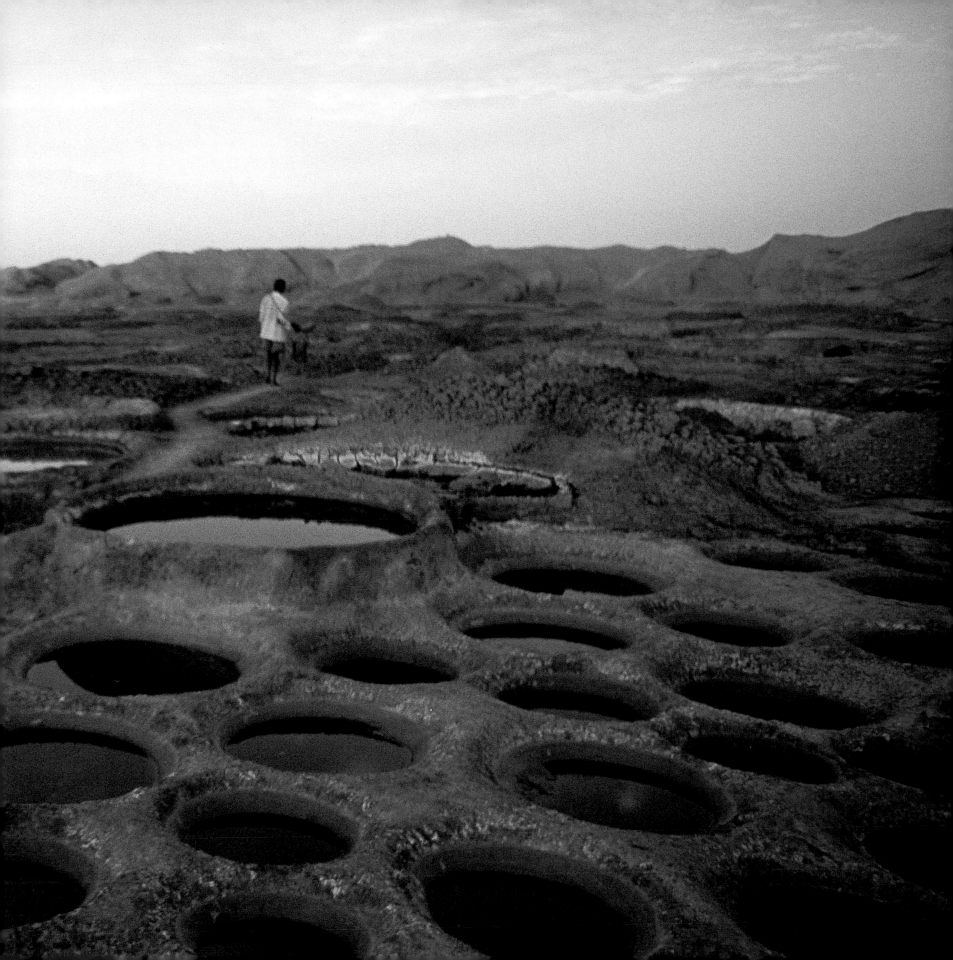

KENNETH GARRETT, 1993. A MAN LEADS HIS HEAVILY LADEN PACK ANIMAL DOWN A ROAD IN SAQQÂRA, EGYPT.

WHAT MAKES THE DESERT BEAUTIFUL

IS THAT SOMEWHERE IT HIDES A WELL. ❧

GEORGE STEINMETZ, 1997. CAMEL-BORNE TRAVELERS ARE GUIDED ACROSS THE MAURITANIAN DESERT ALONG OLD CARAVAN ROUTES. THE SAHARA'S EXOTIC BEAUTY AND HARSH CLIMATE HAVE LONG BEEN A LURE FOR ADVENTURERS. CAMELS REMAIN ONE OF THE MOST RELIABLE FORMS OF DESERT TRANSPORTATION.

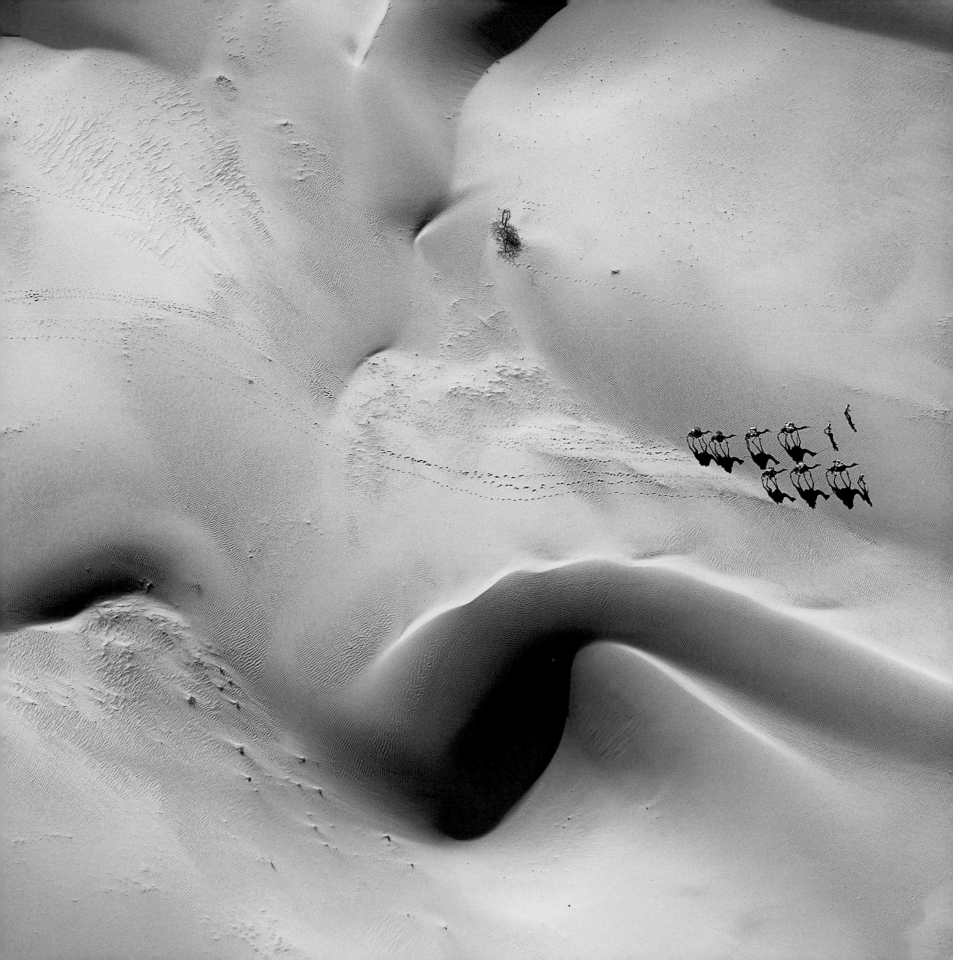

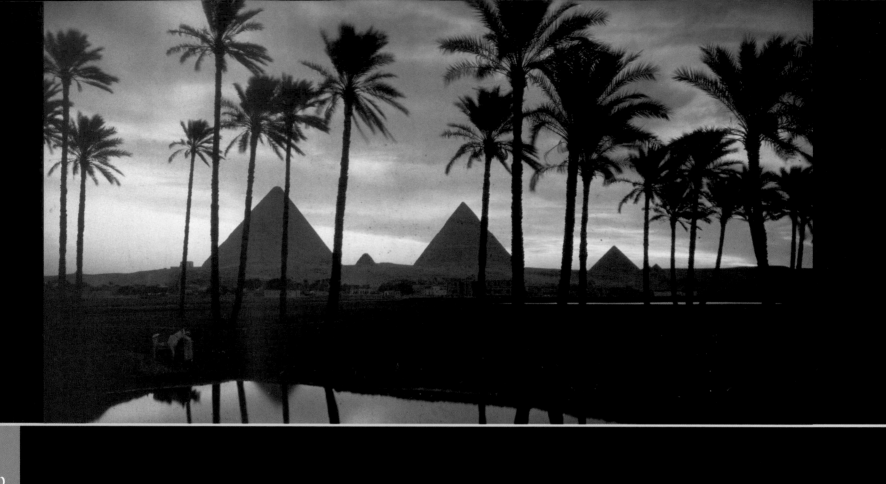

330

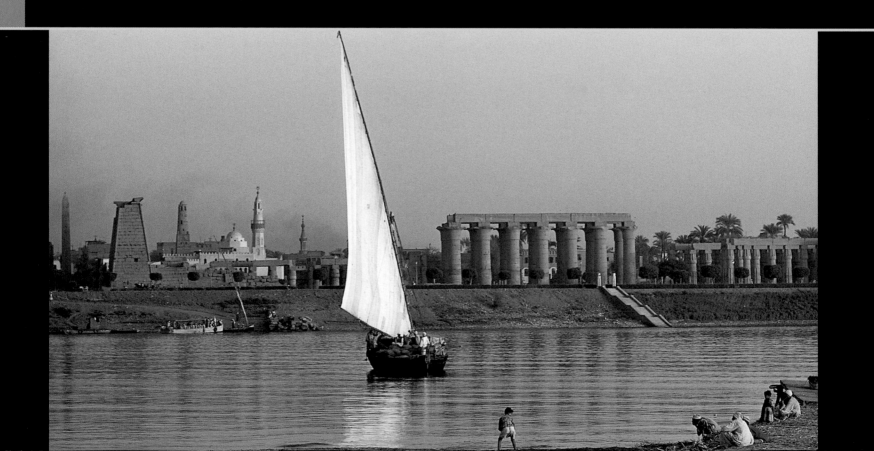

TOP: GERVAIS COURTELLEMONT, 1926. VISUAL POETRY: AN AUTOCHROME OF THE PYRAMIDS OF GIZA REFLECTED IN WATER.

BOTTOM: UNKNOWN PHOTOGRAPHER, UNKNOWN DATE. TEMPLE OF LUXOR, EGYPT.

CARSTEN PETER, 2004. A TUAREG TRIBESMAN LEADS HIS
CAMELS THROUGH THE SAHARA DESERT.

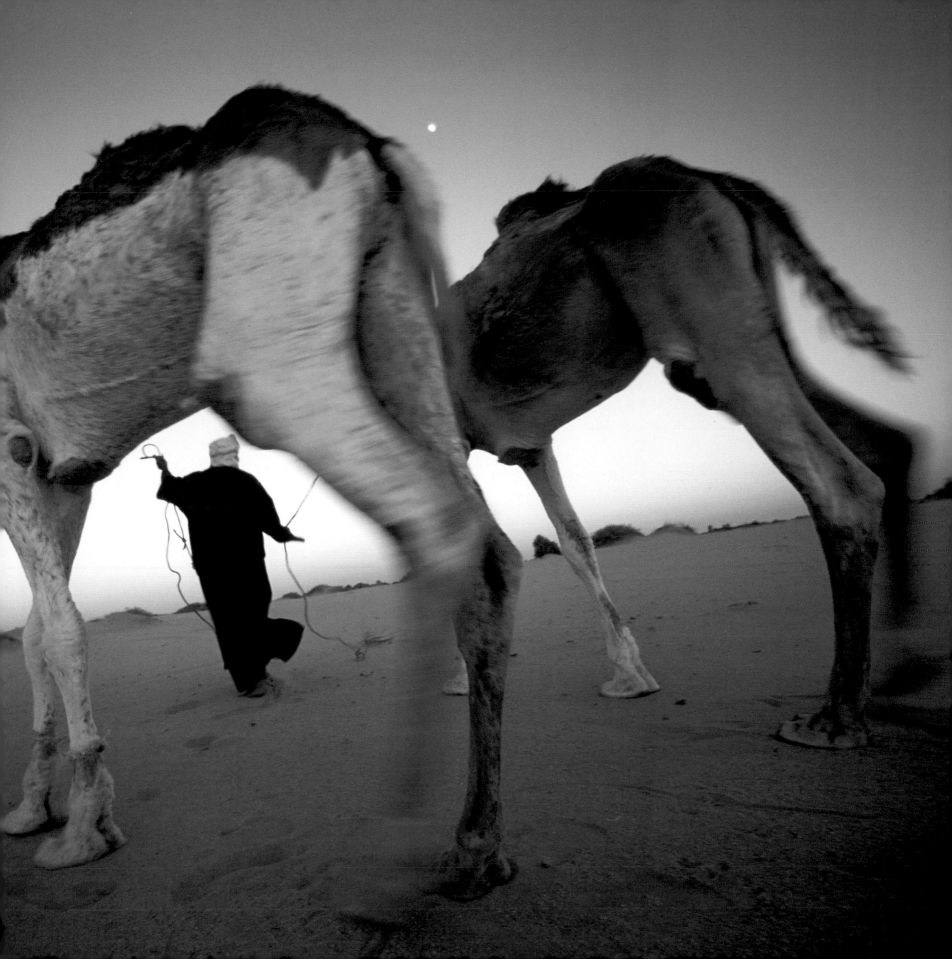

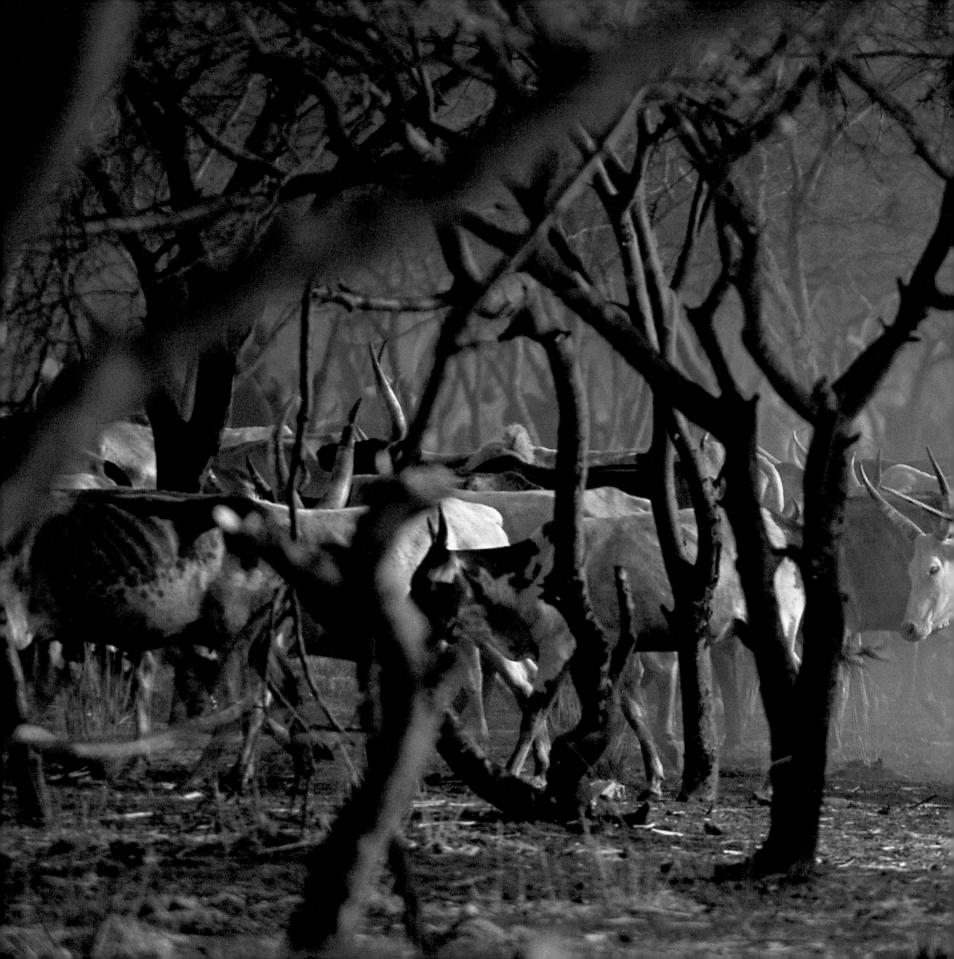

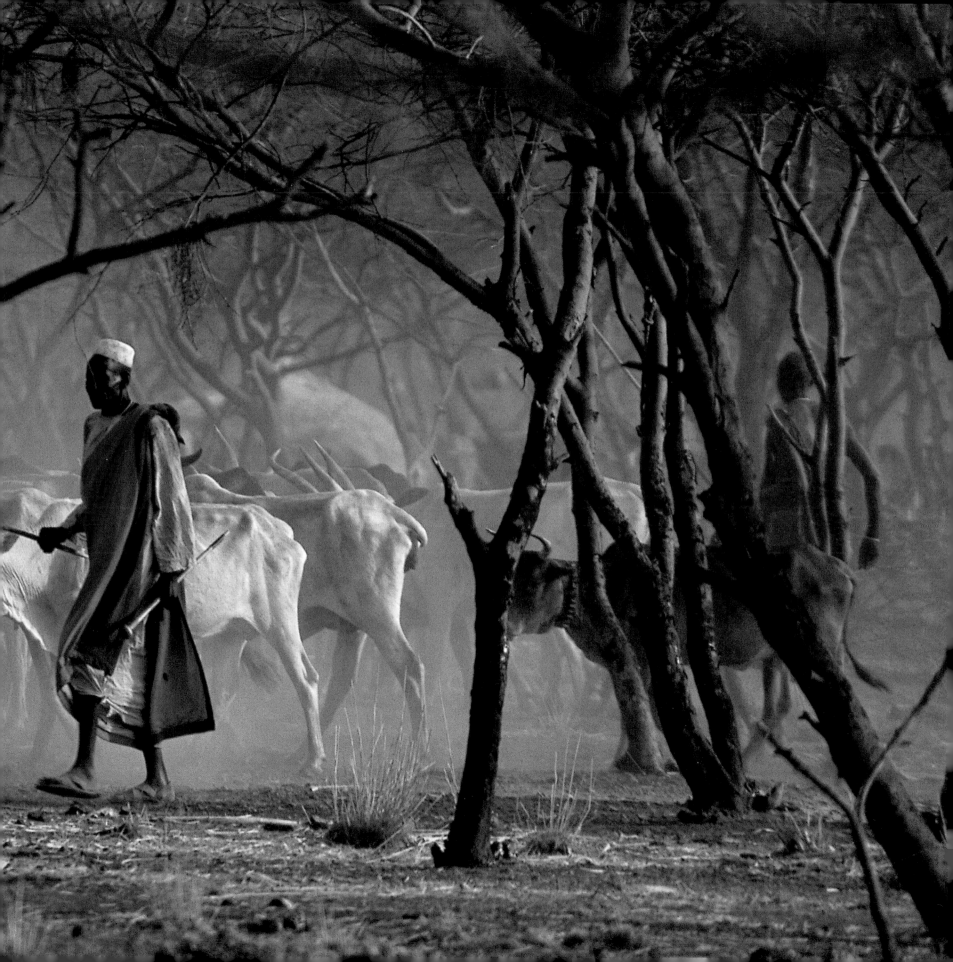

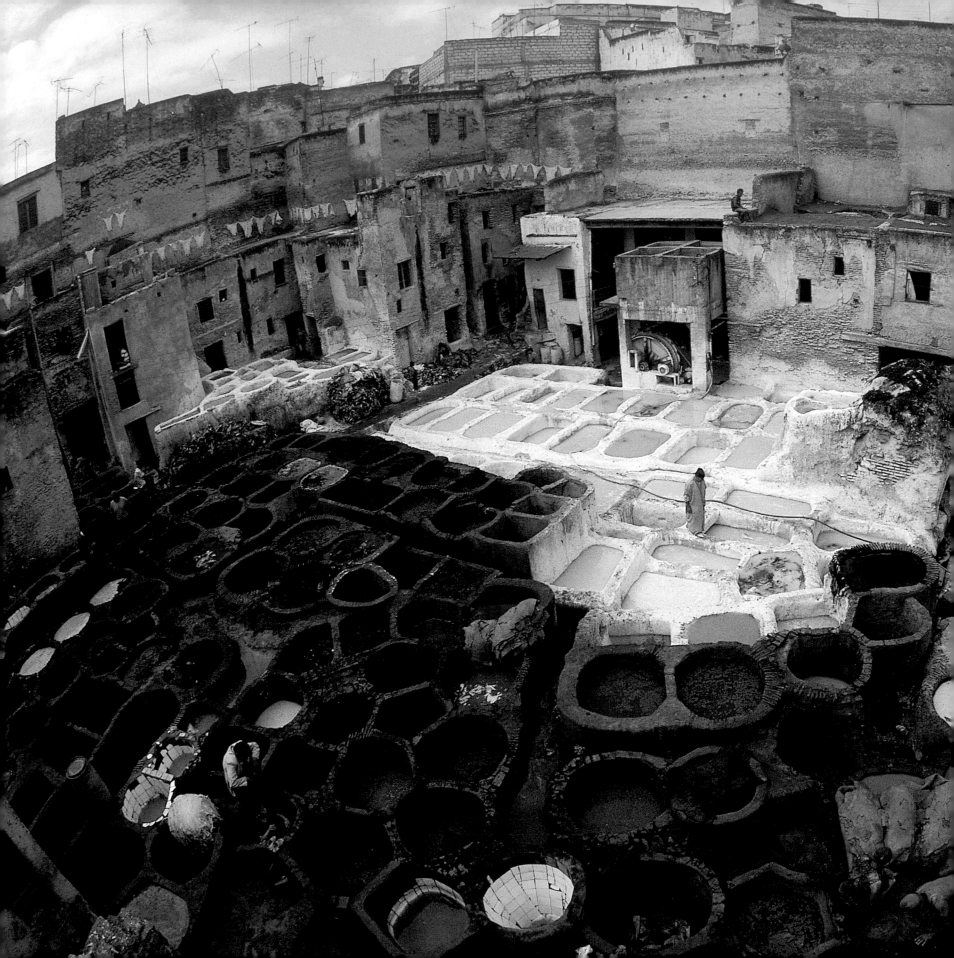

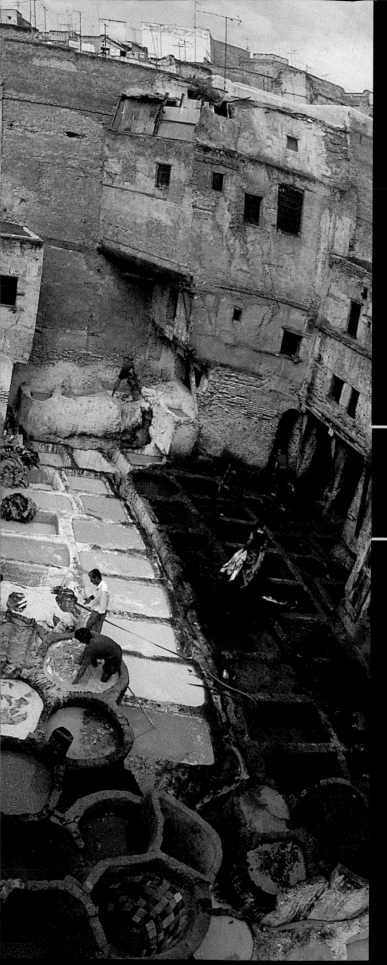

337

*338* Alexandra Boulat, 2004. Berber man visiting his grandmother in Taarart, Morocco.

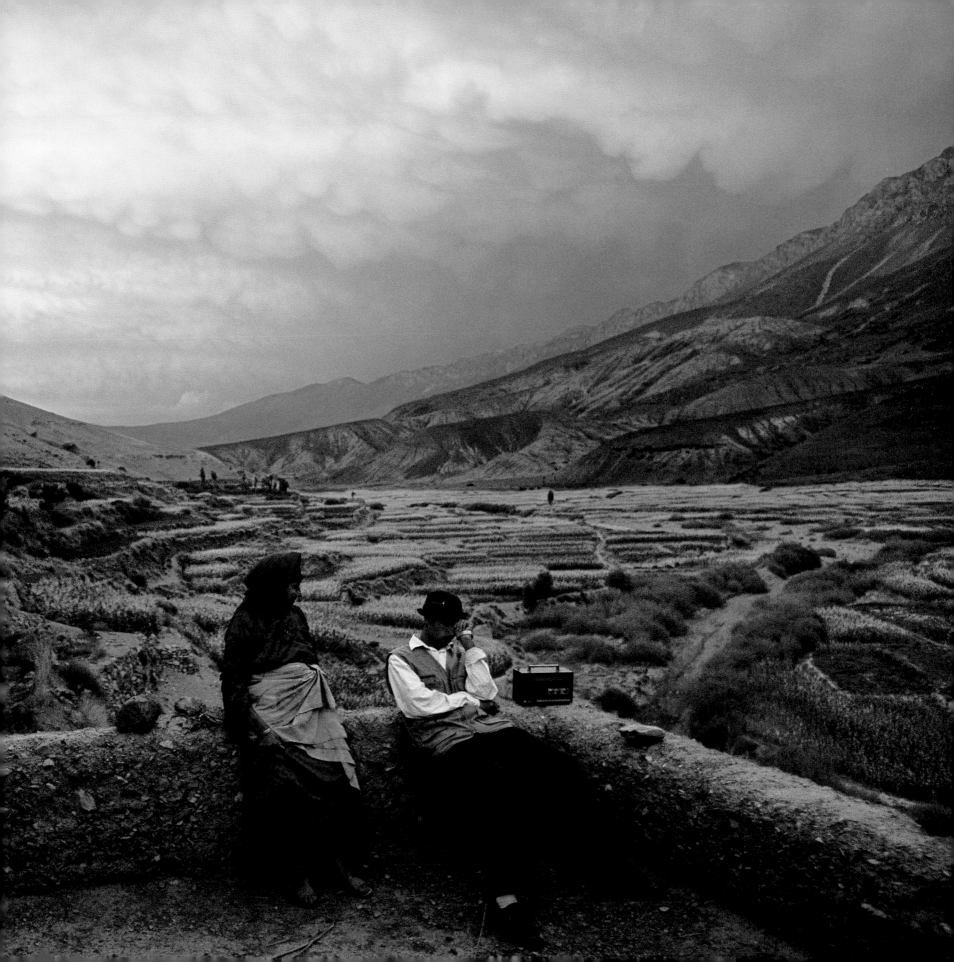

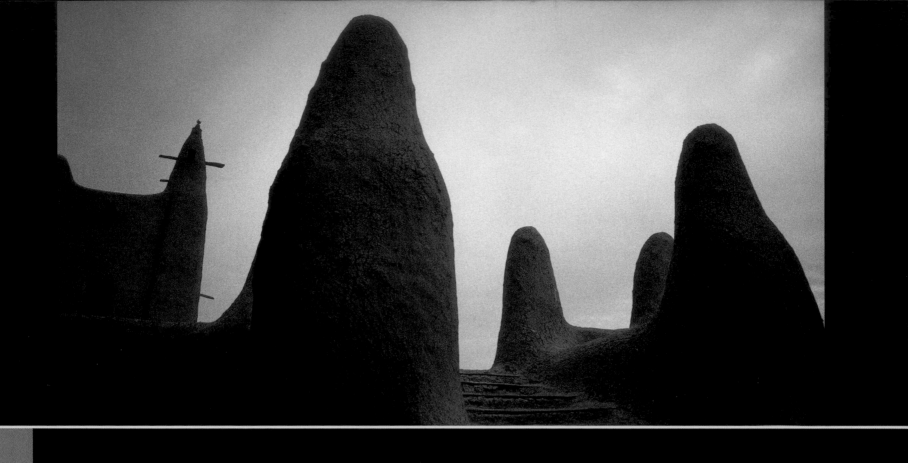

340

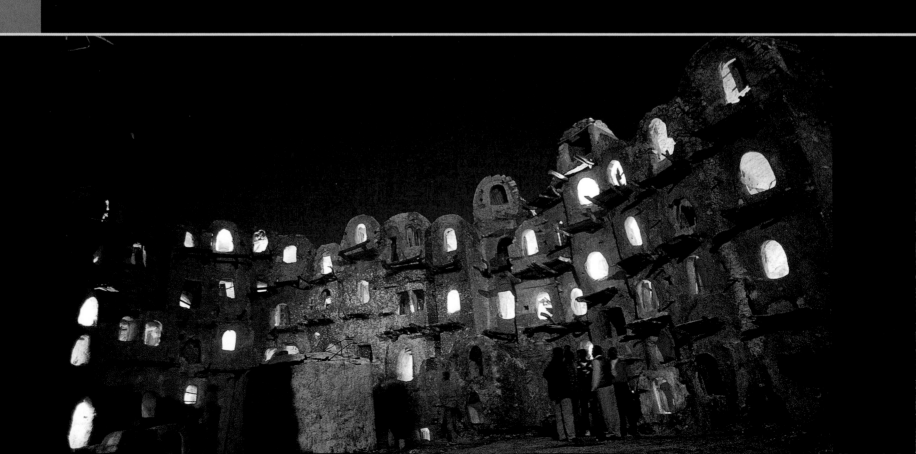

TOP: SARAH LEEN, 2001. ANCESTRAL PILLARS OF THE GREAT MOSQUE IN DJÉNNÉ, MALI'S SACRED CITY ON THE EDGE OF THE SAHARA.

BOTTOM: REZA, 2000. A FORTRESSLIKE TREASURY IN KABAW, LIBYA, BUILT IN THE 12TH CENTURY. VILLAGERS HID GRAIN IN ITS VAULTS FROM DESERT RAIDING PARTIES.

W. ROBERT MOORE, 1938. AN EGYPTIAN MAN LOOKS OUT FROM A TRELLISED WALKWAY.

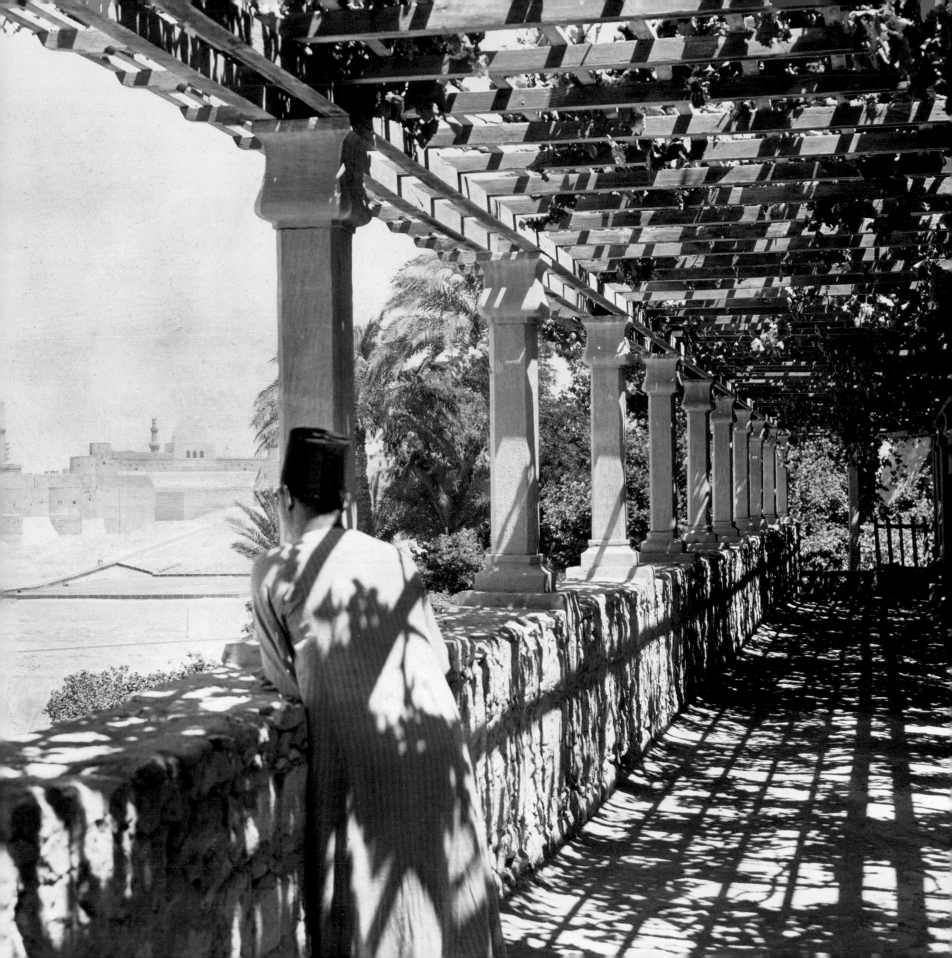

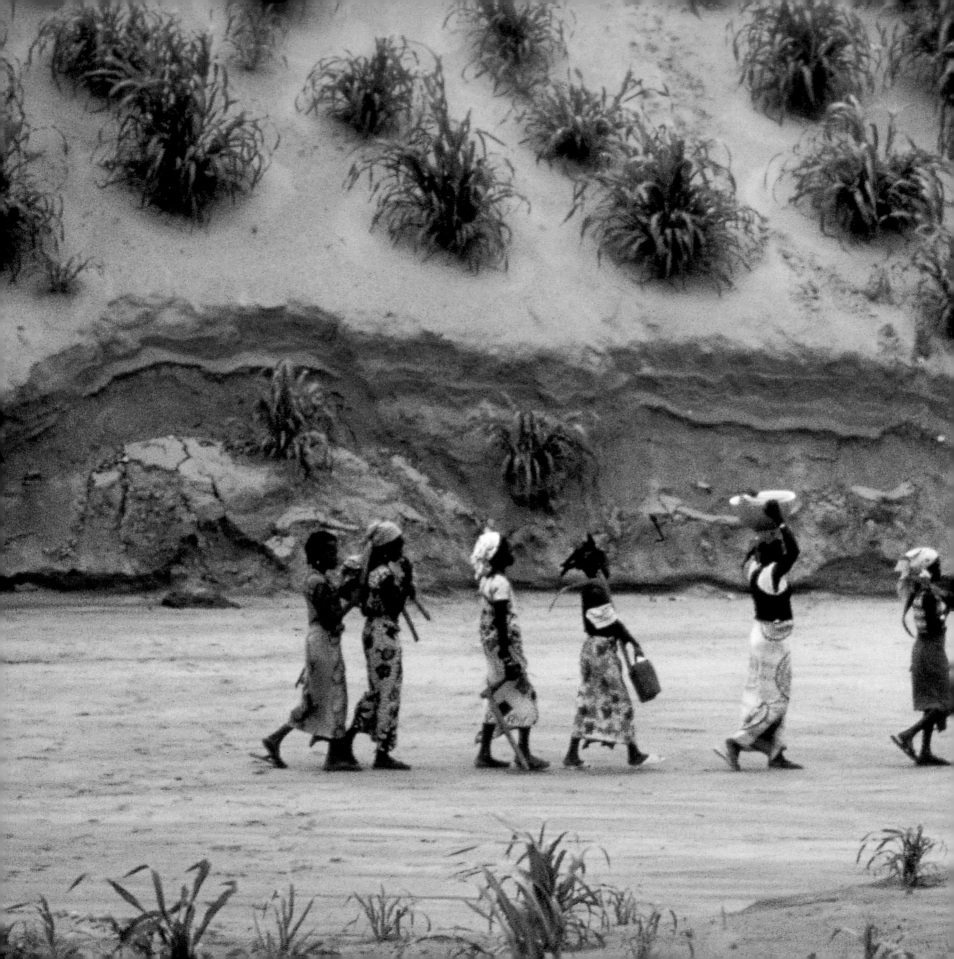

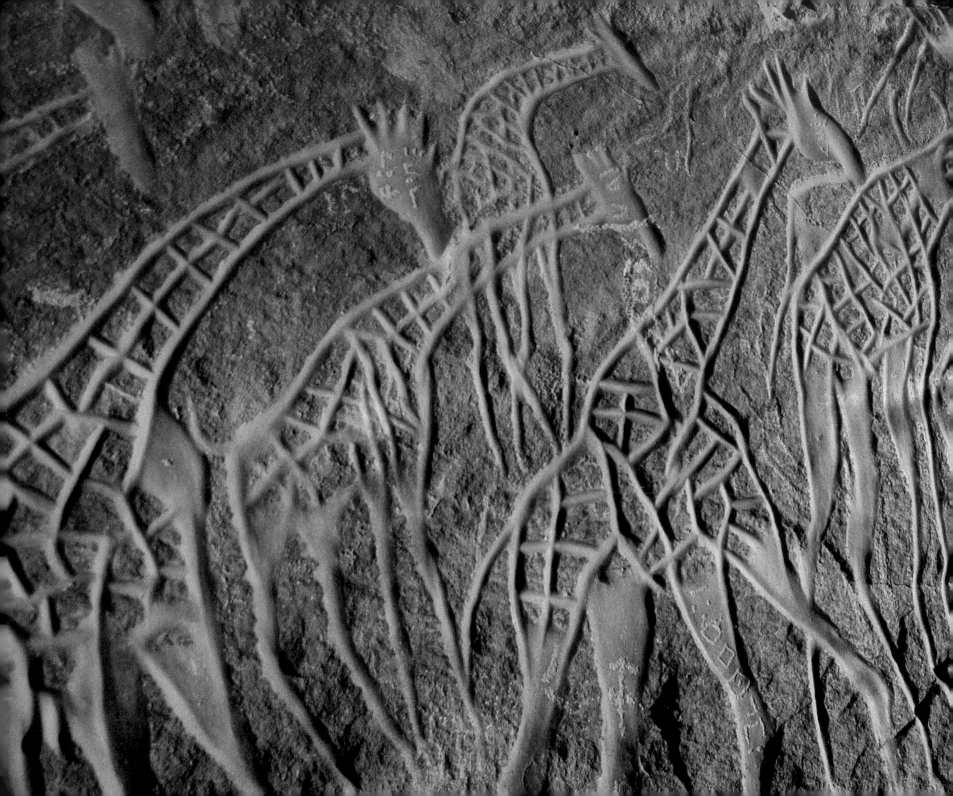

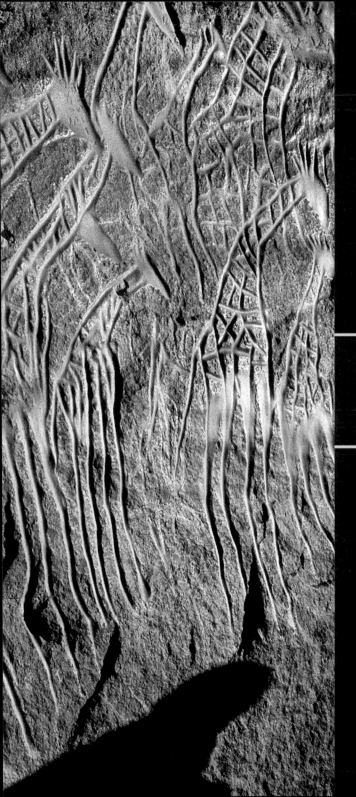

PREVIOUS PAGES: STEVE MCCURRY, 1986. WOMEN WALK PAST MILLET GRASS PLANTED TO STEM EROSION IN THE DESERT, TAHOUA, NIGER.

LEFT: DAVID COULSON, 1999. A 7,000-YEAR-OLD CARVING OF GIRAFFES ON A ROCK WALL IN THE LIBYAN DESERT.

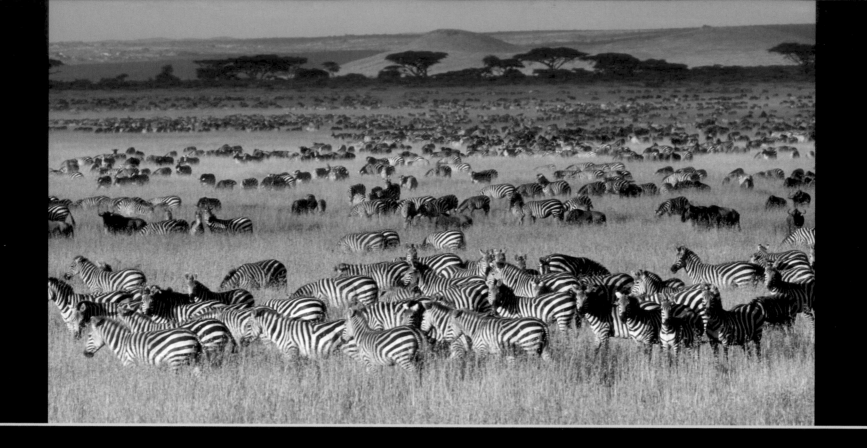

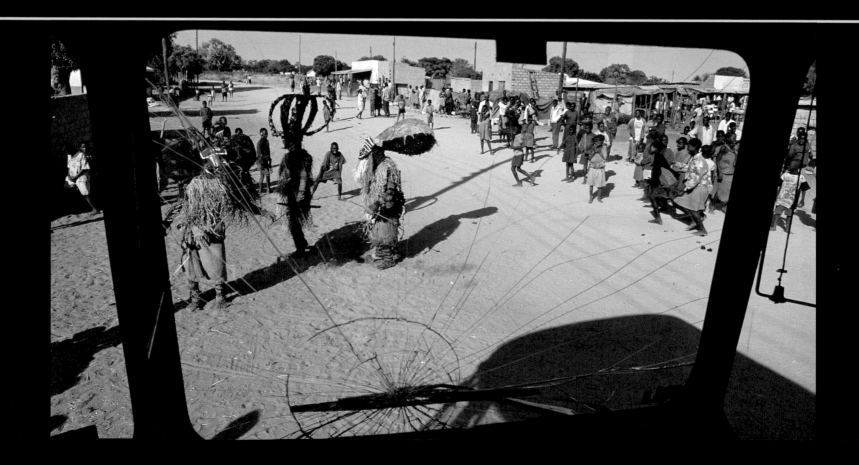

# 9 SUB-SAHARAN AFRICA

350

# SUB-SAHARAN AFRICA

Does it matter where modern human beings originated? For thousands of years, philosophers, scientists, and ordinary people have sought to determine whence we as a species came. This interest in our collective beginnings transcends all cultures, languages, and geographic boundaries and has spawned various notions of creation.

Many religions trace human lineage to a primal set of parents, such as the Biblical Adam and Eve, dwelling in an earthly paradise. In 1987 researchers at the University of California, Berkeley, zeroed in on a more specific spot when they announced that a study of mitochondrial DNA, carried only by females, showed all modern human beings are descended from a woman who lived in sub-Saharan Africa about 143,000 years ago. The theory of an "African Eve," as she was quickly dubbed, immediately sparked controversy.

That debate continues. Some scientists support the theory, others have presented evidence suggesting human beings did not come only from Africa, but evolved in various places at about the same time, intermingling with pre-human populations. Various religious groups have also attacked the "out-of-Africa" idea, as well as the very notion of Darwinian evolution.

This book isn't meant to resolve questions of human origin. But in exploring some of the world's fascinating places through photographs selected from the archives of the National Geographic Society, the question of where we come from is, in effect, being answered. The Earth we see here is our place of origin. From that perspective, it doesn't really matter where *Homo sapiens* first appeared or whether they mixed with pre-human species such as Neandertals or *Homo erectus.*

Beyond the shared planetary address, however, there is strong evidence suggesting all human beings are fairly closely related genetically, and that a dominant genetic strain of all people living today came from sub-Saharan Africa. Skulls and bones of the earliest known *Homo sapiens* were found in 1966, along the Omo River in southern Ethiopia. Paleoanthropological studies show *Homo habilis,* the earliest member of the genus of humans, lived some 1.8 million years ago near Tanzania's Olduvai Gorge and Olduvai lake basin. From studying the bones and tools of these hominids,

scientists believe them to have been creatures of flexible, adaptive behavior, migrating when necessary to seek fresh sources of food and shelter.

That behavior doesn't prove a direct link to "African Eve" or any other mother. But it fits a familiar pattern of human migration that runs from the beginning of recorded history to the present. So until someone comes up with older, smarter ancestors, let's think of ourselves as one big, if not happy, family from Africa and these photographs of Rwanda, Democratic Republic of the Congo, Mauritius, Zambia, South Africa, Ethiopia, Kenya, Zimbabwe, Tanzania, Cameroon, Eritrea, and Botswana as pictures of our primal backyard.

It is an indisputably amazing place, the subject of countless writings and depictions. The history and culture of its peoples have had profound effects on the development of Western life as we know it. This is remarkable considering that Europeans first arrived, for good or ill, in the southern half of Africa in the 15th century, and that serious study of African ethnography and archaeology is only about 150 years old. The groundbreaking research, literally and figuratively, into the origins of modern humans has come in just the past 50 years.

Since its founding in 1888, the National Geographic Society has been a strong supporter of research into Africa's history, geography, and cultures, and the Society's magazine is a prime source of what knowledge many Americans have of sub-Saharan Africa. For National Geographic's photographers, the place has always been a rich smorgasbord of subject matter. That abundance of postcard-ready imagery has sometimes posed a problem. For decades, the magazine's photography centered on the physical beauty of the place and its peoples, cultures, and wildlife. Unpleasant aspects of life there, such as colonialism, racism, slavery, economic exploitation, and political oppression, were either glossed over or ignored.

Despite the universal appeal of a gorgeous sunset on the Serengeti Plain or cheetah cubs wrestling in the bush, such images are just small parts of the array of contemporary life found across the southern half of Africa. The place is a microcosm of human development from prehistoric time to the present, home to mud huts and hunter-gatherer lifestyles as well as urban high-rises inhabited by yuppies.

There are also great economic, political, and social disparities across the region. Life in the countries of southern Africa

can seem brutally alien when one reads accounts of genocide in Rwanda, civil war in Sudan, or the ravages of the AIDS epidemic across the region. Robert Caputo's photos of a woman walking past a field in Eritrea littered with tanks destroyed in its 30-year rebellion against Ethiopia and of passenger-laden barges stuck for three days on a sandbar in the Congo River attest to the difficulties of daily life there.

But that life isn't really so far removed from the rest of the world. Depravity, disease, and despair can be found everywhere. So can many African traditions, such as that of body art, which many Africans practice in some form. Are the cornrow hair braiding and decoration, the piercings, and layers of necklaces unique to sub-Saharan Africa? Not anymore. Similar styles can be seen in Paris, Moscow, Los Angeles, or Tokyo. For thousands of years, African artists have sought to depict the history of their people, to tell about their way of life, their existence in a sometimes harsh physical environment, their hopes, fears, myths, and rituals. Just as artists everywhere do.

None of these links prove that modern human beings originated with a woman in sub-Saharan Africa. But the family of man has certainly lived there long enough to consider it home. One can't help but wonder what an African or Biblical Eve or any mother of humanity might have to say to her teeming brood at day's end. Probably the same things mothers everywhere say: Wash yourself, eat your food, stop all that fighting, and go to sleep. Tomorrow's a new day. Maybe that's all that really matters, not where we began, but where we are and where we're going.

PREVIOUS PAGES: BOBBY MODEL, 2001. JUSTIN HAIGLER STANDS INSIDE AN ICE CAVE ON MOUNT KENYA'S NORTH FACE.

LEFT: MICHAEL NICHOLS, 2003. THE FOG-ENSHROUDED RAIN FORESTS OF RWANDA'S VIRUNGA MOUNTAINS ARE ONE OF THE FEW REMAINING HABITATS FOR MOUNTAIN GORILLAS.

357

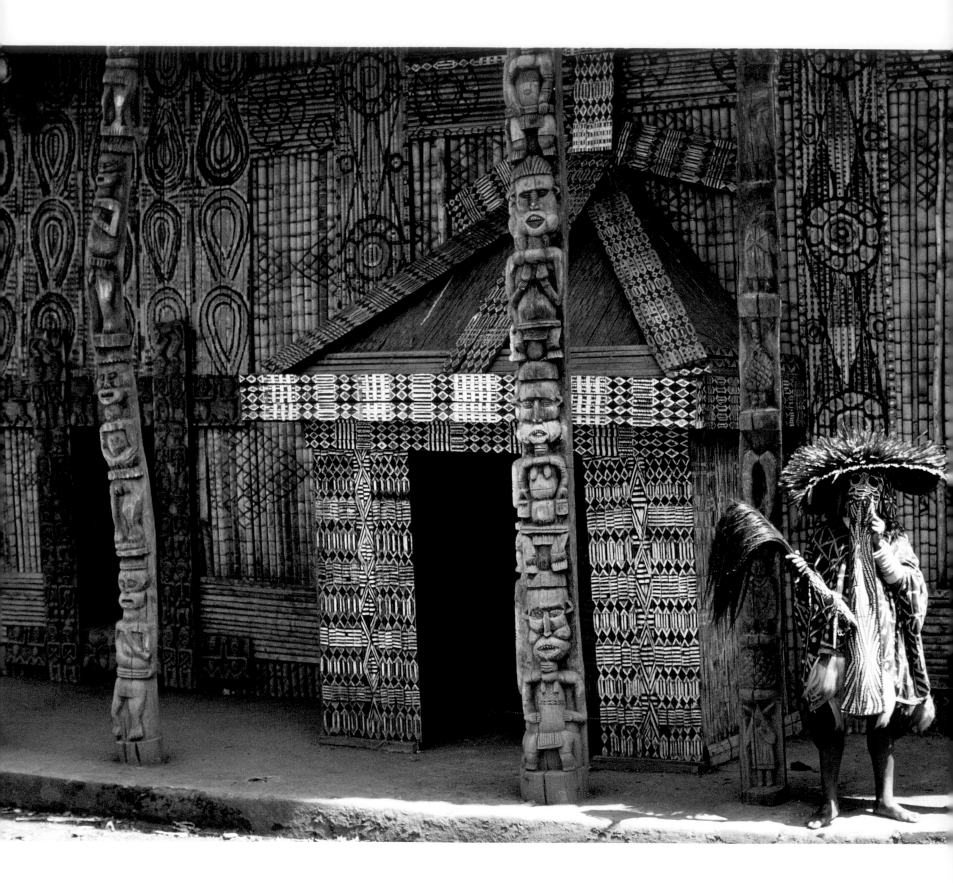

Fabby K. J. Nielen, 1984. The carvings at the king's house at Bandjoun, Cameroon, represent past royalty and servants.

359

Frans Lanting, 1995. smiling crocodile in Botswana.

362

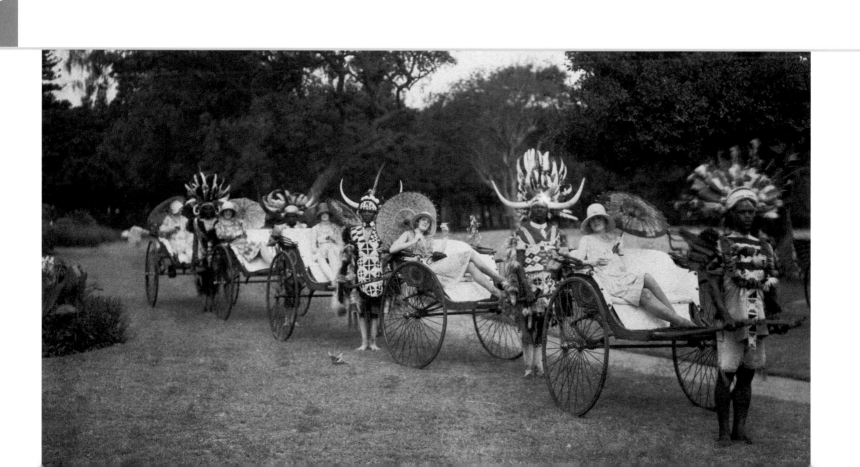

TOP LEFT: ROBERT CAPUTO, 1991. BARGES STUCK FOR THREE DAYS ON THE CONGO RIVER IN THE DEMOCRATIC REPUBLIC OF THE CONGO.

BOTTOM LEFT: MELVILLE CHATER, 1930. ZULU TRIBESMEN WEARING NOVELTY HEADGEAR PULL WHITE CUSTOMERS IN DURBAN, SOUTH AFRICA, DURING APARTHEID'S RULE.

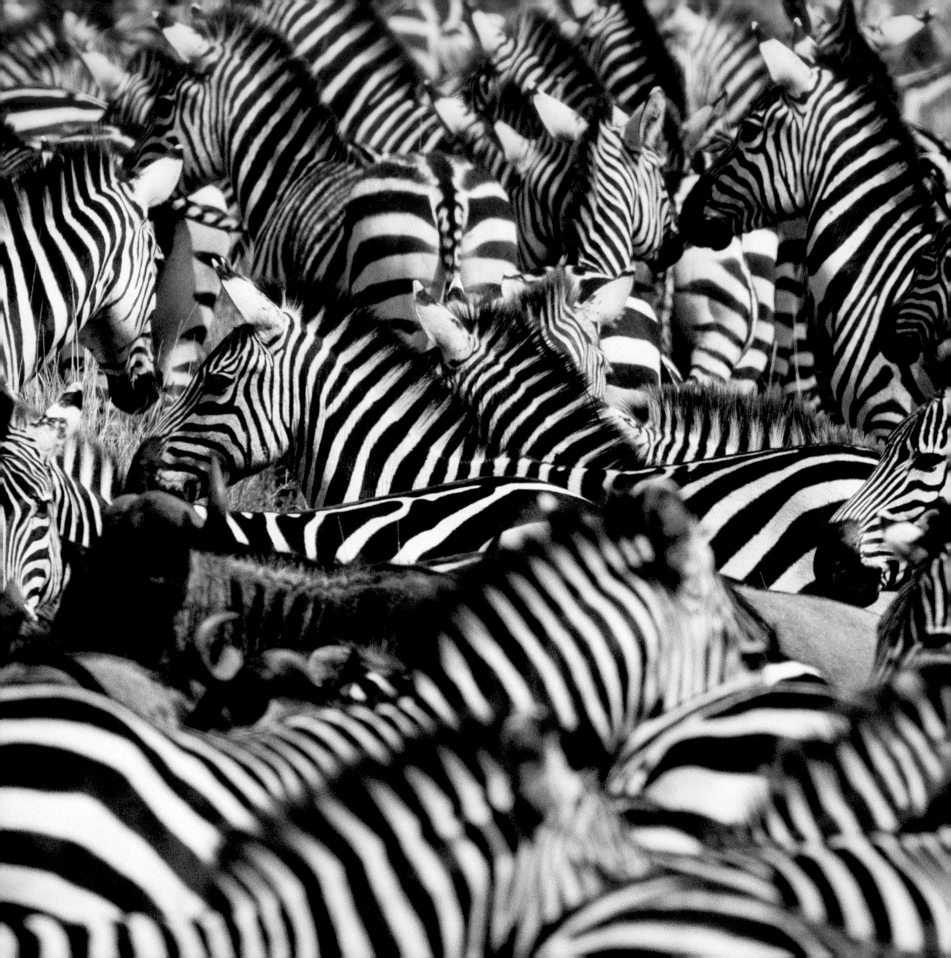

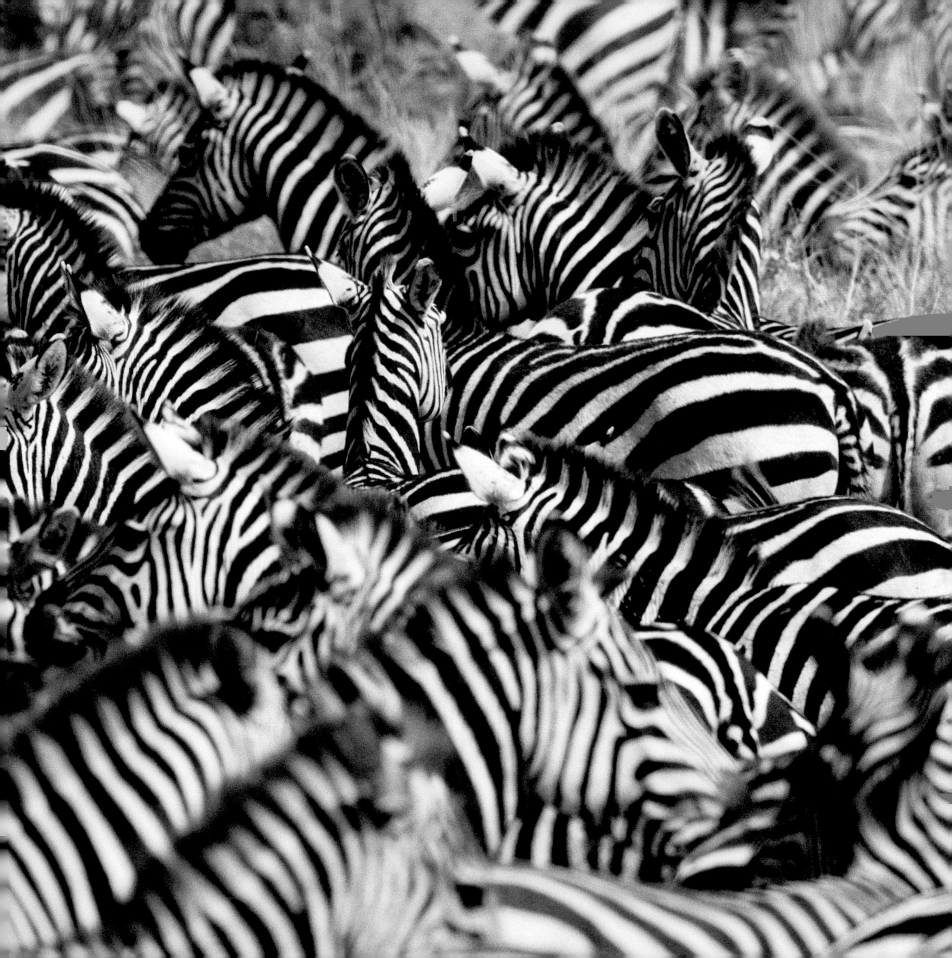

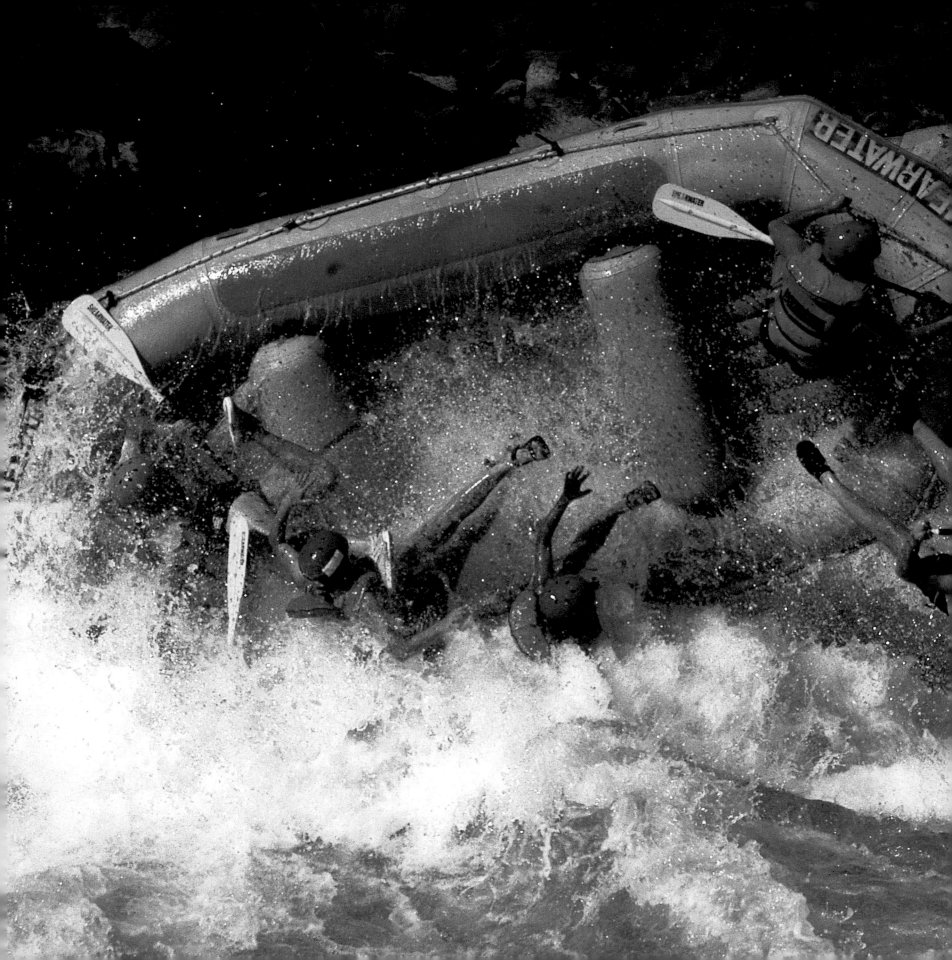

PREVIOUS PAGES: ANUP AND MANOJ SHAH, 2003. A HERD OF PLAINS
ZEBRAS, *EQUUS BURCHELLI,* MILL ABOUT DURING MIGRATION IN KENYA.

LEFT: CHRIS JOHNS, 1997. WHITEWATER RAFTERS FLIP ON THE
ZAMBEZI RIVER NEAR VICTORIA FALLS, ZIMBABWE.

367

LEFT: ROBERT CAPUTO, 1991. DUGOUT CANOES TIE UP TO A BARGE ON THE CONGO RIVER IN THE DEMOCRATIC REPUBLIC OF THE CONGO.

RIGHT: JOHN CANCALOSI, 2000. AFRICAN WOMEN STAND OUTSIDE A THATCHED ROOF HUT IN SHANGANI VILLAGE, ZIMBABWE.

AFRICA'S ABUNDANCE OF POSTCARD

READY IMAGES CAN BE PROBLEMATIC. ❧

TOMASZ TOMASZEWSKI, 2004. A MAN STEPS OUT OF A VAN
EMBLAZONED WITH PORTRAITS IN JOHANNESBURG, REPUBLIC OF
SOUTH AFRICA.

JODI COBB, 1998. A TRIBESMAN WITH HIS FACE PAINTED PREPARES FOR A RITUAL DANCE IN ETHIOPIA'S OMO VALLEY.

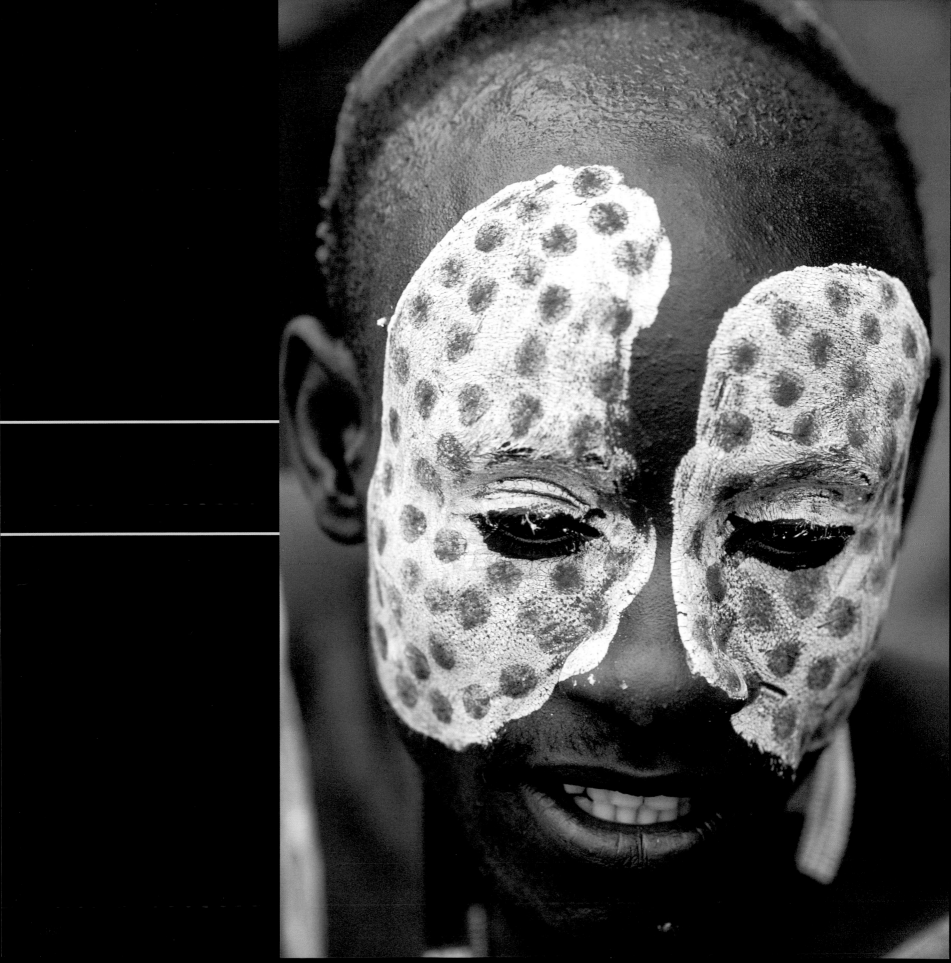

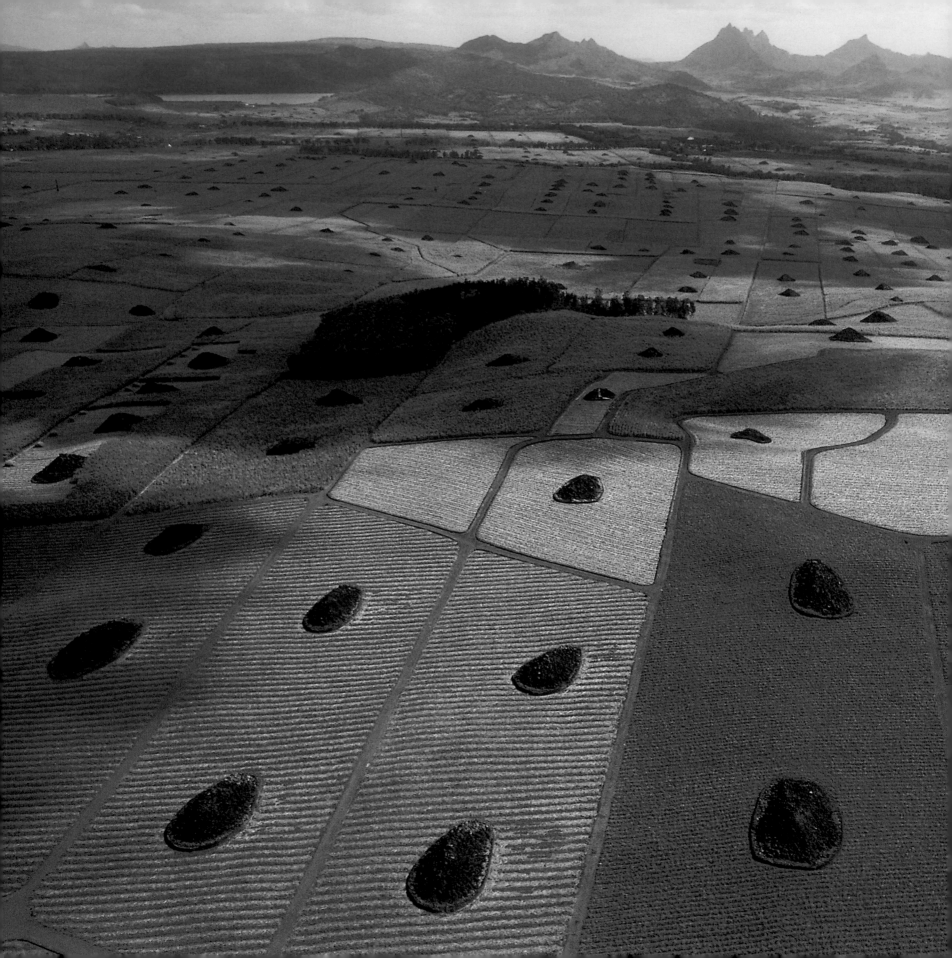

LEFT: JOSEPH RODRIGUEZ, 1993. VOLCANIC ROCK PILES AND SUGAR CANE FIELDS IN MAURITIUS.

FOLLOWING PAGES: STUART FRANKLIN, 2000. MINERAL DEPOSITS, LAKE NATRON, NORTHERN TANZANIA.

375

378 CHRIS JOHNS, 1999. FOURTEEN-MONTH-OLD CHEETAH CUBS PLAY IN TALL GRASS, BOTSWANA.

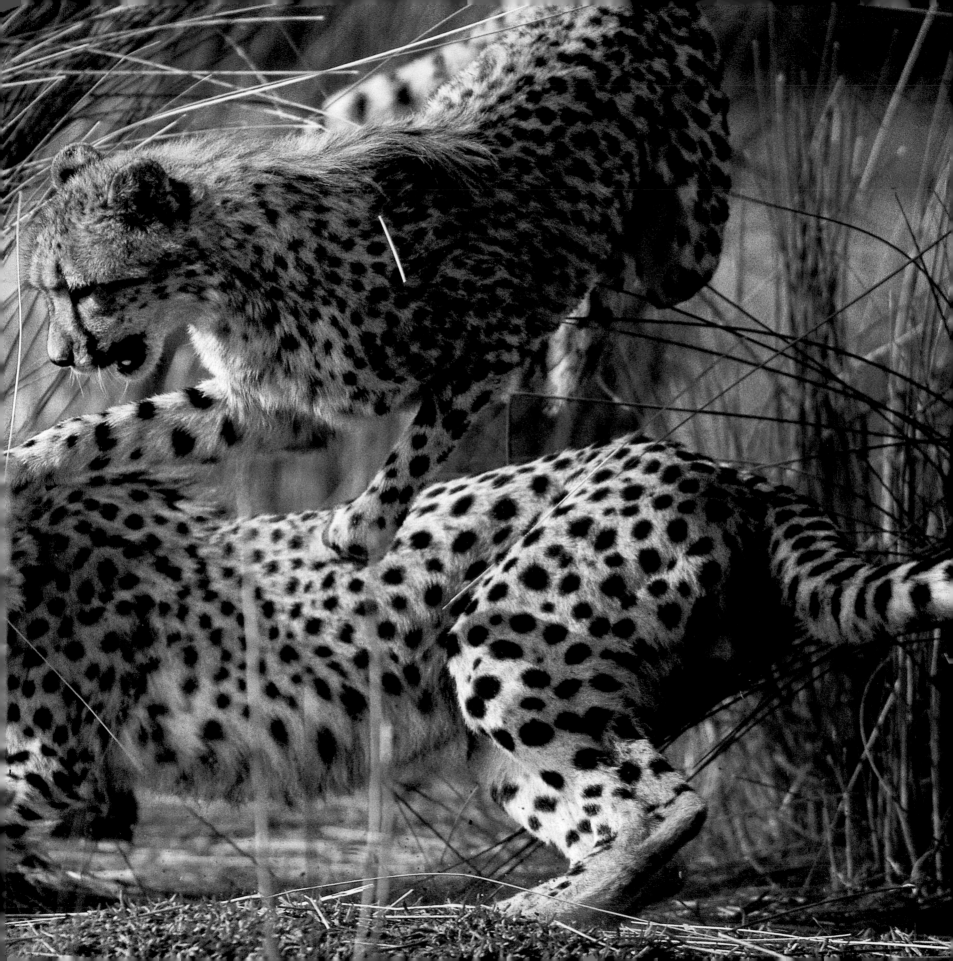

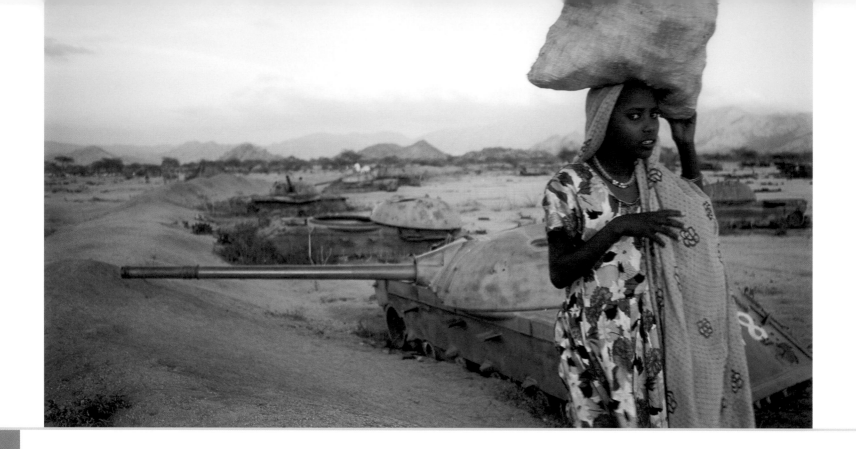

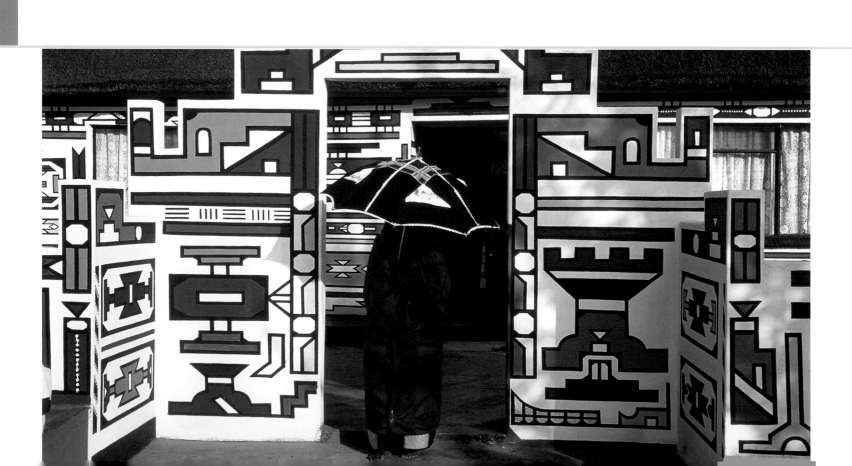

TOP: ROBERT CAPUTO, 1996. AN ERITREAN WOMAN WALKS PAST TANKS DESTROYED IN THE COUNTRY'S 30-YEAR WAR TO GAIN ITS INDEPENDENCE FROM ETHIOPIA.

BOTTOM: CAROL BECKWITH AND ANGELA FISHER, 1999. FRESHLY PAINTED GATEWAY TO A NDEBELE HOMESTEAD IN REPUBLIC OF SOUTH AFRICA.

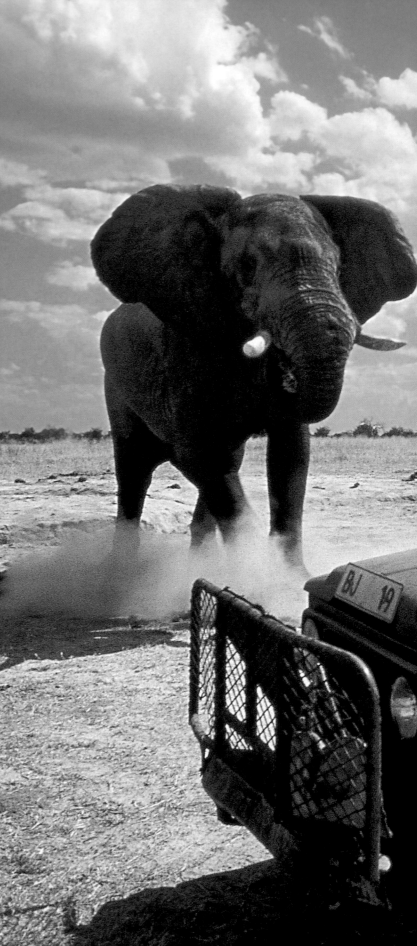

MICHAEL MELFORD, 1995. PHOTO SAFARI IN BOTSWANA'S CHOBE NATIONAL PARK.

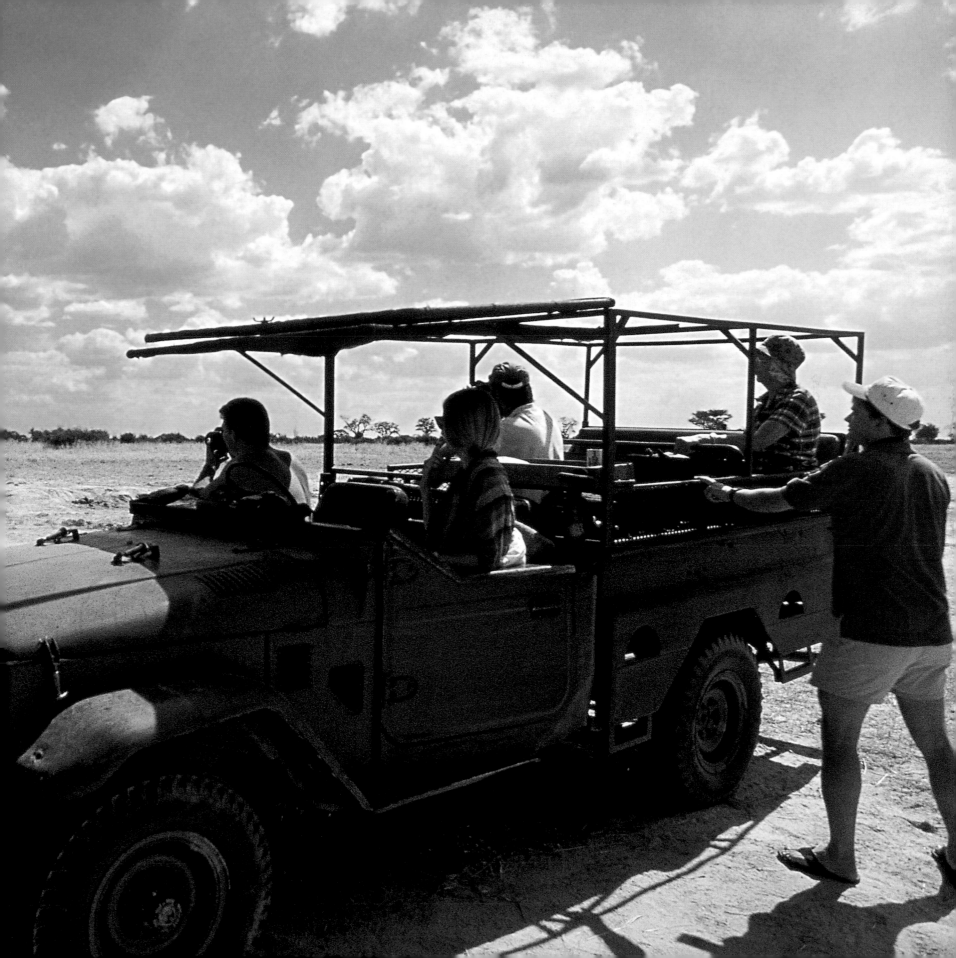

384 STEVE McCURRY, 1996. VICTORIAN BATHING HUTS AT SAINT JAMES BEACH, CAPE TOWN, REPUBLIC OF SOUTH AFRICA.

GEORGE F, MOBLEY, 1982. ACACIA TREES AT SUNSET IN SERENGETI
NATIONAL PARK, TANZANIA.

*387*

# 10 NORTH AMERICA

PREVIOUS PAGE TOP: RICHARD OLSENIUS, 2001. TRAVELERS HAVE CREATED A SIGNPOST FOREST ALONG THE ALCAN HIGHWAY, WATSON LAKE, YUKON TERRITORY, CANADA. THE ROAD CONNECTS ALASKA AND CANADA.

BOTTOM: MAGGIE STEBER, 1997. A BOY STANDS IN FRONT OF A SIGN SUPPORTING QUEBEC SEPARATISM IN MONTREAL, CANADA.

# NORTH AMERICA

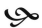

Home for National Geographic photographers can be several places. In professional terms, it is Washington, D.C., where the National Geographic Society is headquartered. Many of the photographers reside in or near that city, although like many Americans they may still consider home to be the place where they grew up. But in the broadest sense their home is Western culture, prevalent throughout North America.

Being a cultural insider has some obvious advantages and disadvantages for a photographer. Most of the people who took these pictures are citizens of the United States or Canada, familiar with those countries' social, political, and economic ways. As insiders, however, they are burdened with some cultural baggage that can be heavier than photo gear.

The photographers' main audience is also on home turf. Some of them may have visited the places depicted or, even if they haven't, may cherish preconceived ideas about how those places should be photographed. The majority of NATIONAL GEOGRAPHIC magazine's readers, for example, have seen countless photographs of places in North America via newspapers, magazines, advertising, books, films, television, and the Internet. Many have taken photographs of the continent's landscape, whether it is Manhattan, Monument Valley, or the Bay of Fundy. So have some of the medium's greats, such as Alfred Stieglitz, Carleton Watkins, and Ansel Adams.

That is formidable and unavoidable competition. While National Geographic photographers' pictures aren't created expressly to be fine art, some of their works are. Yet someone will always compare them unfavorably to Stieglitz, Watkins, Adams, and other photographic artists. On the other hand, a reader might look at a photos and say, "Big deal. It looks just like a picture I took on our trip to San Francisco."

It might, indeed. But there is a significant difference. While National Geographic's photographers function as observers and explorers, as they do elsewhere, in North America they serve as intermediaries. By investigating the place with a camera and a refined sense of the culture, especially its aesthetic traditions, they are, in effect, explaining North America through photographs to its inhabitants, beginning with themselves.

No other publication or photographers do that so well. Since the early 1970s, National Geographic's North American

photographs have featured a unique balancing of fine art, photojournalism, and vernacular photography, of culture high and low, of style and substance. They are open, accessible pictures, examining with insight, affection, and subtlety the many layers of life in Canada and the United States, while addressing the transient and multivalent sense of home so many Americans share. Look closely at the photo of sailors touring New York's Times Square and you'll find cultural references ranging from Rembrandt's "The Night Watch" to Sinclair Lewis, Cindy Sherman, fast food, and hip-hop. There's a certain genius in that.

These pictures are a miniscule sampling of the photos of North America housed in the National Geographic Society's archive of more than ten million photographs, and they do not presume to tell the whole story of the place. But they convey a strong sense of North America's vastness, geographic diversity, and restless contemporary life.

Some of the photos take a broad view of the landscape, as in Maria Stenzel's shot of the snowy Adirondack Mountains or Skip Brown's picture of a windsurfer on a sculpted Oregon beach. Others, like Jim Brandenburg's photo of torch flowers on a patch of tallgrass prairie in Minnesota or the glaring neon sign of a roadside in Kingman, Arizona, photographed by Vincent J. Musi, capture lyrical details bearing huge cultural significance.

Prairies, for example, cover roughly 1.4 million square miles in the central part of the North American continent, stretching from Canada to Mexico and western Indiana to the Rocky Mountain foothills. These vast grasslands once provided grazing for immense herds of bison, elk, and deer. Nearly all of that land is now used for agriculture. Brandenburg's ethereal flowers, which Albrecht Durer might envy, symbolize a gigantic ecosystem destroyed.

Musi's motel picture leads to a different cultural space, carved from the kind of just-past and high-octane nostalgia Americans relish. Without showing any pavement, he evokes an icon of American culture: Route 66. Although the road, which meanders from Chicago to Los Angeles, was "decertified" as a federal highway in 1985, its mythical status endures. For millions of people around the world, Route 66 will always be the road West, a two-lane ribbon of asphalt, flowing across prairies, streams, mountains, and deserts.

Los Angeles wasn't the lure that pulled people onto what John Steinbeck described in his masterpiece *The Grapes of Wrath* as "…the mother road, the road of flight." It was the promise of fresh opportunities, the same promise that led

European settlers to keep pushing westward across Canada and the United States until the land or their luck ran out.

Along the way, they reshaped the terrain, displaced and decimated the native inhabitants, and turned the paths created by moccasins and ponies' hooves into roads. Long before Route 66 received its official title in 1926, man was moving along it. Parts of its northern reach from Chicago to the mouth of the Missouri River followed the portage route of Pére Jacques Marquette and Louis Joliet, who explored the upper Mississippi River in 1673. The section that traversed Missouri to Fort Smith, Arkansas, was an ancient Osage Indian trail. Over the years, the highway became an integral part of popular culture, inspiring songs such as "Get Your Kicks on Route 66," a pop hit by Bobby Troup in 1946, covered later by a host of singing stars, and a CBS television series in the early 1960s.

The Alcan Highway connecting the Canadian northwest with Alaska is another road with mythical status. It runs through a different section of the American psyche: wilderness. Whether there really is any pristine wilderness left or merely relatively unspoiled landscape is debatable. But the notion of wilderness as an escape, a refuge, a sacred space, or a place to be conquered and exploited remains a powerful cultural force.

Travelers have put signs identifying their home cities and towns along the roadside in Watson Lake, Yukon Territory, since the road was built during World War II. Richard Olsenius's photograph of that signpost forest looks at first glance like a straightforward documentation. But the low angle of the sun and the deep background shadows add a wisp of gravitas, making the clustered signs look like a crowded cemetery for journeys past. Like headstones, the signs help those who come after to recall and consider who and what came before and what lies ahead.

Such thoughts may get knocked out by the first bump further down the Alcan, Route 66, or some other road in the United States or Canada. We always seem to be going somewhere. Along the way, we can see avarice, ugliness, and banality interspersed with scenes of raw energy, transcendent beauty, and spiritual grace. With luck, the roads lead us home and our pictures prove we survived the trip.

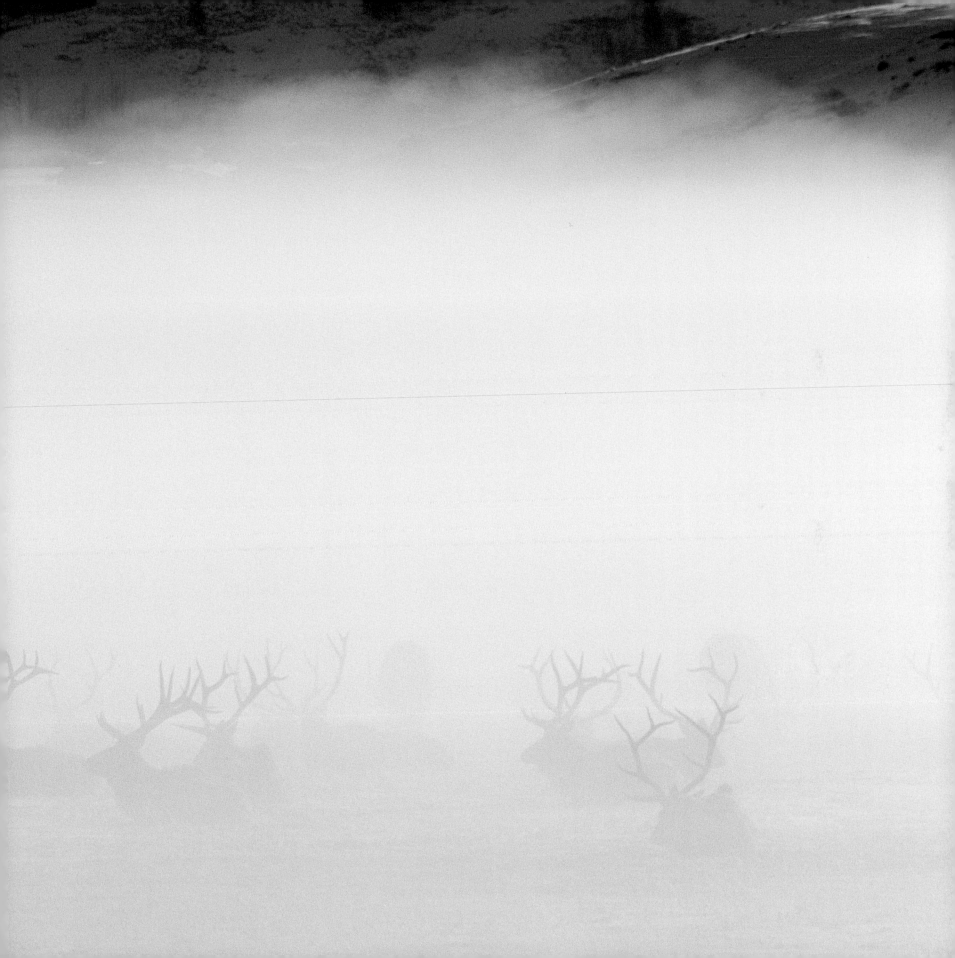

VINCENT J. MUSI, 1997. A MOTEL IN KINGMAN, ARIZONA, EVOKES
AMERICA'S "MOTHER ROAD": ROUTE 66.

399

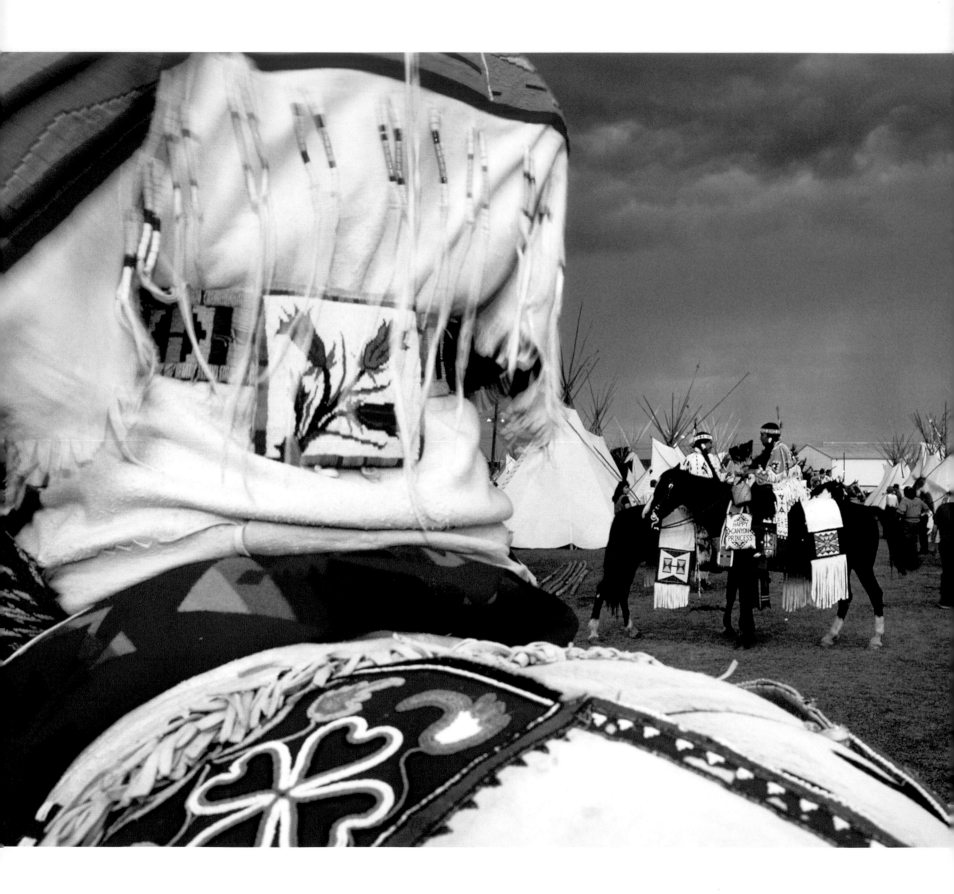

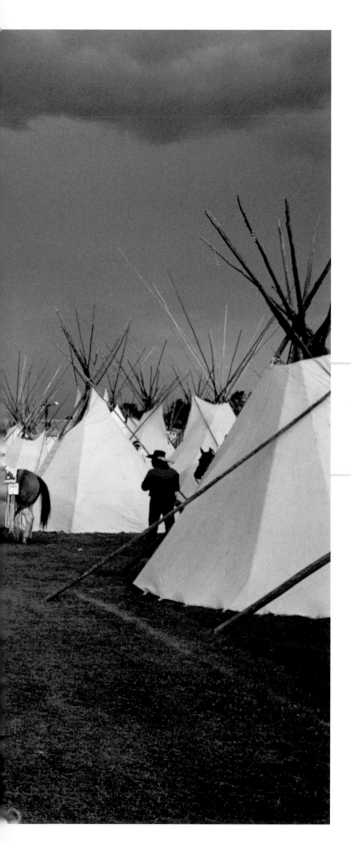

PREVIOUS PAGES: STEVE WINTER, 2003. MIGRATING SANDPIPERS, BAY OF FUNDY, NOVA SCOTIA, CANADA.

LEFT: WILLIAM ALBERT ALLARD, 1997. AMERICAN INDIANS AT THE PENDLETON ROUND-UP RODEO, PENDLETON, OREGON.

403

DAVID DOUBILET, 1998. SNORKELERS OGLE FISH AND CORALS IN THE FLORIDA KEYS.

℘ PHOTOGRAPHERS INVESTIGATE PLACE WITH

A CAMERA AND A REFINED CULTURAL SENSE, ∾

NORBERT ROSING, 2001. A MOUNTAIN LION LOOKS OUT FROM THE EDGE OF A CLIFF IN MONUMENT VALLEY, NAVAJO TRIBAL PARK, ARIZONA.

JIM BRANDENBURG, 1993. TORCH FLOWERS ADORN A PRESERVED PATCH OF TALLGRASS PRAIRIE IN MINNESOTA.

TOP: SAM ABELL, 1988. A MISTY SUNRISE IN THE RESTORED SHAKER VILLAGE AT PLEASANT HILL, KENTUCKY.

BOTTOM: SKIP BROWN, 2001. A WINDSURFER TRAVERSING SAND DUNES ON THE OREGON COAST.

PREVIOUS PAGES: THEO WESTENBERGER, 2000. U.S. NAVAL PERSONNEL ATOP A DOUBLE-DECKER BUS IN TIMES SQUARE, NEW YORK CITY.

RIGHT: STEPHEN ST. JOHN, 2000. FISHING FLOATS AT A BAIT SHOP IN NEWCASTLE, MAINE.

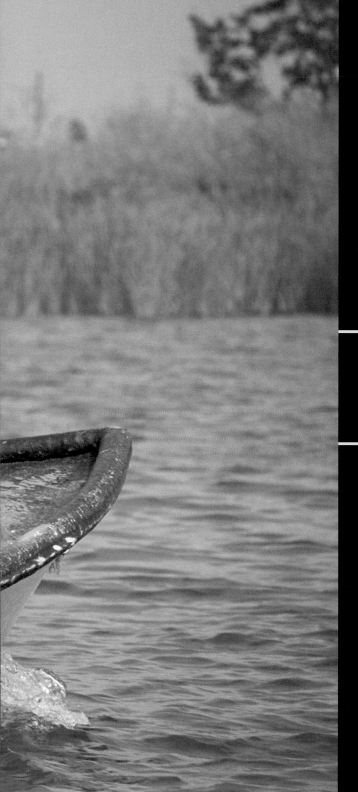

MEDFORD TAYLOR, 2003. FISHERMAN ON A CRAB BOAT IN ALABAMA.

417

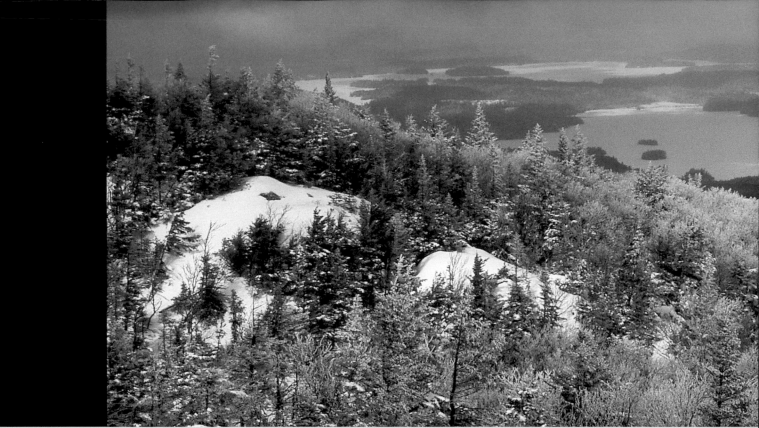

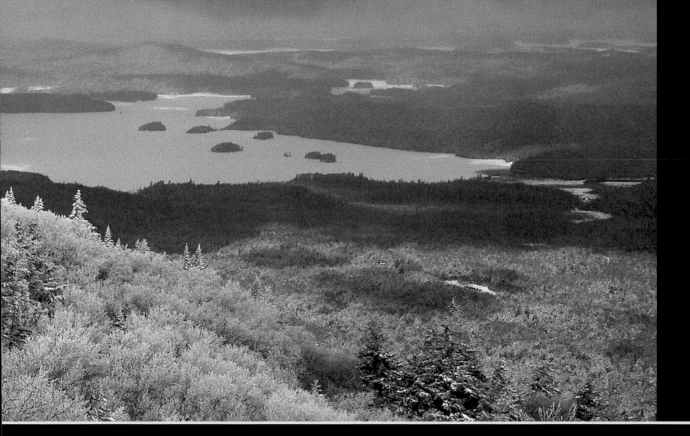

WILDERNESS LEFT IS DEBATABLE. &

419

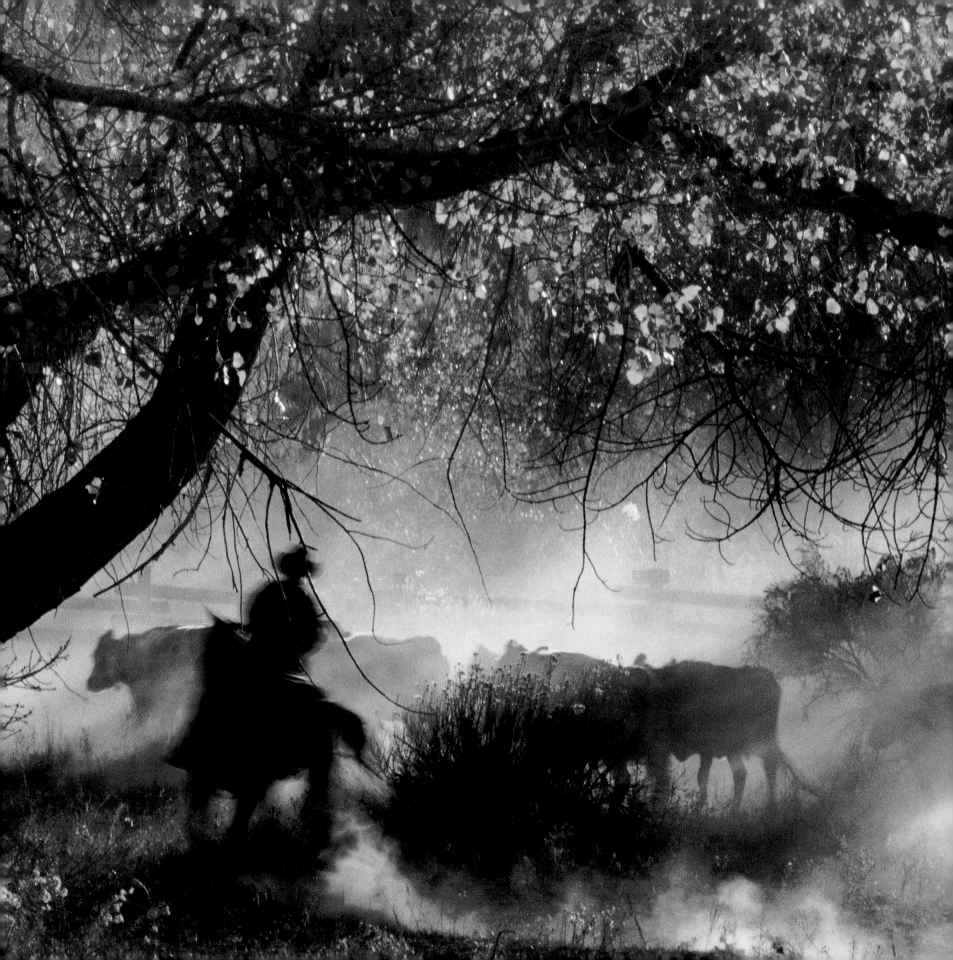

DIANE COOK AND LEN JENSHEL, 1999. COWBOY RIDING HERD NEAR ESCALANTE NATIONAL MONUMENT IN UTAH.

421

CHARLES KOGOD, 2004. ASPENS TURN TO AUTUMN GOLD IN THE ROCKY MOUNTAINS.

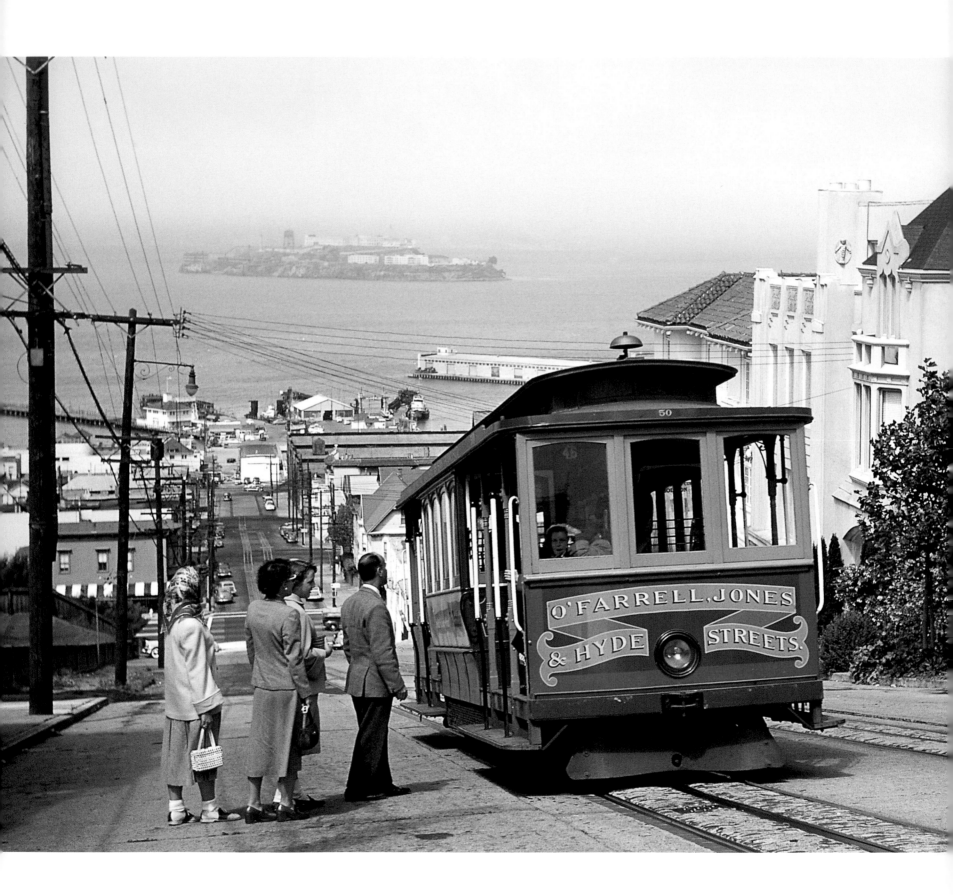

J. Baylor Roberts, 1954. Hyde Street, San Francisco, California, with cable car and Alcatraz Island in the background.

425

PREVIOUS PAGES: DAVID ALAN HARVEY, 1998. NASCAR RACING.

RIGHT: SARAH LEEN, 2001. AN AMERICAN BISON IN YELLOWSTONE NATIONAL PARK'S SNOWY LANDSCAPE.

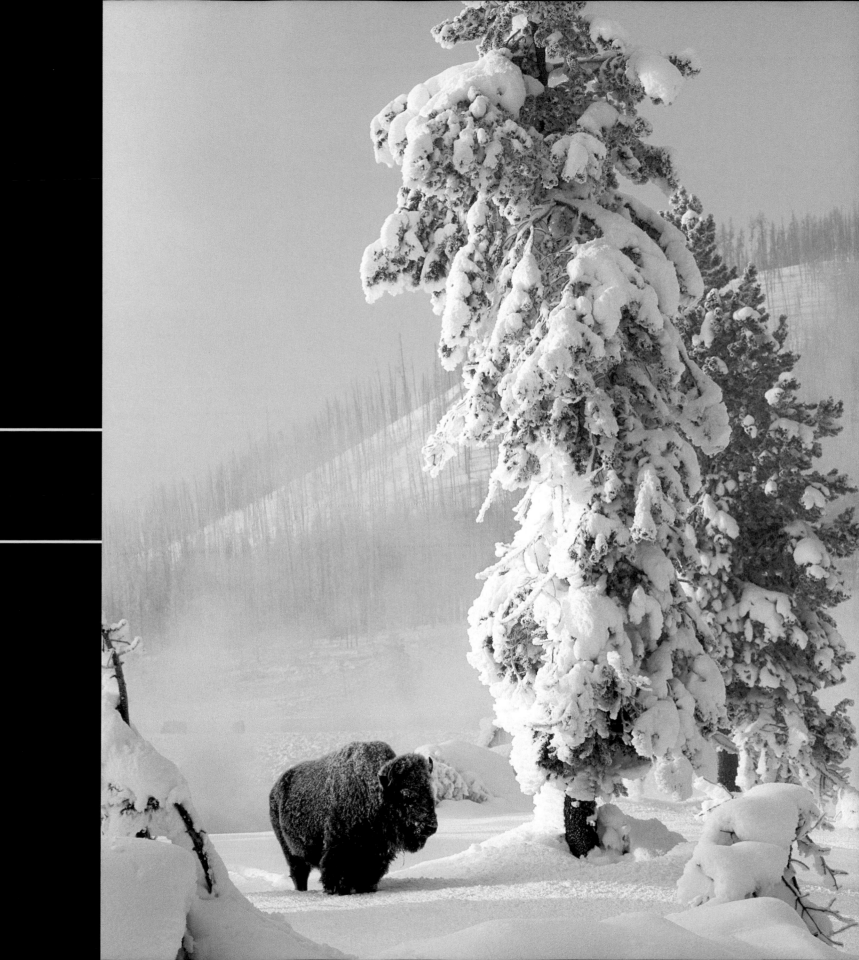

PREVIOUS PAGES: JIM RICHARDSON, 2001. AERIAL VIEW OF THE COLUMBIA RIVER IN BRITISH COLUMBIA, CANADA.

LEFT: STEPHEN ST. JOHN, 2004. SEA GODDESS AND BLACKBEARD AT THE MAINE LOBSTER FESTIVAL PARADE IN ROCKLAND, MAINE.

433

# 11 CENTRAL & SOUTH AMERICA

436

# CENTRAL AND SOUTH AMERICA

When Hiram Bingham reached the top of a steep slope in the Peruvian Andes on July 24, 1911, he didn't simply find Machu Picchu, the lost city of the Incas, he laid claim to it for himself and posterity. That sense of personal and public possession would grow stronger when the young Yale professor returned on subsequent expeditions, financed in part by the National Geographic Society, and took hundreds of photographs, planting the cultural equivalent of surveyor's stakes.

Many of those photographs were published in NATIONAL GEOGRAPHIC magazine's April 1913 issue, which was devoted entirely to Bingham's report titled, "The Wonderland of Peru." His words and pictures brought Machu Picchu international fame and Bingham celebrity, fortune, and power. He became a star lecturer and author and later Connecticut's governor and U.S. Senator.

Bingham's 1913 photograph of the Inca ruins is a prime example of the powerful role photography plays in the complicated issue of ownership of great places. Nowhere is that issue more pressing than in South America, Central America, and the islands of the Caribbean. Combined, they form one of the world's most biologically diverse areas.

It's important to remember that a local guide told Bingham about the ruins and took him most of the way there. When the sweat-soaked professor reached the ridge crest, he first encountered Indians who gave him a drink of spring water. At the site, he found some terraces had been cleared and crops planted. The people living nearby obviously knew about the ruins, but had chosen isolation. The place obviously didn't hold the same meaning for them as it did for the tall, skinny American, with his ambitions, connections, and camera.

Legally, Machu Picchu belongs to Peru. Yet, ever since Bingham's photos were published, its figurative ownership has been expanding. Many people believe they have a stake in the place and have photos to prove it. With published photos, there is a chain of possession. Someone holds copyright to the image, usually the photographer or the publication. That ownership begins with the effort and investment that went into getting the picture. There is a kind of hunter-gatherer ethos attached to photography, manifested in the verbs commonly used to describe the act: take and shoot.

Once the photo is printed somewhere, the viewers take possession with their eyes. This may last only for the time it takes to turn a newspaper page, or it may be more enduring if they buy a photographic print or a book such as this one. Here you can look repeatedly, forming a deeper relationship to the picture and subject. That cute, red-eyed tree frog, which Michael Nichols photographed in Brazil, for example, is no longer some anonymous amphibian from the equatorial jungle. It's yours. You might as well name it.

A similar process occurs on the societal level. Whether consciously or subconsciously, people look at pictures of a place such as the Amazon rain forest and make it their own by putting it in the context of their cultural values. In the Western world, for example, photographs of the Amazon are subject to our ideas about property ownership, public and private space, and the scientific, educational, commercial, and spiritual value of the natural world, as well as the rights of indigenous peoples.

Since those ideas mean different things to different people, so do the pictures. A scientist might look at the photo of a snorkeler floating in a pool in the Cuatro Ciénegas Natural Protected Area, a 500-square-mile region of freshwater lakes, pools, and marshes in Mexico's Chihuahuan Desert, and think such a unique, beautiful ecosystem must be protected at all costs. The same picture may move another person to wonder about visiting the place and whether there is a nice hotel nearby. To a real estate developer, the photo could suggest the perfect place to build a resort. For a farmer living near the Cuatro Ciénegas, the picture might call to mind a favorite swimming hole and a certain irritation with all the outsiders claiming to know what's best for the place. Everyone involved considers his view valid.

The question of whom such a special place belongs to is of critical importance in the Amazon, which Thomas Lovejoy, the senior biodiversity advisor for the World Bank, describes as, "…the world's greatest wilderness, greatest forest, and largest repository of biodiversity. When I walk into the forest I feel at home, enveloped by nature. It is wilderness for the sophisticate, where the wonders are tiny and intricate, and where nature paints with more shades of green than one would think possible."

The peoples, cultures, flora, and fauna of the Amazon are unique. But they do not exist in a vacuum. Remote and inac-

cessible as parts of the Amazon are, NATIONAL GEOGRAPHIC magazine and other media have brought them to the world's attention. As a result, scientists, government officials, nature-lovers, and businesspeople from South America and the rest of the world have come to hold a stake in what is happening in the region.

So do the rain forest's indigenous people whose cultures and lives depend upon it. Experts believe there are groups living deep in the Amazon jungle who have never had contact with outsiders. Peru, Brazil, and other nations have designated tracts of the forest as preserves for some tribes. At the same time, the region is under tremendous development pressure from logging, mining, and oil and gas companies. Poor South Americans are migrating to the Amazon, seeking work as loggers and miners. Tourists looking to experience and photograph the Amazon's wonders keep coming. As a result, the native people retreat farther into the jungle and the character of the place is diminished.

While photographs helped create this situation, they can't do much to resolve it. The Amazon's indigenous peoples have proven highly susceptible to diseases and illnesses, such as tuberculosis and flu, brought in by outsiders. One person's photo vacation deep in the Amazon might be another person's demise.

Even Machu Picchu, the 500-year-old city whose structures were made from blocks of granite fitted together so well by Inca engineers that no mortar was needed, isn't immune to such pressures. Some 300,000 people a year visit the place these days, drawn by tales and photographs of its magical setting, a jewel-box city hidden in lush jungle green surrounded by towering, snow-capped peaks and rushing rapids.

The visitors pump money into Peru's economy. But their growing numbers put physical strain on the site and create trash and a certain amount of congestion on the ruins paths, stairs, and trails. Many of the visitors carry cameras and shoot pictures. They won't reap the kind of fame that Bingham sought and won, but like him, they go home with pictures that stake their small claim to one of the world's greatest places.

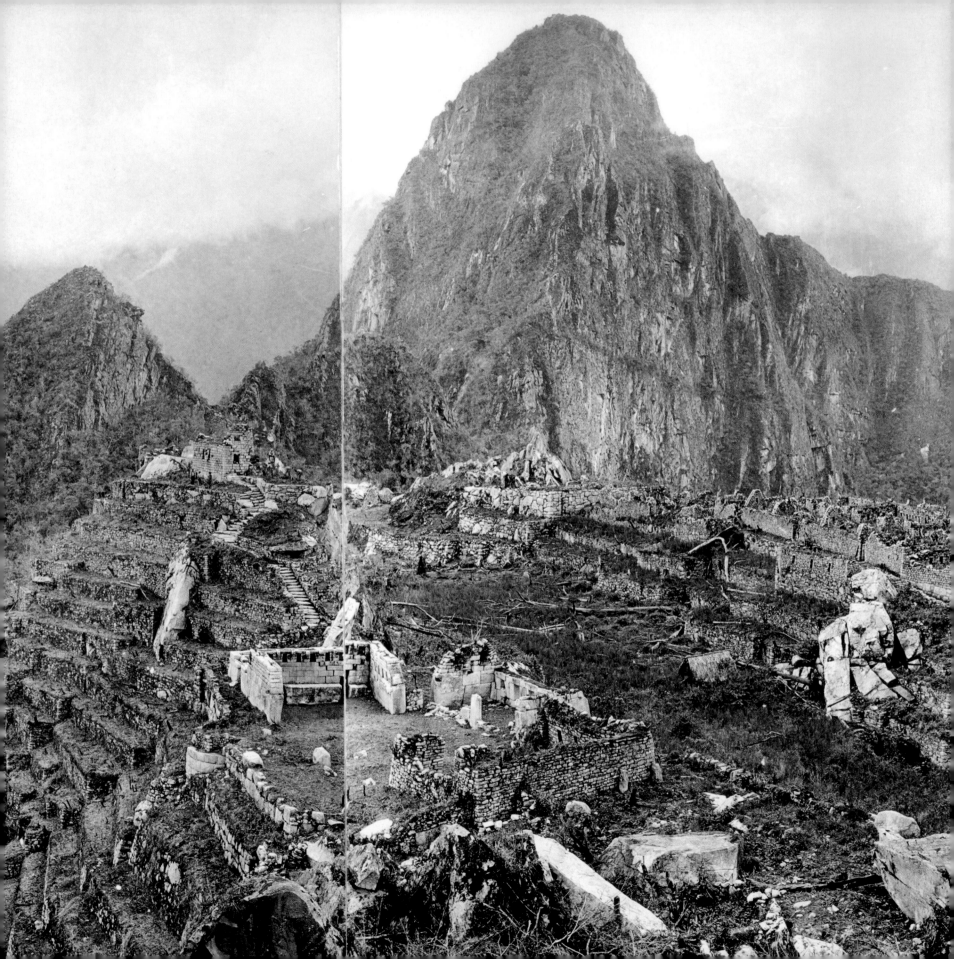

PREVIOUS PAGES: AMY TOENSING, 2003. NEW HOUSING DEVELOPMENT IN SANTA ISABEL, PUERTO RICO, IS A GOVERNMENT-SPONSORED ALTERNATIVE TO THE CROWDED BARRIOS.

LEFT: HIRAM BINGHAM, 1913. RUINS OF MACHU PICCHU IN PERU, DISCOVERED BY BINGHAM. SOME 300,000 PEOPLE A YEAR NOW VISIT THE SITE, INCREASING ENVIRONMENTAL AND DEVELOPMENT PRESSURES.

MICHAEL NICHOLS, 2003. TREE FROG CLIMBING A BRANCH IN THE
AMAZON BASIN, BRAZIL.

**PREVIOUS PAGES: STEVE WINTER, 2003. TWO MEN EXPLORE A FLUVIAL CAVE IN A *MOGOTE* IN CUEVA DEL PANEL, VALLE DE VINALES, CUBA.**

**LEFT: DAVID ALAN HARVEY, 1999. PLAZA VIEJA, A CENTERPIECE OF ONGOING REHABILITATION OF HAVANA, CUBA'S HISTORIC QUARTER.**

450    STEVE VAUGHN, 2001. A BOAT LIES AT ANCHOR IN WATERS OFF THE BAHAMAS.

THROUGH PHOTOS, PEOPLE STAKE A SMALL

CLAIM TO THE WORLD'S GREATEST PLACES. ℘

Pablo corral Vega, 2000. wildflowers in the mountains of Venezuela.

454

458

TOP LEFT: SISSE BRIMBERG, 1996. MEXICANS CELEBRATING DIA DE LOS MUERTOS (THE DAY OF THE DEAD) KEEP VIGIL IN CEMETERIES, GREETING THE SOULS OF LOVED ONES WITH PRAYERS, FLOWERS, AND FOOD.

BOTTOM LEFT: SISSE BRIMBERG, 1996. A YOUNG MEXICAN BOY CARRIES A DECORATED CROSS FOR THE "DAY OF THE DEAD" CEREMONY IN SAN PAULITO, PUEBLA STATE, MEXICO.

Luis Marden, 1936. A boy is framed in the window of a cathedral destroyed by an earthquake in 1773, in Antigua, Guatemala.

STEPHANIE MAZE, 1984. CHILDREN OF THE CANDOMBLE CULT WEAR TRADITIONAL CEREMONIAL GOWNS TO ATTEND THE "FESTA POPULAR DE SÃO LAZARO," SALVADOR, BRAZIL.

ROBERT CAPUTO, 1998. A CAPYBARA IS ROPED DURING THE PRE-EASTER ROUND-UP AT A RANCH IN VENEZUELA. TRADITION HOLDS THAT THE SEMI-AQUATIC ANIMAL IS A FISH AND SO OFFERS GUILT-FREE DINING DURING LENT, WHEN FAITHFUL CATHOLICS SHUN MEAT.

465

GEORGE GRALL, 1995. A SNORKELER FLOATS IN A POND IN THE CUATRO CIÉNEGAS NATURAL PROTECTED AREA, A 500-SQUARE-MILE REGION OF FRESHWATER LAKES, POOLS, AND MARSHES IN MEXICO'S CHIHUAHUAN DESERT.

KENNETH GARRETT, 2003. A STONE CARVING OF TAN TE' K'INICH, A ROYAL FAMILY MEMBER IN THE RUINS OF THE CITY OF AGUATECA, A CLASSIC MAYA ARCHAEOLOGICAL SITE IN GUATEMALA.

Left: Tomasz Tomaszewski, 1995. Boy with balloons at a girl's 15th birthday celebration, Yucatan, Mexico.

Following Pages: C. W. Blackburne, 1902. St. Pierre, Martinique, before the 1902 eruption of Mont Pelée.

471

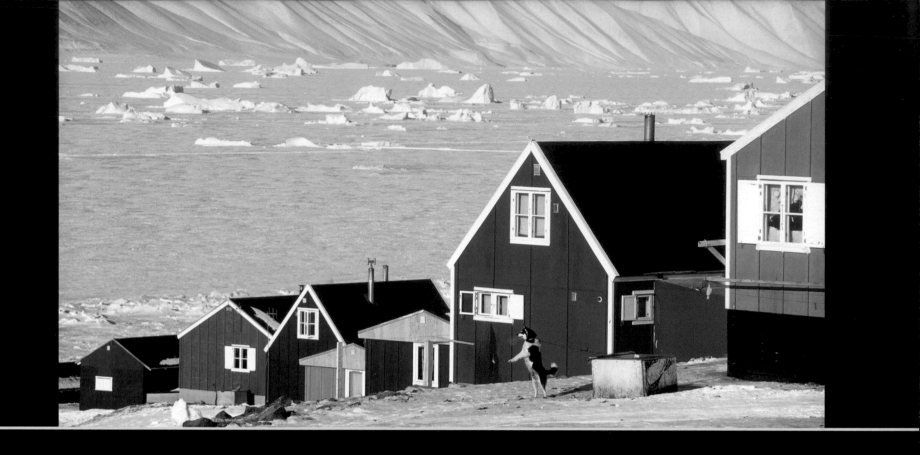
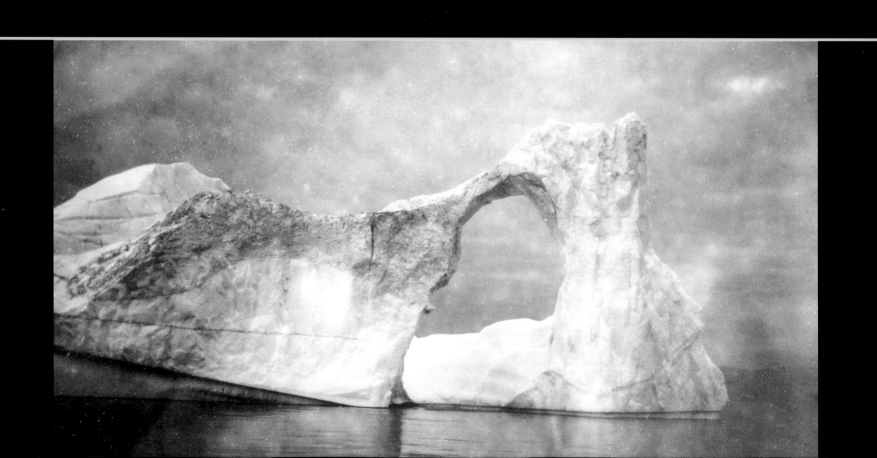

# 12 POLAR REGIONS

PREVIOUS PAGE TOP: MICHAEL LEWIS, 2003. COLORFUL DANISH-STYLE HOUSES IN QAANAAQ, GREENLAND.

BOTTOM: ROBERT E. PEARY COLLECTION, 1896. ICEBERG IN DAVIS STRAIT, ARCTIC OCEAN, TAKEN ON THE PEARY ARCTIC EXPEDITION OF 1896.

# POLAR REGIONS

No one lives at the geographic North and South Poles. Very few human beings have ever visited them. The layers of history and culture that have shaped so many other places and our perceptions of them seem absent at the Poles. Yet, more than anywhere else on Earth, the polar regions are places mediated by culture in general and photography in particular.

The era of polar exploration, which began in the late 18th century and culminated in the 20th when Robert E. Peary and Roald Amundsen led the first expeditions to reach, respectively, the geographic North and South Poles, coincided with the rapid development of photography, photomechanical reproduction, and telecommunications. These technologies allowed a global mass audience to read in timely fashion about explorers' latest efforts and, more important, to see photographs of the people, places, and things involved. In the United States, the National Geographic Society's magazine was the primary source of polar coverage.

Reaching the Poles was as much a cultural milestone as a geographic and scientific coup. It was geography as mass entertainment, a blockbuster mix of drama, tragedy, individual initiative, national pride, and race-course excitement played out against a dazzling landscape by larger-than-life characters who knew how to use a camera from both sides of the lens. The Poles were objects and objectives assigned tremendous significance by the countries, cultures, and people striving to reach them. Peary summed up the prevailing attitude when he wrote in his diary on April 6, 1909, "The Pole at last!!! The prize of 3 centuries, my dream & ambition for 23 years. Mine at last. I cannot bring myself to realize it. It all seems so simple…"

It wasn't. Nor was it his for long. In addition to courage and luck, Peary's expeditions, like those later of Richard E. Byrd at the South Pole, required a great deal of planning and financial and logistical support, some of which was provided by the National Geographic Society. It was money well spent. In return, the Society shared in the international acclaim and prestige that came to Peary. The polar regions would also become one of the Society's enduring passions and quintessential photographic subjects. An entire issue of the magazine was devoted to Peary's accomplishment. His photos, and others taken during the expedition, quickly transferred visual claim to the North Pole to the general public.

Even before Peary reached the geographic North Pole, the public was fascinated by photos of the polar regions. That fascination has endured. It begins, of course, with the unique landscape, climate, and cultures found in these places. Although the Arctic Circle is often depicted as a lifeless snow desert, people, animals, and plants have lived within it for thousands of years, adapting to the cold, the snow and ice, the long hours of darkness in winter and sunlight in summer. A variety of plant and animal life also flourishes in Antarctica under even harsher conditions.

The polar regions are also compelling photographic subjects, offering a variety of shapes, colors, and light found nowhere else on Earth. There are countless gradations of white, blue, red, purple, and green in these photographs taken in Russia, Canada, Antarctica, Norway, Alaska, Greenland, and the Arctic Ocean. The forces of nature create ice sculptures that could have been fashioned by Henry Moore or Constantin Brancusi. Snowfields seem like pure minimalism, while the northern lights and midnight sun bring surrealism's time- and mind-bending essence to life. Even when humans and the built environment are in the picture, the place dominates. Its power almost defies depiction. A photograph freezes the colors of snow and ice at a moment in time, giving them a monotone look. But their hues constantly shift. Photos cannot capture the fluidity of those changes.

Nature reigns in these places, and human beings must struggle to make their marks against invisible forces such as cold, wind, and their own frailties. That confrontation can be seen in the photograph of members of Sir Douglas Mawson's expedition to Antarctica in 1912-13, battling the wind as they hack ice to make drinking water, or in David Alan Harvey's contemporary shot of Inupiat whale-hunters dragging a sealskin boat, the same kind of craft used by their ancestors, across the ice to the Chukchi Sea near Barrow, Alaska.

For men such as Amundsen, Peary, Mawson, Ernest H. Shackleton, and Robert Falcon Scott, confronting the polar elements was the price to be paid for gaining scientific knowledge and for a shot at the historic recognition and public acclaim accompanying achievement of a geographic first. For the indigenous inhabitants, that confrontation is simply a fact of existence. In both cases, the polar regions gave meaning to their lives, and the people gave and still give meaning to the place.

Wondrous as the polar regions' landscape looks, that alone does not explain their immense appeal. Neither does their

remoteness and inaccessibility nor their howling winds and temperatures that have reached minus 100°F in Antarctica. The Poles' great power is as vast, empty spaces ripe for imagining, blank slates bookending an invisible axis about which our planet rotates. For those of us who may never go there, the polar regions offer what Canadian pianist and intellectual Glenn Gould described in his radio documentary, "The Idea of North," aired on CBC Radio in 1967, as "a convenient place to dream about, spin tall tales about, and, in the end, avoid."

Gould's fascination with the North prompted him to actually travel above the Arctic Circle, collecting voices and impressions for his documentary. The people he recorded spoke about their lives and their desires for, among other things, separation from modern life, solitude, and an existence in closer harmony with nature that hasn't been spoiled by man.

This notion of the polar regions as places distant, pure, and unspoiled, where a person must rely on himself and focus on the essentials of existence, is recurrent in the literature inspired by those places. Perhaps that idea of self-reliance against long odds is the ultimate magic of the Poles. Even as photographs, they force us to think about life as a straightforward matter of survival or death. They bring us closer to the fragile, finite pole of the self, around which all our lives rotate.

As with all places, whether we go to them or only visit through photographs, meaning comes first from the individual, from one's personal experience of the place or its image and what role one gives that experience in the story of one's life. It is a cliché but nonetheless true that the greatness of any place, whether it is seen from inside or out, directly or indirectly, is in the eye of the beholder. Whether you are on the top or the bottom of the world or anywhere in between, there are many great places. Some people see them, others don't, and some never even bother to look. But may you always find yourself in one whenever you open, or close, this book.

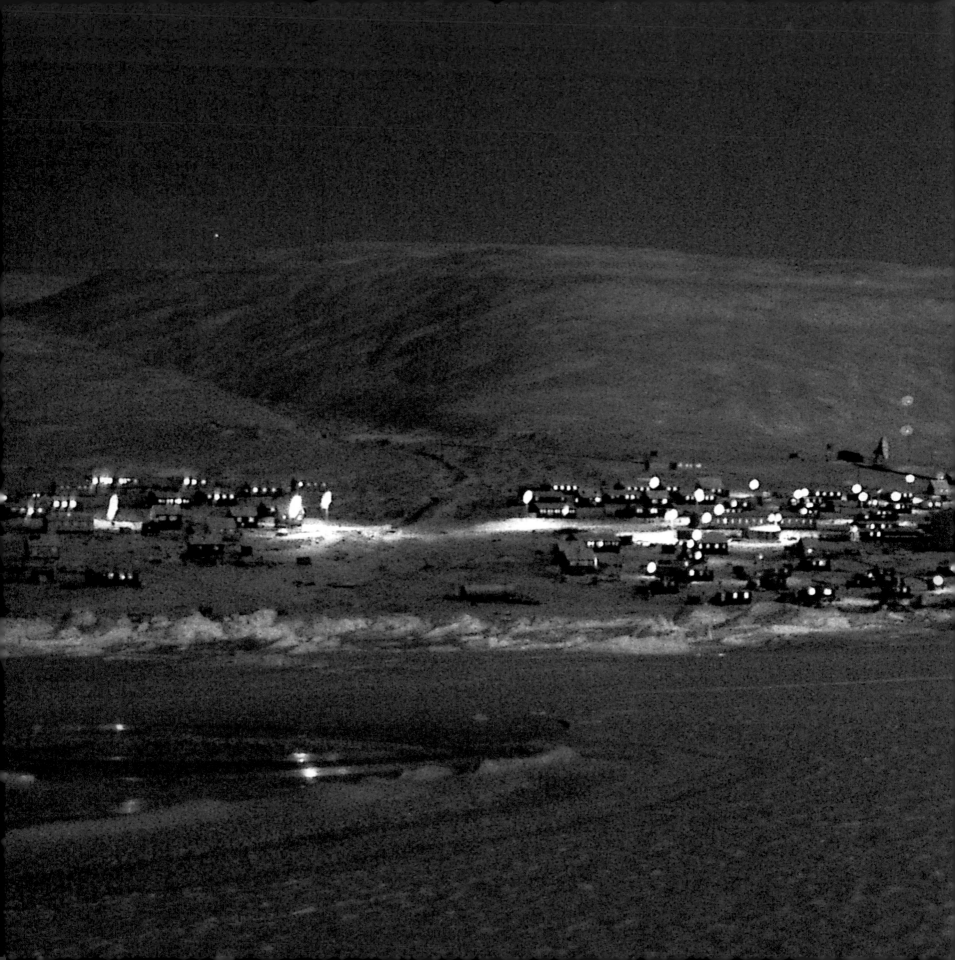

*483*

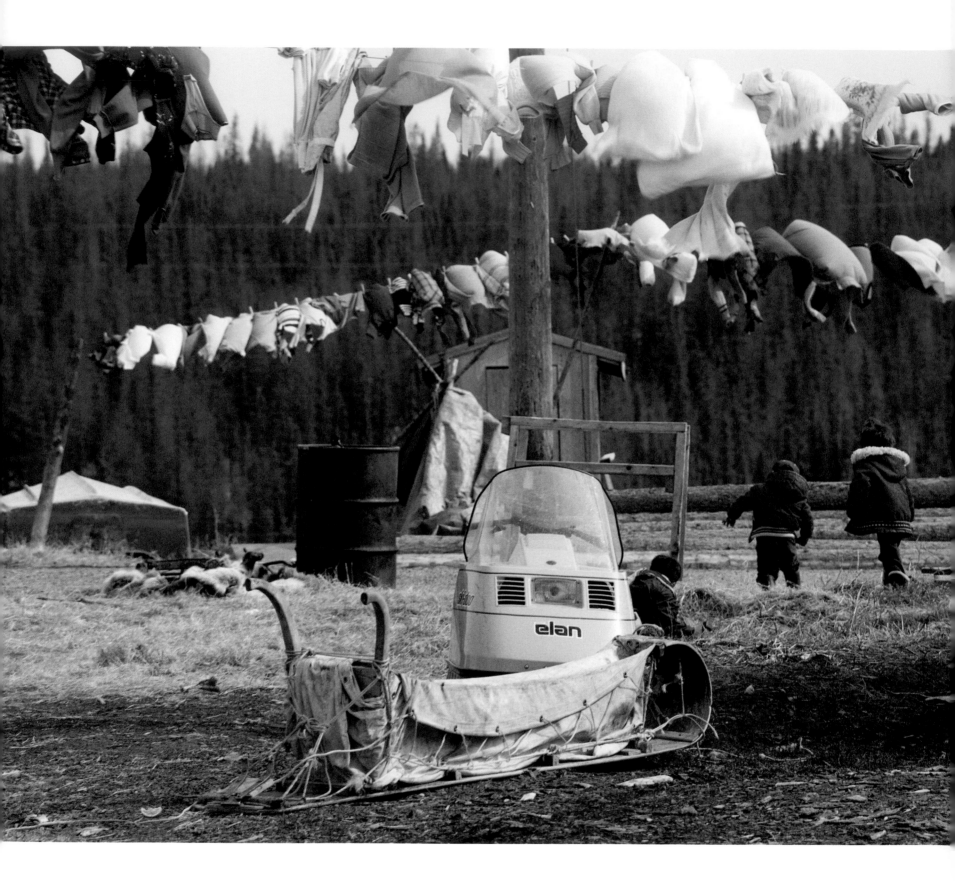

PRIIT VESILIND, 1982. NATIVE CHILDREN WITH LAUNDRY AND OLD AND NEW WAYS OF TRAVEL, NA-DENE INDIAN COMMUNITY OF NORMAN WELLS, MACKENZIE RIVER, NORTHWEST TERRITORIES, CANADA.

485

BILL CURTSINGER, 1986. EMPEROR PENGUINS SWIM BENEATH THE ICE IN A NEVER-ENDING HUNT FOR SQUID. CONTRAILS OF AIR BUBBLES ESCAPE FROM THEIR FEATHERS WHEN THE BIRDS ACCELERATE. SHALLOW AND NUTRIENT RICH, THE WATERS OF MCMURDO SOUND IN ANTARCTICA PROVIDE AN AMPLE FEAST.

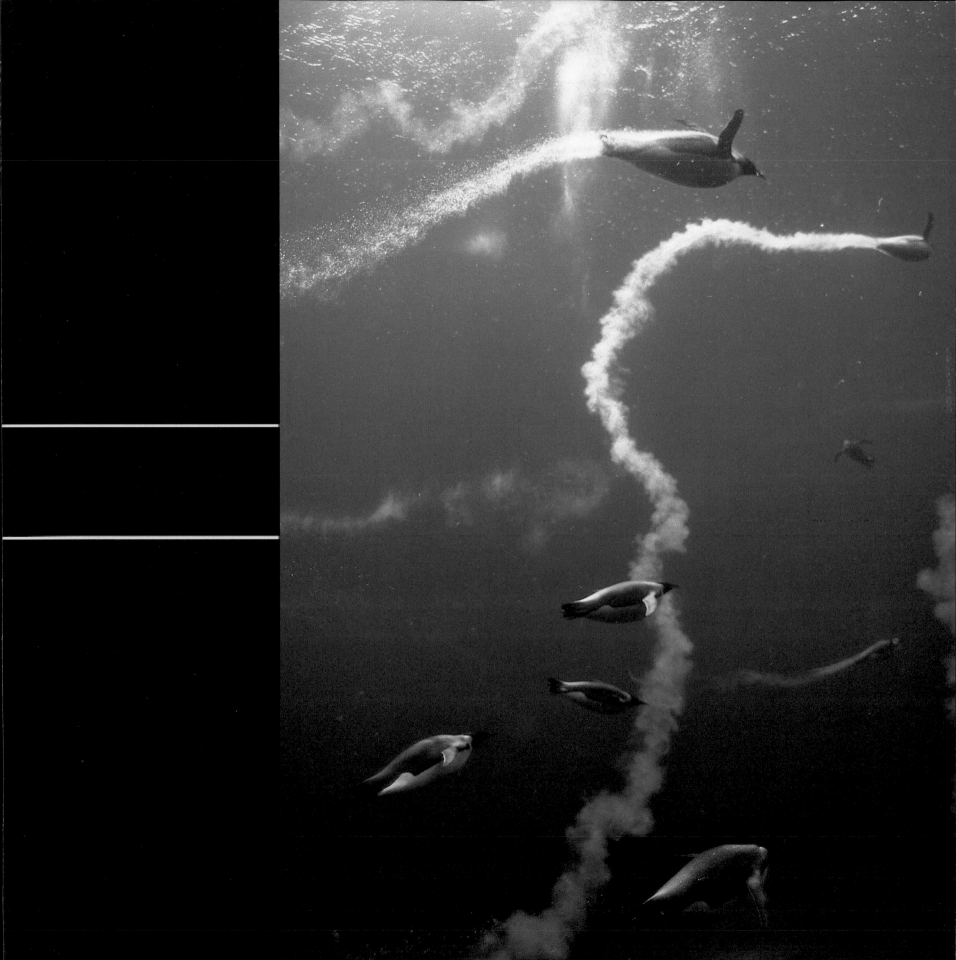

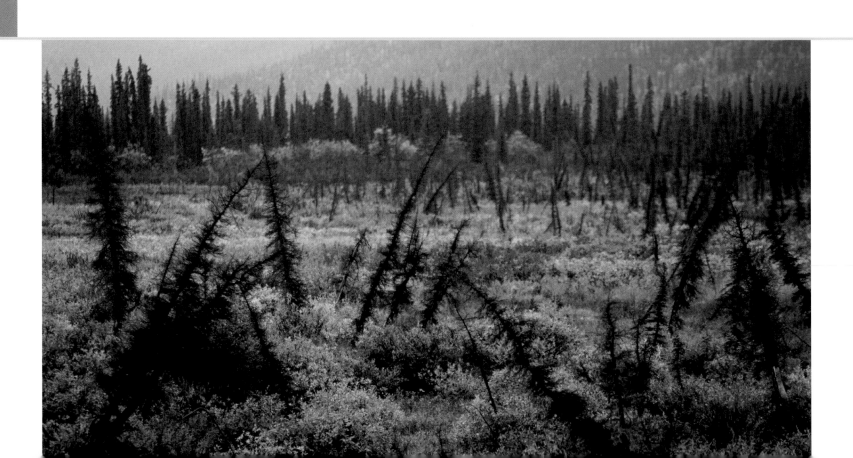

TOP LEFT: RALPH LEE HOPKINS, 2004. SUNLIGHT PEEKS THROUGH THE FOG TO HIGHLIGHT SEA STACKS IN NORWAY'S SVALBARD ARCHIPELAGO.

BOTTOM LEFT: RICHARD OLSENIUS, 2003. EARLY FALL OFF THE DEMPSTER HIGHWAY ALONG THE BROOKS RANGE, ALASKA.

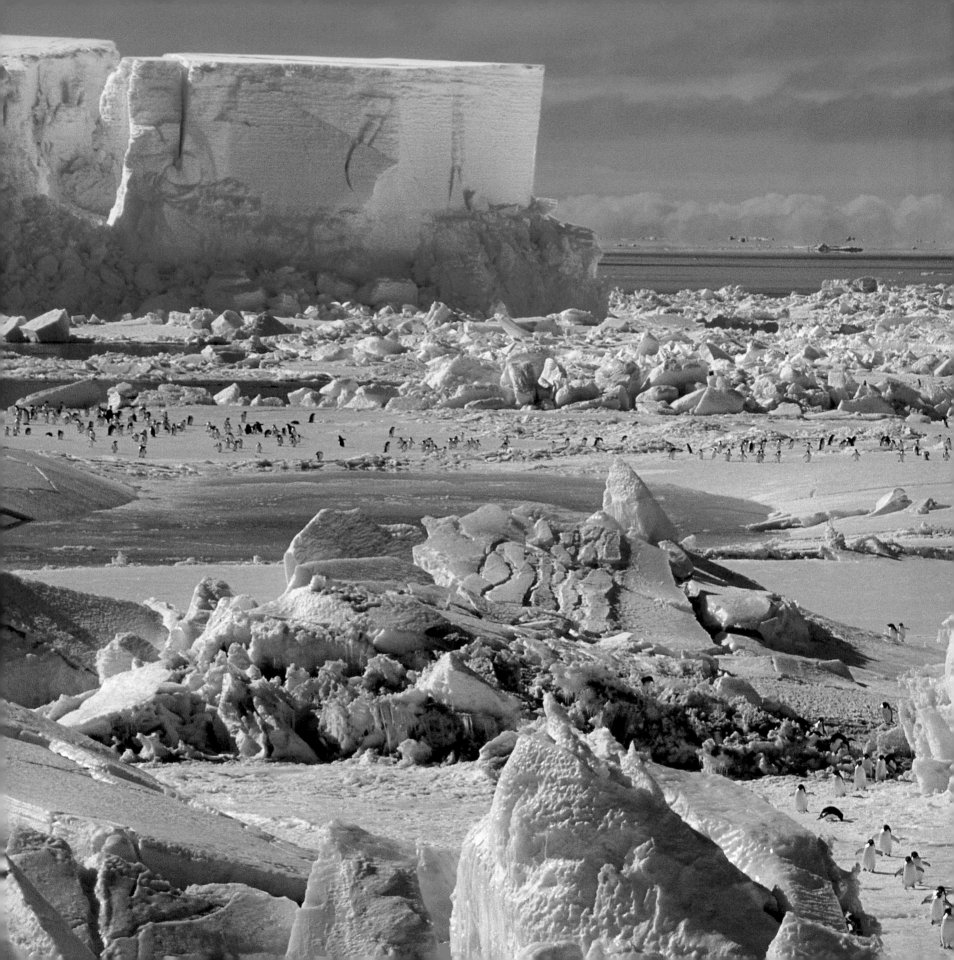

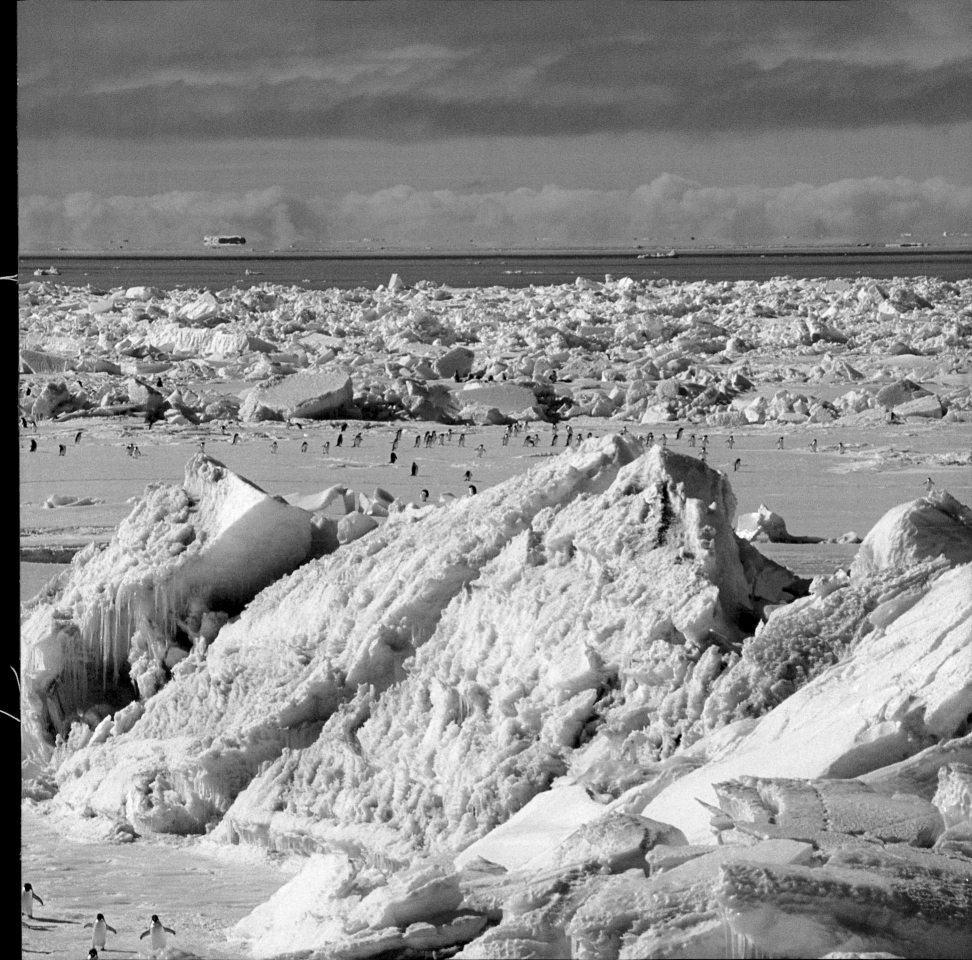

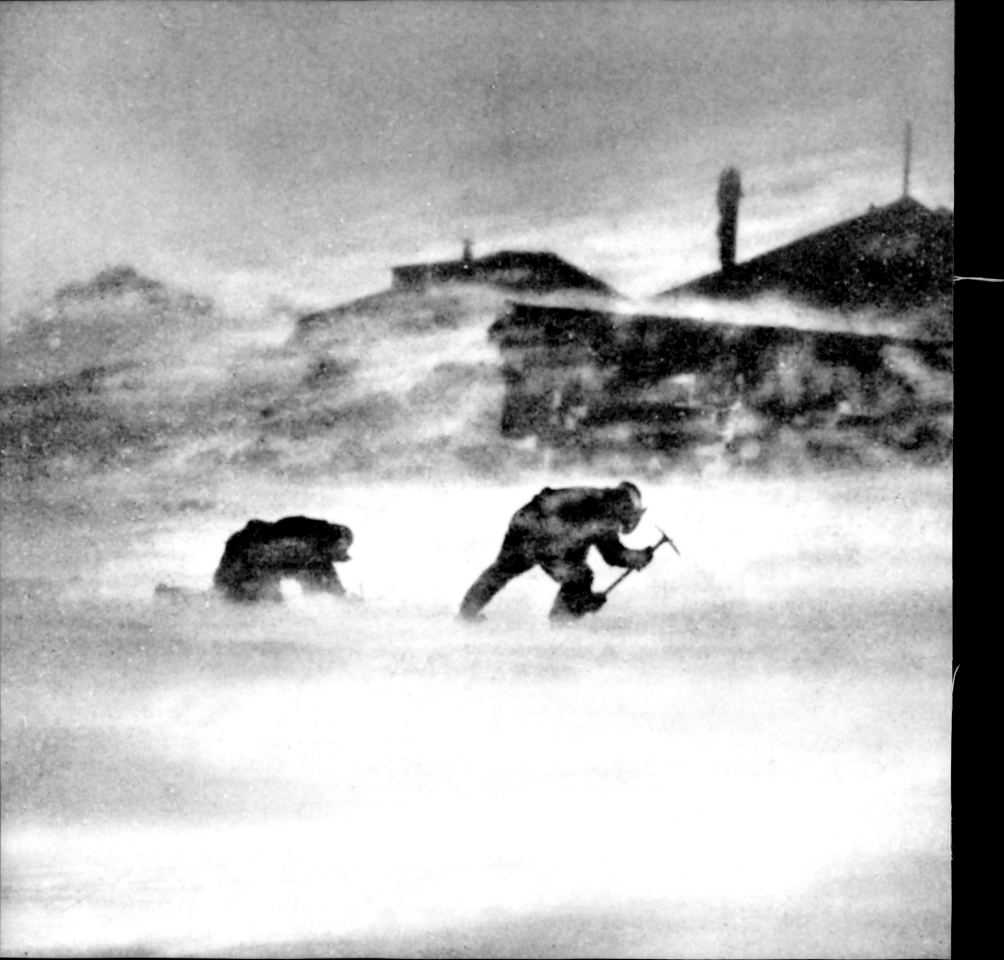

*493*

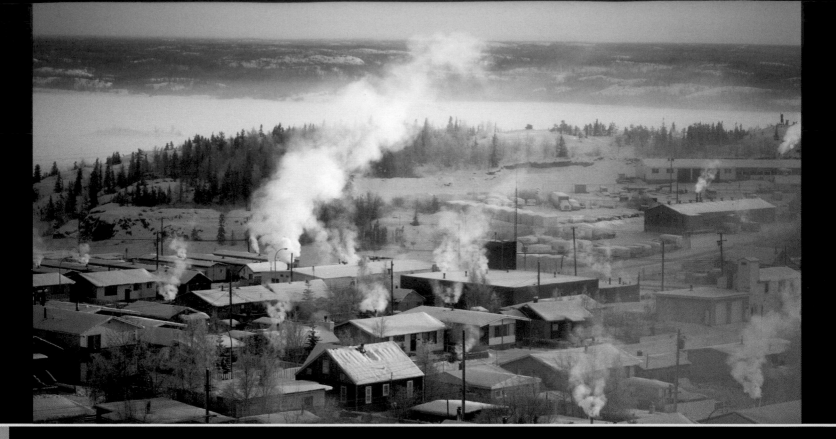

LEFT: PRIIT VESILIND, 1982. YELLOWKNIFE ON THE NORTHWESTERN SHORE OF GREAT SLAVE LAKE, THE LARGEST TOWN IN CANADA'S NORTHWEST TERRITORIES.

RIGHT: MARIA STENZEL, 2001. THE SUN CASTS A REFLECTION ON THE WATER DURING A LATE SUMMER NIGHT IN ANTARCTICA.

POLAR REGIONS ARE PLACES MEDIATED

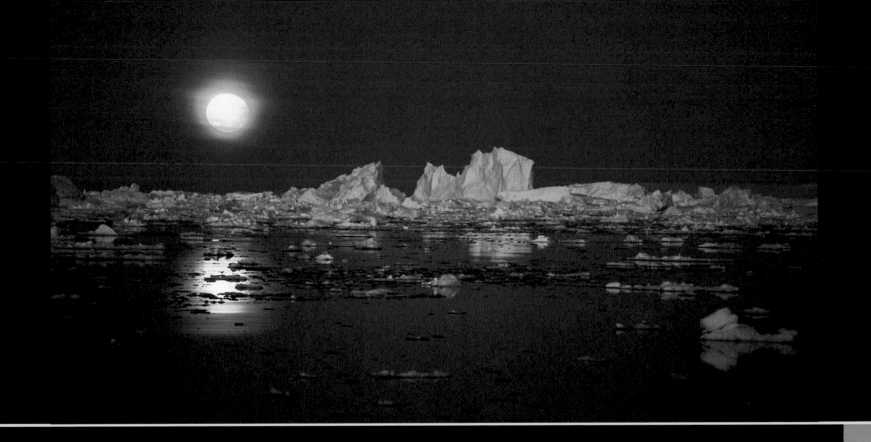

MAINLY BY CULTURE AND PHOTOGRAPHY. ☞

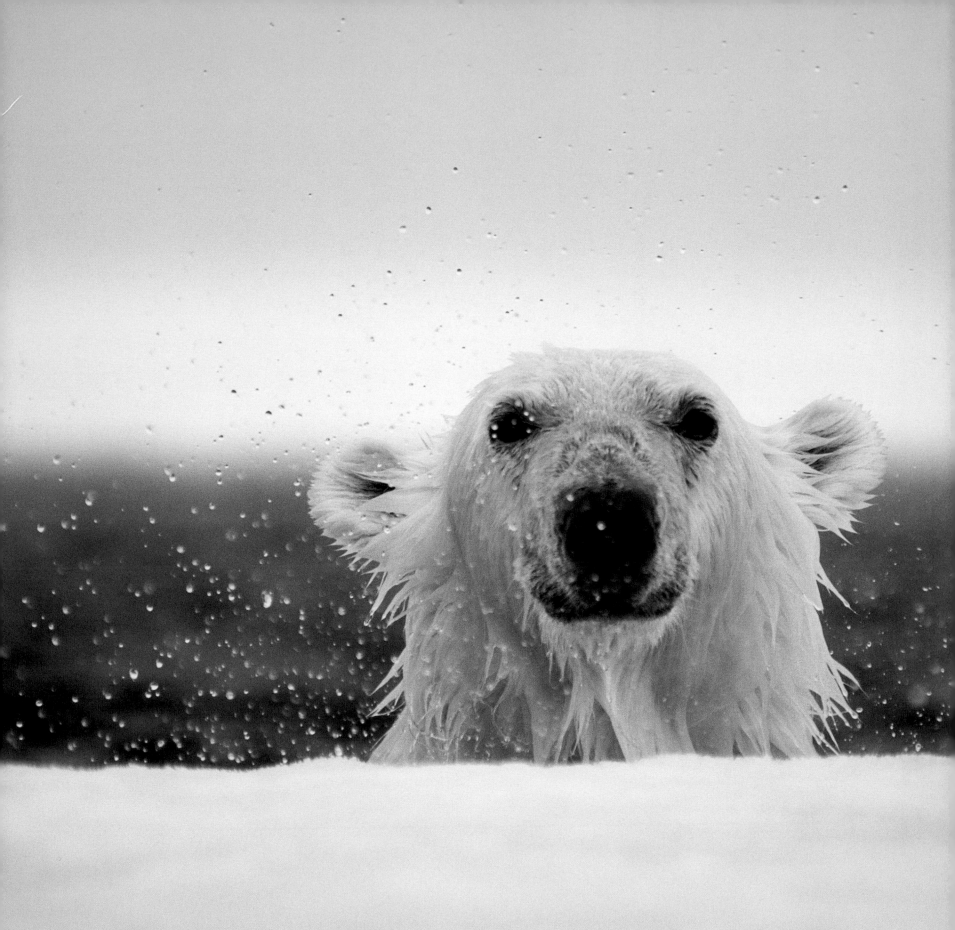

PAUL NICKLEN, 2001. A WET POLAR BEAR STICKS ITS HEAD UP ABOVE THE ICE IN NORTH BAFFIN ISLAND, NUNAVUT, CANADA.

497

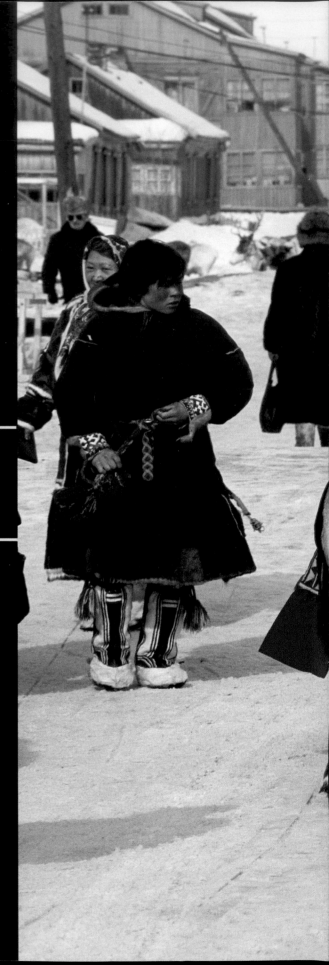

498 Maria Stenzel, 1996. A Nenets woman leads her decorated reindeer through Yar Sale during the annual festival. Yar Sale, Yamal Peninsula, Siberia, Russia.

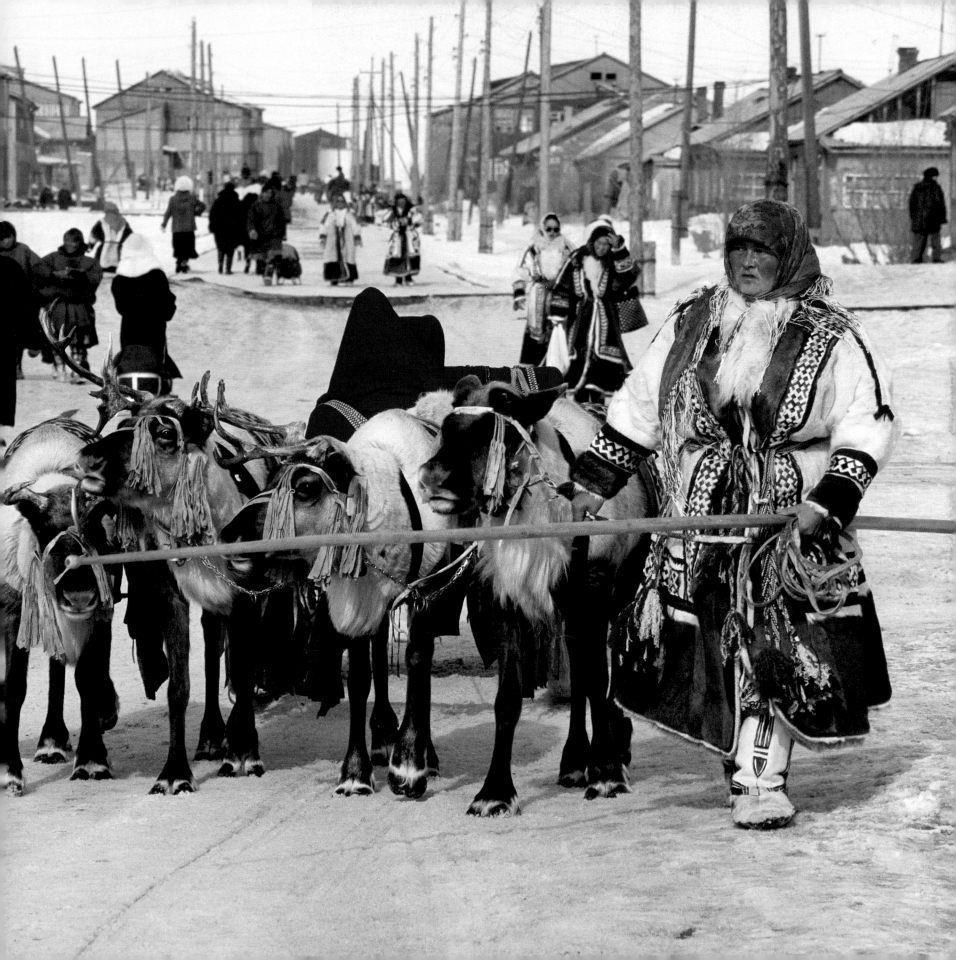

LEFT: MARIA STENZEL, 1995. BRIDGE OF THE ICEBREAKER *NATHANIEL B. PALMER* IN AN OPEN LEAD, BELLINGSHAUSEN SEA, ANTARCTICA.

FOLLOWING PAGES: DAVID ALAN HARVEY, 2001. AN ESKIMO CREW HAULS A SEALSKIN BOAT TO THE CHUKCHI SEA, BARROW, ALASKA.

501

# WIDE ANGLE
## NATIONAL GEOGRAPHIC GREATEST PLACES

By Ferdinand Protzman

## PUBLISHED BY THE NATIONAL GEOGRAPHIC SOCIETY

John M. Fahey, Jr., President and Chief Executive Officer

Gilbert M. Grosvenor, Chairman of the Board

Nina D. Hoffman, Executive Vice President

## PREPARED BY THE BOOK DIVISION

Kevin Mulroy, Senior Vice President and Publisher

Marianne R. Koszorus, Design Director

Leah Bendavid-Val, Director, Photography Books

## STAFF FOR THIS BOOK

Leah Bendavid-Val, Editor

Melissa Hunsiker, Assistant Editor

Rebecca Lescaze, Text Editor

Susan Blair, Illustrations Editor

Peggy Archambault, Art Director

Anne Moffett, Researcher

R. Gary Colbert, Production Director

Rebecca Hinds, Managing Editor

Meredith C. Wilcox, Editorial Illustrations Specialist

Mike Horenstein, Production Project Manager

Theodore B. Tucker, IV, Design and Production Assistant

## MANUFACTURING AND QUALITY CONTROL

Christopher A. Liedel, Chief Financial Officer

Phillip L. Schlosser, Managing Director

Clifton M. Brown, Manager

Library of Congress Cataloging-in-Publication Data

Available on request

One of the world's largest nonprofit scientific and educational organizations, the National Geographic Society was founded in 1888 "for the increase and diffusion of geographic knowledge." Fulfilling this mission, the Society educates and inspires millions every day through its magazines, books, television programs, videos, maps and atlases, research grants, the National Geographic Bee, teacher workshops, and innovative classroom materials.

The Society is supported through membership dues, charitable gifts, and income from the sale of its educational products. This support is vital to National Geographic's mission to increase global understanding and promote conservation of our planet through exploration, research, and education.

For more information, please call 1-800-NGS LINE (647-5463) or write to the following address:

National Geographic Society
1145 17th Street N.W.
Washington, D.C. 20036-4688 U.S.A.

Visit the Society's Web site at
www.nationalgeographic.com.

## ACKNOWLEDGMENTS

The editors of *Wide Angle* are indebted to the National Geographic Image Collection, Image Sales, Digital Imaging Lab, and National Geographic Archives, especially Brian Drouin, Susie Riggs, Paula Allen, Lisa Mungovan, Sanjeewa Wickramasekera, Erika Norteman, Bill Bonner, Charles W. Harr, Betty Behnke, and David C. Uhl.

We also thank our colleagues at North American Color, especially Lisa Baker, Sue Blesch, Mike Eddington, Pete Groff, and Kellie Pijaszek.

Finally, our appreciation goes to our colleagues in National Geographic's International Licensing and Alliances, especially Robert Hernandez, Howard Payne, and Maeyee Lee, for their support and involvement in this project.

Note on dates: Date of first publication appears with previously published pictures; date of acquisition appears with unpublished photographs; when exact dates are unknown, approximate dates are given.

Ferdinand Protzman is an award-winning cultural writer and critic and author of the highly acclaimed book *Landscape: Photographs of Time and Place*. His reviews, essays, and articles have appeared in the *Washington Post*, the *New York Times*, the *Wall Street Journal*, the *International Herald Tribune*, *ARTnews*, the *Harvard Review*, *Forward,* and *Zeit-Magazin*. He contributed an essay to *National Geographic Photographs: The Milestones* and wrote the afterword to Arion Presse's limited edition of *The Voices of Marrakesh*, by Nobel Prize-winner Elias Canetti.

Photographs on pages 2 to 27: Pages 2-3: Stuart Franklin, Huangshan (Yellow Mountains), Southern Anhui Province, China; Pages 4-5: George Steinmetz, Great Barrier Reef, Australia; Pages 6-7: Robb Kendrick, Khumbu Region, Nepal; Pages 8-9: Reza, Israel; Pages 10-11: Sam Abell, The Birch Allée , Yasnaya Polyana, Russia; Pages 12-13: Sisse Brimberg, Elverhoej, Sjaelland, Denmark; Pages 14-15: James L. Stanfield, Segovia, Spain; Pages 16-17: Kenneth Garrett, Bahariya Oasis, Egypt; Pages 18-19: David Doubilet, Okavango River, Botswana; Pages 20-21: Diane Cook and Len Jenshel, Escalante National Monument, Utah, USA; Pages 22-23: Peter Essick, Perito Moreno Glacier, Lake Argentino, Glaciers National Park, Patagonia; Pages 24-25: Norbert Rosing, Nunavut, Northwest Territories, Canada; Pages 26-7: Steve Vaughn/Panoramic Images, Mexico; Pages 30-31: Sam Abell, Yasnaya Polyana, Russia; Robert Estall Agency: 346-7, 358-9, 380 (low);Getty Images: 260-1; Magnum Photos: 320-1; Minden Pictures: 361; National Geographic Image Collection: 12-3, 24-5, 30-1, 40, 52-3, 56-7, 60-1, 67, 73, 94, 109 (up), 132, 149, 166-7, 190 (both), 218-9, 230 (both), 238, 250-1, 254-5, 266-7, 270 (low), 280-1, 288, 296-7, 300-1, 326-7, 332-3, 348 (up), 354-5, 356, 369, 388 (up), 400-1, 406, 410 (both), 415, 416-7, 429, 432-3, 434, 444-5, 474 (up), 482, 484-5, 488 (both), 494, 496-7; Panoramic Images: 26-7, 62-3, 170-1, 282-3, 450-1.